Museums and Modernity

Leisure, Consumption and Culture

General Editor: Rudy Koshar, *University of Wisconsin at Madison*

Leisure regimes in Europe (and North America) in the last two centuries have brought far-reaching changes in consumption patterns and consumer cultures. The 1980s and 1990s have seen the evolution of scholarship on consumption from a wide range of disciplines but historical research on the subject is unevenly developed for late modern Europe, just as the historiography of leisure practices is limited to certain periods and places. This series encourages scholarship on how leisure and consumer culture evolved with respect to an array of identities. It relates leisure and consumption to the symbolic systems with which tourists, shoppers, fans, spectators, and hobbyists have created meaning, and to the structures of power that have shaped such consumer behaviour. It treats consumption in general and leisure practices in particular as complex processes involving knowledge, negotiation, and the active formation of individual and collective selves.

Museums and Modernity

Art Galleries and the Making of Modern Culture

Nick Prior

BERG

Oxford • New York

First published in 2002 by
Berg
Editorial offices:
150 Cowley Road, Oxford, OX4 1JJ, UK
838 Broadway, Third Floor, New York, NY 10003-4812, USA

Berg is the imprint of Oxford International Publishers Ltd.

Library of Congress Cataloging-in-Publication Data
Prior, Nick.
 Museums and modernity : art galleries and the making of modern culture / Nick Prior.
 p. cm. – (Leisure, consumption and culture, ISSN 1468-571X)
Includes bibliographical references and index.
 ISBN 1-85973-503-7 – ISBN 1-85973-508-8 (pbk.)
 1. Art museums–Europe–History. 2. Art museums–Great Britain–History. 3. Art and
state–Europe. 4. Art and state–Great Britain. I. Title: Art galleries and the making of
modern culture. II. Title. III. Series.
 N1010 .P75 2002
 708.9182`1–dc21

 2002002816

British Library Cataloguing-in-Publication Data
A catalogue record for this book is available from the British Library.

ISBN 1 85973 503 7 (Cloth)
 1 85973 508 8 (Paper)

Typeset by JS Typesetting, Wellingborough, Northamptonshire
Printed in the United Kingdom by MPG Books, Cornwall

Dedicated to Mum, Dad, Julian and Sarah for their love and support . . . and to the memory of Chris who is much missed

Contents

Acknowledgements

It's somehow more honest and affirmative to admit the messy realities and dialogues of life into what on the surface appears to be a unitary product of the authorial voice. Like galleries themselves, text emerges through the filters and noises of history, both prosaic and grand. It carries the weight of years of transition – personal, intellectual, political and accidental – and derives from influences far too convoluted and shapeless to recover properly in a page. So I must flatten it.

I am indebted to John Orr, John Holmwood and Stana Nenadic, each in their varying ways sources of professional and personal motivation, for their input as supervisors for the doctoral thesis that this book is based upon. Grateful thanks also go to Bridget Fowler and Gordon Fyfe for comments on the project in their capacities as external examiners, to Rudy Koshar as general editor, to Kathryn Earle and Ian Critchley at Berg Publishers and to Fintan Power for his meticulous reading of the manuscript. With respect to access to primary materials thanks go to the librarians and staff at the Royal Scottish Academy, the National Gallery of Scotland, the Scottish Records Office and National Library of Scotland. Were it not for the patience and expertise of this group of people I would probably still be floundering in archives. I am grateful, also, to the Faculty of Social Sciences at the University of Edinburgh for the generous allocation of a faculty initiatives fund to help with the illustrations and copyright permissions. Copyright holders of the illustrations are acknowledged below the images themselves.

On a less formal, but no less important, level I need to identify and credit a cluster of people who in disparate ways formed the kind of support system evaluated in Becker's *Art Worlds*: colleagues at both Derby and Edinburgh, for providing those innumerable moments of 'life' born of humour, intellect and other substances; Chris and Mads, for courage; my brother, whose talent and humility was the reason I took up this sociology lark; Sarah, for her enduring encouragement, love and toleration in guiding me through tough times; and, finally, my mum and dad, without whom none of this. Thank you to the entire lot, for the entire lot (although all errors are solely mine).

Some of what is now Chapter 2 appeared as 'Museums: Leisure Between State and Distinction', in *Histories of Leisure*, Rudy Koshar (ed.), Berg: Oxford, 2002. A revised version of Chapter 5 appeared as 'A Different Field of Vision: Gentlemen and Players in Edinburgh, 1826–1851', in *Reading Bourdieu on Society and*

Acknowledgements

Culture, Bridget Fowler (ed.), Sociological Review Monographs, Blackwell: Oxford, 2000. I am indebted to Blackwell Publishers for permission to reproduce sections of this chapter. Chapter 6 first surfaced as a working paper published by the Department of Sociology, University of Edinburgh, in 1996, appeared in shortened form in *Cultural Logic: An Electronic Journal of Marxist Theory and Practice*, http://eserver.org/clogic, volume 2, number 2, Spring 1999 and then as 'The Art of Space in the Space of Art: Edinburgh and its Gallery, 1780–1860', in *The Museum and Society*, Gordon Fyfe, Susan Pearce and Kevin Hetherington (eds), Continuum–Athlone Press: London, 2002. Finally, part of Chapter 4 appeared as 'The Art of Criticism: The Critic as Arbiter of Taste in the Scottish Enlightenment', *Edinburgh Working Papers in Sociology*, no. 19, 2000. Much of the material published here, however, has been reformulated and revised.

Nick Prior
Edinburgh
November 2001

List of Figures

List of Figures

Part I

Museums and Modernity in Europe and England

Introduction

To be modern is to live a life of paradox and contradiction.

(Berman, 1983: 13)

Today it goes without saying, to paraphrase Adorno (1972), that nothing concerning the world of art museums goes without saying. In a climate of international brinkmanship and hyper-commodification art museums have become objects of intense scrutiny: academic, corporate, governmental, journalistic. They inhabit a space subject to the increasing excesses of the late modern in all its ambiguity, enjoying unprecedented global growth yet also being transformed beyond the limits of the museological as it was shaped in the modern age. The current interest is caught in a moment of cultural inflation, academic expansion and millennial tension. On the one hand, 'saving' Canova's *Three Graces* from export to the Getty Museum has been heralded as a 'national victory' in Britain. In the summer of 1994 the state refused to give the piece an export licence after a high profile campaign staged by the National Galleries of Scotland and the Victoria and Albert Museum. Instead, the neo-classical piece was sent on a national tour, boxed in its own installation space and 'auratised' with a set of celebratory exhibition notes. On the other hand, the developing fascination with museums is testament to the greater reflexivity that modern societies have performed towards their own institutions and material objects in general. Higher education, for instance, has witnessed the growth of 'museum studies' departments and courses that pore over the details of museum policy, object relations and social change.

Over the past decade, as a result, a body of work has developed in distinction to an unencumbered conventional history that has scrutinised the intricate social, political and historical relations that structure and are structured by the museum. Born of interdisciplinary exigencies and pockets of academic vision, this body of literature has begun the complex task of widening the scope of analysis in order to subject practices of collecting, classifying and displaying to conceptual probes drawn from the social sciences and humanities (Bennett, 1995; Duncan, 1995; Fyfe, 2000; Karp and Lavine, 1991; Lorente, 1998; Lumley, 1988; McLellan, 1994; Pearce, 1992; Pointon, 1994; Pomian, 1990; Vergo, 1989). In this nascent intellectual space it has become possible to level a new set of questions at the

museum, based in a rethink of the nature of material culture, patronage, memory, nationhood and modernity. No longer is the museum deified as a neutral store-house of civilisation's most cherished values, an object out of time and place whose history is adequately captured by 'official' accounts written within the institutions themselves. It is revealed to be a vital institution in the formation of powerful ideologies, categories and identities, perpetuating dominant national myths or providing cultural cement for socio-political order (Sherman and Rogoff, 1994). In short, 'theorizing museums' (Macdonald and Fyfe, 1996) has become a matter of attending to the socially and historically embedded nature of museolog-ical space, understood as a constitutive process as well as an institutional structure.

While the art museum is not the analytical demarcation of this book, it still forms the main target.[1] The aim is to 'problematise' the evolution of an institution that has too readily remained under the protective guardianship of national tradition and cultural authority. The book seeks to find useful ways of bringing the art museum's genesis into focus by taking seriously both Fyfe's (1993) call for scrutiny of the role of class and nation-state in the emergence of national galleries and Pointon's for an analysis of the 'politics of cultural control in which terms such as "public" and "access" have a long and problematic history' (Pointon, 1994: 1). It should be seen, therefore, in the light of a critical socio-cultural history that aims to unpick relations between governance, class and 'high' cultural forms, partic-ularly exhibitionary forms, in those places where the roots of modern culture were being laid most visibly.

The task is to arrive at an adequate, relational understanding of the evolution of what Malraux (1954) has called the 'project of the museum' – as much to do with *ideas* of space, representation and collection practices as the actual physical entity named 'museum'. What *was* modern about the museum as a 'project'? Why did museums emerge when and where they did? How were museums imbricated with the evolution of modern art worlds? Were museums accessible or exclusionary? Who were the art museum's most active patrons? And to what extent did such institutions help formulate the cultural and political identities of these champions? Unlike other studies in the area, this book does not focus on a single institution in a specific period; nor does it concentrate on the project of the museum as a general modality of education and classification. As a critical history the aim is to place the rise of national institutions into a socio-cultural framework that ranges over two and a half centuries of development, moving between general statements on social change and the nation-state to detailed attention to spectatorship and the space of the museum. Such an endeavour inevitably requires attention to a range of primary and secondary material and a fiercely interdisciplinary approach. So, whilst value is extracted from nominally bounded disciplines such as sociology, art history, political theory and museum studies, the separation of these is meaningless once a process-account of cultural forms is begun (Abrams, 1982).

The book makes use of a comparative historical schema based on three cases: continental Europe, England and Scotland. The schema is further divided according to three historical configurations: pre-modern absolutism, eighteenth-century Enlightenment and nineteenth-century bourgeois modernity. In each case the task has been to critically investigate the evolution of spaces of visual display in relation to particular social imperatives and configurations of rule – absolutist, enlightened and national – that assigned a certain cultural efficacy to such spaces. Differential trajectories of this evolution are clearly present and contrasts are indeed developed in the three cases. If the 'continental model', particularly the Louvre, forms the *locus classicus* of museum development, then the English model is once-removed and the Scottish model twice-removed. Indeed, Scotland is a useful case study precisely because its 'eccentric' profile helps to relay the distinctive textures of a particular national instance whilst clarifying the main trajectories of museum development elsewhere. There remain, however, distinct correspondences between the models discussed, particularly in the widespread symbolic appropriation of art museums as realms of 'distinction'.

The thrust of the argument here is that the museum, like modernity itself, is Janus-faced, double-coded, ambivalent (Berman, 1983; Nochlin, 1971; Negrin, 1993). On the one hand, museums catered for shifts in the structure of governance, peeling away older remnants of monarchical or aristocratic grandeur and religious servitude. Through this process they were opened up to the emerging space of the nation with its origins in civil society and a representative generality. On the other hand, art's marriage with the value of 'taste' connected the emblems of art with the struggle for a refined identity that was so crucial to the bourgeoisie's historical position. Hence, the art museum became a contributory badge of quality fought for by ascendant social groups struggling for symbolic power within the art world. For this reason the gallery was predisposed to exclude in the act of distinction, symbolically purifying itself of higher and lower historical tendencies. By foregrounding questions of nationhood, social class and power, then, I hope to chronicle a history of prohibitions as well as invitations, tracing specific histories of institutional control in each of the cases mentioned.

Underpinning the book is a set of rather diverse theories and methods drawn most commonly, but not exclusively, from neo-Marxist approaches to art and culture. Culture is approached as a problematic, not in the sense of a definitive or universal accomplishment, but as a process of forms, dispositions and structures, taking on varying profiles within bounded limits of possibility. At base, art works are seen to be both reflective and constitutive of economic and social processes: not a set of inert, perfunctory units contained in a gallery or a mirror-image of 'objective relations', but neither untouched by such external relations. Art works are revealed as complex forms that contribute to the production of social relations, part of the equipment whereby particular social groups maintain socio-cultural

ascendancy (Wolff, 1991).[2] The book claims not merely to be an institutional analysis, therefore, but a *sociology of art* that 'gets its hands dirty' with the texts, the pictures, the styles, the genres (Zolberg, 1990). To this extent it is also a dialogue with 'new art history' (Rees and Borzello, 1986) and a call to widen the scope of British (and particularly Scottish) art history beyond the largely uncritical realms of the rhapsodic catalogue or glossy monograph.[3]

Of course the idea that art is an embedded social activity is neither new nor particularly remarkable. It forms the starting point for any sociology or history of art worthy of the name. While ideologies of cultural transcendence and romantic isolation still undergird popular and elite delineations of the artistic object they no longer rest so easily in the firmament of scholarly and artistic life. Both the 'critical' and 'empirical' traditions of writings on art (Chaplin, 1994) have steered analysis towards extra-aesthetic factors that reside in the art–society problematic – whether they be the effects of capitalism, class and dominant ideology in the writings of Lukács, Hauser, Max Raphael and T.J. Clark, the mundane practices of the artist's 'support personnel' in Becker's (1982) institutional ethnography, or the sophisticated and cross-cutting influences of gender, race, language and power in the work of the 'new art historians' (Wolff, 1981; Zolberg, 1990; Pollock, 1988; Rees and Borzello, 1986). Much remains to be done, however, particularly in the field of museum studies, to think through the complex interface between cultural forms and the social. Theoretically informed empirical studies are particularly needed in moving towards a more robust sociology of museums; and, it will be argued, there can be no better starting point in this attempt than the work of the French sociologist Pierre Bourdieu.

Bourdieu's work provides the most analytically sophisticated and empirically productive set of concepts available, to represent the intricate mediations between aesthetic practice and social space. The concept of field (*champ*), in particular, marks the development of a 'science of the sacred' (see Swartz, 1997: 47), of artistic practice, that takes analysis beyond fuzzy references to 'context', 'art world' and 'institution' (Danto, 1999). Field, instead, suggests the existence of partially independent regions of social activity, such as artistic practice, structured according to a relational set of struggles that take place over currencies or resources particular to that field – intellectual distinction in the educational field, power and wealth in the political field, the authority to define legitimate art in the cultural field (Bourdieu, 1998; Jenkins, 1992; Calhoun, 1990; DiMaggio, 1979; Garnham and Williams, 1986; Lash, 1990; Zolberg, 1992). The structure of a field at any given moment is determined by the particular relations existing between the positions agents occupy in that field. The field is, thus, a dynamic, protean constellation which changes in accordance with transformations in the relative positions of agents, who must possess a minimum amount of knowledge or skill to be accepted as legitimate participants (to 'play the game'), but who enter with

historically given endowments (either in the dispositional form of the *habitus*, or in objectified form as material goods).[4]

What is useful in the field concept is its ability to take in a broad range of processes pertaining (in name only) to the production, distribution and reception of cultural goods. Bourdieu's (1993) phenomenally rich and detailed model considers: 1) the works themselves as situated within a space of possibilities and the historical development of these possibilities; 2) the producers of the cultural goods as located within the field, with their own strategies, trajectories and dispositions; 3) the structure of the field itself - its logic and operation and its system of available positions as occupied by artists and agents of legitimation and consecration; 4) an examination of the position of the field of artistic production within the broader field of power; and finally 5) the social conditions giving rise to particular forms of aesthetic perception and an analysis of that perception.

It is to this extent that Bourdieu's 'genetic structuralism', when applied to art historical cases, is as good an approach to the totality of socio-art relations as there is. It is clearly a demanding analytical method, transcending the limitations of external and internal analysis that are customary in the field of study (Bourdieu, 1990a). But by encouraging a 'diacritical reading' of art (intertextual *in extremis*) a properly relational sociology of art grounded in advanced, multi-level analysis, can be attempted. Moreover, though charged with promoting an over-integrated and, at times, reductionist analysis of art and social space, Bourdieu's analytic is a decent starting position to which nuances, complexities and contingencies may be articulated. So while the book often meanders away from a strict Bourdieusian reading in order to focus on the peculiarities of different national histories or to invite other authors who deal more substantively with the eighteenth century, or aspects of governance, for instance (shortcomings in Bourdieu's own work), his principal assumptions nevertheless underpin much of what will be said here. I will be treating Bourdieu as a figure who provides key orienting propositions and heuristic tools adequate for a productive cultural analysis, and therefore good to think 'with' and 'against' (Jenkins, 1992).

Flowing from the general to the specific, the book is structured in the shape of a 'V', focusing initially on general trends in European societies and descending to the particulars of a chosen case study. It is organised into five substantive chapters, three of which focus on the Scottish case but all of which help throw light on models of museum development generally, and signal the importance of shifting levels of analysis from local conditions of production to broader historical trends. Part I comprises two chapters that deal with the formation of the art museum and its location within the modern cultural field in continental Europe and England. The first, Chapter 2, is concerned primarily with the transformation of the European princely gallery into the public art museum, a transformation bound up with the historical unfolding of the European state system and processes

of cultural autonomisation. The second, Chapter 3, charts the formation of the National Gallery in London as an evolutionary process structured by the slow professionalisation and purification of the gallery space. Part II attends more specifically to Scotland. Edinburgh's national gallery, I will argue, was the summation of pointed struggles for recognition amongst a group of modern artists, whose claims to space, coupled with a desire for autonomy, drove the art field. These struggles were tied up, in turn, with changes in the composition and power of Scotland's upper classes and the resources that certain factions could draw upon to affirm their own social and cultural interests. The outcome, in 1859, was a neo-classical space dedicated purely to art, hived off for a special form of cultivation and contemplation.

Questions of 'space' are raised towards the end of book as a means of dealing more substantively with the relationship between galleries, power and cultural authority. Again using Bourdieu, but also cognisant of the work of Lefebvre, the book attempts to map elements of space according to the tension between regulation and use. In Chapter 6 I reconstruct Scotland's National Gallery building and its contents as it appeared in 1859 in order to take a hypothetical walk through the gallery and reveal its operation to be based on a set of ideo-logics that served to make professional and bourgeois audiences (as secreted in the educated *habitus*) feel at home, but at the same time to symbolically exclude the lower classes and the uninformed. Space, in other words, is analysed as a mode of establishing identities, boundaries and subject positions: the gallery is scrutinised for the circulations of codes and texts that spoke of the gallery's history in civic refine-ment, professional distinction and the need to distanciate the high from the vulgar.

The account is concluded with a brief discussion of Scotland's position in the European and British contexts and of the status of case studies in the construction of models of museum development. Scotland's unique historical mix of socio-cultural forces – the Enlightenment, civil society and Romanticism – suggests the need for closer attention to local conditions of production in cultural histories of the national art museum. Historical divergences, however, must be read within certain broad limits that delimit the shared ground of modern European museums. A common tension is revealed in the projects of both the nation and the art museum between orthodox representations of the public and the socially layered reality of participation.

I propose, therefore, to treat the museum and its publics as an allotrope – an element with dual properties – if only because such institutions were engrafted in radically ambiguous processes of social change in Europe from the sixteenth to the nineteenth centuries. From this perspective, the coupling of cultural and political co-ordinates has had particular implications for the function of the museum visit and the meanings attached to the social groups who have participated – willfully or not – in the museological encounter. Pinched between elitism and

democracy, religiosity and secularism, tradition and modernity, the museum has had to constantly negotiate its identity in relation to its audience – a fact as evident today in the shift to a more 'popular' institutional product as it was in the early nineteenth century when radicals and reformers unshackled museums from their religious, monarchical or private pasts. Thinking the museum, then, involves the acknowledgement of the ambivalent nature of modernity, the ability to conceive of paradox as an essence of modern life. This has been the historical double-bind of the museum.

It is well known that the French Romantic artists Eugene Delacroix and Theodore Gericault were regular visitors to the Louvre in the 1820s and 1830s. Much of their basic education, their handling of paint, sense of perspective and draughtsmanship, was gleaned while copying the likes of Rubens and the Venetian school. This was also the case with a whole host of European modern artists who flocked to Paris as it became the fertile centre of the art world. The deep significance of such a seemingly prosaic act may well have escaped the notice of those who attended museums so routinely in the first half of the nineteenth century. But their attendance speaks volumes, in condensed form, for the complex and profoundly ambiguous trajectory which led up to the art museum's modern existence; for the social upheavals, historical accidents, collective or individual initiatives, which accumulated from the sixteenth century to deliver the national art museum in all its paradoxical glory.

What was significant about these artists was how closely their artistic fortunes were bound up with that of the art museum, in general; and how their relationship to the underlying principles of the museum's project developed into an attitude which registered the summation of the museum's role in the modern cultural field. The very ability of Romantic artists such as Delacroix and Gericault to paint for a growing open market, prioritise the values of originality and creativity, and thereby affirm a form of artistic subjectivity (the hallmark of Romanticism) was testament to the historical development of the relatively autonomous art field. The shift away from direct commissions with the development of the entrepreneurial system of artistic production was also one of the prerequisites for the foundation of the art museum and the shedding of its princely garments. More than inhabiting the same socio-cultural space, however, for the first time the likes of Delacroix and Gericault visited museums in order not just to copy and educate themselves, but to take a critical stance towards the official gloss of the museum and the objects it housed. The Romantic reaction to tradition, to the institution of art is a well-known phenomenon. It is the beginning of a force in art whereby the avant-garde begins to challenge traditional or academic authority. This is the dynamic at the heart of modernism itself, reaching a definitive position with Manet and the Impressionists.[5] What is important, here, is the explicit position the art museum had reached by mid-century, becoming what modern Romantic artists and, later, avant-garde

artists and critics from Baudelaire onwards despised in 'bourgeois' art. In this process of reaction, however, the art museum also provided the referential well-spring from which modern artists borrowed to push art beyond itself and to attack the institution of art itself. The amassing of works provided the resource for the creative practices of modern artists; the museum, in short, was the precondition for the development of modern art (Negrin 1993).

This sense of reliance on the museum's existence indicates the process by which the present ransacks its history in order to construct its modernity, but it also speaks volumes for the privileged position of the museum by the nineteenth century. Precisely because of its centrality and efficacy, in other words, the museum became both a target and a historical resource for cultural practitioners. The ambiguities implied in this relation between artists and the museum is final testament to the profoundly contradictory nature of the museum's emergence. What is of interest about such ambiguities pertains not to the aesthetics of Romantic opposition but to the history of which it speaks.

Notes

1. To clarify terms: 'art museum' and 'gallery' are used interchangeably in the book, for the semantic distinction (North America's tendency to call everything a museum and Britain's more specific appellation 'gallery') is more apparent than real. Both are separated, however, from non-art museums at pertinent times in the following narrative.

2. Or as Wolff puts it herself, 'the necessary project for the study of art is an approach which integrates textual analysis with sociological investigation of institutions of cultural production and of those social and political processes and relations in which this takes place' (1991: 713).

3. 'New art history' was the title given to a collection of essays and critical interventions of writers such as T. J. Clark, Victor Burgin, Paul Wood, Griselda Pollock, Linda Nead, Svetlana Alpers and members of the Open University group. All in their varying ways progenitors of an approach to art that critically assimilated concepts current in radical philosophy, political theory, sociology and cultural studies, these writers stripped away many of the myths of autonomy and majesty that had saturated art history up to the 1970s. They asked a different set of questions of visual 'texts' that brought social relations of power, inequality, politics, class and gender directly into the equation of art and society. For complex reasons that must remain undeveloped, Scottish art history has largely remained untouched by the incursions of 'new art history', despite some attempts at a more theoretical and critical dialogue with questions of power, patronage, class and ideology in the context of Scottish art (Forbes, 1997). The absence of a fully developed tradition of cultural studies in Scotland is perhaps an important factor here, as is the relatively 'traditional' nature of many of Scotland's art history departments.

4. Implicit in Bourdieu's vision of the development of fields is a theory of modernisation that maps the terrain of social formations in relation to how autonomous its constituent fields are (Lash, 1990). The greater the distance between fields (economic and cultural for instance), the greater the ability fields have to 'refract' outside incursions and the greater the potency an immanent form of capital has in that field, all indicating a mature social system. The field is therefore a critical mediating configuration wherein external structures are brought to bear upon and are negotiated by individual and institutional practice. As we shall see, for much of the period under study here, the artistic field struggles to attain this level of autonomisation from the political/economic field.

5. In Foucault's (1977) view, modernism was the first tradition of museum painting because it expressed a self-conscious relationship to the tradition of painting and of the institution of art as a whole. Manet's *Déjeuner sur l'herbe* and *Olympia*, for instance, were works which self-consciously rendered the tradition of painting as subject matter itself. Through this they achieved a particularistic relationship to the museum and its contents. To an extent, though, this relation was anticipated in the Romanticism of Delacroix and Gericault and their reflections on the old masters and the canon.

From Court to State: The Emergence of National Art Museums in Continental Europe

All art objects bear meaning upon their production, display and consumption. Here, as Pomian indicates (1990), a relation can be posited between the visible (the collection, for instance) and the invisible (the past, but also taste, wealth, distinction and so on). We respond less to the intrinsic attributes of cultural goods, than to the symbolic meanings given to them (DiMaggio, 1987; Veblen, 1949; Bourdieu, 1984). Central to any consideration of the character and function of the museum, therefore, are the following questions: who is the collection for? Who sees or takes most meaning from seeing? Which social identities are at stake? What social function has the collection? And how does the gallery space operate to fulfil this function?

This chapter pursues an answer to these questions in the form of a socio-cultural genealogy of the national art museum in Europe. There are two broad aims. Firstly, I want to provide a brief survey of the European art field and the position of the national art museum within this field, from around the sixteenth to the mid-nineteenth centuries. This is really an endeavour to construct a continental model or archetype – mainly of France, Germany, Austria, Spain, Italy and the Netherlands – from which the English and Scottish cases are removed. Secondly, I wish to set up some theoretical parameters to the problem of museum formation in relation to questions of ideology and power: to the interests of cultural elites, mechanisms of state administration and forms of governance.

To these ends, I have organised the narrative according to three historical types or profiles:

1. the princely gallery of the sixteenth and seventeenth centuries;
2. the inchoate museum of the eighteenth century;
3. the relatively 'pure' space of the nineteenth century.

These are useful historical configurations that help to make the history of the art museum more intelligible and patterned rather than explanatory devices in

themselves. By cutting the project of the museum into distinct but overlapping schemes it becomes possible to reflect on historical contrasts and comparisons and to highlight broad trajectories in arrangements which are often differentiated.

What follows, then, is an attempt to comprehend the art museum's emergence sociologically (a 'sociogenesis', if you like), but also politically and culturally, as the construction of a cultural artefact imbued with political meaning. I seek to establish why institutions such as the Louvre became visible during the modern period in the form that they did. What, in short, made them pertinent, effective and beneficial? And to whom? Like any problem of genealogy, this initially begs an excursion further into history than one would normally expect of such an apparently modern institution.

The Classical Precursors

Reading back through classical and medieval periods to search for precursors to the public art museum yields interesting, if over-historicised results. Many commentators have suggested that the 'museum idea' be traced back to antiquity: to the ancient Grecian and Roman treasure spaces of Delphi and Olympia, Hadrian's villa at Tivoli, the 'museum' at Alexandria or the Acropolis in third century BC Athens (Lee, 1997; Mordaunt-Crook, 1972; Alexander, 1979, Lewis, 1992b). After all, it was in ancient Greece that the word *mouseion* was first identified as signifying the home of the muses, the nine daughters of Zeus, progenitors of learning and inspiration.

Equally, museum historians have pointed to the amorphous accumulations of *objets d'art* in the medieval period as informing the modern museum. The churches and monastic libraries which housed ecclesiastical miscellanies and treasures in the Middle Ages are often claimed as anticipating later forms of accumulation and display. The collection of Jean, Duke of Berry, brother of Charles V of France, for example, is cited by Mordaunt-Crook (1972) as an important 'secular-based' fourteenth-century collection which, in its heterogeneity, foresaw the breadth of later collections.

There is a sense in which valuable connections can be made between these various cultural forms. Indeed, as I shall argue below, history is a palimpsest and cultural forms are always open to preceding influences. Yet, reading back in this way also has its dangers; it can be superficial and selective. Ancient collections of paintings, sculpture and manuscripts were primarily votive offerings to the gods, homages to divine figures or sacred 'pavilions for the cities' (Schildt, 1988: 85); and it is interesting to note that none of the muses were dedicated to the visual arts. Medieval collections, on the other hand, were, in function, spaces of the spirit. They formulated anagogic experience in cultural form and operated as spaces of

Christian glorification, not as secular buildings for the display of 'art'. The display of objects, in other words, was not conceived as an act in itself. Indeed, the notion of 'art' as we recognise it today was clearly inconceivable. As Williams (1976) and others have indicated, before the seventeenth century the idea of art had no specialist connotations and the artist was perceived as but one craftsman among many, serving a community and employed in a direct relationship with a patron and his demands.

A more convincing precursor to the art museum is to be found in display arrangements developed from the Renaissance period, in the form of the princely gallery. Without delving too deeply into the historical detail relating to the royal gallery as prototype art museum, it will nevertheless be instructive to set up a profile of this arrangement in order to chart the subsequent trajectory of particular elements relevant to the national art museum.

The Princely Gallery, Absolutism and Court Culture

According to Seling (1967), the term 'gallery' has a history detectable to at least the sixteenth century: hence Shakespeare's quip in *Henry V*, 'For in my gallery thy pictures hang'. But greater clarity was given to the gallery form in the early seventeenth century. By 1632 the Zeiller dictionary was calling a gallery 'a corridor where pictures hang' (Seling, 1967: 114), clearly denoting its modern usage. Bazin, for instance, quotes an Italian architect who, in early seventeenth-century Vienna, wrote:

> In this city the gallery is not used so much for the exterior of public places as in France, Spain and elsewhere; for some time, following the Roman example, it has been introduced into the houses of many senators, gentlemen and collectors of antique marbles and bronzes, medallions, bas-reliefs and paintings by the most celebrated and prestigious masters who have ever lived. (quoted in Bazin, 1967: 129)

The gallery (Italian: *galleria)* developed as a distinct space of representation in tandem with the cabinet, the closet of curiosities which formed the basis to other types of museums.[1] The significance of the long, grand gallery revolved around its use as a sumptuous, luxurious *salon* where works of art served as crucial components of the overall appearance and decor. Renaissance collections like those of Lorenzo the Magnificent (1449–92) and the Medici family came into their own with the dominance of Florence as an art centre from the fifteenth century. As a feature of the Renaissance palace, galleries were the standard form of display for such collections, and came to constitute a *physical* space solely for the

presentation of works of art (symbolically the space played an entirely different function, as we shall see). Examples included the gallery at Sabionetta and the Uffizi galleries, initially the 'offices' of the Palazzo Vechio but converted into a picture gallery in 1582 by Francesco I (Bazin, 1967).

Historically, the formation of collections was bound up with the waxing and waning of imperial states. The mechanics of rule associated with absolutism hinged on the exploitation and conquest of overseas lands. Art was a standard form of booty for absolute rulers and their officials in Europe, who took full advantage of the treasures on offer in subjugated territories. The Hapsburgs in Spain acquired treasures and placed them in their royal palaces, as did Cardinal Richelieu for the Bourbons of France. Slightly later, Jules Cardinal Mazarin, the sagacious French connoisseur, accumulated an important collection of art on the back of French military victories and was often bribed with art, provided the calibre was high enough (Meyer, 1979: 19).

As imperial power swung away from Italy in the sixteenth and seventeenth centuries towards the absolutist systems of France, Spain, Prussia and Austria, the gallery form underwent certain modifications, but retained the function laid down for it during the Renaissance. Indeed, despite the broadening of the gallery idea in general – the co-option of the model by the French lower aristocracy and gentry for their *hôtels,* the preference for lateral lighting, the penchant to enhance paintings by hanging them against red backgrounds – its operation as a space of visibility was firmly fixed as *princely* and its physicality as *palatial.* This can be clarified with a discussion of the princely gallery's mode of functioning, its internal arrangements, and, first of all, the system of political rule which gave it meaning.

The transition to the more centralised system of rule that was absolutism paralleled the gradual erosion of the polity of the estate. This was fuelled, in part, by the new political environment faced by principalities in their quest for rule. Political management began to depend much more on the implementation of territory-wide laws, the centralisation of administrative government, modern fiscal policies and the creation of military might.[2] Certainly, in France, Spain, Prussia and Austria, such a shift to absolutist structures of governance was crucial to the ability of these increasingly centralised states to compete in the theatres of European politics. As Poggi writes:

> From this perspective, the dynamic causing the shift operated not so much within each state considered in isolation as within the *system* of states. The strengthening of territorial rule and the absorption of smaller and weaker territories into larger and stronger ones – processes that had gone on throughout the historical career of the Ständestaat – led to the formation of a relatively small number of mutually independent states, each defining itself as sovereign and engaged with the others in an inherently open-ended, competitive, and risk-laden power struggle. (Poggi, 1978: 60)

Central to these European power plays were the magnificent courts of the absolutist regimes. As Elias (1983) has demonstrated, court society implied a tightly woven set of social relations founded on the need to display rank and royal splendour in the structure of certain rituals and procedures. In Europe by the seventeenth century, court masques, musical presentations, theatre and other conspicuous shows of luxury constituted an ornate performance of power concerned with exhibiting royal authority to court, kingdom and outside princ-ipalities. Louis XIII's and XIV's elaborate enactments of royal splendour at Versailles, for instance, are good examples of how the court heightened personal and public authority. The king stood at the pinnacle of this exalted stage and acted out his life in front of attendants and officials. In turn, these actions took on the ceremonial significance of state performances. Above all, the culture of the court was always a *display* built on a logic of competition, rivalry and the construction of external demarcations from other principalities.[3] Hence, European courts also vied for the privilege of patronising renowned artists and competition for prize works was rigorous amongst them. Court artists such as Bernini and Caravaggio were still treated as artisans, lower middle-class servants (Rubens, the rich son of a high-state official, is an exception), but in the seventeenth and early eighteenth centuries court artists began to enjoy a degree of professional and financial stability (Warnke, 1993).

As a style based on ceremonial monumentalism and excessive grandeur Baroque was the ideal artistic vehicle and expression of courtly logic. In effect, Baroque was a means of spectacularly disclosing the power-strivings of the king, of playing out the theatrical appearance of court as an external imposition, as a *Gesamtkunstwerk* (a total work of art). At Versailles the ostentatious combination of decoration, art, sculpture, painting and landscaped gardens, for instance, fused as the grandiose gesture of court life in the seventeenth and early eighteenth centuries. Qualities such as 'beautiful', 'refined', 'elegant' now depended on the authoritarian directives of the king and his courtiers, and artists were trained in state-run academies which secured the aesthetic hegemony of absolutism.[4] All this implied the suppression of individual effort, subjective expression and the instigation of a system of direct patrimonial patronage with precise conventions and demands.

But what about the role and function of the gallery space itself? How did it serve the same absolutist ends which art appears to have done? How, in other words, did the interior *space of representation* represent the *social space of the prince*? An answer must start with the anatomy of the building itself. Among Elias' findings in his dissection of the physiognomy of court life is the significance accorded to buildings and their spatial arrangements. Dwelling places were ordered according to the rank of the owner: *la maison* for the bourgeois, *l'hôtel* for the noble and *le palais* for the prince or king. Each visibly manifested the traditional

boundaries of absolutism in a symbolic representation of rank: 'A duke must build his house in such a way as to tell the world: I am a duke and not merely a count' (Elias, 1983: 63), and no other person would dare to build a residence which tried to emulate or surpass that of the king in magnitude or ornamentation. The interior of courtly spaces, similarly, articulated the requirements of conspicuous display and it is here that the princely gallery functioned as a celebration of the magnificence of the sovereign.

Such exhibition spaces began as lavish corridors, sometimes reception halls or ceremonial suites, wherein the king or prince impressed himself upon important officials and visitors. The Belvedere of Innocent VIII in Rome was joined by such a momentous corridor to the Vatican, as was the *Grande Gallerie* of the Louvre, the latter connecting the chateau in the city (the Louvre) to the country residence (the Tuileries). Other exhibition spaces began as integral features of private estates, houses or annexes to houses (Bazin, 1967).

Although some collections were open to the public before the mid-eighteenth century (usually on payment of a fee or by strict appointment and on restricted days only), such accessibility was secondary. Certainly, the notion that there might

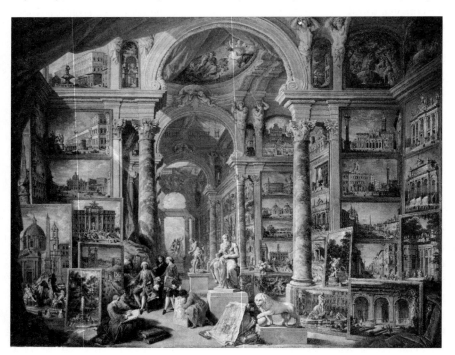

Figure 2.1 Giovanni Paolo Pannini, *Modern Rome*, 1757, The Metropolitan Museum of Art, Gwynne Andrews Fund, 1952 (52.63.2).

be a duty to give access to an undifferentiated public would have appeared nonsensical. The princely gallery was a viewing space for a limited public. Visitors, as Hudson affirms, 'were admitted as a privilege, not as a right and consequently gratitude and admiration, not criticism was required of them' (1975: 6). The visit reflected this. One was paying homage to the prince and encountering his symbolic presence not merely admiring the artefacts. The visitor, as the prince's guest, might have contemplated individual works but his or her gaze acquired meaning only in relation to the aura of the prince, not from the works of art themselves.

On the one hand, then, as the typographic perceptual field of the Renaissance slowly gave way to the more visually oriented universe of the *ancien régime* added potency was given to the ordering of visual representation. As Lowe (1982) indicates, this placed a greater emphasis on outward appearance, the primacy of sight and representation in space. On the other hand, display was 'fundamentally non-reflexive, visual and quantitative' (Lowe, 1982: 13): that is, the organising principle was spectacle. Typical princely collections like those of Philip II of Spain, Cardinal Geronimo Colonna and Cardinal Mazarin were visually ordered according to a principle of quantity and excess – a 'spectacle of treasures' that interiorised the personal world-view of the prince (Graña, 1971). Pictures were arranged floor-to-ceiling in a tapestry-like effect, visually ordering the magnificence of the ruler in a system of superabundance which clearly contrasts with today's techniques of display. As Bazin comments: 'if our ancestors were to wander through our museums, with their great expanses of empty wall, they would find them poor and in bad taste' (1967: 129); and he goes on to quote a visitor to Roman *Paolozzo* in 1729 who exclaimed:

> The entire decoration of a room consists in covering its four walls, from ceiling to floor, with paintings in such profusion and with so little space between them that in truth, the eye is often fatigued as amused. (cited in Bazin, 1967: 129)

Works of art, in fact, were often modified (cut down or enlarged) to fit into this general schema without the knowledge or consent of the artist, reinforcing the trammelled status of the artist before the eighteenth century. Pictures had a decorative rather than expressive or individuated function at this time. Certain subjects were considered more apt for certain rooms than others: landscapes for great chambers, mythological icons for banqueting halls, pastoral scenes for halls and intimate portraits for 'withdrawing chambers'. Otherwise, paintings were made to order, via a contract, with the 'client' having overwhelming control over the materials, subject matter and style. Royal portraits, for instance, often depicted the king and his courtiers in the allegorical style, making the important iconic relationship between the king and divinity. Painting was clearly too functional to be left solely to painters (Baxandall, 1972; Clifford, 1987).

Complementing the spectacle of abundance was a more subtle technique of royal legitimation in the form of iconographic programmes designed to place the ruler in a system of hierarchical value. Busts or portraits of princes were often placed at the focal point of a glorious heritage represented by other illustrious emperors or noteworthy figures from history. In the seventeenth century, for instance, the collection of the Hapsburg emperor Rudolf II was systematised so as to centre the ruler in a sonorous pictorial narrative which illustrated the munificent effects of his rule (Duncan and Wallach, 1980). The Antiquarium of Albrecht V of Bavaria in late sixteenth-century Munich was, similarly, marked by portraits of renowned emperors of the past whose deeds the prince appropriated as his legacy. Part of the impetus for the arrangement of the princely collection was clearly founded in the desire for a form of immortality. The prince was aspiring to a mixture of everlasting life, glory and fame (Pomian, 1990).

To bring some of this together, then. Fyfe (1993), drawing on Veblen and Bourdieu, writes of cultural forms and institutions as embodying certain systems of domination termed 'modes of distinction'. In the case of the princely gallery, the possession of artistic goods was a direct indicator of social standing. Displays of symbolic power in courtly society were moments of 'conspicuous consumption' that pointed up the need for 'public' recognition and superabundance in the social field. Culture, in this connection, served the ends of absolutist power by staging or actualising it, making it spectacularly manifest. Works of art were expressions of private influence and individual wealth, trophies which indicated possession, social ascendancy and control. In the gallery, the eye of the visitor was socialised within the aura of the prince's cultural authority, whose presence was ubiquitous:

> Visitors are presented with the viewpoint of the patron. They are likely to encounter signs of the patron's presence even in his or her absence – the very conditions of access, the patrimony of family portraits, the preoccupations, perhaps the obsessions of the collector, the prince's private study and an architecture which is tribute to the patron's authority/authorship. (Fyfe, 1986: 25)

It is in this sense that the pre-modern gallery was an 'absolute space of representation' (Bennett, 1995) in which ways of seeing were reduced to the reproduction of the power of the monarch. Its point of reference was singular, its function patrimonial and the elements contained within it indivisible. Ideologically, spatially and visually, absolutist displays of art functioned as appendages to royal power which had no need to claim popular representation or generality.

Looking ahead, we might say that the configuration of aesthetic, political and socio-economic conditions which congealed around the princely model gave it a function that was to be reconfigured or transformed from the second half of the eighteenth century. And yet its continued dominion was, as I shall point out, still felt long beyond the point the social system which bore it had withered.

The main question for now centres on the subsequent historical trajectory of the art museum in Europe. It is pertinent to ask, in other words: how did we get from this personalised display of treasures to the 'modern', 'secular', 'public' institution which we find today? What made the new museum's emergence attractive and compelling? And how did the gallery function to produce and sustain emerging social interests?

The Emergence of the National Art Museum: Introductory Comments

> Some historians seem to be unable to recognise continuities and distinctions at the same time.
>
> (Panofsky, 1955: 26)

The difficulty in answering these questions lies with the complexity, variety and protracted nature of art museum development in Europe – a convoluted historical genesis which has left its mark on the modern institutional form to this day. The temptation is to envisage the shift from the princely gallery to the national art museum as a tidy disjuncture, usually fixed with the French Revolution, and to set up various points of departure: from private to public, from religious to secular, from restriction to access, from spectacle to education, from monarchical to bourgeois, and so on. Furnished in these terms, what we end up with is two neat profiles with a 'menu' of polar opposites – aesthetic, temporal, political, cultural, sociological – revolving around the pre-modern/modern schema.

Yet, such a search for straightforward breaks, discrete sets of oppositions or distinct moments of 'birth' or 'arrival' is misguided. History does not unfold in a series of packaged moments and to characterise the different traditions according to ready-made conceptual spans is to replace classification with caricature. Cultural forms and institutions are always pervaded by configurations of a past time as well as a present time. Features of a modern culture are never totally divested of their original normative arrangements and constitutions. Rather, features are reconfigured or restructured under new conditions and form mutated combinations. In Williams' sense (1981), aspects which were once dominant are thrown into relief but retain a residual effect, emergent tendencies flower into dominance and so on. In this connection, the princely and the public arrangements are not separated by an iron curtain, but, at certain moments, co-exist; they are not antithetical forms of negation but are composite dispositions which engender in the modern form certain institutional idiosyncrasies.

Like modernity itself, in fact, the museum has been found to be ambivalent. Historically, it has oscillated between contrasting sets of values and exhibited apparently self-contradictory behaviour: functioning as an inward-looking, elitist

temple of patrician scholarship but also as an instrument of 'populist', democratic pedagogy; providing an experience which is 'religious', ritualistic and ceremonial, but offering artefacts which have been 'scientised' and secularised. Indeed, as Nochlin condenses it: 'As the shrine of an elitist religion and at the same time a utilitarian instrument of democratic education, the museum may be said to have suffered from schizophrenia from the start' (1971: 646). All this is a product of the museum's complex history.

In any case, these cautionary provisos and institutional ambiguities have to be held in mind through the following narrative. Yet, if formulated in more *nuanced* terms, the constitution of differences between the pre-modern and modern configurations remains of value. It has to said that there are significant alterations in the morphology of the art museum from the mid-eighteenth century which need to be identified and unpacked. Though they are often imperceptible inflections in an historical curve, to ignore these changes would be to disavow the fact that the museum underwent variations in condition at all, which is disingenuous. What follows is an attempt, then, to comprehend these shifts and present a socio-genesis which is sensitive to both continuities and differences: a process-oriented account which recognises alterations, if you like. For it is a matter of indicating evolution but avoiding strong forms of historicism.

Two broad sections have been set aside in order to investigate the dawn of the art museum in Europe. 1) An investigation into eighteenth-century developments in Europe's social, political and cultural fields as a period of transition and promise. I will be flagging advances at the level of ideas in relation to the concept of art and its classification as well as developments in the matrix of institutions, discourses and individuals that made up the fine art field in the second half of the eighteenth century. This will feed into a description of some early 'enlightened' conceptions of the art museum itself. 2) A more substantial pursuit of some of the above developments but with particular attention to the early nineteenth century, considered to be the 'golden age' of the art museum. This will include: the growing confidence of bourgeois cultural elites with their distinctive 'modes of distinction', the full maturation of structures of artistic production and the rising importance of the nation-state as a catalyst to the national art museum. I will bring some of these arguments together in a characterisation of the national art museum as a 'relatively pure' space of representation which indicates, by the mid-nineteenth century, a realm of aesthetic efficacy that is definitively modern.

Enlightened Absolutism and the Rise of Civil Society

Eighteenth-century Europe was fertile ground for the establishment of modern forms of thought, politics and culture. The Enlightenment fostered the ideals of

progress, universal human rights and the triumph of reason so central to the configuration of modernity. As Habermas indicates, its aim 'was not only the control of natural forces but also the understanding of the world and of the self, moral progress, the justice of institutions and even the happiness of human beings' (1981: 103). It would be well-nigh impossible to do justice to the richness of Enlightenment culture and politics in the following. As one of the richest periods in European history, critical analysis of the eighteenth century constitutes a burgeoning field of study that must remain relatively untouched here.[5] Equally, the conditions pertaining to each European region are varied, involving different sets of urgencies which imprint at different speeds on different artistic fields. But some broad points are worth making for heuristic purposes.

In my present schema, the eighteenth century can be considered as a period of accelerated social transformation which set in train many of the cultural developments which are part and parcel of our art landscape today. In particular, we begin to see the key accoutrements of art world personnel, discourses and institutions in this period, vital for the empowerment, recruitment and legitimation of artists and their audiences. The gallery, too, starts to shed some of the features it displayed in the sixteenth and seventeenth centuries, taking a more recognisably modern form.

Before addressing the sphere of high art, though, let me sketch the political backdrop to this period of provenance. I have already alluded to the absolutist structures of rule which took hold during the sixteenth to early eighteenth centuries in continental Europe. I argued that this system provided the political *raison d'être* for the princely gallery and its circular form of power. Here, I mentioned Poggi's formulations regarding the centralised princely state and Elias' statements on the court as expressive of this central administration. Following Poggi, I will continue to trace the trajectory of political systems of rule on the continent as they appear in the eighteenth century, 'beyond absolutism'. I will also explore some ensuing ramifications for the visibility of a 'public sphere' where many of the important cultural developments of this period are played out.

According to Poggi (1978), European absolutism was stretched in the latter half of the eighteenth century to accommodate shifting relations between the state and larger society, heralded, for Poggi, in the 'enlightened absolutism' of eighteenth-century Austria and Prussia. On the one hand, the emergence of a gap between the state and the social sphere inhabited by 'private individuals' was a result of increasingly centralised power. As the state became more visible and concrete it also moved 'up and away from the larger society to a level of its own, where specifically political personnel and functions were concentrated' (Poggi, 1978: 78). From these lofty heights, the multitudes were treated as objects of rule, with obligations and duties, as taxpayers, potential soldiers and so on. To this extent, they were reduced to a function 'other' than the state, unqualified to take an active role in governing themselves and therefore as suitable objects of governance.

On the other hand, such a process helped to crystallise civil society into a self-sustaining, autonomous realm of private individuals with its own aims and demands. A fencing off of ordinary social relations from (and against) the traditional imperatives of absolutism had become the principal aim of civil society itself. In the long term, this increasingly dualistic configuration transformed the system of rule by 'realising the civil society's demand for an active, decisive role in the political process' (Poggi, 1978: 79).

The prime agency of civil society was the segment of political actors whose power and confidence, based on the possession of capital, blossomed with the capitalist mode of production and the market. The bourgeoisie's emerging social identity as a class placed it in opposition to the old priorities of the absolutist state. Its financial, cultural, intellectual and legal rights, in particular, were felt to be in jeopardy under the absolutist regime. A challenge to absolutism, then, had been set by the bourgeoisie who broke through the limits on absolutist discourse by positing a radical critique of royal privilege and the excesses of courtly life. Such grievances were aired in societies, journals and associations where new forms of thought, assembly and critique arose away from the court. This is what Habermas (1989b) has termed the 'public sphere'.

If civil society was the broad ground on which a new conceptualisation of social space was enacted, a space of moral improvement, increasing inner wordliness and 'natural sympathies' (of Locke and the *philosophes*), it was the public sphere which fully articulated this vision. According to Habermas, the bourgeois public sphere was a discursive alliance of reasoned individuals whose principles were common sense, universal morality, secular rationality and public welfare. It was, in effect, a mediating device between the state and civil society 'in which the public organises itself as the bearer of public opinion' against 'the arcane policies of monarchies' (Habermas, 1989b: 137). As a politically charged environment the aim of the public sphere was to foster mechanisms of representation (an elected assembly, for instance) at the heart of the state, in opposition to individual rulers. Much of this world-view was carried out publicly in coffee houses, literary salons, scientific societies, the media and so on:

> In this way, certain social groups, predominantly bourgeois, though sometimes mixed with elements from the nobility and the lower clergy – progressively put themselves forward as an audience qualified to criticise the state's own operation. They were seeking, as it were, to complement the 'public sphere' constructed from above with a 'public realm' formed by individual members of the civil society transcending their private concerns, elaborating a 'public opinion' on matters of state and bringing it to bear on the activities of state organs. (Poggi, 1978: 82)[6]

The Eighteenth-century Field of Cultural Production

The public sphere was fertile ground for the development of many of Europe's modern cultural and intellectual schemes and institutions. Unfettered by the court, it acted as a space of possibilities, a forum for liberatory ideas and provided the conditions for envisaging new ways of thinking, doing and seeing. In effect, the public sphere prised open a gap between itself and absolutist traditions in which the modern tools of art, politics and thought were forged.

As Burgin has written: 'The basic configuration of ideas and institutions which circumscribe our view of "Art" today was first assembled in the eighteenth century' (1986: 149). I would like to sketch out three sets of components comprising this fine art configuration: firstly, the ideational modernisation of art and related concepts; secondly, the rise of market patronage and the popularity of more 'bourgeois' art genres; and thirdly, the broadening of the public constituency for art works in Europe and the increasingly important role of critics.

The Modernisation of 'Art' and Related Concepts

It was the growing autonomy of cultural, intellectual and artistic formations from pre-modern ties which provided the basis for the radical overhaul of the concepts of 'genius', 'creation', 'artist' and the practice of aesthetics. These, in turn, combined to form the discursive conditions for the emerging view of art as somehow special, sacred or pure – a view which helped, in the long run, to conceptualise the need for a building solely for its display.

An initial separation at once suggests itself here, though, in relation to the concept of *autonomy*. We must keep in mind the distance between two points which often get fused in writings on art: on the one hand, the actual historical process whereby institutions, individuals and cultural formations achieved a certain distance from archaic religious and royal commands (a process which rested in reality on the reinscription of art into a system of commodity relations); and on the other hand, the doctrine of aesthetic autonomy as it was espoused in the late eighteenth and nineteenth century discourse on art, positing a free-floating, self-determining object of beauty. At a certain level the two are related. Indeed one of the difficulties in separating them rests with the tendency for the *ideology of the aesthetic* to snatch away *historical autonomy* to make it something else, something pure or absolute. But there is real value in remaining cognisant of the differences between institutional and ideological autonomy. The separation promotes methodological clarity and a critical stance on claims to art's *absolute* autonomy – to art as beyond social analysis (Bowler, 1994).

Taking the protean idea of 'art' first. Many scholars have pointed to the eighteenth century as the period when art began to take on its specialised meaning.

Batteux's *Les Beaux Arts Réduits à un Même* of 1747 was one of the first texts to impose a distinction between 'fine arts' (poetry, painting, architecture, oratory, sculpture, music, dance) and the 'liberal' or 'mechanical' arts – a separation that still has currency today. In accordance with changes in capitalist commodity production generally, the underlying separation of artist and artisan confined the latter to the sphere of craft, industry or technology (Williams, 1976). 'Art', on the other hand, generated a different set of connotations related to the higher orders of experience and contemplation and the absence of low or vulgar spheres of human practice. In other words, art was marked off as a specialised sphere with its own internal laws and forms – a process fully expressed in the body of writing known as 'aesthetics'.

Baumgarten's term 'aesthetics' referred to the discipline dealing with questions of beauty and taste, which gained sway in Europe from the 1770s. The fundamental idea of modern aesthetics revolved around the work of art as an 'organic totality', and its task was to lay out both the autonomy of the beautiful and the position of the 'genius artist' in the creative process as the irreducible product of *natural* powers. I stress natural over supernatural because the shift away from the conception of genius as referring to a non-human or divinely inspired spirit is exactly the shift to a modern conception of art and social order. For as Mason (1993) suggests, the idea of 'genius' is a secularisation of the divine creator of the Christian world-view.[7]

Aesthetic writing from Winckelmann, Hume and Diderot to Kant, Schiller and Reynolds mirrored this venture into the modern world with its attendant push towards rationality and cultural autonomisation. The very ability of such figures to write in bourgeois public spheres away from the court was testament to institutional autonomy and the rise of new cultural markets in literature. The growth of periodical literature, including the kind of aesthetic commentary Diderot indulged in, gave critics space to pit a universe of reason against the one-dimensional value system of aristocratic opinion. Indeed, coteries of groups and select societies given to discussing matters of art and high culture flourished in the coffee houses and inns of Europe.

But aesthetic writing also played a role in defining art as conceptually opposite to other forms of being. Aesthetics spoke of its object in terms of criteria internal to itself and independent of extraneous laws or commands, as a mode of being which was entirely self-regulating and self-determining, existing beyond the material and the everyday. For the high-priest of this doctrine of autonomy, Kant, art was that which was free, 'devoid of all interest', a product of creative genius, itself 'the exemplary originality of a subject's natural endowment in the *free* use of his cognitive powers' (cited in Mattick, 1993a: 172, 174). Its antithesis was 'pleasure', the 'bodily', and anything which serviced a lower form of enjoyment. A new kind of human subject was called for to contemplate art's beauty. He was

the disinterested, virtuous and sensitive individual, whose model was the cultivated bourgeois, having appropriated the civilised codes of the aristocracy – the two cultures which Kant himself straddled (Eagleton, 1990). Reception of the 'pure' implied a 'knowing subject', who was 'freed from subjectivity and its impure desires' (cited in Bourdieu, 1984: 487).

The Market, Patronage and 'Bourgeois' Art Styles

Yet, art's rise to autonomous status in reality involved the gradual replacement of pre-modern forms of patrimonial patronage with production for the more diffuse market. This proved to be a highly significant force in breaking down archaic structures of artistic production and traditional modes of taste as well as inscribing greater numbers of consumers into the art field. A rapidly growing cultural matrix of professional agents, critics, dealers, connoisseurs and publishers developed to support this system. By the end of the eighteenth century in most European countries, the artist was enmeshed in a complex set of socio-economic relations and cultural markets detached from the court, whose trajectory was taking art further into the bourgeois cultural modernity of the nineteenth century.

Institutional autonomy was a prize bought at the price of incorporating art into the market. Although there is historical overlap between 'patronal' and 'market' relations, they can be distinguished in practice in that 'production for the market involves the conception of the work of art as a commodity, and of the artist, however else he may define himself, as a particular kind of commodity producer' (Williams, 1976: 44). Turning art into an object of exchange was a feat born of the rise of the money economy and the displacement of royalty and nobility in the arts by bourgeois imperatives. The court as a cultural centre was slowly being undermined and replaced by new patrons and institutions for artistic support in the later eighteenth century. In music, theatre, literature and painting the dissolution of courtly art was particularly evident. In France, for instance, the courtly magnificence of Louis XIV was discontinued under Louis XV, as the *ancien régime* waned. Instead, the bourgeoisie gradually took possession of the tools of culture, and reproduced its taste along the way. As Hauser has written, 'it not only wrote the books it also read them, it not only painted the pictures, it also bought them . . . now it is the cultured class *par excellence* and becomes the real upholder of culture' (1962: 9).

Such a situation was already apparent in the Netherlands by the seventeenth century. Here, the Protestant middle class attained economic dominance comparatively early as the Dutch Republic expanded overseas, innovated internally and produced the most advanced mercantile system in Europe (Westermann, 1996). The Dutch art market was, accordingly, a fierce but highly specialised system controlled by *burghers* and commercial groups, distributed through fairs and

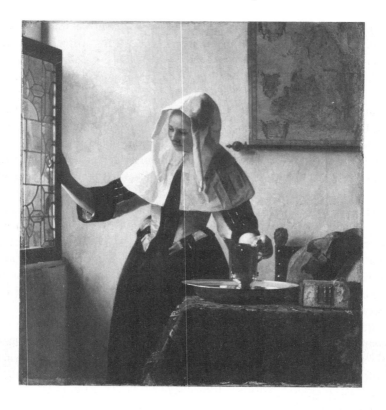

Figure 2.2 Johannes Vermeer, *Young Woman with a Water Pitcher*, 1660–67, The
Metropolitan Museum of Art, Marquand Collection, Gift of Henry
G. Marquand, 1998 (89.15.21). All rights reserved, The Metropolitan
Museum of Art.

auctions and fuelled by private speculation (Hoetink, 1982). At the top of the
patronage hierarchy were the *Stadtholders* in The Hague, commissioning specific
artists for portraits or history paintings. More routinely, artists operated in cities
such as Haarlem, Antwerp, Utrecht and Amsterdam, with their open markets.
Pictures were distributed to middle-class buyers through dealers, bookshops and
picture shops or eventually found their way abroad into the palaces of German
princes, English country houses or the picture cabinets of Catherine the Great (Van
Luttervelt, 1960). This gave artists such as Rembrandt, Hals and Vermeer greater
room to experiment or practice in a variety of styles (Pevsner, 1970). However,
most art fetched low prices – around twenty guilders per picture – and the constant
struggle to balance artistic freedom with financial security was made all the more
difficult with volatile fashions and fluctuating trade (Westermann, 1996).

The Dutch case is clearly peculiar and irreducible merely to class or religion, not least because the segregations between 'popular' and 'bourgeois' culture may not have been so marked as elsewhere (Schama, 1991). Still, we may recognise some homologies between social conditions extant in the Dutch Republic during the seventeenth century and those in other parts of Europe a century later, particularly Scotland, as argued later. Moreover, stylistic similarities in painting across European cases suggest a *certain affinity* between commercial aggrandisement (with an implied social agency) and art. For one of the crucial inner features of the works of Hals, Vermeer, Ostade and Steen, as well as Greuze and Chardin in France and David Allan and David Wilkie in Scotland, was the representation of a more middle-class sphere of taste. Vermeer, for instance, painted realistic portraits of women, localised landscapes and vernacular scenes from folk-life which paralleled Dutch resistance to absolutism. And Greuze, while not wholly abandoned by the aristocracy, drew on the everyday dramas, sentimentalised village idylls and scenes of parental tenderness that were bourgeois in charm and market appeal. Unlike the heavy ceremonials of classical Baroque, with its singular function of glorification, bourgeois art was relatively accessible, naturalistic and expressed a kind of intimacy and institutional freedom (Witkin, 1995).

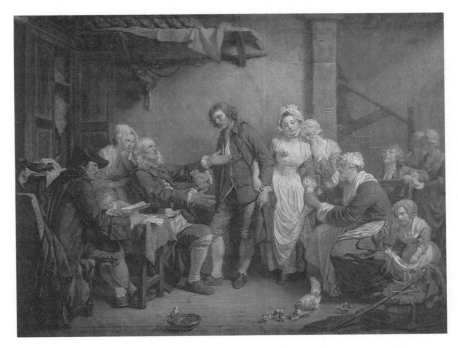

Figure 2.3 Jean Baptiste Greuze, *The Village Bride*, 1761, Musée du Louvre, ©Photo RMN.

The movement away from Baroque is evident, in France, by the early eighteenth century, in the lighter and more delicate pictures of Watteau and Boucher – both exponents of the intimate and playful rococo. Indeed, this was a period of contradictory stylistic impulses: tradition and liberation, formalism and improvisation, ornamentalism and subjectivity. The domination of the *Académie Royale de Peinture et de Sculpture,* with its hierarchy of members and genres (history painting at the pinnacle, then portraiture, landscape and genre), and closely observed aesthetic canons, continued in the eighteenth century. The king still had a virtual monopoly on large-scale commissions and special permission was required from him if artists were to paint for anyone else. But by mid-century, many of these restrictions were relaxed as a private commercial market vied for attention alongside the official one. Crow (1985), for instance, points to the rise of the *salon* as an alternative outlet for artistic commentary, criticism and painting. The *salon* helped to move art beyond the narrow confines of an original cultural elite and opened it up to the vicissitudes of individual, often middle-class, patrons. As the century wore on, many of these patterns accelerated, impelling Hauser (perhaps rather elliptically) to suggest that by its end 'the only important art in Europe is bourgeois':

> It is possible to differentiate between a progressive and a conservative trend within the middle class, but a living art expressing aristocratic ideals and serving court purposes no longer exists. In the whole history of art and culture, the transfer of leadership from one social class to another has seldom taken place with such absolute exclusiveness as here, where the aristocracy is completely displaced by the middle class and the change in taste, which puts expression in the place of decoration, could not possibly be any clearer. (Hauser, 1962: 2)

By the late eighteenth century, landscapes and genre scenes, in particular, were growing in popularity amongst middle-class collectors and dealers, as well as being dispersed to a broad constituency of non-collectors via engravings, books, tourist memorabilia and so on. The fashion for Dutch and Flemish domestic scenes – depictions of the life of everyday folk – received much derision from the more aristocratic connoisseurs of Europe who considered them immoral and vulgar, as bearing the marks of the commercial system which gave rise to them. But even Diderot praised Greuze's genre pictures and encouraged artists irritated by the traditional critics to show in the market-led *salons.* By the end of the century grand taste had given way to the 'less noble' style of the *petits goûts* – the little pictures. Portraits, too, once only afforded by the high elites, were now commissioned by those of the middling ranks to satisfy their own vanities – a common-place genre for domestic distinction.

Dealers, Critics and the Audience

In contrast to the pre-modern calculation of art's value according to labour or materials (the use of ultramarine blue or gold leaf in the Renaissance, for instance), the commodified art object has no value in the traditional sense. Its attraction from the eighteenth century was tied up with more abstract norms – the genius and creative abilities of the artist, the mysteries of subjective expression, the stroke of the brush, or the purity of the hand. Art's prestige value was something based on the buyer's own desire and the adherence to norms which were believed to reside outside of economic criteria; norms worked up by the new agents of art, the dealers, critics and connoisseurs.

The dealer's was to integrate the artist into the art-economic complex, to introduce the work to a broader public of critics, buyers and collectors and to translate aesthetic into economic value (Becker, 1982). But the dealer also provided a buffer between the artist and the market, to obscure the 'vulgar' machinations of the market from the creative process. This was an important factor in keeping art 'pure', or relatively unsullied from 'lower' orders of social expression. Critics, on the other hand, whose profession emerged with print capitalism, relied on personal judgement to report on individual artists and their styles. Like the journalism of the public sphere itself, aesthetic commentary did not report 'news' but was now committed to opinion. This was important precisely because the critic could make or break reputations.[8]

All this implied a reorientation of the art-audience. The arts were no longer the natural appurtenance of the aristocracy or the preoccupation of small elites, but, like leisure and culture in general, a product for bourgeois apparel. The *salon* exhibitions of France, for instance, fully secular and central to the life of the city from 1737, helped break down limits on cultural consumption by bringing together a 'broad mix of classes and social types, many of whom were unused to sharing the same leisure-time diversions' (Crow, 1985: 1). The journal or newspaper review was aimed not at an hereditary elite but a *general* public. In music, the middle classes were the chief consumers in the late eighteenth century – a constituency of anonymous concert goers with wider tastes, rather than patrons of aristocratic intentions with strict commands and preferences (Lang, 1973). And the novel, perhaps the most popular genre of all, was widely consumed, especially by middle-class women by the late eighteenth century (McKendrick, Brewer and Plumb, 1982).

The Inchoate Art Museum in the Age of Enlightenment

From the above it is clear that the eighteenth century was a crucial watershed for Europe's fields of cultural production. Although subject to different local

conditions, most cities and nations were accumulating the necessary accoutrements of high culture. These included complex mechanisms of production and reward, with a support system for artists, instruments of distribution located away from the court, and an informed audience for art. At this point, however, we must shift focus back to the art museum and ask how best to characterise its development in this century. Can similar 'enlightened' tendencies, in other words, be detected in the art museum?

The difficulty in pinning down the eighteenth century to a neat stage in the art museum's development rests with the fact that it is a period of (often dramatic) transition that promises so much but falls short of delivering the formation in its pure form *en masse*. Certainly, this is not the classic century of the national art museum in Europe. The 'golden age' is the nineteenth century, before which time many of Europe's emerging art museums continued to function as absolute spaces of glorification. Nevertheless, what the eighteenth century did achieve was the gradual erosion of the single-function princely model and the implantation of seeds of development which later flowered into the more complex space of the national art museum. In particular, the eighteenth century laid down three museological modalities: firstly, certain ideational preconditions for the museum's foundation; secondly, the provision of early ideal types and embryonic schemes that were fully realised in the next century; and thirdly, the constitution of a wider public for art museums distanced from the traditions and exclusions of courtly life.

The internal reconfiguration of absolutism made it possible for the first time to think of the art museum as a non-private space with rational, educative or national ends. The demands of intellectuals for a more enlightened and open institution mirrored their attack on royal privilege in general. In response, rulers felt it necessary to pay heed to a larger population and exercise a degree of representative generality. As already mentioned, 'enlightened absolutism' was the administrative characteristic of this system. The modern continental absolutist state adhered in extended ways to population needs, inner resources and the 'subject's well-being' (Poggi, 1978). Accordingly, monarchs gradually lifted the restrictions placed on royal collections from the mid-eighteenth century. Not surprisingly, Austria, the enlightened absolutist state *par excellence,* was one of the first regimes to turn its royal gallery into a nominally 'public' art gallery. The Schloss Belvedere in Vienna was opened around 1784 under the directives of Joseph II.

Similar principles were evident in other royal collections which, at different points in the eighteenth century, were made more accessible to broader sections of the population. In Italy, the Uffizi was donated to the people by the last princess of the Medici family in 1743. In the late eighteenth century Grand Duke Leopold I of Tuscany ordered the modernisation of the Uffizi and by 1782 guide books were available for visitors' use. In Rome and Naples restrictions on access were loosened by popes, cardinals and princes, exhibiting a growing awareness of

'public' representation. The neo-classical Pio-Clementino, for instance, was opened in 1773 by Pope Clement XIV and contained part of the Vatican collection. In Germany (Prussia was, of course, the other exemplar of enlightened absolutism), collections in Munich, Kassel, Dresden and Düsseldorf were opened from mid-century, often as strictly municipal rather than 'state' collections. In 1756, for instance, a building was erected by Johan Wilhelm in Düsseldorf for the sole purpose of exhibiting paintings. And in France, whilst access to Versailles and the treasures of Louis XIV and XV was only possible on considerations of attire, a plumed hat and sword could be hired from the caretaker. In any case, a concessionary exhibition of old masters was opened *gratis* on two days a week in 1750 at the Palais du Luxembourg in response to complaints from artists and public alike over the loan and private storage of Baroque pictures (Bazin, 1967).

Central to this period of museum transition were the ideational principles used to characterise the functioning of such spaces and their objects. The placing of royal collections into public or semi-public contexts involved a reconceptualisation of the space of representation as well as the art works inside. The onus shifted gradually away from co-ordinating enclosed spaces for private pleasure or personal glorification towards an organisation based on the narratives of progress, civil refinement and moral betterment. These were the idioms of the intelligentsia and its public sphere.

The interest in the relics of human achievement, in rare and culturally resonant objects, was a form of modern consciousness based on the rise of a sense of history and modern rationality. As Preziosi states it: 'One of the spaces of memory par excellence in the West since the eighteenth century, the museum is one of our premier theoretical machineries, and in many ways the very emblem of desires set into play by the Enlightenment' (1994: 141). What was distinctive about Enlightenment thought was the adherence to a more secular and inner-worldly universe of belief which stressed system, order and the application of rational principles of classification to what previously had eschewed taxonomy. The binomial method of classifying plants and animals by genus and species introduced by Linnaeus and Buffon was matched by the classification of art according to school and chronology.[9] It was Winckelmann's *History of Ancient Art*, published in 1764, which did most to forward this mode of taxonomy. Now, narratives of progress, in relation both to civilisation in its broadest sense and to national art schools, helped to re-codify the relics of former human achievement.

In Vienna before 1784, for instance, the Austrian royal collection was a limited and disordered hotch-potch of paintings based on the decorative prerequisites of Baroque. Like the standard princely set-up it was the general appearance and format, not the quality, which determined the appearance and function of the display space (Bazin, 1967). From 1778, the 'enlightened' art connoisseur Christian von Mechel was appointed to reorder the royal collection using rational

forms of taxonomy that grouped works according to linear chronology and by school. Many of the sumptuous frames which adorned the pictures under the original scheme were replaced with simpler, more prosaic, neo-classical frames.

The pedagogic utility of the overall scheme was expressed in the catalogue, itself a novelty, where Mechel claimed that a walk through the gallery was to be methodical and instructive:

> so that one learns at a brief glance infinitely more than one could if the same paintings were hung without regard to the period which had made them . . . It must interest artists and amateurs the world over to know there actually exists a repository where the history of art is made visible. (cited in Bazin, 1967: 159)[10]

Even earlier than this, by 1756 in fact, the pictures at Düsseldorf had been arranged in a system of 'master and school', although paintings were still hung floor-to-ceiling. And many of Vasari's principles of art history were employed in 1770 by Luigi Lanzi for the Uffizi cabinet, using a 'grid' to classify European art. Whatever the chronological profile of this system, what is clear is that the rational approach marked an important direction in the order of art works as well as the role of intellectuals in directing the apparatuses of art.[11]

Support for the opening of the royal collection in France, for instance, came from the *philosophes*. In fact Diderot had an even more grandiose scheme in mind. In volume IX of the *Encyclopaedia,* 1765, he outlined the foundation of a *Musée Central des Arts et des Sciences* – a cultural centre for learned activities housed in the Louvre. This was to be based on the *mouseion* of Alexander the Great and would fulfil the historicist and neo-classical tenets of the Enlightenment. It would hold learned societies, scholarly collections and become a training ground for creative artists. It would also become a monument to French nationhood, at this point still embodied in the king, augment the glory of the nation and impress foreign dignitaries.[12] The plan, though officially submitted in 1768, was unsuccessful. But a decade later, under Louis XVI, progressive moves were made which heralded a more modern approach to museum function and display in France.

Count d'Angiviller's appointment as *Directeur Général des Batiments* was crucial to a modern fine arts policy and ended in the supplementation and re-organisation of the royal collection as well as preparations for the transformation of the *Grande Gallerie* of the Louvre into a royal exhibition space. Under this proposed scheme (which looks all the more prescient in retrospect) the gallery was to be a source of national pride, a demonstration of the magnificence of Louis XVI. Official committees discussed the most appropriate lighting methods and the paintings were prepared for hanging. Delays dogged the plans, however, and the scheme was overtaken by the Revolution. One can only speculate how d'Angiviller's scheme would have unfolded, but Mordaunt-Crook's guess may be instructive:

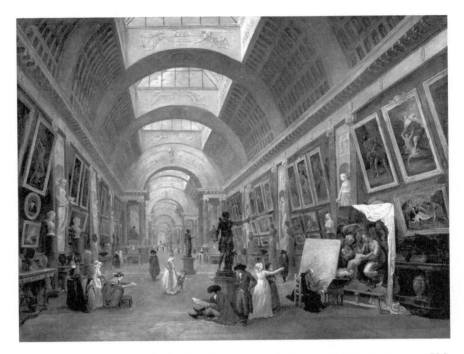

Figure 2.4 Robert Hubert, *Projet d'aménagement de la Grande Galerie du Louvre*, 1796, Musée du Louvre, ©Photo RMN.

The royal collection in Paris might eventually have become a museum, like the royal collection in Vienna, and d'Angiviller playing the part of Christian von Mechel. The Louvre might have become as public as the Belvedere. But, like the Belvedere, it would still have been a royal collection. It required the Revolution to turn the idea of a museum into one of the basic institutions of the modern state. (Mordaunt-Crook, 1972: 34)

In fact, we must be careful not to mistake the eighteenth-century art museum for the fully formed public, national institution of the nineteenth century. All of the requisite socio-historical forces were yet to accumulate into the formula which delivered the institution in its fullest form. The state, for instance, was yet to play its formative role in the eighteenth century; the nation was yet to be brought into line with the state; and culture was yet to be subsumed under the latter's socio-political remit. To this extent, museums in the eighteenth century were not usually owned by the state on behalf of the people as a corollary to citizenship, governance and democracy. Visitors were subjects not citizens and power was represented 'before' them rather than 'for' them. Hence, in many cases, eighteenth-century art museums were still royal museums, housed in royal buildings, playing out the legacy of the princely gallery and 'juridico-discursive' power in the form of royal

glorification (Bennett, 1995). And most significantly, *formal* limits on access were an abiding feature of these collections, which remained specialised, esoteric or cut off from the mass of the public. The Vatican museum, for instance, was not open to the public and the same is true of a host of other collections. The Belvedere in Vienna was only partially open to visitors on three days of the week and then only to those with clean shoes. In Paris, pictures in the Luxembourg gallery were arranged according to a system of 'contrast and comparison' that assumed an ideal audience of *cognoscenti* and amateurs. There were no labels and visitors were more or less instructed to guess authorship (Bazin, 1967; McLellan, 1994). Finally, catalogues were clearly written with the scholar, not the public, in mind (Hudson, 1987).

Of course such limits were also persistent features of the bourgeois public sphere and its cultural enclaves, even in the nineteenth century. Indeed Habermas' idealisation of the public sphere, in general, glosses what are significant structural forms of exclusion of certain social types and discourses. Rules on dirty footwear were also rules marginalising workers and the sharp distinction of private from public spheres provided the basis for enjoining women in the former. As a *bourgeois* public sphere, in other words, it was restricted historically and socially, acting as a vehicle for middle-class distinction; a means whereby a struggle against absolutism was effected, but also where bourgeois norms were made, reproduced and imposed on the social edifice. I shall return to these issues, and how the aesthetic is implicated in them, in the next section. But what made the eighteenth century different in this respect was the lack of any official rhetorics of public access – statist definitions of citizenship, government edicts on the benefits of culture for the popular classes or wider patterns of education and commodity consumption. These were values which suffused the national art museum only in the nineteenth century.

Having flagged these qualifications, though, we should not ignore what are significant signs of cultural modernity in the eighteenth century: developments in the matrix of fine art, generally, and the gradual eclipse of the princely model as the dominant space of representation. Despite the lack of a fully materialised art museum, the shape of a recognisably modern institution begins to form in this period. In particular, the inchoate art museum was more open, specialised and rationalised than any of its predecessors. Employing the newly radicalised space of the public sphere, intellectuals delivered the kinds of epistemological supports and enlightened schemes (ideal types, as it were) which anticipated the form and function of nineteenth-century museums. Moreover, a space had opened up into which the bourgeois class could pour its visions of the museum as a sphere of public instruction and governance, as it took over the reins of power. All this bespoke broad historical changes in the fabric of European society and polity; changes which were to proceed apace in the nineteenth century.

The Emergence of the National Art Museum in the Nineteenth Century: The Golden Age

We arrive in the early nineteenth century, then, at the point where all the crucial political, artistic and social conditions configure to foster the national art museum. Up until now the recipe has been lacking some crucial ingredients. But by the first two or three decades of the nineteenth century, everything is in place and it is rare to find a major European capital which lacks such an institution. Despite local idiosyncrasies in museum morphology, in general, as Duncan observes, 'by 1825, almost every western capital, monarchical or republican, had one' (1995: 32).

Perhaps it is disingenuous to posit any separation between the eighteenth and the early nineteenth centuries. Centuries, after all, are linguistic and cultural constructs, not iron curtains. But there are genuine reasons for doing so. For it is the early part of the nineteenth century which really witnessed the flowering of many of the tendencies which were only planted in the previous century. It is the early nineteenth century which gave clarity and concrete form to the museum project as something taken up *in general* across the European continent. It is the early nineteenth century which saw the mobilisation of the nation-state as the guardian of the museum idea and its crystallisation into something recognisable to us today. It is the early nineteenth century, in short, where nation, state, bourgeoisie and fine art met in their modern forms to deliver an institution in all of its self-contradictory modernity.

The Louvre, founded in 1792, is included in this section because this is where it appears to belong. Everything that museum scholars have valued in the birth of the museum has come to be symbolised in concentrated form in the Louvre: from social class shifts to the decline of the absolutist academy; from modern internal layout to state ideology. In effect, the Louvre has come to take on meta-museological meaning; it is the *sine qua non* of the art museum, the paradigm model and its influence as an archetype on other European cases cannot be overstated. 'Containing the finest collection of Old Master paintings and antique sculpture ever assembled under one roof,' says McLellan, 'the Louvre, founded in the final years of the Enlightenment, became the model for all state art museums subsequently established' (McLellan, 1994: i). Indeed, the very notion of a *national* gallery ordered by art historical principles is an outcome of the French Revolution, as is the notion that all citizens should have access to such museums. The Louvre's early modernity, and particularly the role of the French state, is something remarkable. But it really represents the first of a wave of museum founding in Europe, mostly of the nineteenth century. In this sense it is better placed, analytically, in the nineteenth century.

This final section, then, is an attempt to make sense of the last pieces of the puzzle: the pro-activity of the nation-state and the concretisation of bourgeois

'modes of distinction' (Fyfe, 1993). Typical of the ambiguities of the modern museum project, though, nineteenth-century conditions of formation pull in opposite directions. While the state constitutes the institution as a fully democratic, free and open realm of national glory, as extolling the values of citizenship, civic improvement and moral refinement, the art museum, as an essentially *bourgeois* institution, remains an exclusionary and limited enclave. The first part of this section deals with the former *public* component of museum formation as it is elevated by the nation-state. Here it will be necessary to sketch some co-ordinates of the European state system, the development of nationalism and how the art museum intersected with these movements. I will also point to the ideological role of the museum as an instrument of incorporation, social control and governance. The second part targets the art museum as a *private* realm of 'distinction' and connoisseurship for new cultural elites, marking them off from other social groups. Using the work of Bourdieu, in particular, I will suggest that rhetorics of democratic access masked one of the main functions of art museums – to provide high art with an enclave that was pure and which distanced bourgeois elites from others.

Museums and State Formation

It is often overlooked that national museums are 'national' because of the enterprise of a particular nation, usually in tandem with the relevant state unit. Yet, the relationship between the two is central to an explanation as to why the art museum 'took off' when it did. As Pointon (1994) has suggested, the institution of the art museum offers the cultural historian an attractive exemplar of the operation of state ideology. For sure, the aggrandisement of European state and national power in the late eighteenth and early nineteenth centuries was coterminous with the rise of the modern national art museum. Indeed, the state and the museum mutually circulated their effects in this period. The museum indexed the urgencies and interests of the nation-state, but it also mobilised these interests, providing a powerful cultural base where official ideologies were made and remade. I will return to this point later. But first, a note on definitions and some background material on the modern constitutional state in Europe is needed here. What made the nineteenth century state different from earlier formations, previously discussed?

Clearly, there are a variety of geopolitical forms in Europe with multiple temporal trajectories and representative figures. Furthermore, the process of state formation in Europe, as already implied, was exactly that, a process of long-term proportions, neither static nor complete. There is overlap, in other words, between the forms of rule discussed above and below. A useful attempt at defining the modern state, however, is provided by Tilly (1975) who targets four features:

(1) it is differentiated from other organisations operating in the same territory; (2) it is autonomous; (3) it is centralised; and (4) its divisions are formally co-ordinated with one another. (quoted in Poggi, 1990: 19)

Poggi takes up this definition for his own preliminary characterisation of the modern state as it appears in the nineteenth century. In this formulation, the state finds its systematic shape after the French Revolution. It is an organisation where political power is vested in and exercised through a set of specially formed institutions with their own body of rules and resources, and represents a distinctive and unified set of interests and purposes. Its functions are primarily political; it controls a population within a defined territory, using force, if necessary, and exercises sovereignty over this territory. No other organisation can challenge that control. The state is unitary in the sense that all laws and edicts originate from it and all bodies who exercise power must derive their authority from it. At the same time, states exist in a configuration with other polities with their own autonomy, forms of centralisation, sovereignty and so on. This forms what Harris has called a 'European state system' (Harris, 1993: 273). Finally, all the above features are modern in that they are not found in political forms before the early-modern stage of European history.

The modernity of the nineteenth-century state revolved around its ability to routinely order social life via a highly institutionalised system of political power (Poggi, 1990). As Weber indicated, its unity and impetus was given as an harmonic to capitalist modernisation: modern capitalism evolved 'in alliance with the emergent power of the modern state' (cited in Poggi, 1990: 47). Here, feudal barriers to economic and social progress were targeted by emergent bourgeois elites for destruction, to be replaced by centralised, bureaucratic, capitalist formations. France, England, Spain, Sweden, Portugal and Holland, the 'historic' nation-states, were early models, but the process of state expansion spread outwards to the German-speaking states, Italy, the Balkans, Scandinavia, and so on (Nairn, 1974). By the early nineteenth century, the 'European state system', consisting of both archaic and modern powers, had evolved through a process of heightened conflict for internal sovereignty. These states were ordered by principles of law rather than individual might, moral rather than arbitrary rule, rational rather than impulsive power, and principles of 'justice' rather than divine right.

All this implied security for the 'reasoning public' and its claims to opinion, freedom and political rights. The eighteenth-century bourgeois public sphere now had a place at the very heart of the nineteenth-century constitutional system – constructed in such a way as to actively require public debate and open confront-ation. In this respect, a close relationship now attended between civil society and the specialised state, as those bourgeois became the personnel of the state itself,

shaping the agenda of the state in favour of the free market, capital and the protection of private property.

What gave the nineteenth-century project of the state effective momentum and legitimation was the idea of the 'nation' itself, defined by Smith as the 'named human population sharing an historic trajectory, common myths and historical memories, a mass, public culture, a common economy and common legal rights and duties for all members' (1991: 14). The nation belongs, as Weber suggested, to the realm of cultural values and 'specific sentiments of solidarity in the face of other groups' (cited in Gerth and Mills, 1958: 172). As such, its constituent material is historically fluid and 'imagined', rather than fixed and timeless (Anderson, 1983). Furthermore, its relation to the state is highly complex and varied. Not all states coincide with nations and vice versa. In some cases, France, for instance, the nation was imposed from above by the centralised state – in this case as a territorialist, assimilationist and political unit that crystallised around French citizenship. This was the process that turned 'peasants into Frenchmen' (Weber, 1973). In Germany on the other hand, which suffered from a supine bourgeoisie in the eighteenth century, no centralised state existed until later. Nationhood was more restrictive, ethnocultural and 'differentialist', based on *volk*-centred understandings of German lineage (Brubaker, 1992). In the Netherlands, the seventeenth century territorial partitioning of the region into north and south militated against a unified sense of state and nationhood until 1806 when Napoleon made his brother King of Holland. And in Italy, Austrian rule presented an obstacle to national unity until the late nineteenth century (Seton-Watson, 1977).

Taking the 'view from above', what is clear is that the state gave the nation, as an artifice, clarity and political function. More often than not, nations were the result, not the source, of centralised political administrations.[13] The historical development of nationhood was, in turn, crucial to the success of the modern state as ideas of 'national interest' and 'national welfare' had replaced dynastic or religious forms of legitimation. States presented themselves as states of particular nations and thrived on concentrated national sentiments, particularly modern forms of patriotism. Legal, military, economic and geographical aims were often pursued in connection with the ideas of nationhood and monarchies that were to survive had to adapt to this new ground of legitimation. In return, the state gave itself the role of protector of a nation's language, education and history, claiming to act on behalf of all people; it lauded itself, in other words, as the institutional expression of democratic legitimacy. All this was reduced to an ideational commingling of state territory, sovereign populace and political self-determination, as in the equation nation = state = people (Hobsbawm, 1990).

Nationalism, the movement and ideology underpinning the idea of the nation, whilst not strictly coterminous or reducible to the state unit, was, nevertheless, its cementing force. Traceable in its modern form to the French Revolution, nationalism

helped invent, imagine and stylise the nation through the raw materials of culture, and provided the script with which European nation-states authorised their social and political goals. Nationalism was essentially a political force which tried to meld the state as a political unit with the nation as a cultural one, giving rise to a new phase (roughly between the 1780s and the 1850s) in the history of the nation-state. As Cobban indicates: 'Although nation states had existed for centuries, before the nineteenth century no specific relationship had been posited between culture or language and the political state' (1969: 249). Pre-modern configurations such as the Hapsburg empire had stood over disparate cultures without the need to congeal or mobilise them. With the extension of the franchise, the electoralisation of politics, and the imperative for nation-states to modernise in the nineteenth century, a unified and homogeneous national identity which could smooth over inequalities was essential. Nationalism, in this sense, was the precondition of the formation of modern society, 'and such a vital one that bourgeois civilisation has on the whole remained cast in its mould' (Nairn, 1970: 45).

An important role in these developments was played by intellectuals and professionals whose discursive and political aims corresponded with those of the nation-state. These groups mobilised popular loyalty to the nation, by exploiting new mass systems of communication such as print media. Following the role which Gramsci (1971) attributed to traditional and organic intellectuals, such thinking groups furnished nations with symbolic or semiotic systems of attachment – myths, legends, national figures, invented traditions and so on. They often did so in the idioms of Romanticism, appealing to an idealised golden age of poetic figures, searching for internal subjectivities (the national genius) and furnishing a distrust of the abstract. In Germany, for instance, a form of spiritual Romanticism in the age of Goethe and Schiller actually helped to forge the idea of the nation itself, providing the structures of thought – individuality, uniqueness, inward feeling, faith in the vitality of traditional cultures – for the constitution and consolidation of a particular 'ethnocultural' understanding of nationhood. Equally, nations such as Greece, Hungary, Poland and Italy, who had been 'hosts' to absolutist or Napoleonic rule, wrested power in the Romantic clothes of freedom, employing the trappings of folk-culture and the affirmation of the particular to construct their own sense of nationhood (Nairn, 1974). In Scotland, too, as we shall see, Romanticism was a significant cultural force, but was devoid of the separatist impulses of elsewhere.

The relations between material culture and the state, then, are double-edged. While culture in some ways appears to reflect already existing social relations, this belies its complex and active role. The linguistic, semiotic and symbolic forms of the nation-state (flags, coins, anthems, uniforms and monuments) helped to actively foster an homogeneous, standardised public national culture with its own 'organic' history. Indeed, the formation of a glorious and continuous past, in which

national traditions are legitimated in the present, is an enduring feature of nations and states.

Revolutionary Culture: Rituals of Ceremony and State Art Museums

But what of the affinities between the nation-state and art? How has art and its attendant institutions intersected with the interests of this administrative bloc? Well, the interest the state traces in its excursions into the art world relates both to the preservation of social order and to the consecration of a national culture. It promotes national unity, under the guise of 'heritage', for instance, and the nation's standing among other nations (Fyfe, 1993; Becker, 1982). As Fox (1970) indicates, the liberal state only entered as an active patron in the early nineteenth century, sponsoring projects with official funds for the putative good of the public. It thereby presented itself as the benevolent guardian of the most civilised of human expressions and protector of the arts. In contrast to the patronage of individual aristocrats or monarchs, in other words, administrations authorised their aesthetic pursuits in terms of a representative generality, appealing to the general good and national welfare.

As an example of the relations between the state and art, the French case is instructive. Lynn Hunt (1984) has focused on the revolutionary period as rich in a potent new political culture of symbols, ideologies, languages and everyday routines. The significance of icons such as the liberty tree, classical statues, festivals, the new calendar and so on hinged on their ability to re-invent French society and its social relations 'and to establish the basis for a new national community' (Hunt, 1984: 12). The rhetorical use of a utopianised classical history, the turning towards Greek and Roman models of liberty and democracy, for instance, led to the substitution of public statues of Louis XIV and XV with those of the Goddess of Liberty and Hercules. This was a semiotic representation of sovereignty which connoted civic virtue, national genius, people power and paternalism. Heavily politicised, culture here became an effective instrument that helped to shape the contours of the revolution itself, the ideologies and perceptions of the revolutionary protagonists as well as the idea of the French nation.

The inordinate success of David's role as state-sponsored artist deputy and general propagandist of the Jacobin regime illustrates this point well. David was a crucial figure in the revolution, fashioning the symbolic idioms of popular consumption and masterminding some of the great moments of national *jouissance* – festivals and ceremonies, in particular. He was also pro-active in the re-organisation of Paris's system of museums and academies and the creator of an artistic 'revolution' of his own. David's precise form of 'puritanical classicism', embodied in pictures such as the *Oath of Horatii*, *Oath in the Tennis Court*, and *The Death of Marat*, helped to iconographically meld the republican civic ideals

of classicism with the French state and reiterate its commitment to fraternity and a common French identity.

The *Oath of Horatii*, for instance, was a representation of French *fraternité* based on Roman heroic ideals of civic republicanism. The three brothers in the picture take an oath on their father's sword to die for the glory of their fatherland. Through this they stoically and unanimously pledge their faith to the glorious ideals of freedom, risking self-sacrifice if necessary. The nation is in evidence, here, as a spirit of fraternal citizens (Smith, 1991).

David's works were energetic in style, bold in colour and 'masculine' in content. As such, they bespoke an official taste, translated as the utility of classical art, and sanctioned by a government espousing a rhetoric of 'popular consent' and 'general good'. As far as the revolutionaries were concerned, art no longer signified incidental decoration, ornament or luxurious spectacle, but in itself possessed transformative effects. The conscious turning of art into state propaganda, as an instrument of social change, was something inconceivable in the previous century. But the shackles of patrimonialism and private splendour had been broken: art was no longer of the world, but actively in it, playing a constitutive function. In effect,

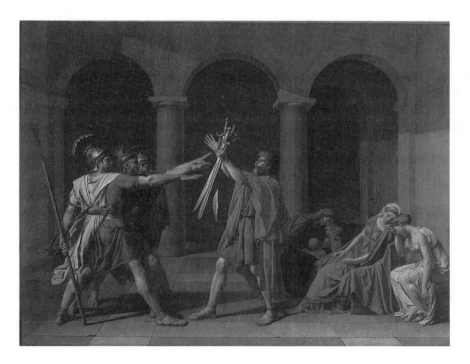

Figure 2.5 Jacques-Louis David, *The Oath of Horatii*, 1785, Musée du Louvre, ©Photo RMN.

of course, this was replacing one form of functionalism with another. The difference was that revolutionary art consecrated national glorification in the form of the state and 'public good' rather than kingship and 'private splendour'. As David was to put it: 'Each one of us is responsible to the nation for the talents he has received from nature' (quoted in Hauser, 1962: 138).

The building of art museums was a form of cultural invention with similar aims and effects. At the beginning of the nineteenth century a host of European nation-states were recognising the role of public museums as instruments of national consciousness, while royal collections were turned over to state or semi-state administrations. Firstly, the augmentation of state-sponsored art museums in the early nineteenth century represented a new urgency to concentrate national pride in the populace at large. National museums, in this sense, took on a similar role to nationalism in general – national and political cohesion and civic progress. Secondly, the centring of such institutions pointed up the importance of national institutions such as museums and academies as tools of national cultural power. According to Fyfe, for instance, 'European state formation as museum', more particularly from mid-century, was motored 'by industrialisation and class struggle' on an international stage (1993: 16). Thirdly, the museum's emergence demonstrated the new value accorded to the national art collection, framed in a museum as a cultural asset for the expanding apparatus of governance.

Carol Duncan has argued that institutions such as museums 'made (and still make) the state look good: progressive, concerned about the spiritual life of its citizens, a preserver of past achievements and a provider for the common good' (1991: 93). Nineteenth-century museums were ideal monuments to democracy. They produced and reproduced a set of key values, including citizenship, public participation and common humanity – all ideological food for the modern state in its role as guardian of a nation's artistic heritage. This was most explicit with the Louvre, the prototypical public art museum and symbol of the bourgeois state as it evolved in the age of democratic revolutions.

In August 1793, the anniversary of the fall of the monarchy, the Louvre was opened by decree as 'a Monument Dedicated to the Love and Study of the Arts'. It consisted of 537 paintings and 184 objects on tables, open to the public on three out of every ten days and displayed in dramatic form the glory of the Republican government. Once a private palace of kings, the Louvre was now a *leitmotif* for the overthrow of the *ancien régime* and homage to the French nation-state. The nationalised museum was intended to 'attract and impress foreigners', in the words of the Minister of the Interior, who continued:

> It should nourish a taste for fine arts, please art lovers and serve as a school to artists. It should be open to everyone. This will be a national monument. There will not be a single individual who does not have the right to enjoy it. It will have such an influence on the

mind, it will so elevate the soul, it will so excite the heart that it will be one of the most powerful ways of proclaiming the illustriousness of the French Republic. (cited in Duncan and Wallach, 1980: 454)

On Napoleon's rise to power, foreign conquests further augmented the collection over the next twenty years with art from Italy, Greece, Egypt and the Low Countries. Such renowned pieces as the *Läocoon*, the *Apollo Belvedere*, Raphael's *Transfiguration* and Corregio's *St. Jerome* were requisitioned by a special committee, led by the expert Denon. Spectacular processions brought the booty back to Paris in chariots under the rhetoric of moral indemnity; these pictures and statues were finding their 'natural' home in the well-spring of 'liberty, creativity and genius'.

In 1803 the Louvre was re-named the 'Musée Napoléon' in honour of the emperor's contribution to its formation. The layout of the collection now fell in with the procedures established in the Enlightenment and followed by other museums. Pictures were organised into schools (Italian, French, Dutch and Flemish), each work was given an explanatory text and a catalogue was provided – the first to be aimed at the average citizen, according to Hudson (1987). France now had a museum which appeared fully secular, public and national: a monument to democracy, civilisation and international cultural domination.[14]

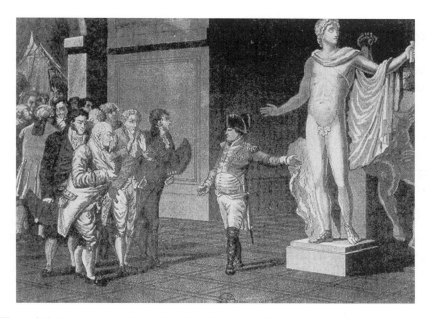

Figure 2.6 Anonymous etching, *Napoleon Bonaparte Showing the Apollo Belvedere to his Deputies*, c.1800, © Bibliothèque nationale de France, Paris.

In their seminal essay, 'The Universal Survey Museum' (1980), Duncan and Wallach outline the ways in which museums function ceremonially to concentrate national pride by using certain methods of inscription, display arrangements and decorative schemes. In the Louvre, the development of display principles which grouped works of art according to national schools and art-historical periods re-codified the exhibition space to suit the visibility of the French republic in two main ways.

On the one hand, the art objects inside were no longer displayed as repositories of wealth or colonial power but were re-socialised to connote spiritual value or national genius. The Louvre's chronological hang, based on international standards of taxonomy, transformed signs of luxury, status and splendour of the *ancien régime,* into objects of a universal spirit (genius) but embodied most gloriously in the particulars of French art. On the ceiling of the vestibule of the Louvre, for instance, four medallions symbolised the key art historical schools, each person-ified by a female figure holding a famous example of its sculpture. For Egypt, a cult statue was displayed; for Greece, the *Apollo Belvedere;* for Italy, Michel-angelo's *Moses;* and for France, Puget's *Milo of Crotona.* France, in this schema, became the *telos* of humankind's most civilised achievements. Now presented alongside art's awakening, flowering and renaissance, the French nation and its individual geniuses took their places in the Louvre within the developing canon of art history. A visit to the Louvre was 'scripted' accordingly as a ritual of national glorification, with the interior space forming 'an ensemble that functions as an iconographic programme' (Duncan and Wallach, 1980: 451).

On the other hand, the visitor was now addressed as an idealised citizen of the state and inheritor of the highest values of civilisation. S/he was the recipient of the nation's most profound achievements, beneficiary of the state's ideals of democracy, not the subordinate of the prince or lord. Social relations between the visitor and the collection had shifted, in other words, away from those pertaining to the absolute space of representation, where the visitor was the prince's guest, towards notions of equal access, giving every citizen, in principle, universal rights to art. In short, the state as an abstract presence replaced the king as host: all of which is summed up usefully by Duncan in her book *Civilizing Rituals*:

> The public art museum addressed its visitor as a bourgeois citizen who enters the museum in search of enlightenment and rationally understood pleasures. In the museum, this citizen finds a culture that unites him with other French citizens regardless of their individual social position. He also encounters there the state itself, embodied in the very form of the museum. Acting on behalf of the public, it stands revealed as keeper of the nation's spiritual life and guardian of the most evolved and civilised culture of which the human spirit is capable. All this it presents to every citizen, rationally organized and clearly labelled. Thus does the art museum enable the citizen–state relationship to appear as realized in all its potential'. (Duncan, 1995: 26)

Other European Examples

Such was the Louvre's influence on other nations that museum building accelerated markedly from the early nineteenth century, often with the consent of heads of state in those nations. Napoleon's excursions into Spain, Italy and Holland provided a climate in which new national galleries could be formed in subject cities such as Madrid, Milan, Naples and Amsterdam, founded on French-inspired principles of nationhood. In 1810, for instance, Napoleon decreed the formation of a museum of painting in Madrid, to be partly funded from religious orders. This project never materialised, but the idea of a national institution in Spain was persistent enough to underpin the opening of the Prado to the public in 1819. The Prado was opened by Ferdinand VII and consisted of 311 paintings accompanied by a catalogue.

In Germany, on the other hand, and to a lesser extent Italy, the princely kingdom was administratively pro-active. In the former, nationhood lacked the vital political dimension and Germany's system of divided states made for a less integrative structure of rule, precluding the idea of a single state-sponsored gallery – Germany had no single capital city, for instance (Hoffmann, 1994). Yet the Altes Museum in Berlin was opened in 1830 on return of the paintings acquired by France and helped articulate national identity in Prussia after the Napoleonic Wars (Telman,

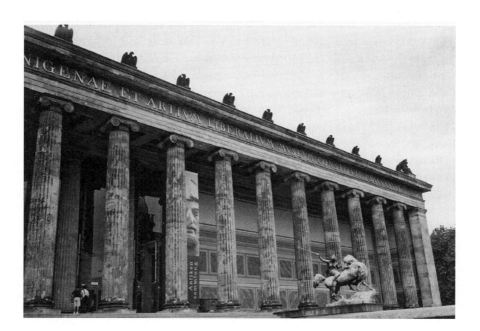

Figure 2.7 Altes Museum, Berlin, photo: author.

1996). The works inside no longer served as expressions of private wealth (of the Hohenzollern family), but came to symbolise Prussian national heritage. Indeed, in the 'Riga Memorandum' of 1807, the Prussian minister von Altestein advised the king that the 'fine arts are the expression of the highest condition of mankind' (cited in Duncan and Wallach, 1980: 457) and that the nation had a duty to make them accessible to all. Elsewhere in Germany, the collections of the Alte Pinakothek and the Glyptothek, both in Munich, opened in the 1830s and a Bavarian national museum was established in 1867 (Alexander, 1979).

In the Netherlands, despite having one of the richest fields of visual art in Europe, as well as a powerful bourgeoisie, the country suffered a form of syncopated rule which vitiated the project of the museum. As in Scotland, religious divisions fractured social life and undermined the possibility of expansion in collections already decimated by the Reformation, whilst national unity was made all the more uncertain with French military occupation and divisions between the Protestant north and Catholic south. Besides the short-lived National Art Gallery in the Huis ten Bosch at The Hague, the foundation of a national institution, in the form of the Rijksmuseum, dates from 1808. This was the year in which Napoleon's brother, Louis Napoleon, transferred his court from Utrecht to Amsterdam. Amsterdam was to become, in this scheme, a centre for art, science and learning, with an equivalent to Paris's 'Musée Napoléon'.

Important Dutch collections were amassed at the king's palace in the seventeenth-century town hall at the Dam and the Royal Museum was opened in September 1808. In 1810 Holland was annexed directly to France and lost its local purchase grant on the abdication of King Louis Napoleon. On Dutch independence the museum was once again elevated into a state institution with a patchwork collection of Dutch and Flemish masters formed through donations and bequests. In 1815 the collection was moved to the Trippenhuis and opened as the Rijks-museum in 1817. As in Paris, London and Edinburgh, the building was shared with the Royal Academy, putting a premium on space. Finally, by 1830, with the outbreak of revolution in Belgium, the number of purchases was severely cut and the museum stagnated (Van Luttervelt, 1960; Westermann, 1996).

Notwithstanding local idiosyncrasies, then, what is clear is that the museum had been decked out in its national costume by the early nineteenth century. Extreme examples can be found elsewhere. Lewis (1992a), for instance, indicates the role that museums in Hungary and Czechoslovakia played in this period. In the former, the national museum was built with voluntary taxes and helped to congeal a sense of national heritage so crucial to the independence movement. In Prague, the ascendance of nationalism supported the founding of a museum in 1818 given over to the concentration of cultural identity and the study of Czech and Slovak history. In Russia, despite functioning as a royal museum up to the revolution, the Hermitage, opened in 1852 by Nicholas I, is said to have fulfilled most of the

functions of a national museum (Lewis, 1992a).[15] And in France, as well as the Louvre, Lenoir's *Musée des Monuments Francais,* formed during the early stages of the Revolution, was devoted partly to art and partly to national history.[16]

What better way to symbolise the civility of these national undertakings than through a style of building universally recognised as civilised? Throughout the nineteenth century, scores of museums, libraries and other cultural institutions were built in the Greek revivalist form, connoting the potent values of classical republicanism and democracy and ideas of learning and inspiration. The building's external spatial structure dramatised certain modes of experience and safeguarded the ideological interests of those who sponsored it. The temple façades, the porticos and columns, the neo-classical ornamentation all served to demonstrate the civility and nobility of the state and its claims to reproduce the historical values of imperial Rome. The neo-classical style transformed the building into a 'ritualistic event', and marked off the visit as virtually sacrosanct. 'As such' writes Duncan, 'it helps bind the community as a whole into a civic body, identifying its highest values, its proudest memories, and its truest truths' (1991: 90–91).

Official state competitions for designs often stipulated the style to be Greco-Roman. Seling points out, for instance, that the design of the Glyptothek in Munich had been directed by the Crown Prince of Bavaria, who wrote to the architect asking him to prepare 'a building suitable for arranging works of sculpture' according to the 'purest Greek style', with 'a portico of fluted columns in the Doric order' (1967: 111). The architect, Klenze, later said of the building: 'A museum is no drawing office, academic menagerie and studio'; it existed 'for all kinds of visitors . . . more an institution for the nation than for the student of art' (quoted in Seling, 1967: 112). In France in the period 1744–1846, architectural competitions for museums, libraries and galleries were an important exercise for French national academies. And other neo-classical museums included the Prado, the Pio-Clementino and the Altes Museum.

According to Markus (1993), mechanisms of official architectural sponsorship guaranteed that the social and functional demands of the sponsor were heeded but also veiled (as was the case with Foucault's 'disciplinary spaces' – prisons, asylums, workhouses, schools and other 'moral spaces'). The arbitrary nature of the design 'pact' as a form of socio-political power was masked behind programmatic and technical briefs, with their neutral and objective patina. All this made revealing the power behind the official text to be an impossible enterprise, if only because power was made invisible. As Charles Saumarez-Smith has commented on national museums generally: 'One of the things that is uncomfortable about the way a state-run museum operates is that it maintains a belief in anonymous authority' (1989: 17). This 'governmental' side to public museums represents an additional entry point to the intercourse between the state and national art museums.

Museums, Governance and the 'Ethical State'?

At the 'micro' level the state's interest in 'civilising' its population imprinted in a variety of ways, many of which Foucault (1977), at pains to avoid state reductionism, has subsumed under the processes of 'normalisation' and 'discipline'. As administrations expanded and sought to extend their control over society, they increasingly specified norms of individual behaviour and conduct by example and enforcement. Increasing daily bonds between citizen and state solidified in areas such as education, welfare and policing, but also in the fabric of museum culture.

Much of the content of such improvement was a legacy of courtly society. As Elias (1982) has noted, for instance, formal and informal regulations on sex, violence, table manners and spitting grew out of courtly etiquette. The development of bourgeois modes of conduct, however, took a pointed form in the nineteenth century as this class translated eighteenth-century civilising impulses from the public sphere – cafés and debating societies – into the promulgations of government itself. But bourgeois elites no longer wanted to merely educate, they needed to govern the populace, particularly that section of the populace which could pose a threat to their new-found security.

Museums were, in this sense, institutions which fitted neatly into the project of what Gramsci called the 'ethical state' as it sought to 'raise the great mass of the population to a particular cultural and moral level, a level (or type) which corresponded to the needs of the productive forces for development' (Gramsci, 1971: 258). Like other 'improving' spheres such as libraries and public parks, museums were enlisted as instruments of social management which, as Bennett has explained, exemplified a new form of 'governmental' power. This aimed 'at producing a citizenry which, rather than needing to be externally and coercively directed, would increasingly monitor and regulate its own conduct' (Bennett, 1995: 8).

Statements on the moral efficacy of museums from the founders of these institutions constituted the museum as a tool of public enculturation. As 'antidotes to brutality and vice', as Henry Cole was to put it in 1874, museums were believed to improve the moral health of the subordinate classes by improving their 'inner selves', their habits, manners and beliefs.[17] Hence, the value of rational programmes of education in science and history museums in the nineteenth century rested on their promotion of forms of pedagogy and noble feelings. A visit to the museum was considered to be a 'rational recreation' which might lift popular taste and design, improve the industriousness of the population and help prevent disorder and rebellion. In Britain, projects like the Great Exhibition of 1851 (the first of many world fairs in Europe) and the complex of museums subsequently founded around South Kensington demonstrated this instrumental purpose. A general public had been invited to partake of the moral benefits offered by the mix of amusements, educational displays and trade fair stands at Crystal Palace,

support for which was found in an English social-democratic tradition that willed the encounter between the masses and higher pleasures (Greenhalgh, 1989).

Schemes of education and statements on moral improvement, then, were servitors for new forms of self-management and social cohesion that absorbed the problematic 'masses' within the legitimate confines of liberal power.[18] In Foucauldian terms, the political rationality of the museum illuminated a technology of power that governed by seeming not to govern. The state worked at a removed distance to shape mental and moral behaviour, to regulate conditions of life of individuals and populations. 'Governmental' power, in this sense, worked in contrast to the modalities of absolutist, one-dimensional force, by investing itself in populations which governed themselves. Or as Bennett puts it:

> Rather than embodying an alien and coercive principle of power which aimed to cow the people into submission, the museum – addressing the people as a public, as citizens – aimed to inveigle the general populace into complicity with power by placing them on this side of a power which it represented to it as its own. (Bennett, 1995: 95)

For Bennett, this accounts for the discourse of museum reform in the nineteenth century as it pleaded for universal access. Clearly, new technologies of power and governance could only be effective if the museum doors were open to those at which these technologies were aimed. The museum had to be refashioned in the nineteenth century to give its civilising role priority – detaching the museum from ethics of royal splendour and placing it firmly within the realms of popular enlightenment and social regulation. Hence the 'reordering of things' in the museum according to Enlightenment tropes of evolution was a programme of public instruction which called up the citizen as a 'progressive subject' who would be 'auto-tuned to the requirements of the new forms of social training' and whose functions 'provided the museum with a salient point of external reference and connection' (Bennett, 1995: 47).

Art Museums, Exclusion and Bourgeois Distinction

While convincing as an explanation of the governmental rationale of state-run museums in the late nineteenth century, the thrust of such arguments, however, remains relatively weak in relation to early nineteenth-century art museums. If Foucauldian and Gramscian interpretations are suitable armatures in the realm of governance and moral regulation (and even Foucault's system must be criticised for failing to register the state in any meaningful sense) then they must be supplemented by interpretations that pay closer attention to the dimension of distinction in the rise of art. For as Bourdieu writes: 'Museums could bear the

inscription: Entry for art lovers only. But there clearly is no need for such a sign, it all goes without saying' (1993: 257).

Despite, then, expressing national sentiments of political virtue and encouraging, *prima facie*, the inclusion of new publics, art museums were also restrictive enclaves for elites and their attendant 'modes of distinction' (Fyfe, 1993). In fact, art museums were far less embedded in discourses of popular instruction than, say, natural history or science museums because fine art was also the symbolic resource for the differentiation of bourgeois elites from other social groups. Hence the idea of public access, far from being a total or complete translation of Enlightenment values concerning edification, was, rather, based on a limited conception of what 'the public' comprised of.

One of the shortcomings of Habermas' (1989a) comments on the public sphere is his tendency to idealise it as a universal realm of progressive sociability and to fail to take seriously the class, gender and property bases to participation. Many commentators have picked up on this omission in order, in some cases, to rescue Habermas' principal statements from idealism. Landes (1988) and Fraser (1993), for instance, have argued that the conception of a 'public' necessarily implied the construction of a less visible and politically significant realm of privacy, or domesticity, where women were restricted to play out their 'naturally' assigned roles as mothers, carers, rearers and household servitors. This embedded them ever deeper into the provinces of hearth and home and their attendant values of eroticism, artifice and play. Eley (1994), on the other hand, acknowledges the value in some of Habermas' analytical and historical propositions but is critical of his overlooking of the public sphere as the institutionalised support for the nineteenth-century bourgeoisie and, as such, 'the constitutive organisational form of a new force for cultural and political change, namely, the natural social power and self-consciously civilised values of a bourgeoisie starting to see itself as a general or universal class' (1994: 304). These charges formulate into a general critique of the voluntary associations, reading clubs and discussion circles comprising the public sphere as organisations of repression, exclusion and differentiation. They also point up the normative presuppositions underlying the very definition of this sphere as 'public'.[19]

The emergence of the art museum is heavily implicated here. As a realm of cultural association the museum was never merely an instrument of nation-state cohesion, based on the inclusion of wider national constituent publics. It was also a chief institutional site through which middle-class elites could elaborate their own signifiers of cultural distinction, articulate a distance from other social groups and select appropriate categories of social behaviour for inclusion or exclusion. Despite being lauded as fully democratic institutions, unconditionally open to all groups, the practices of art museums served to reinforce the cultural divide between classes. It has been the work of Pierre Bourdieu that has been most

important in investigating this exclusionary side to high art and its institutions, and some of his key propositions will be considered.

In the process of its formulation as an institution of high culture, the art museum, more than other museums, was set up in opposition to places of popular assembly such as fairs, taverns and commercial stores. The codes of behaviour expected and enforced in museums comprised part of a strategy, which 'clear[ed] a space for polite cosmopolitan discourse by constructing popular culture as the "low-Other", the dirty and crude outside to the emergent public sphere' (Stallybrass and White, 1986: 87). The realm of the 'carnivalesque', in other words, was negatively coded as 'vulgar', 'barbaric' and hence as 'other'. The modes of behaviour associated with the popular classes were emphatically occluded from the museum in a way which marked a division between the groups which seemed to 'belong' to the museum and those which were alien. Hence, from internal regulations on the prevention of vandalism, the touching of pictures, the banning of dirty footwear and the carrying of babies, to prescriptions against swearing, spitting, brawling and drinking, the museum demonstrated the type of visitor and behaviour to be discouraged. This paralleled the situation in the literary circles, debating societies and coffee houses of the public sphere generally.

At the same time, ambiguities remained in the effort to make the museum visit a pedagogical experience for popular publics. Despite all the rhetorics of universal access and popular education which underpinned the Louvre, for instance, as McLellan (1994) observes, its internal functioning actually helped to exclude the uneducated and privilege the educated and initiated. Very little help was given to uninitiated visitors by way of popular guides and there was no education department. Similarly, Sherman (1989) notes that in late nineteenth-century France, provincial museums lacked descriptive labels that would instruct the public. Instead, pictures were arranged in the cluttered Baroque style, without different-iation or an attempt at democratic pedagogy.

In *Vormärz* Berlin, limitations inherent in the organisation of the Altes Museum spoke of a logic of separation and exclusion in the nineteenth century. According to Telman, the museum differentiated the refined from the common by engender-ing in the latter 'an attitude of awe, wonder and quasi-religious respect' (Telman, 1996: 10-11). Indeed, an artifice used by the architect Schinkel to promote a mood of 'sacred solemnity' was to arrange his classical sculpture on very high pedestals in order to place the visitor on a plane spiritually inferior to that of the sacred objects. In other art museums, undifferentiated public access was fiercely countered by artists and curators faithful to the idea that unmediated or popular access spoilt the silent contemplation of art works (Hudson, 1975). As Thackeray was to write in 1841: 'Genteel people . . . do not frequent the Louvre on a Sunday. You can't see the pictures well, and are pushed and elbowed by all sorts of low-bred creatures' (quoted in Moriarty, 1994: 27).

Across Europe, museums still implemented restricted hours of opening that discouraged working people from attending and audience screening was a widely used method of discriminating between the studious and the plebeian, favour lying purely with scholarly and artistic patronage (Wittlin, 1949). Sir Henry Ellis' belligerent response to suggestions that the British Museum might be opened to the 'vulgar classes' on popular holidays in 1835, for instance, is telling: 'I think', he replied, 'the most mischievous portion of the population is abroad and about at such a time . . . the exclusion of the public is very material, inasmuch as the place otherwise would really be unwholesome' (quoted in Altick, 1978: 248). Meanwhile, in Russia, looking the part was a precondition of acceptance into the Hermitage up until the 1860s, initial directives stipulating that visitors had to acquire an admission ticket and wear regimental or aristocratic attire (Lewis, 1992a).

For Bourdieu, such museological discriminations make sense if we recognise the role of art and high culture as fulfilling certain social functions of legitimating social differences and thereby reproducing power relations. *The Love of Art* (1991) was Bourdieu's initial attempt at an empirically based study of museums which assaulted Kantian and other essentialist theories of cultural taste and cultural production which assumed certain *a priori* faculties towards aesthetic pleasure. The sensitivity to experience higher artistic pleasures, a quality that may be experienced by any human being, as Kant had it, is revealed by Bourdieu as the privilege of those who have access to the conditions in which 'pure' and 'disinterested' dispositions are acquired. Hence, museum visiting is unveiled as a socially differentiated activity resting on the possession of educational and cultural dispositions towards art practices and products and, as such, almost the exclusive domain of the cultivated classes.

Cultural competence, for Bourdieu, is a precondition for the classification and organisation of artistic knowledge. Individuals can only decipher works of art 'aesthetically', as it were, if they have a mastery of the codes and systems of classification which are able to process styles, periods, techniques, and so on. Repeated contact with art via formal and informal education processes encourages the accumulation of these instruments of appropriation, leading to an 'unconscious mastery' of the parameters of deciphering art objects. Having a 'feel for the game' (*sense pratique*), or a familiarity with art objects, is the outcome of culturally acquired systems of perception, not something naturally or universally programmed. However, this feel is expressed in a form which emphasises its natural, quasi-instinctual and pre-reflexive quality, in the dispositional form of the cultured *habitus,* itself an expression of favourable material conditions of existence.[20]

Cultural proficiency, then, appears as a gift of natural talent and taste, available to all on an equal basis. It is not recognised as an accumulated outcome of differential learning and training, requiring at least some distance from material

necessities and leisure time. Members of the initiated classes, from this perspective, accept as a 'gift of nature a cultural heritage which is transmitted by a process of unconscious training' (Bourdieu, 1993: 234). The 'masters of judgement and taste' appear as rising above the vagaries of material processes, even though they are a distinct product of such processes. Culture, in short, is achieved by negating itself as culture (i.e., acquired) and presenting itself as nature (or grace).

It is to this extent that the art museum and its objects remained the natural appurtenance of middle-class elites. The museum comprised a 'pure' space, symbolically opposed to the vulgarities of inns and fairs, where the values of civilised bourgeois culture were coded and decoded by this class itself. As Sherman (1987) does, we can make sense of a seemingly trivial instance such as the refusal to give up umbrellas at the doors of nineteenth-century French provincial museums as an important illustration of the bourgeois urgency to retain the objects and codes of its distinction. The umbrella was a particularly resonant object of middle-class apparel, carried even in clement weather. Its shape and possession codified the *habitus* and deportment of this class to itself and to others within the museum. Its function was to effect a visible mechanism of differentiation of the holder from other competing groups by speaking of his or her refinement, aloofness or delicacy.

As for art perception itself, bourgeois taste was that which could render visible the more formal and revered qualities of the museum's objects; which could bracket off the disinterested appreciation of style from 'naive' or 'popular' responses. Bourgeois individuals, in other words, were more likely to come to the museum with the instruments of a 'pure gaze' capable of apprehending the work as autonomous; that is, 'as it demands to be apprehended (i.e., in itself and for itself, as form and not as function)' (Bourdieu, 1993: 256). Inseparable from the development of the autonomous artistic field generally (the capacity for artists to escape the constraints of absolute aesthetic norms, for instance, and the parallel shift to an open market with its dealer/critic system) the pure gaze opened up the museum visit as a learned and informed experience. It made visible the hidden qualities of the museum's objects: stylistic features, authorship, the subtleties of pictorial conventions and representations.

In contrast, for Bourdieu, the lower classes could only reduce art to schemes culled from their everyday life – to function, to its age, renown or price – categories which emerged from the 'existential' social situation of this class. This is the kind of response to art which Kant termed 'impure' and 'barbarous' because it reduced pleasure to the material senses. It was a response which came to be denied and marginalised by the dominant aesthetic because it expressed a 'lower', 'distasteful' and 'coarse' form of enjoyment that was the antithesis to disinterested and refined appreciation.

Such a separation between modes of art perception had, by the early nineteenth century, crystallised into the normative and institutional distinctions subtending systems of cultural production arranged around two poles: restricted/high culture versus large scale/popular culture (Bourdieu, 1993). High art was the symbolically potent system of classification codified by the appropriate cultural experts, discourses and nationally consecrated institutions that included orchestras, theatres and other 'serious' civic institutions with established conventions of public demeanour and cultural restraint. Museums emerged within this system as a similar organisation of cultural authority, based on the collective action of elites that bounded these elites ever closer to consecrated culture (DiMaggio, 1987). All this underpinned the sense of belonging of some social groups over others in the art museum – a feeling that was reinforced in the minute details of its internal functioning:

> Everything, in these civic temples in which bourgeois society deposits its most sacred possessions, that is, the relics inherited from a past which is not its own, in the holy palaces of art, in which the chosen few come to nurture a faith of *virtuosi* while conformists and bogus devotees come and perform a class ritual, old palaces or great historic homes to which the nineteenth century added imposing edifices, built often in the Greco-Roman style of civic sanctuaries, everything combines to indicate that the work of art is as contrary to the world of everyday life as the sacred is to the profane. The prohibition against touching the objects, the religious silence which is forced upon visitors, the puritan asceticism of the facilities, always scarce and uncomfortable, the almost systematic refusal of any instruction, the grandiose solemnity of the decoration and decorum, colonnades, vast galleries, decorated ceilings, monumental staircases both outside and inside, everything seems done to remind people that the transition from the profane world to the sacred world presupposes, as Durkheim says, 'a genuine meta-morphosis'. (Bourdieu, 1993: 237)

Free entrance, in short, was also optional entrance, in practice put aside for those who felt at home in the museum's confines. The rhetorics of universal access, of the art museum as a glorious gift to all of the treasures of a valorised past, may have transcended any notion that the museum was effectively *closed* for some. Indeed, as Bourdieu notes, never is ideology so powerful as when it is dressed up in the idioms of democracy, citizenship or universal enlightenment. Yet it remained the case that the founding of art museums and galleries was inseparable from the struggle of the bourgeois class to elevate its own world-view whilst appearing to rise above the realities of material life in the early nineteenth century. As the bourgeoisie reconciled the stylistic demeanour of the aristocracy with instrumental reason, it used the aesthetic (one tool among many, incidentally) to define a space for itself, a sanctuary of high culture that served to produce and reproduce this class's claim to the status of cultural superiors of the social system.

Artistic practices and institutions such as museums served to reproduce class relations as incorporated in the *habitus*, since this very internalisation perpetuated the logic of class-derived practice. Legitimate or high culture, as defined, deliberately or not fulfilled a social function of naturalising social differences, and illustrated the way in which consensual recognition of the dominant culture was guaranteed. This was partly dependent on the estrangement of a significant portion of the public from high culture's enclaves. Notwithstanding the fact that museums had been opened up to the possibility of popular use by more amorphous metropolitan crowds – and one should not discount the possibility of a more fluid and disordered relationship between social class and the museum than is apparent in Bourdieu's scheme – it is nevertheless clear that the exclusionary logics of the former princely collections were stubbornly residual in national, public art museums. To a large extent, the art museum functioned as a space of mystification and distanciation as well as social regulation and leisure. It remained, in fact, the least accessible museological institution because the aesthetic was at the heart of the middle class's struggle for political and cultural authority.

Conclusion

Beginning around the sixteenth century as an overtly private palace of princely glorification, the proto-art museums of European absolutism took up their positions in fields of unitary power, and lent spectacular support to the excesses of sovereign might. In the eighteenth century, in line with transformations in European political administrations, intellectual thought and artistic relations in general, the 'enlightened' art museum accumulated, in embryonic form, the features of a modern rationally organised, relatively open institution. Its physiognomy indexed the emergent relations between the state and the public sphere as the *ancien régime* gave way to a more 'democratic' bourgeois universe of social, political and cultural relations.

By the early nineteenth century these forces had achieved optimum effect, and new important forces were added. In particular, the expansion of state-sponsored museums in the early nineteenth century was a dual process. On the one hand it represented the interests of increasingly bounded European nation-states. National art museums reflected and sustained an array of important official ideologies and identities – popular sovereignty, citizenship, democratic rights and the values of national communities in relation to representative governments. Museums (more so than art galleries) also helped states to integrate their populations into national cultural and territorial units via utilitarian programmes of social regulation and improvement. On the other hand, the art museum was the basis to forms of social exclusion, developed out of the institutions and discourses of the eighteenth

century public sphere as a training ground and power base of bourgeois authority. The elaboration of a distinctive sanctuary of high art was part of the construction of new forms of bourgeois distinction from older, competing and lower social strata. Once valorised as an enclave of cultivated taste, pure refinement, and divested of the vulgarities of economic materiality, the art museum helped to secure and naturalise the social and cultural dominance of the *cognoscenti* by appearing to fit naturally with this class's social being. Whilst not causing social differences or inequalities, the art museum nevertheless helped to sustain them.

These were the two modalities or defining principles of power which gave the museum its finality in the nineteenth century. True, they often pulled in different directions, at times resulting in potentially critical tensions. Indeed, they still do today as the museum grapples with the historical dilemmas of double-coding: whether to be shrines for the few or educators for the many, to appeal to the popular (often attacked as 'dumbing down') or connoisseurial (charged as elitism), to be arenas for secular research or churches for the auratic object. But this never seemed to undermine the efficacy of the museum's social, political and artistic aims. In fact it is testament to the museum's resilience that it has dealt with the fabric of ambiguity and paradox which lies behind its history, accommodating these tensions into its very being. Hence, most of the European examples mentioned – the Prado, the Rijksmuseum, the Altes Museum, the Louvre – continue to flourish as national, but also respectable middle-class, institutions of fine art.

The function of this chapter has been to present a set of historical and analytical propositions regarding the socio-cultural genealogy of the national art museum in continental Europe and to relate this to systems of class, power and ideology. I have had to make broad generalisations, unite disparate European cases and offer little in the way of detailed historical description, in order to provide the initial parameters to which the British case(s) can be compared and contrasted. It is now time to transfer my attentions away from continental Europe and towards national art galleries as they develop first in England and, then, in Scotland.

Notes

1. The cabinet (Italian: *gabinetto* and German: *Wunderkammer*) initially represented a personal space in which private possessions were placed for safekeeping. Its meaning changed from the sixteenth century, however, to become a square shaped room replete with artefacts, natural history specimens, medallions, botanical rarities and sometimes paintings and sculptures. Rubens, for example, kept his own cabinet in the famous apse-shaped room containing paintings, busts and medallions. It is this latter mode of visibility which is said

to have provided the morphology for the modern natural history museum (Mordaunt-Crook, 1972; Bazin, 1967; Alexander, 1979; Lewis, 1992a).

2. The modernisation of fiscal proceedings and greater centralisation in geographical and bureaucratic management became key policies for administrations in France, Austria and Prussia. In the latter case, both Frederick William I and Frederick the Great carried out policies of administrative centralisation in the eighteenth century (Poggi, 1978), whilst Louis XIV's ordinances and codes of 1665 and 1690 aimed to co-ordinate all of France's matters of civil and criminal life.

3. When the court is termed 'public' this often implies a very limited 'audience' of court officials and other European dignitaries rather than *tout le monde*. Yet a degree of broader public visibility was necessary when displays of power were called for – tournaments, festivals, royal anniversaries and so on (Poggi, 1978). Princely representation, on this count, is less 'private' and 'cut-off' from general visibility than is sometimes implied, although its power is paraded 'before' the people rather than 'for' them (Habermas, 1989a).

4. The *Académie Royale de Peinture et de Sculpture* began in 1648, and was transformed into an appendage to royal authority later under the king's official of fine arts, Le Brun. The academy made state appointments, ran royal commissions and conferred titles on members as well as socialised and trained artists.

5. For a broad overview see Bartholomew, Hall and Lentin (1992).

6. Poggi makes some useful comments on the continuities between the absolutist regime and the emerging nineteenth-century constitutional state which relate to my earlier comments on reconfiguration. He points to the lack of a 'break' with the old regime and the overlap of interests between the bourgeoisie and the absolutist apparatus of rule as long as the latter could be modified to accommodate bourgeois control. The danger from below was a significant deterrent. The bourgeoisie 'had to guard against the potential democratic-populist implications of such ideas as popular sovereignty or equality of citizenship' (1978: 85). Some of the mechanisms of traditional rule remained attractive to secure against this. Elias (1983) makes a similar point in his comments on the incorporation of courtly codes (etiquette, for instance) into bourgeois life as the latter undergoes its process of 'civilisation'.

7. Mason explains: 'The modern concept of genius is . . . one aspect of that overall change in which the balance between god's bounty and human achievement shifted decisively toward the latter. Just as political rule came to be justified not by divine right or historical precedent but rather in terms of (more or less) democratic consent, or as, later, May Day ceased to be a celebration of the earth's fertility and became an assertion of the power of labour, so genius became a wholly human phenomenon, independently productive and deriving its value from itself' (Mason, 1993: 210).

8. The review, for instance, was part of the market system whereby art's exchange value could be improved, where artists could get their works known and noticed by the right collectors and dealers (Burgin, 1986). An additional change of focus is evident in the role of private merchants, pushing classical norms of taste below questions of attribution and authenticity. Classical norms are not totally displaced, however, but gain strength away from the market in the works of aristocratic connoisseurs and art historians.

9. According to Foucault (1970), the organising principle of science in the 'modern episteme' is based on the flow of time. In geology and biology, for instance, organic life is organised temporally, according to transitions and evolutions; and it is the inner momentum of organic life which is said to explain this. An interesting parallel is suggested, here, by Bennett (1995) between this conception and that of art as a formal, almost organic entity with parallel flows through time characteristic of art history.

10. The importance to the museum of art history as a classificatory discipline cannot be over-stated here. As Duncan and Wallach assert: 'Without the museum, the discipline of art history, as it has evolved over the last two hundred years, would be inconceivable. Viewed historically, art history appears as a necessary and inevitable component of the public museum' (1980: 456). Duncan and Wallach go on to indicate, rightly, that art history – a product of the eighteenth century – was one way in which the middle class rationalised the experience of art, using it ideologically to secure a position of power/knowledge.

11. The intellectual pressure put on the kings of Prussia in the late eighteenth century by Aloys Hirt, historian of ancient architecture and Professor of Fine Art in Berlin, is testament to this emerging confidence. The king ought to establish a museum 'for public instruction and the noblest enjoyment' opined Hirt; 'Genuine art can only thrive, where one has patterns, and they ought to be arranged in beautiful order, and [be] easily and daily accessible to all'. He continued, 'it is below the dignity of an ancient monument to be displayed as an ornament' (cited in Seling, 1967: 113, 112). Hirt was eventually given charge of a new scheme for an art museum in Berlin but nothing came of this.

12. This was the enlightened opinion of Lafont de Saint-Yenne, who, in a pamphlet of 1747, called for the Louvre to be restored into a royal art gallery. Such a scheme perhaps also expressed the social reformist impulses of the physiocrats (Mirabeau, for instance), providing a space of civilisation and etiquette, where the 'popular classes' could be 'educated' – a view which, in the next century, was to profoundly shape the 'statist' direction of the national art museum.

13. Indeed as Hobsbawm puts it: '[the nation] is a social entity only insofar as it relates to a certain kind of modern territorial state, the "nation-state" and it is pointless to discuss nation and nationality except insofar as both relate to it' (1990: 9–10).

14. As what Walter Benjamin (1986) termed 'capital of the nineteenth century', Paris also had the most vigorous art market in Europe and much of its cultural status related to this. Lorente has written on the nineteenth-century metropolises of Paris and London as 'art capitals' with highly developed art fields that attracted collections, living artists, dealers and patrons. An early form of culture as urban regeneration was most evident in Paris and accompanied the victory of the city over the country in cultural matters generally. Artists naturally gravitated to Paris and used modern communication systems to keep an eye on developments in the capital while residing elsewhere. Paris, in this sense, 'became an artistic Mecca. Artists from all around the world would take periodic pilgrimages to Paris and, once back home, they would keep an attentive eye on its art scene' (Lorente, 1996: 190).

15. Initial directives stipulated that visitors had to acquire an admission ticket and wear regimental or aristocratic attire. These conditions were abolished in the 1860s, yet the Hermitage remained under nominal royal authority until 1917 (Lewis, 1992a).

16. Moreover, France's provincial museums inhabited the same cultural and ideological space as the Louvre, as agencies for state prestige. As Sherman has written, the *envois* system of the early nineteenth century, whereby surplus Old Master works from the Louvre were sent out to the provinces of Bordeaux, Marseilles and Rouen, made the state visible throughout France. 'It would be only a mild exaggeration', he writes, 'to say that the state attached less importance to the pictures themselves than to the labels on them that said '*Don de l'Empereur*' (gift of the emperor) or later, more modestly but no less clearly, '*Dépôt de l'Etat*' (deposit of the State)' (Sherman, 1989: 14).

17. Such 'improvements' were clearly bound up with ideas of national advancement; a utilitarian instrument of moral betterment was simultaneously an instrument of national welfare.

18. It is no accident that the fear of popular disorder attended the wake of unsettlement on the continent, the rise of working class movements and the semantic shift in the word 'mass' to connote 'mob' and 'unruly crowd' (Williams, 1976).

19. The case for the social exclusion of women from cultural spaces like museums has been developed by Landes (1988). In this account, respectable women took to other spaces such as the department store or public park, where 'women safely reimagined themselves as *flâneurs,* observing without being observed' (Walkowitz, cited in Bennett, 1995: 30). However, it could be that women were not excluded from the museum in the same way and to the same extent that the lower classes were. In fact as Bennett indicates, women were often believed to be mediating agencies for the state's projects to 'civilise' working men, and as such to be welcomed into the museum environment.

20. *Habitus,* in Bourdieu's use of the Latin term, consists of a system of dispositions acquired in the process of childhood socialisation which function on the practical level as both categories of perception (organisational schemas and principles of classification) and generators of practices and actions. It is Bourdieu's answer to the question regarding how it is that behaviour takes certain trajectories without it being the product of a conscious strategy or reductive cause. Bourdieu's answer is that agents to an extent fall into their behaviour; they act and react to particular situations in a way that is neither necessarily calculated nor simply generated mechanically according to rule obedience. This is the 'feel for the game' which comes by familiarisation towards particular situations, objects and sensations. It is in essence a corporeal quality in that it exists in and through bodily practices – ways of talking, holding oneself, moving, perceiving, acting. The competences are, in fact, such an integral part of the circumstances in which they are acquired, learned and developed that they are rendered largely incapable of being perceived in their arbitrariness. They merely become 'ways things are' (Bourdieu, 1977; 1984; 1990a; 1990b).

3

'The Peculiarities of the English': The Formation of the National Gallery, London

E. P. Thompson's recognition of the 'unique equilibrium of forces' (1978: 255), the distinct elements in the complex mix of English social development, is a worthy one. It does not seek to over-conflate historical models and yet remains mindful of genealogical commonalities in the onset of European bourgeois modernity. England is late in the development of its national art gallery. This is not to say that it is anomalous, beyond comparison; merely late. The French had their Louvre in 1793, the Swedes their moment of glory a year later; the Prado had been founded in 1819 and the Rijksmuseum in 1808. England's National Gallery stuttered into existence in 1824, and remained in conditions tantamount to a private mansion until 1838.[1] 'That nation', one French art theorist quipped of England during the Napoleonic Wars, 'has no centralised, dominant collection, despite all the acquisitions made by its private citizens who have naturally retained them for their private enjoyment' (cited in Haskell, 1985: 51). By 1836, the government's Select Committee on Arts, and their Connexion with Manufactures concurred with this assessment, adding that 'a private collector may be an excellent judge of cabinet-pictures; but he may not have the comprehensive knowledge required in the choice of a national collection' (SC, 1836: 10).[2] Key questions followed: on what basis should the national collection be assembled, displayed and arranged? Who should be the new superintendents of national high culture? And what was the best way of opening up the collection to a national public without reducing it to sensual amusement?

The present chapter is an attempt to investigate some of the social conditions that mustered around state–art relations in England, chiefly from the seventeenth century, and to sketch the gradual development of a national space for art in the early nineteenth century. It falls into three broad sections which can be matched to those constructed previously: a period of radical uncertainty in the seventeenth century, a time of socio-cultural transition and recovery in the eighteenth century and modern deliverance in the early nineteenth century. In each profile the

development of artistic institutions resembled, in some respects, that on the continent; in other respects English cultural development was distinct, based on evolutionary idiosyncrasies. The National Gallery, it will be argued, traced out a process through which modernity folded back on itself in the formation of a new cultural order. Despite its origins in the country house collection and civic humanism, the gallery accommodated the imperative to modernise at the behest of a state increasingly concerned with national improvement and social harmony. Ambiguities inherent in this movement were exacerbated by the siting of the gallery in Trafalgar Square, a space of urban confluence and potential danger to notions of aesthetic purity and cultural distinction worked up by the professionals who championed it.

A Very Fractured Start

The story begins, quite fittingly, with a false dawn. For two decades it looked as if England might vie for competition with the grand courts of Europe, and become a rival to Madrid, St Petersburg, Naples and Paris. Charles I promised much in the way of cultural vivacity and grandiloquence, as something like an international Baroque system of acquisition and display settled itself in the heart of the English court. Windsor Castle, St James's Palace, Hampton Court and, most importantly, Whitehall were being regenerated in the formal image of the Spanish court of Philip IV, itself a catalyst to Charles's ambition to be one of the great patrons of the age.

A gallery of pictures and a collection of works, as we have seen, were the signposts of princely magnificence in Europe, and Charles I lost no time in assembling such trappings of princely taste. By the 1630s, Inigo Jones had been briefed to assemble a regal palace, including a Palladian banqueting hall decorated in 1635 by Rubens with images of peace in the Union and a portrait of James I 'ascending, god-like, into the empyrean' (Thomas, 1977: 191). The walls of Charles's 'Private Galerie' at Whitehall were similarly adorned with portraits of the kings and queens of England in an iconographic cycle of Stewart kingship (Waagen, 1854; Lightbrown, 1989). The will to absolute sovereignty could only be realised, for Charles, through the housings of patronage and the visuals of kingship. Court masques were, hence, staged in unprecedented fashion in England, divested of gluttonous excess but still presenting the kind of priestly *mise-en-scene* Charles admired in Madrid.

Picture collecting, however, was Charles's great avocation and by his death the King had amassed over 1500 works, including pictures by some of the most important German, Italian and Flemish masters, as well as Raphael's papal tapestry cartoons. On the advice of more established collectors like the Duke of Buckingham

and the Earl of Arundel, Charles fulfilled his patronal ambitions by exploiting oversees contacts, making large-scale purchases (such as the infamous Gonzaga pictures) and commissioning fêted artists such as Rubens and Van Dyck. He was the subject of some of the most resonant and glorified images of Caroline culture, soaked in the ethereal glow of dignity, refinement and grace, despite his diminutive size, Scottish accent and stammer (Brown, 1995). Like a modern day Medici, Charles assembled a courtly constellation that melded iconographic glorification with spatial grandiloquence, consecrated through the sheer scale of pictures and their display.

The promise of absolute kingship and its cultural offshoots, however, were severed on the scaffolding at Whitehall Palace in 1649. Parliament had been increasing in power since the mid-sixteenth century: now it took centre stage in one of most dramatic scenes in European history, wresting power from the monarch and restructuring elite rule as it went.

The execution of Charles I was as close to revolutionary republicanism as England got. But whereas France symbolically represented the move away from absolutism in a national art museum, England did so by selling the very art that would have formed the core to such a collection. The Commonwealth Sale of 1649 had been arranged by Parliament in order to dispose of the accoutrements of majesty: pictures, with their scent of private ostentation and devotion to catholic culture, were particularly vulnerable. What many regarded as the 'sale of the century' brought an abrupt end to this short period of cultural lavishness in England. Hundreds of works of art were dispersed throughout Europe, many of them finding their homes in the courts of princes from whom Charles had acquired them in the first place (Brown, 1995; Haskell, 1989).

Puritan antipathy to the finery and grandeur of royalty marked itself long after the Civil War, for shows of regal power were always attenuated, lest history should repeat itself. Although never as acerbic as the equivalent north of the border, Puritanism nonetheless stripped much of England's ecclesiastical culture, as cathedrals were sacked, libraries seized and pictures burnt.[3] Clearly, in such a tense political climate, collecting was something of a risk and some of the most significant collections – those of the Earl of Arundel and the Duke of Buckingham, for instance – were offered up for sale. As for Parliament, the provision of central funds for collecting was out of the question, as the state's *raison d'être* was increasingly marked by economic rationalisation and the curbing of unnecessary luxuries (Pears, 1988).

At the Restoration, a court culture still existed – compositions by Purcell, buildings by Wren, portraits by Lely. The latter's brief 'to paint blatantly alluring sex', for instance, bound the imperatives of courtly taste with the practices of official 'face painters' (Baker, 1912, cited in Foss, 1971). Lely, at Charles's request, painted a naked Nell Gwynne, as well as various courtiers in settings that attempted

to elevate their symbolic standing at court (Foss, 1971). But any overt deployment of cultural spectacle was unwise and actively discouraged. Financially constrained, and ideologically weakened, a centralised unit of court patronage was fitful in its *modus operandi*. Matters of *realpolitik* tempered Charles II's expenditure on aesthetic matters and for the rest of his reign no large-scale purchases and few commissions were made beyond decorative schemes and portraits. Many painters, both indigenous and foreign, fled London to look for alternative outlets, leaving only a small coterie of court artists amongst whom favour was concentrated. Moreover, the lack was not lamented, for pragmatism heralded a more substantial prize: 'Great pity it was we lost the Pictures; but however, we may console ourselves with the reflection, that we preserved our Liberties' (Walpole, cited in Pears, 1988: 134).

The settlement of 1688–1714 made any attempts at aesthetic grandiosity even more improbable. Kensington Palace, the dwelling of William III and Mary, possessed some spaces for artistic display – two 'long galleries' in particular – but these did not compete in regal splendour with examples in France and elsewhere. Britain's concerted lurch towards a national Protestant identity was clearly implicated in the commercial aggrandisement of the modern age (Colley, 1992); but the turn towards sobriety and abstinence did not favour the kinds of centralised enactments of visual power that induced national collections in Europe. In any case, the wars with France preoccupied the king above any need for Baroque affirmation, and many of the institutions of art, music, poetry and theatre dissipated. Whilst there were 10,000 artists, actors, courtiers, servants and cooks living at Versailles by the 1740s, England had less than 2,000 at any particular location in the same period (Colley, 1992). Even Kneller's court art – his *Hampton Court Beauties*, for instance – lacked the *largesse* and awe of previous attempts under the later Stewarts. In the meantime, William III chose to turn Greenwich into a hospital for retired seamen and when Queen Anne succeeded in 1702 Hampton Court was neglected.

This is really to say no more than that state-building in England was gradual and deliberate. It was distinguished by social, religious and political conditions that made it unlikely to assemble a national collection either by the magnanimous offer of an enlightened monarch or by the confiscation of such a collection by 'the people' in revolution (Duncan, 1995). In contrast to France, the king and court did not limit the boundaries of social power and the English upper classes were courtly neither in style nor ambition. Moreover, the social barriers between higher elites and the bourgeoisie, which operated in France to distinguish Louis XIV from lower orders, were less solid and more permeable in England (Elias, 1983).

What is distinctive about English social development, as many commentators have observed, is its evolution as a series of adaptations and 'waves' rather than disjunctures (Thompson, 1978; Anderson, 1964; Corrigan and Sayer, 1985).

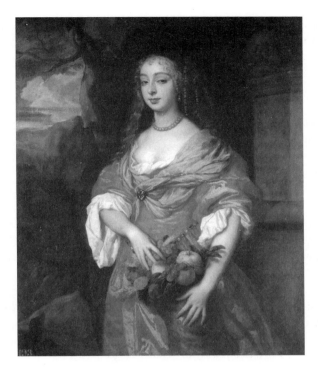

Figure 3.1 Sir Francis Lely, *Jane Needham, Mrs Myddleton*, c.1665, The Royal
Collection © 2001, Her Majesty Queen Elizabeth II.

However motivated the middle-ranks were to rise triumphant from the vestiges of
feudal convention, it was never on the cards for them to do so without a process
of absorption and accommodation. Indeed, the very strength of the English system
of rule rested with its capacity to accommodate profound change whilst giving the
impression of maintaining immutable links with the past. This was as true of public
schools and universities as it was of the Church of England and the military
(Wiener, 1981). The transition to an eighteenth-century 'civil society' in England
was therefore less a matter of confrontation with absolutism, and more a gradual
easing into power of Britain's most powerful social constituency – the aristocracy.

Civic Humanism and the Country House Collection

It is not difficult to see why England, and more particularly London, assumed its
position of dominance in the art market during the eighteenth century. The potent
mix of urban, commercial modernity and aristocratic wealth delivered to the visual

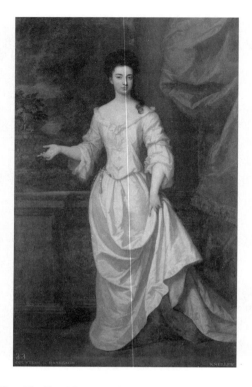

Figure 3.2 Sir Godfrey Kneller, *Margaret Cecil, Countess of Ranelagh*, c.1690, The Royal Collection © 2001, Her Majesty Queen Elizabeth II.

arts a support system that rivalled that of France. From academies and patrons to picture dealers and the world of publishing, the Georgian art field underwent a rapid transformation in sites and forms of cultural production (Humphreys, 1992; Mannings, 1992). Up to 50,000 paintings and half a million etchings and engravings were imported from Italy, France and Holland during the century, whilst auction houses and dealers distributed over 100,000 pictures in the same period (Brewer, 1995b).

Hogarth's achievements at mid-century reflected a thriving urban market in popular prints and a movement towards commerce that freed up a space between high and low culture in which a complex visual language of caricature could proliferate (Donald, 1996). Artists like Reynolds and Hogarth were well received in Europe on the basis that they were professional artists backed by powerful academies – St Martin's Lane, founded in 1735, and the Royal Academy itself, founded in 1768. A public of consumers eager for literature, music and the arts crystallised in this era, linking, via a commercial matrix, the practice of artists with

the cultural needs of middle and upper-class audiences (Brewer, 1995b; Plumb, 1972; Bermingham and Brewer, 1995; McKendrick, Brewer and Plumb, 1982). And a burgeoning 'public sphere' in England's capital, comprising coffee houses, clubs and journals like the *Spectator*, helped to channel the flows of intellectual achievement into the realities of commercial, agricultural and artistic improvement, even if this did not amount to a self-conscious movement of enlightenment as it did in France and Scotland (Habermas, 1989a; Brewer, 1995a; Becker, 1994).

Not that the crown contributed a great deal to this rapid take-off. While Hanoverian succession was an expedient political tactic, and though George III made some financial contributions to the Royal Academy, there was further dilution of courtly authority. The greatest value of royal patronage was not in sustaining widespread forms of cultural production but as social cachet for the public stabilisation and official legitimation of organisations such as the Academy. Pye's later description of George III as a monarch without taste for the fine arts or 'sense of their national importance . . . his majesty never honoured Reynolds even with an interview' expressed the disappointment felt by artists hungry for patronage (Pye, 1970: 140). For the benefits to be gained from royal patronage were no longer immediately visible and artists often went unrewarded for their work. More attractive outlets for patronage lay elsewhere. It was left, in fact, to the aristocracy to foster the complex of artistic institutions and practices of the eighteenth century; which it did under the discursive authorisation of gentlemanly status – taste, politeness and civility.

For much of the century the approved gentleman of taste emerged in the practices and sites of England's artistic and political culture. Although relations between factions of the old aristocracy and new commercial classes were never without tension, for now the landed (particularly Whig) oligarchy was acceptable to modern capitalist interests precisely because it was, unique in Europe, a modernising capitalist force. Wealthy estate owners combined capitalist productivity on the land with an assured solidarity and security. 'Taste' was one dimension of this security, concentrating aristocratic notions of virtue in the context of civil society. The unity of English society under the banner of 'country' was the assertion of a community of propertied citizens, relatively distinct from the crown's patronage powers, whose classical education (culled from the Grand Tour, for instance) marked them as rulers in both politics and the arts.

As Pocock (1972) has indicated, modern notions of citizenship grew from the Renaissance traditions of classical republicanism and civic humanism, and were articulated in the classical idioms of the Georgian age through figures such as Harrington and Bolingbrooke. Classically, 'the moral health of the civic individual consisted in his independence from governmental or social superiors, the precondition of his ability to concern himself with the public good, *res publica*, or commonweal' (Pocock, 1972: 121). Since economic well-being and possession of

independent landed property underpinned the capacity to remain cushioned from the vagaries of 'corruption' and 'interestedness', these conditions both reflected and sustained the aristocrat's social ascendancy. The 'agrarian man of independent virtue' (Pocock, 1972: 121) translated into the arts as the connoisseur, the critic and the true judge of beauty. It was a model implied in Reynolds's *Discourses,* in which the first President of the Royal Academy sanctified 'grand manner' pictures that evoked classical or historical scenes in noble style, above landscape or common portraiture. And it was a model that found expression in a range of writing on aesthetic themes and practices, from the picturesque, with its disavowal of working landscapes, to taste, genius, landscape gardening and beauty. In Shaftesbury, the aestheticisation of virtue translated into the importance of taste as 'disinterested perception', which, of course, was 'directed to the higher and nobler species of humanity' (cited in Humphreys, 1992: 17). In Locke, only possessive individuals were qualified citizens of civil society; in Smith, the idealised man of taste was implied in the 'impartial spectator'; in Hume it was the good judge of beauty.

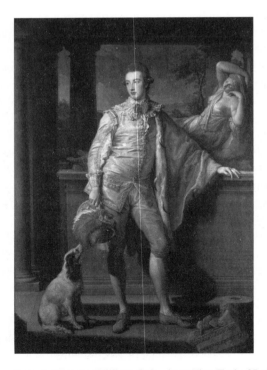

Figure 3.3 Pompeo Batoni, Thomas William Coke, later First Earl of Leicester, 1774, Collection of the Earl of Leicester, Holkham Hall, Norfolk/Bridgeman Art Library.

All of these eighteenth-century aesthetic interventions reinforced a community of consensus, the solidarity of a morally virtuous social group suited to govern; and by implication the exclusion of and distanciation from social forces that fell outside this community – the bodily, the material, the particular, the unpropertied, women and the lower classes (Barrell, 1986; Bohls, 1993; Stallybrass and White, 1986). The aesthetic sphere in eighteenth-century Britain emerged as a means to unify a common class identity; it therefore transposed and reproduced the imperatives of aristocratic social and economic power into the sphere of the arts. Bohls summarises:

> The capacity to abstract from the particular to the general, developed, for example, through a taste for the right type of art, 'elevates' citizens' minds, helping them overcome differences between their private interests and individual ways of seeing by leading them toward a consensual apprehension of the world at the fundamental level of perception itself. Reynolds implies that the promotion among a select group of citizens of a cohesive community of vision or taste, a civic humanist art, contributes to the 'security of society'. That security depends on solidarity among the governing elite to resist those who, because their labor confines their views to sense gratification and private interest, are a constant danger to the state. (Bohls, 1993: 22)

In other words, Bourdieu's description of the 'aesthetic attitude' as a 'paradoxical product of conditioning by negative economic necessities – a life of ease' (1984: 3) is one that encapsulates the growing socio-cultural authority of Britain's aristocracy. That civic humanism was a discourse increasingly destabilised by the discourse of commerce and the market is clear (Solkin, 1992), but core elements remained in transmuted form, to become central to the formation of British civil society and an understanding of the 'nation' itself (Pocock, 1975). Nestled between traditionalism and modernity, the culture of an English aristocracy repackaged the role of the human subject in an ethics suffused with gentlemanly taste and deportment. Civilised conduct, to this extent, leant on the insouciance and grace of traditional aristocratism: 'its index', writes Eagleton, 'is the fluent, spontaneous, taken-for-granted virtue of the gentleman, rather than the earnest conformity to some external law of the petty bourgeois' (1990: 32). Nowhere was this assured sensibility more visible than in country house culture and the social space of the eighteenth-century English art collection.

This century was, indeed, the classical age of the country house, in which no English gentleman could effect influence without recourse to the best of architecture, fashionable landscape design and rich furnishings (Jackson-Stops, 1985; Girouard, 1978). The refined, Palladian and neo-classical piles of Vanburgh, Wren, Campbell and Adam, which proliferated across England, were fittingly restrained and chaste – not over-elaborate, but splendid enough (Jeffery, 1992). Size still

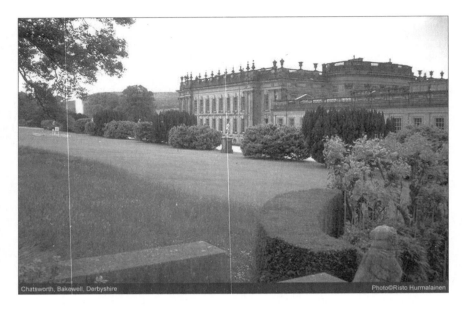

Figure 3.4 Chatsworth House, photo courtesy of Risto Hurmalainen, http://www.dlc.fi/
~hurmari/ristohome.html

mattered, however. The great houses of Chatsworth, Houghton, Blenheim and
Woburn matched in grandeur the socio-political influence of England's leaders.
Any aspiring gentleman had to make visible his credentials in the stature of the
house, itself a sign of cultural prestige and political power. Not surprisingly, around
80% of the membership of the House of Commons and nearly all of the House of
Lords were comprised of this country house elite in the eighteenth century
(Girouard, 1985).

City and country were, by this token, inextricably linked within the class-driven
development of English capitalism (Williams, 1990). On the one hand, town
provided landowners with modern ideas on how to run their estates, turning them
into agents of improvement. On the other hand, country provided them with the
wealth, political power and social prestige that guaranteed their ruling position in
the social order (Williams, 1973). As the discourse of civic humanism had it,
property was *the* precondition for the virtuous exercise of citizenship and public
office: an independent, property-owning landed class was, therefore, the proper
and natural ruling class.

Robert Walpole's estate in Norfolk was certainly a dimension of his political
power. Houghton was, in fact, built by leading architects and craftsmen from the
1720s and contained one of the most lavish collections of pictures in England. It
was also a source of intra-class rivalry such that Walpole's brother-in-law and

Figure 3.5 Holkham Hall, photo courtesy of Risto Hurmalainen, http://www.dlc.fi/
~hurmari/ristohome.html

political rival, Lord Townshend, pointedly refused to be at home whilst Walpole was entertaining. Townshend believed his own seat at Raynham to be in every way superior to Houghton and the political friction between the two was infamous and unremitting (Girouard, 1978).

Also in Norfolk, Thomas Coke's Holkham Hall, built partly by William Kent between 1734 and 1762, was the summation of loyal support to Walpole himself. Coke was appointed post-master general and became Earl of Leicester in 1744. His social ascendancy demanded a suitable context in which to assert influence, so plans were made for a Palladian-style house, with hexastyle Corinthian portico, state rooms and expansive gardens. Inside, an immediate sense of classical republicanism was circulated by the marble entrance hall, a 46 by 70 feet rectangular space based on Roman temples and lined with alabaster columns. This was reinforced by the 105 foot statue gallery, the social centre of the house, which contained a series of classical sculptures – Diana, Thucydides and the statue of Marsyas, in particular (Waagen, 1854; Sicca, 1992).[4]

The fashion for covering walls with Italian cut velvet fitted well with the display of old masters, and Holkham's decorative arrangements were formative here.[5] The Saloon, predictably, displayed a Rubens (*Return of the Holy Family*) and a Van Dyck (*The Duc d'Arenberg*), and in the Georgian period acted as a reception room for the State Apartments. The South Dining Room, in effect another state reception room, was home to grand manner portraits by Batoni, Gainsborough, two portraits in the style of Titian and Holbein, and a portrait of Sir Lionel Talmash by Sir Peter Lely. Finally, 'the landscape room', which also functioned as a State Dressing Room, was decorated solely in seventeenth and eighteenth-century Italianate landscapes by Poussin, Claude, Vernet and Rosa.

Though such displays were not targeted at a general public, what the country house did was contain and elicit the requisite patrician power to those that mattered – fellow dignitaries, MPs, landowners and nobles. Holkham, for instance, regularly attracted Whig politicians and Norfolk gentlemen who, on submission of their title,

would be shown around the house and invited to an evening's 'congress'.[6] It is in this sense that the country house was 'a show-case, in which to exhibit and entertain supporters and good connections' (Girouard, 1978: 3), and the collection a 'triumphant act of enclosure' (Pears, 1988: 180) for a republic of taste. Such aristocratic collections, therefore, were not hermetic units of private delectation, for that would defeat the object of display. The eighteenth-century English country house collection, as Duncan (1995) argues, fell in between the private and public realms, its rationale reinforced by the formation of other collections in similar spaces, such as the British Museum.

Despite some differences in style and function, the aristocratic collection in England acted in a similar register to that evident in 'enlightened' Europe at the same time. At the very least, the ideal public was the same: that constituency of propertied men, the educated and the influential, who comprised civil society during the eighteenth century. Collecting, displaying and viewing certain forms of art (old, foreign, grand manner) was one way in which these 'men of taste' distinguished themselves from the older vestiges of absolutism and the lowly pleasures of the popular. Not merely conspicuous display, then, art indexed a realm of discernment that 'classified the classifier' – that connoted a Grand Tour education, in particular. 'It seems reasonable to suppose', writes Pears, 'that the collection of paintings demonstrated more than simple wealth, that spending money on art was a cautious choice with a specific purpose behind it' (Pears, 1988: 161).

All of which inserted art into a space of tension between the realms of the visible, the affirmation of art-as-wealth, and the invisible, of art as index of national taste, connoisseurship and moral worth. Indeed, it was this tension between extravagance and nationalisation that grounded debates over national art galleries in the early nineteenth century. For now, however, England's landed oligarchy had no obvious reason to form a national collection. As Duncan writes: 'Their existing practices of collection and display already marked out boundaries of viable power and reinforced the authority of state offices' (Duncan, 1995: 39–40).

State, Class, City: The National Gallery and Ambiguities of the Modern

The state of Britain and the British state were gradually changing, however. Growing pacts between landed, commercial and industrial forces in early nineteenth-century England served to drive a wedge between the practices of 'Old Corruption', outmoded remnants of grandeur and inefficiency, and the modern stratum of 'bourgeois' preparing to govern. At least, the elaboration of a system of rule emerged in contradistinction to privilege, landed oligarchy and populist forms of revolution and resistance to commercial change, such as Chartism and Luddism

(Thompson, 1978). This inflection in English social development was marked by greater adherence to ideas of 'nation' and the broadening of citizenship and political influence to those barred from power in the Georgian period. The Great Reform Act of 1832 was the most dramatic expression of this inflection, extending the franchise to propertied middle-class males. And though cultural institutions cannot be read as mere reflections of these changes (the National Gallery did not suddenly rise as a thorough-going 'bourgeois enclave'), certainly the context that circumscribed their possibilities was an important influence on the trajectory of such institutions.[7]

The following is an attempt, therefore, to describe the foundation of the National Gallery as a contested space within finite limits of possibility. There have been several attempts at analysing this development. While Trodd (1994) has focused on the gallery as a technology of power that attempted (often unsuccessfully) to recruit subjects into the disciplinary space of education, Taylor (1999) has pointed to the consonance between debates over the foundation of the National Gallery and concerns over public hygiene; and while Colley (1992) has pointed to the belated nature of the gallery in relation to patrician collection habits and national heritage, Duncan (1995) has revealed this nationalism through the ritualistic order of an increasingly rationalised gallery itself.

In keeping with the theme of this book as a whole my reading of the National Gallery will be through the concepts of modernity and ambiguity. In particular, I want to pursue the argument that the gallery faced forwards and backwards (the well-known Janus-face of modernity) as it underwent cultural modernisation. Pushed and pulled between competing visions of how it should operate, the National Gallery was forced to turn against, whilst drawing upon, the residues of its past. As so often in England, transformation was accomplished through modern uses of traditional forms and the mapping of filiations from the past.

The early nineteenth century was a crucial period of modernisation in England's art field. To start with, the insertion of art into a more intense commercial market exposed pictures more forcefully than ever to the laws of supply and demand. As Macleod notes, the commodification of art in early Victorian Britain was in essence an 'exchange of symbolic value for currency' (Macleod, 1996: 1). The advent of organisations like the Art Union of London, which distributed contemporary engravings and art prizes, brought art into the purview of a broad middle-class audience (King, 1985), while non-aristocratic collectors like Robert Vernon and John Sheepshanks (army contractor and Yorkshire woollen manufacturer, respectively) managed to form collections of contemporary British art without abandoning their activities as businessmen (Steegman, 1987).[8] As for the Royal Academy, despite its aristocratic pedigree its progress was caught between the authority of the market and the ideology of professional autonomy, though the signs were that the former was gradually winning out (Trodd, 1997).[9]

These accomplishments lent a higher visibility to the middling ranks and helped to free artists from aesthetic directives and aristocratic demands (Rosenthal, 1992; King, 1985). Commercialisation, in other words, had produced a more open space of practice in which a less elevated bourgeois taste could proliferate and where artists could live by their own brushes. A greater variety of styles – from the regal to the domestic – was apparent in portraiture, and the emphasis on informality and the attempt to convey individuality through character were present in both Ramsay and Lawrence. Meanwhile, genre painters such as Wilkie, Morland and Wheatley were in greater demand, feeding off and into public taste for simple, domestic scenes and idealised images of the 'virtuous poor'. They could also elevate the style, however, to suit grander patrons, as was the case with Wilkie's *Village Politicians*.

As for landscape painting, which was dominant up to the 1830s, a similar 'break with tradition' (Gombrich, 1972: 394) to that of portraiture is apparent in the shift from the generalised Italianate scenes of the Augustan age, towards a more local set of references that congealed a modern sense of national identity in the work of Constable and Turner. Both were regular contributors to the annual Academy exhibitions, their pictures subject to intense scrutiny by public and press alike (Whitley, 1930). Indeed, Turner's visual dialogue with the Napoleonic wars produced the century's most evocative images of a bountiful, stable and self-sufficient England at a time when the continent was blockaded. Constable's naturalism, on the other hand, reinforced landscape painting's tendency to deal with observable physical characteristics rather than ethereal angels or nymphs – a trend that destabilised the preoccupation with idealism that was current in the eighteenth century (Bermingham, 1986).

Clearly, public taste had begun to dissolve the associations of art with aristocratic living. The dominant ideal of history painting was an increasingly isolated one, for public support would rarely now be given for such large-scale undertakings. Moreover, while the patches and threads of civic humanism were still embroidered in artistic production and criticism, this discourse was increasingly marginalised. The hierarchy of artistic forms and the model of artistic content that was proposed within it were distant from the predominant conditions of artistic production in this period (Copley, 1992). What had been a dominant lexicon of judgement and taste had, in fact, been long chipped away by Addisonian notions of politeness, Enlightenment precepts of truth and the realm of commercial exchange (Solkin, 1992).

Connoisseurship, instead, was coming to be defined in a space delimited not by the amateur ramblings of the leisured gentleman, but by the visions of radical Parliamentarians, professional critics and artists. It is perhaps too early to call this the affirmation of a 'pure aesthetic', as artistic justifications for art were often laid at the door of improvements to commerce, design and manufacturing. Yet the trend

towards hiving off art into a more unique sphere of value was clearly a strategy used to differentiate modern bourgeois professionals from older aristocratic elites in the early nineteenth century. Taste was becoming more and more dependent on specialist knowledge, professional opinion and artistic expertise, rather than ownership and display.

In effect, the call for national spaces for art in England tapped into, but also thickened, these complex processes of class formation and artistic distinction. From the 1820s and 1830s, in particular, movement towards the foundation of a *national* gallery was part of the more widespread process of identity formation and the accruing of symbolic power amongst England's bloc of bourgeois. At the heart of this endeavour was the desire to control art classification and redefine spaces of art in distinction to older spaces like country houses.

On the face of it, the transference of private property into public art was presented with insurmountable difficulties. Firstly, the British government was still rather reticent to sponsor national cultural projects and artistic ventures in the early nineteenth century. The state in this post-Napoleonic moment had administrative and financial limitations which paralysed cultural sponsorship (Minihan, 1977). Expenditure had, in fact, been curbed after the war effort by a parsimonious Treasury already noted for its offensive against royal ostentation. Secondly, from the state's perspective, support for unbridled forms of national patriotism might become hijacked by over-inclusive notions of political community and a corresponding extension of the franchise (Colley, 1992). Caution amongst the traditional guardians of government and patronage towards state-led cultural initiatives, therefore, signified a wariness towards the stirrings of broad-based nationalism on the French scale. This angered artists, patriots and writers like Prince Hoare, Secretary for Foreign Correspondence at the Royal Academy, whose survey of the international arts scene lamented the lack of official support for a school of history painting in Britain (Funnell, 1992).

Patriotism in the arts was left, instead, to voluntary organisations and private philanthropy. The British Institution for Promoting the Fine Arts in the United Kingdom was one such organisation. Founded in 1806, this was an exclusive gentlemen's club of self-financing patrons and aristocratic collectors that operated outwith the parameters of government. Its aim was to promote the higher branches of art, particularly history painting, through the collection and display of old masters, but it also held annual exhibitions of works by contemporary native artists and thereby formed an alternative outlet to the Academy. Founding members included Sir George Beaumont, Sir Thomas Bernard and John Julius Angerstein (whose collection was later to form the nucleus of the National Gallery) and its popularity amongst an art-going public is signalled by entrance receipts to the annual exhibitions in Pall Mall, which in 1806 indicated more than 10,000 visitors (Fullerton, 1982). Commentators noted that the Institution was 'the favourite

morning lounge of our fashionable amateurs' (*The Morning Post*, 1806, cited in Hemingway, 1995: 99) and although its presence in the cultural field indicates a strategy of survival on behalf of an aristocracy in a modern art market, it nevertheless enabled patricians to shape the growth of British art without yielding a national gallery (Funnell, 1992).

The state, from this point of view, was largely a peripheral organ, unwilling to soil its hands with public funds and therefore massively different from interventionist models of state–art relations on the continent (Solkin, 1992; Minihan, 1977). Funnell writes, for instance: 'We can see how wide the gulf was between those foreign art worlds, funded and regulated by the state, and the institutional structure prevailing in London' (Funnell, 1992: 156). Driven by a rhetoric of free trade, the British government nurtured a self-regulatory art world: it was not to provide a false stimulus but to let artists and institutions flourish unfettered.

Certainly there is truth in this characterisation. It was evident, for instance, that the state was turning down offers of gifts and bequests from important Victorian collectors, many of whom were amassing works in consequence of the dispersal of pictures after the French Revolution.[10] One such offer was made by Noel Desenfans, the French picture dealer whose collection of old masters was declined by the British government at the end of the eighteenth century. Desenfans even drew up a plan for a building to house his collection at no public expense but this was also ignored. Instead, on his death, the collection was bequeathed to Sir Francis Bourgeois on the condition that it should be exhibited and preserved to the public. The pictures eventually formed the core of the collection at Dulwich College, and then to the picture gallery itself, opened in 1821, but only to those who could obtain tickets (Dulwich Picture Gallery Catalogue, n.d.). Indeed, in the absence of state initiatives, collections in London were generally unavailable to a wide public without special arrangements. Whilst the collection of the Marquess of Stafford (which included part of the Orléans collection) was the first private nobleman's house to be opened to visitors in London, in 1806, the Marquess found it necessary to introduce regulations limiting admission to friends and family. Equally, the collection of Lord de Tabley (Sir John Leicester) could only be accessed in 1818 by ticket-holders familiar to the owner and his acquaintants, despite the fact that the gallery contained contemporary British works (Waterfield, 1991). As Whitley put it: 'The ordinary Englishman therefore, had still no opportunity of seeing pictures without payment or restrictions' (1930: 1–2).

That the British state was not an exhibitionistic patron, however, should not conceal the operation of nuanced forms of official guidance and the state's role as a mediator of culture-class relations. As with education, industry, welfare and leisure, the art world cannot be understood in complete isolation from patterns of governmental power (Pearson, 1982). State regulation of cultural forms and the channelling of national identity was not monolithic, but it was present. This was

particularly so from the second decade of the nineteenth century, as government became increasingly receptive to the actions of voluntary and philanthropic groups in English civil society and the attendant cultural strategy of opening up privileged spaces under the aegis of the 'nation' (Duncan, 1995).

In other words, as the state came to define acceptable forms and images of social activity in general – normalising and regulating the limits of economy, culture and politics – so it began to construct a nineteenth-century state art apparatus (Corrigan and Sayer, 1985; Fyfe, 1993). This apparatus consisted of museums, academies, art schools and national collections that, in effect, classified and marshalled art, by shaping cultural identities and policing artistic boundaries. At the very least, the state operated a mixed cultural economy stance, combining 'arm's length' principles that encouraged the founding of 'quangos' (the Royal Academy for example), with protection and guidance. Its incursions were particularly evident in order to curb monarchical and aristocratic expenditure, but were also evident when aristocratic exclusivity gave away to greater bourgeois and, in the case of design, working-class exposure. In other words, the state became 'interested' when art was reaching a wider audience and when struggles or conflicts in the art world itself began to spill over into the public sphere (Fyfe, 1993: Minihan, 1977).

Programmes of state sponsorship, in fact, shaded very heavily into nationalist rivalry, giving an edge to projects such as the decoration of the Houses of Parliament, rebuilt after the fire of 1834, and the 'acquisition' of the 'Elgin marbles' in 1816. Both were drawn into wider discourses of national improvement and the permeation of taste into subordinate branches of art. State patronage in these matters was to be justified as a practical endeavour – as an intervention geared towards improving public taste by raising standards of design and technique. English nationalism, here, took on a similar hue to the nationalisms in other western European nations; it grew from an understanding of political rationality and national community that articulated the interests of civil society to the state. Benthamite groups were significant players in this strategy, calling for an end to privilege, widening political inclusion and defending the imperatives of national-state improvement. The state, here, was not something to be disciplined as an organ of despotism, but inhabited in order to guarantee freedoms.

Parliament's purchase, in 1824, of Angerstein's collection of old masters represented a significant lurch towards national cultural power and international brinkmanship in a context of changing class relations. The collection, comprising thirty-eight paintings, was typical of a private gentleman's taste – narrowly confined to 'classicising' artists like Claude and Poussin, members of the Caracci family and contemporary British academicians like Reynolds and Hogarth. The purchase had been made possible on repayment of a substantial war debt by the Austrian government, although government parsimony dictated that Lord Liverpool struck a hard bargain in reducing the collection price to £57,000 (Martin, 1974).

Angerstein, a Russian émigré and founder of Lloyds of London, represented the modern flavour of mercantile capitalism and philanthropy in early Victorian Britain. He was part of a growing breed of non-aristocratic patrons who shaped the nineteenth-century art field by supporting national art and nurturing a growing middle-class public, but who were often excluded as *arrivistes* from the higher reaches of elite society. The diarist Joseph Farington, for instance, recounts the tensions between Angerstein's middle-rank *habitus*, his aspirations to be a gentleman and his movement within elevated socio-spatial circles:

> Mr Angerstein is much respected for his good heart and intentions but is considered deficient in education and very embarrassed on all occasions when he is required to express himself . . . [he] might have been at the head of popularity in the City, but has chosen to associate chiefly at the west end of town. (cited in Lloyd, 1966: 376–7)

Indeed, it was in the more patrician west end of town, at 100 Pall Mall, that Angerstein chose to locate and display his collection. This was Angerstein's own town-house, by all accounts a moderately sized abode containing 'a parlour on the ground floor and two apartments on the first floor' for the purposes of exhibition (quoted in Whitley, 1930: 74). But at least it saved the government, who bought the lease, from having to erect a new building. The collection was to remain in this location for ten years.

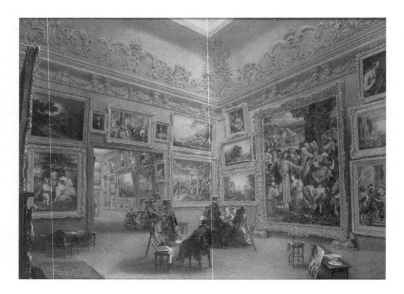

Figure 3.6 Francis Mackenzie, *The National Gallery when at Mr J.J. Angerstein's House, Pall Mall, prior to 1834*, c.1834, V&A Picture Library.

A watercolour by Francis Mackenzie, entitled *The National Gallery when at J. J. Angerstein's House, prior to 1834* (1834), shows the house after Angerstein's death in 1823 and suggests how the early National Gallery was, in essence, an aristocratic patrimony hung according to decorative principles. In the centre was Sebastiano del Piombo's *The Raising of Lazarus*, widely perceived as the nation's most edifying picture due to its associations with Raphael's *The Transfiguration of Christ* and the painter's pedigree as a master of High Renaissance Italian painting (Waagen, 1854; Thomas, 1999). Many of the smaller surrounding pictures were added at a later date on considerations of size, giving the arrangements a neo-rococo flavour. Through the archway, for instance, can be seen Rubens' *Rape of the Sabine Women*, framed in eighteenth-century style by decorative curtains (Waterfield, 1991).

The gallery opened to the public in May 1824 on four days a week, from 10 a.m. to 5 p.m. with Fridays and Saturdays set aside for copyists. It was closed on Sundays. The first keeper of the National Gallery was William Seguier, and the first trustees, appropriately called the 'Committee of Gentlemen', included the then Prime Minister, Lord Liverpool, the Earl of Aberdeen, Sir George Beaumont, Sir Charles Long (later Lord Farnborough) and Sir Thomas Lawrence. The keeper's administrative duties were rudimentary in nature, limited to the hanging and occasional cleaning of pictures, whilst the 'quango' model of trusteeship continued the fuzzy logic of a cautious state that had vested power in a body of 'independent' aristocrats.

That the National Gallery would begin to attract bequests and gifts was predictable. In fact two collections were added in rapid succession – those of Holwell Carr in 1825 and Sir George Beaumont in 1826. The latter's bequest included works by Rubens and Canaletto whilst Carr's contribution contained the Venetian High Renaissance art of Tintoretto and genre scenes by Rembrandt. It was soon apparent, as a result, that the space set aside for the national collection was singularly inadequate. Hullmandel's lithograph *The Louvre and Pall Mall* visualised the contrast between the Louvre's grand spatial panorama and the timid mediocrity of Angerstein's town-house. The implication was clear: official backing of the Louvre had given it a kind of mythical power both as cultural spectacle and national ritual. England's official superintendents were yet to fully appreciate the potency and purpose of a thorough-going national gallery.

Moving the entire collection just a few doors down from the Angerstein residence, to 105 Pall Mall, was a temporary solution occasioned by the collapse of the former house, but it did not placate critics of the gallery, many of them inspired by Whig success in the 1830 election. *The Times* had already published a leading article declaring the gallery to be a national disgrace in its physical paucity and administrative shortcomings. Other journals like the *Examiner* and the *Morning Chronicle* redoubled the offensive against crowded conditions and

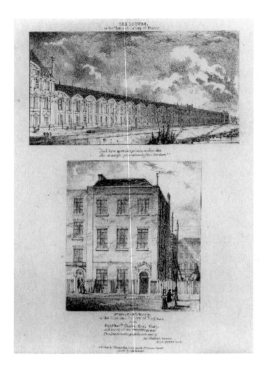

Figure 3.7 Charles Hullmandel, *The Louvre or the National Gallery Paris, and No. 100 Pall Mall or the National Gallery of England*, lithograph, c.1830, © National Gallery, London.

injudicious purchases (Whitley, 1930). It was clear something had to be done to provide a place fit for viewing the pictures, a place properly conducive to national improvement and cultural legitimacy. For most, therefore, Earl Grey's announcement in 1832 that a purpose-built gallery was to be erected was long overdue. It was to be located on the site of the King's Mews, in the centre of what was to become Trafalgar Square – a 'place politique' of empire and nation in an area already subject to John Nash's Regency clearances (Mace, 1976). In Lord Farnborough's view at least, the gallery was a metonymy of English Enlightenment: it was to convey the virtues of a nation whose collection was assembled not by military pillage but connoisseurship; that is, by English practices of bequests and gifts, not French practices of revolution and the stripping of the shrine (Lord Farnborough, 1826).

The motion was carried and £43,000 was budgeted for the gallery's establishment, although this estimate had already escalated to £76,000 by 1833. Excavations began in 1833 at the site near Charing Cross and the foundation stone

was laid in 1834. The architect was William Wilkins, whose design for a neo-classical building on the north side of the square was chosen over plans by John Nash and C. R. Cockerell; not a popular choice among disaffected radicals and writers, many of whom saw the selection as an act of 'jobbery' and undue personal influence. The building, too, faced a barrage of criticism in the press, parliamentary reports and government offices: it was slung too low, its original design interfered with the view from Pall Mall of the portico of St Martin's church, and it was wanting in architectural decorum (Purser, 1833). Charles Purser, Wilkins' architectural rival, called the design an act of 'vandalic barbarity' (Purser, 1833), whilst both *The Athenaeum* and *The Literary Gazette* published a series of attacks on the 'egotistical' Wilkins and his 'objectionable elevation', 'his pure Greek', wrote the *Gazette,* 'violating every rule of every order, and superadding features of the most anomalous absurdity' (*Literary Gazette*, No. 841, Saturday 2 March 1833: 138).

Even before the gallery was opened in April 1838, then, the knives of reformists were out to puncture the brief optimism that accompanied the foundation of the long-awaited edifice. With the Whigs in power and a Reform Bill passed, it was time to think anew the relationship between nation, culture and the arts.

Professionalisation and the Spirit of Reform

A wave of institutionalised state-led reformation took shape from the 1830s as part of the pragmatic, stepwise construction of modern cultural institutions in Britain. This realigned the cultural landscape with the modalities of bourgeois rationality, a major function of which was to subject previous regimes of cultural order to a critique bordering on stigmatisation (Corrigan and Sayer, 1985). Parliamentary scrutiny was pressed through various forms of official knowledge acquisition – commissions, reports, inquiries – that served, *inter alia*, as rituals of state power. These included the 1836 Select Committee on Arts, and their Connexion with Manufactures, the Select Committee on Fine Arts, 1841, the Select Committee on Works of Art, 1848, and three select committees on the National Gallery, in 1850, 1853 and 1857. In effect, each unit of official discourse expanded the state's presence as a moral social regulator, fostering new cultural identities and cutting away the dead wood of patrimonialism in the process.

It was the 1836 Select Committee that constituted the most radical and hard-hitting instrument of official cultural inquiry. Headed by renowned radicals such as Thomas Wyse, William Ewart and Edward Strutt (MPs for Manchester, Liverpool and Derby, respectively), the committee was a cultural echo of the reformist spirit of 1832.[11] It was in turns critical, probing, irreverent and nationalistic, making 'official' grievances that were going on in the public sphere at the time. It was also full of leading questions and pre-cooked answers, more an exercise in Benthamite self-righteousness than a transparent medium through

which the truth of witnesses' reports were articulated (Taylor, 1999; Fyfe, 2000). But it remained a most effective and far-reaching vehicle of cultural modernisation nonetheless.

The committee's remit was twofold: firstly, to 'inquire into the best means of extending a knowledge of the arts and of the principles of design among the people (especially the manufacturing population) of the country'; and secondly, 'to inquire into the constitution, management and effects of institutions connected with the arts' (SC, 1836: ii). United under the banner of 'national improvement', then, the committee addressed itself to education, design and manufacturing on the one hand, fine arts and the role of institutions like the National Gallery on the other. Indeed, it would be safe to say that the resolution of one set of questions led straight to the Great Exhibition, national schools of art and design and the formation of the South Kensington complex of museums, the other to a modernisation of the National Gallery itself.[12]

As far as the committee was concerned, a properly organised national gallery was an important tool of national improvement and social order. It was imperative, therefore, that free admission was secured and a regime of access encouraged, to expose the lower ranks to works of art that might improve their habits and morals. Ewart and Wise, together with MPs such as Joseph Hume, were vociferous champions of free public access to all institutions in Britain that contained important art works, including the Royal Academy, which charged one shilling for entry. With a tinge of nationalistic rivalry, the committee pointed to the continent where 'a taste in favour of the arts appeared to be general and diffused, and to be operating upon the mass of the population' (SC, 1836, part I: paragraph 190–1). In Italy and France, the committee explained, libraries, museums and exhibitions were free and widely accessible; and in Bavaria, 'the peasants come from the mountains, almost from the plough, and wander through the gallery with the most perfect freedom' (SC, 1836, part II: paragraph 716). In Britain, the National Gallery had only just been founded, and was yet to fit the model of a national institution dedicated to the recreation and refinement of the 'laborious classes' (SC, 1836: paragraph 10).

The point behind such idealism was clear: it powered a substantial critique of previous regimes of exclusion and the self-serving culture of aristocracy. Only when influence had been wrenched from this constituency could the nation enjoy the cultural benefits of civilisation.[13] Naturally, many of the 1836 Select Committee's members were already piqued by news that the new building was to be shared between the national collection and that bastion of exclusion and unaccountability, the Royal Academy. Ewart was particularly scathing of the new arrangements and his grilling of the architect, Wilkins, reveals the internecine struggles that were unravelling themselves in an increasingly differentiated art field. If only the Royal Academy had not entered the gallery, Ewart states, the national collection would

be much more enriched with samples of ancient sculpture and drawings. And was it not slightly anomalous that one half of the building would encourage the admission of a broad public, whilst the other half would 'be able to exclude such portion of the public as it does not choose to admit'? (SC, 1836, part II: paragraph 1166). Others concurred. Haydon disapproved of the Royal Academy's 'exclusiveness, its total injustice' (SC, 1836, part II: paragraph 1063), whilst the *Literary Gazette* levelled its vitriol at what it called the '(pseudo) National Gallery', a monstrous hybrid and lamentable waste of money:

> We lament it on account of the bad effect it must have on every patriotic man, who might, under better auspices, be inclined to enrich the National Collection by gifts of private munificence, but who will not bestow treasures on an inadequate institution, half gallery, half academy, half public, half chartered, half civil, half military, half wealthy, half pauper, half barbarous, half Grecian, half Gothic, and altogether incompetent and ridiculous. (*Literary Gazette*, 14 September 1833)

The trustees of the National Gallery fared no better. Artists, professionals and intellectuals, including some of the most enlightened museological figures in Europe such as Gustave Waagen and Baron von Klenze, spoke disparagingly of the selfishness and lack of professionalism that marked themselves in the practices of the management. The charges were various and unrelenting. Trustees were negligent in their attendance at meetings and were too preoccupied in their public posts to spare the time for other duties. They missed opportunities to acquire important art works and presided over cleaning strategies that were detrimental to the pictures (the formation of a treacle-like substance had, according to the *Art Journal*, blackened the pictures beyond recognition). They failed to historically systematise the collection and instead operated an acquisition policy based on the individual tastes of the trustees. Most importantly, they lacked the critical acumen and sound art historical knowledge befitting guardians of a national collection – a fact expressed in their penchant for cabinet pictures and examples from the Caracci over Raphael. Possessors of collections they may have been, but, as the former timber merchant and picture collector Edward Solly put it, 'they have not taken the pains to make it their study to attain that general knowledge which requires a great deal of deep research' (SC, 1836, Part II: paragraph 1836).[14]

Management by amateurs was reflected in an inept institution, revealed the committee. The gallery was outmoded, inefficient and failing in its claims to be a monument worthy of a rich nation. Certainly compared to arrangements at the Louvre and the museums of Berlin, Munich and Madrid, England's National Gallery was behind the times. In 1835 the collection amounted to 126 pictures and even this stretched the available space, the lion's share of which, on Wilkins'

admission, had been given to the Royal Academy. Internal arrangements smacked of the auction house, with pictures so crowded on the walls that even as late as 1853 they affronted the 'educated eye' (Yapp, 1853: 49). Bequests reinforced the sense that this was a collection formed of private taste, arranged by gentlemen who were in essence 'idle dilletanti' with a second-hand knowledge suited to 'parish concerns' rather than experts whose knowledge sprang from a 'pure source' (*Morning Chronicle*, 29 August 1831: 223).

Things were not immediately about to improve either. The stricken William Seguier, first keeper of the gallery, revealed that no plans were in store for any re-arrangement of the collection into schools, a practice that had been employed by experts for almost a century in some parts of Europe. Labels were a good idea, agreed the keeper, but again had not been installed. The acquisitions policy, while sufficiently wide enough to bring in a substantial number of minor artists, was loose and yet to be rationalised. As for institutional decision making, Seguier expressed no knowledge of who appointed the building committee and how the trustee system operated. The *Morning Chronicle* summarised the sense of reproval when it declared: 'The Committee of Taste have no taste, and the National Gallery is anything but national' (*Morning Chronicle*, 29 August 1831: 223).

Not long after Sir Charles Eastlake took over as keeper upon the death of Seguier in 1843, the National Gallery was still shared by the Academy and the national collection and still subject to parliamentary scrutiny. In fact it took years of enforced modernisation before the National Gallery was bought properly into line with models on the continent, although as Duncan (1995) notes, it was never to be a 'universal survey museum'. A new set of institutional norms and protocols were eventually installed on the back of Select Committee recommendations throughout the 1840s and 1850s, in effect securing a closure on many of the archaic practices of the early years. The *coup de grâce* as far as the old system was concerned was executed by the 1853 Select Committee on the National Gallery, which, after culling evidence from 10,410 questions, pointed to 'fund-amental defects' in the constitution and management of the gallery (SC, 1853: xxxv). Its modernising resolutions reverberated long into the nineteenth century and included the following: trustees were no longer to be appointed by virtue of their public duties; the office of keeper of the gallery was to be replaced by a salaried director, appointed by the Treasury, who would produce annual reports for public inspection; cleaning was only to be carried out by qualified and competent professionals; more specimens of Italian art were to be acquired; and, in return, an annual purchase grant was promised (SC, 1853).

The trustee model was to function as a modern cultural bureaucracy with a particular purpose: 'to keep up a connexion between the cultural lovers of art and the institution, to give their weight and aid, as public men, on many questions of art of a public nature that may arise, and to form an indirect though useful channel

of communication between the Government of the day and the institution' (Treasury Minute, March 1855, quoted in Taylor, 1999: 62). That the policy of selecting and acquiring art works was to be placed in the hands of the director was a sure indication that artistic authority lay with experts and professional managers. With these new managerial arrangements emerged a concentrated desire to expand and codify the collection for public instruction and improvement. The rough and ready numbering system of the 1830s (whereby the paintings were classified by the order they arrived in the collection) had slowly given way to a new era of aesthetic order.

A more historical interpretation of the collection rested on a deepening of historical time *vis-à-vis* the European schools. It was Sir Charles Eastlake's intention to reclassify the collection according to style and technical merit such that separations could be made between 'Italianate masters' and Dutch or Flemish pictures. The latter should be hung, suggested Eastlake, according to modern principles of display whereby the source of light and the picture would not be seen by the viewer simultaneously (Eastlake, 1845). The director also managed to acquire works from the early Italian school in line with the committee's recommendations, including Guido's *Ecce Homo*, Giorgione's *Knight in Armour*, Botticelli's *Adoration of the Magi* and Michelangelo's *Madonna and Child with Angels* (at the time attributed to Ghirlandaio). Whilst Ruskin's 'great hope' regarding the National Gallery, 'that it may become a perfectly consecutive chronological arrangement' (SC, 1857: paragraph 2041), would not be realised until the end of the century (catalysed by the removal of the Royal Academy to Burlington House in 1868) a more ordered methodology of art-historical display was at least slowly being implemented (Thomas, 1999).

Despite continued tensions between government control and a system of trusteeship based on the 'arm's length' principle, and despite continued limitations in physical space, a national gallery, accountable to the state, guided by professional elites, and cognisant of European fashions *was* gradually founded in England's metropolis. The easing in of expertise and the easing out of possession had been fuelled by a partnership between professionals and the state – a process evident in the Civil Service, law and medicine as well as the fine arts (Perkin, 1990). Modernisation, in other words, was pressed through a wave of professionalisation and a spirit of reform as specialists serviced the cultural requirements of the state under the rubric of expertise. What Fyfe calls the 'credentialist attack on patronage' (Fyfe, 2000: 27) reflected a subtle inflection within the curvature of class relations and the cultural field itself, away from patronage and oligarchic rule towards new standards of connoisseurship and art history. Thus, the development of new positions and cultural identities in the metropolitan art world – curators, picture cleaners, cultural bureaucrats, directors, museum professionals and so on – conveyed new ideologies of national cultural power and the elevation of taste as

a form of cultural capital (Bourdieu, 1993). The result was a more forward-looking National Gallery under state bureaucratic control, carried through the precepts of professionalisation and bourgeois rationality.

'Aesthetical Idlers' and the Dissonance of Dirt

At the core of this modernisation, however, was a double-bind: the gallery had to be slowly divested of its previous connotations with aristocratic living, including the cultural management of the amateur; but the new arrangements in Trafalgar Square threatened to undermine the very idea of aesthetic purity and cultural distinction that was basic to the idea of a gallery of pictures and the professionals who championed it. In particular, the siting of the gallery in Trafalgar Square placed the gallery in a precarious position, open to the unpredictable behaviour of a teeming mosaic of urban life. The conditions of possibility for the National Gallery were the same conditions, therefore, that undermined the possibility that the gallery fulfil the functions set down for it in the rhetorics of national improvement. The city of London, in short, created conditions it couldn't overcome.

By the 1850s concern for the dirty state of the pictures had turned into an obsessive search for the origins of filth and ways of eradicating it. Both the 1850 and 1853 Select Committees and the 1857 Site Commission dedicated extensive time to ascertaining what processes and substances were most injurious to the pictures, even calling upon the expert testimony of physicist and chemist Michael Faraday. Blame was levelled at two main objects: the London atmosphere and the presence of the masses. In both cases, what structured the discourse of cultural defilement was an antipathy to dirt and a redoubling of the effort to keep the gallery for a deep, rather than a surface, level of contemplation. This in turn articulated the logic of practice, that is the *habitus*, of particular types of gallery visitor.

As long as the gallery remained at Pall Mall, the 'best part of London' (Waagen, 1854: 55), its function as a relatively pure institution of art was guaranteed by the 'privacy' and suburban exclusivity of the site. Hazlitt's visit to the Angerstein collection in 1824 induced a quasi-divine respect for aesthetic purity. More private mansion than public gallery, the Pall Mall space, for Hazlitt, guaranteed conditions of deep appreciation for art. This was not cheap commerce or some popular show, it was the pure thing itself:

> The eye is not caught by glitter and varnish; we see the pictures by their own internal light. This is not a bazaar, a raree-show of art, a Noah's ark of all the Schools, marching out in endless procession; but a sanctuary, a holy of holies, collected by taste, sacred to fame, enriched by the rarest products of genius. For the number of pictures, Mr Angerstein's is the finest gallery, perhaps, in the world. We feel no sense of littleness:

the attention is never distracted for a moment, but concentrated on a few pictures of first-rate excellence. (William Hazlitt, 1824: 7)

Hazlitt's visit portrays a state of artistic innocence before the fall: it was arguably the last time a deeply cognitive encounter with art could be guaranteed in London's national gallery. Pall Mall retained a sense of solitude, silence and aura, it was 'the mind's true home' (Hazlitt, 1824: 7).

By the 1850s a discourse of defilement had undercut such Romantic eulogies and marginalised the optimistic rhetorics of national improvement present in the 1836 Select Committee. That the shift to Trafalgar Square was felt ambivalently was clear from the outset. Despite the centrality of the site, the gallery's proximity to chimneys, barracks and a washhouse raised fears that London's poisonous and lower tendencies would leak into what should have been a space of cultural rectitude. The architect Charles Purser had by 1833 expressed his wish that 'our National Gallery may not be prostituted, in its virgin purity, by an alliance with a soldier's barrack' (Purser, 1833: 71). In the same year, the *Literary Gazette* railed against Wilkins' plans for a gallery hemmed in by the inconveniences of the barracks and a refuge for the destitute; it should, preferably, 'stand single and alone in grandeur and grace; rather than see it cabined, cribbed, confined – a masked battery for soldiery, with gateways through which to debouch, should occasion require it' (*Literary Gazette*, No. 841, 2 March 1833: 140).

These fears had translated into a concern, by the 1850s, with the state of the pictures, the surface of which, according to many witnesses, had been devastated by soot and dirt. Sulphurous acid, in particular, was a residual substance identified by Faraday as heavily present in the coal-rich environment of the metropolis. As the biggest city in the world, London, it was surmised, was unique in this respect: its atmosphere produced more industrial matter and therefore more dirt upon the pictures than found in other cities. 'London', in the words of Thomas Unwins, 'is as bad a place as possible for the preservation of pictures; no city can be so bad as London' (SC, 1850: paragraph 232). Indeed, witnesses were drawn into contrasts between England's capital and other continental cities. Where Madrid had a 'pure' atmosphere, Berlin, according to Waagen, had no manufacturing base, no steam engines or surrounding industry (SC, 1850: paragraph 570); and where the bright skies of the Grecian plain produced a sense of isolation, London, saturated with its own industrial power and commercial exchange, soiled and confused everything (*Literary Gazette*, No. 840, 23 Feb 1833: 122).

The city, in this respect, created conditions it could not overcome: it was both the guarantor of an accessible national gallery in the heart of the metropolis (in distinction to the private country house) and the bane of the pure aesthetic and the idea of cultural purity. Like modernity as a whole, the city giveth and it taketh

away; it was both the shining symbol of progress and the *bête noire* that haunted cultural professionals and their desire for distinction.

Moreover, the city had an agency: the image of urban filth quickly shaded into an image of the public as carriers of dirt who choked up the space. Dirt had become personified and named: it was the ganglion of lower constituencies variously called 'mob', 'crowd' and the 'idle', but which also encompassed the 'labouring' or 'working' classes. By this movement, the city, as Trodd recognises, was inserted into the discourse of cultural management through the promiscuous image of the crowd (Trodd, 1994: 43). Previously defined according to a kind of education-deficit model (as receptacles to be filled with taste), the lower classes and their bodies had become an egregious threat; they had, in short, become turbulent.

Indiscriminate crowds had been identified as a blight on the gallery by almost all of the commentators asked to survey the state of the gallery and the damage to the pictures. The production of scientific truth intersected with a conceptualisation of the crowds in Faraday's testimony as a miasma-producing body. Organic miasma was a kind of unwholesome effluvium given off by humans in the process of perspiration: through heat it had a tendency to decompose and produce harmful ammonia and sulphurous substances. The more bodies there were, the more the miasma (Faraday, SC, 1850: paragraph 666). Very quickly, the truth of miasma had crept into the discourse of the cultural institution. For Eastlake, dust and smoke were 'evils arising from the crowds' (SC, 1850: paragraph 383); for Colonel Rawdon MP, a 'poisonous influence' arose from the 'organic miasma from the crowds that are in the town' (Rawdon, 1851: 15); for the President of the Society of British Artists, Frederick Hurlstone, the masses were more destructive to the pictures than the smoke of London (Hurlstone, SC, 1852–3: paragraph 7119); for Ford there was a specific odour in the gallery which he attributed to the 'breath of crowds in it' (Ford, SC, 1852–3: paragraph 7982).

Not only were the crowds poisonous, however, they were also inattentive: their presence was not pure and neither was the logic of their gaze. In fact, many were entering the gallery in order to shelter from the rain, or, worse still, had chosen the site as somewhere to eat. The space had become sullied with boisterous children, orange peel and 'country people' with their picnics and penchant for gin. Mondays, in particular, had become a source of consternation for the gallery's superintendents:

> the lower class of people assemble there, and men and women bring their families of children, children in arms, and a train of children around them and following them, and they are subject to all the little accidents that happen with children, and which are constantly visible upon the floors of the place; and on the days especially that the regiment which is quartered behind the National Gallery is mounting guard at Saint James's the music attracts the multitude; and an immense crowd follows the soldiers,

and then they come into the National Gallery; as soon as the procession is over, the multitude come in, who certainly do not seem to be interested at all about the pictures. (Unwins, SC, 1850: paragraph 82)

In other words, sections of the public were using the space as a site for sensuous amusement, a lower form of human activity as the Kantian aesthetic had it. Desires and accidents of the body had suppressed cognition and the contemplative pleasures of the head. The figure of the 'aesthetical idler' (Ford, SC, 1852–3: paragraph 7968) pointed up what was at stake in the management of the gallery space – the gap between a project set in rhetoric and the messy realities of urbanism: the fact that vagabonds and loungers were present in 'chambers sacred to Rafaelle, Titian and Reynolds' (letter from Mr Doyle to Lord John Russell, 1851, quoted in Rawdon, 1851: 25); the fact that an idealised public constructed by previous committees could not be realised in practice (because London was London), a fact brutally ironised in John Leech's *Punch* cartoon *Substance and Shadow* and embodied in Ford's perceptive realisation: 'we cannot expect the multitude to go in exactly for the object for which we would wish them to go in' (Ford, SC, 1852–3: paragraph 7994).[15]

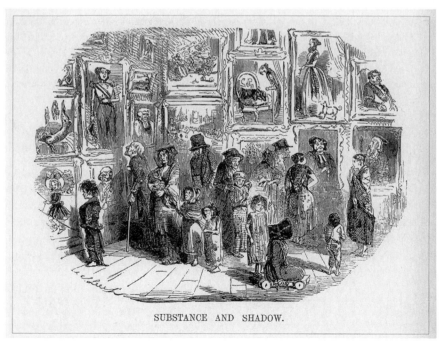

SUBSTANCE AND SHADOW.

Figure 3.8 John Leech, *Substance and Shadow*, 1843, *Punch*, vol. 5, July 1843, p. 23, courtesy of *Punch*.

A double-bind was therefore lodged at the heart of the trustees' and the government's relationship to the public: they had to deal with a potentially disruptive public – 'the fullest tide of human existence' (SC, 1847–8: 11) – that they were obliged to invite as part of the project of the National Gallery. The optimistic paternalism aimed at the lower classes in earlier years (what the middle classes could do for those below them) had quickly transposed into panic over the protean nature of this public (what the lower classes were doing to the middle class and its sites of assembly). Some commentators identified a process whereby the middle and upper classes, particularly ladies, were actually driven away from the gallery because conditions of reception were crude and the crowd lubricious. 'Have you ever been there on Whit Monday?' James Dennistoun is asked by the 1852–3 Select Committee: 'I should studiously avoid it' he replies, stuffed as it is with 'crowds of all classes of people, children, nursemaids, peasantry, and people of that description, who come in merely for the purpose of sitting down on a bench, or for various other purposes' (SC, 1852–3: paragraph 5881). Prime Minister Sir Robert Peel spoke for many when he summed up his suspicions in a letter to William Russell in 1850:

> I have my misgivings as to the fitness of the present site for a collection of very valuable pictures, combined with unrestricted access, and the unlimited right to enter the National Gallery, not merely for the purpose of seeing the pictures, but of lounging and taking shelter from the weather; to attempt to draw distinctions between the objects for which admission was sought, or to limit the right of admission on certain days, might be impossible; but the impossibility is rather an argument against placing the pictures in the greatest thoroughfare of London, the greatest confluence of the idle and unwashed. (Sir Robert Peel, quoted in William Russell, SC, 1852–3: paragraph 8186)

What was to be done? Peel alludes to one mooted solution: the restriction of access on some days, via payment, in order to set aside sacred time for the higher classes. Others offered their own solutions: the erection of ticket booths separate from the gallery where visitors would have to present themselves in advance of the visit, the requirement to buy a catalogue and therefore the weeding out of poorer elements, the use of glass to cover the pictures, and even the opening of the gallery on Sundays, after church. The latter suggestion hinged on the assumption that that lower classes would be clean and suitably attired: 'It is almost their only day', says Ford, 'besides which they would be nicely dressed, and the fear of dirt would be less' (Ford, SC, 1852–3: paragraph 8015). Just as dirt had become dissonant, so the desire to reterritorialise the space, to claim space back in an act of purification, had become a matter of urgency. For dirt had become central to the symbolic division between gallery and carnival, suburb and slum, civilised and savage (Stallybrass and White, 1986).

By far the most potent solution, therefore, was the transfer of the whole collection from Trafalgar Square to Kensington Park: purification by gentrification. Land had been identified at Kensington Gore as a potential site to house the collection in more pastoral surroundings. Moving to a 'purer atmosphere', further from the busy haunts of urban life, would 'save the pictures' (Faraday, SC, 1850: paragraph 695) and restore the best conditions for picture-seeing and studying. This would be more acceptable and appealing to the middle classes, it was reasoned, but would also provide labourers and their families with a walk out of the city and appease rational recreationalists who, after the 1834 Select Committee on Drunkenness, recommended public walks, healthy exercise and gardens as a palliative to licentious behaviour (Golby and Purdue, 1984). Moreover, Kensington had been identified in the testimony of architect and land surveyor Thomas Cubitt as an area clear of factories, breweries and working-class housing, a quality place enjoying wide streets, large houses and high rents. It was a key recommendation of the 1853 Select Committee, therefore, that Kensington Gore was better suited to the preservation of the pictures, and that appropriate land should be 'purchased jointly by the Royal Commissioners of 1851 and by grant of Parliament' (SC, 1852–3: xviii).

But the National Gallery stayed put, for state pragmatism, parsimony and indecision, as so often before, won the day. The 1857 National Gallery Site Commission was embarrassed to admit that it could not arrive at any definitive decision over whether to move the gallery out of the metropolis. Ambiguity had woven itself so very tightly into the project of the gallery that the commission failed to adjudicate over the variety of opinions on offer. The oscillation between keeping the gallery in the accessible heart of the metropolis and the desire to withdraw to more salubrious conditions was emblematic of the gallery as a site of competing visions and of the state as a removed but rationalised presence. And in any case, by then, proceedings had already helped to vent the misgivings felt by cultural professionals towards the site, thereby cementing the identity of the professional bourgeoisie itself.[16]

What distinguished this newly enfranchised group from the demotic was its cultural capital and antipathy to dirt, both of which marked out boundaries between *habituses* which belonged to the gallery and those out of place. It wasn't just that the lower classes were odorous and idle, they really did not have it *in them* to contemplate high art. The lower classes might experience vulgar pleasures and forms of base enjoyment, but they had no capacity to 'appreciate' works of high class (Waagen, SC, 1850: paragraph 607). Pure art was above them, above their level of sensuous amusement. Very few of them came to the gallery 'with a real desire to study the pictures' (Ford, SC, 1852–3: paragraph 7968), even fewer experienced an aesthetic reaction to them. The logic of distinction, of vision and division, was both constant and abundant in the various committees of the 1850s, helping articulate the institutional culture of the gallery itself:

There is wide distinction between art and fine art; in the latter the knowledge of artisans whose bread is earned in laborious work must be always very limited, compared with those who have original genius for it. (Cockerell, SC, 1852–3: paragraph 1460)

I think that you will find that on wet days many persons go in there with no other object than to obtain shelter from the rain; and much more copious emanations and exhalations would arise from their clothing than from that of other persons who went decently dressed, and for the real purpose of seeing the pictures. (William Russell, SC, 1852–3: paragraph 8187)

Their opinion of painting differs very much from mine. What I would admire as fine art that class of people would not admire. What you, or I, or anybody else would perhaps call a vulgar painting, an imitation of life, a smuggler, a bull-fight, a grand battle, anything very illustrative, they understand and admire; but the purer class of art seems to be above them. (James Ferguson, Site Commission, 1857: paragraph 2634)

I think there is no pleasure in looking at those fine paintings in the midst of a crowded and noisy locality. (Richard Ford, SC, 1852–3: paragraph 7946)

These statements return us to Bourdieu's thoughts on artistic distinction, 'symbolic violence' (1977; 1984; 1990a) and the emergence of the 'pure gaze', which in its 'break with the ordinary attitude towards the world . . . is also a social separation' (Bourdieu, 1984: 4). But they also reveal residues of civic humanism in the discourses of nineteenth-century art and governance, with its distrust of the bodily and material. Indeed, born of a mix of national, patrician, public and educational ideals, the gallery's guardians would be preoccupied with issues of access, distinction and exclusion for years to come. For such was the project of the 'great arch' of bourgeois culture (Corrigan and Sayer, 1985) and the sediments of centuries laid therein.

Notes

1. Whilst the British Museum was incorporated in 1753, its origins lay with the cabinet of curiosities rather than the picture gallery: it remained a select space for the amateur gentleman, lacked state funds and contained no paintings beyond those that illuminated aspects of natural history or science (Saumarez-Smith, 1989; Mordaunt Crook, 1972).

2. I will refer to Select Committee Reports via the abbreviation SC throughout this chapter.

3. Brown (1995) notes, for instance, that in 1643 a committee of the House of Commons, under Puritan influence, confiscated the contents of the Queen's chapel in Somerset House and chucked an altarpiece by Rubens into the Thames.

4. When Waagen, director of the royal gallery in Berlin, visited Holkham in 1835, he described the statue gallery as of 'fine proportions, and with its rare and beautiful contents has a truly noble effect' (Waagen, 1854: 414).

5. Country house pictures were seldom as individuated as they appear today. As well as the more 'cluttered', aristocratic hang, the walls of English country houses were covered in fine textiles, fancy tassels, bows and decorative ornamentation that reinforced the overall splendour (Clifford, 1987).

6. The difficulties of gaining access to country houses were partly practical (transportation, obtaining appointments, getting on the right side of the domestic servant), but also intentional. Owners often prescribed the need for correct dress and asked for a fee or else only invited 'persons of the first rank, to first rate connoisseurs and first rate artists' (the Earl of Stafford, 1806, cited in Pears, 1988: 178).

7. In other words, Bourdieu's description of the 'prismatic effect' of (cultural) fields points up the importance of recognising the complex process of mediation that must be central to any analysis of culture (see Bourdieu, 1993).

8. Caught between aristocratic prescripts and more common sympathies, an expanding commercial elite made its presence particularly felt in English provincial cities like Birmingham, Manchester and Liverpool. 'Not content to imitate the aristocracy', writes Macleod, 'these energetic businessmen recast the cultural system in their own image in an attempt to create a stable social category for their class' (Macleod, 1996: 2). In this respect they helped to shape the contours of many of the constituent elements of the cultural field: museums, libraries, art magazines, public exhibitions, art schools, commercial galleries, and so on. Defence of the ameliorative effects of middle-class patronage was guaranteed by the *Art Union*, a contemporary art journal which encouraged the collecting of British works fresh off the easel. As Steegman (1987) notes, however, collecting old masters in the style of the eighteenth-century *cognoscenti* was still held to be a more noble practice of acquisition, and the new collectors of contemporary British art were often stigmatised as uncultured *arrivistes*.

9. The strength of the Academy was a decisive factor in the way the art field developed in Britain. Subject to the most virulent complaints of reformers and centre of all the most dramatic cultural altercations of the century, the Academy still managed to retain hegemonic status as champion of 'pure art' and host to the most talked about exhibitions in the capital. Its collective ideological struggle to define the 'artist-as-creator' concentrated trends towards artistic autonomy that suggested a final rupture with heteronomous relations of patronage (Fyfe, 1986, 2000; Bourdieu, 1993). Its power and resilience, in this respect, rested with its unique fusion of aristocratic power, royal assent and the guarded acceptance of a public market.

10. Dr Waagen remarks in his *Treasures of Art in Great Britain* that England had become a favourite destination for such pictures. The turmoil of the revolution 'brought an immense number of works of art into the market, which had for centuries adorned the altars of the churches as inviolably sacred, or ornamented the palaces of the great, as memorials of ancient wealth and splendour. Of these works of art England has found means to obtain the greater number and the best. For no sooner was a country overrun by the French than Englishmen skilled in the arts were to hand with their guineas' (1854: 21).

11. As chairman of the 1836 Select Committee, William Ewart was the most vocal and visible of these three. Son of a Liverpool merchant, Ewart was educated at Eton and Christ Church and entered Parliament in 1828 as Whig MP for Bletchingly, Surrey. By the early 1830s he was MP for Liverpool and had become a strong voice in favour of commerce, the

abolition of capital punishment and the opening of public museums and galleries to the public free of charge (*Dictionary of National Biography*).

12. This split is evident, for instance, in the structure of art education in Britain. Whilst the state leaves the Royal Academy a degree of control over fine art, a 'second level' system of education is set up in response to the requirements of industrial capitalism – to produce design cognisant technicians and raise public taste. State sponsored schools of design were set up from the 1830s on the back of proposals of the 1836 Select Committee; these were, in turn, taken over in the 1840s by Henry Cole, co-organiser of the Great Exhibition, who embraced a more general notion of public art education (Pearson, 1982).

13. Grandiose statements connecting fine art with improvements in morals and manufacturing in the 1836 Select Committee were often, therefore, aimed at hauling in an unaccountable aristocracy in favour of more expansive notions of modern nationhood, rather than realistic depictions of a state of affairs where fine art had become (or was to become) handmaiden to commerce.

14. This was a critique that echoed long into the 1840s and 1850s in newspapers and journals. 'How much longer', asked 'Verax' (the pseudonym of the artist Morris Moore) in a letter to *The Times*, 'are idle *dilettanti* to be our caterers of art? Let us not be told that many of these personages are distinguished for energy and ability in other pursuits or professions; their being so offers a strong presumption of their insufficiency' (Verax, 1847: 19). In an 1853 letter to Prince Albert, William Dyce continued the attack, arguing that no advances had been made to organise the collection according to an historical arrangement despite many new purchases and bequests. The trustees must be more discerning and competent in their selections, Dyce declared, 'rather than taking anything that comes on the market, bought through dealers and auctions' (Dyce, 1853: 8). Again, the implication was clear: knowledge trumps ownership in matters of fine art.

15. The cartoon depicts a lowly public, invited magnanimously into the space of purity, but so dislocated, shocked and preoccupied with survival as to be unwilling participants in the encounter with art. The accompanying text reveals the irony: 'There are many silly, dissatisfied people in this country, who are continually urging upon Ministers the propriety of considering the wants of the pauper population, under the impression that it is as laudable to feed men as to shelter horses . . . We conceive that Ministers have adopted the very best means to silence this unwarrantable outcry. They have considerately determined that as they cannot afford to give hungry nakedness the substance which it covets, at least it shall have the shadow. The poor asked for bread, and the philanthropy of the State accords – an exhibition' (*Punch*, vol. 5, July 1843: 23).

16. This is the logic identified by Stallybrass and White by which the erection of symbolic boundaries between high and low – the 'demarcating imperative' (1986: 191) – is constitutive of the bourgeois subject and sites of dominant culture. In this sense, the dissonance of dirt and the cultural negation of the low were key factors in structuring the National Gallery itself as well as the identity of the professional bourgeoisie who managed the space. The low may have been denied but its imaginary power was implicit in the sense-making of refined social groups: the need to mark itself by what it was not.

Part II

Art, Society and the Birth of the National Gallery of Scotland

Stirrings of the Modern: Art, Civil Society and the Scottish Enlightenment

At this point I want to effect a subtle change in the tempo and detail of the argument in order to focus on a particular case study – that of Scotland. Not, perhaps, the most visible or alluring of cases to choose: its national gallery, founded in 1851, did not ascend in spasms of revolutionary fervour; nor was it the glorious monument of a centralised state with an ideological script and patterns of individual conduct to marshall. The developmental trajectory of exhibitionary cultures in Scotland was, instead, relatively distinct and convoluted. Like Scotland itself, a *nation sans état*, the National Gallery of Scotland oscillated between socio-political dependence and cultural autonomy. And yet this is precisely what makes the Scottish case so fascinating – its location between local conditions of cultural production (as informed by the Reformation, the Scottish Enlightenment and Romanticism) and wider trends towards modern nation-building and bourgeois society. Focusing on Scotland, in other words, adds purchase to understanding the development of national art galleries because of its unique historical configuration. It is, indeed, often only by reflecting on the 'marginal' or 'difficult' cases that we are able to fully understand the nature of the core phenomenon.

The next three chapters will be taken up with a substantive analysis of the relationship between refined visual culture and social change in Scotland. The task is to construct a sociological account of the rise of modern structures of artistic production in Scotland's capital. How did a fine-art field, with a fully developed national art gallery, emerge in Edinburgh? What role did the gallery play in articulating or refracting the world-view of the nation's cultural leaders? And what does this say about the relationship between Scotland's social structure and its visual arts?

The investigation begins, in this chapter, with some historical background material on early modern Scotland and the cultural catalyst that was the Scottish Enlightenment. Chapters 5 and 6 will portray a more detailed socio-genesis of the cultural field in the early nineteenth century and the rise of the National Gallery

of Scotland as a space of professional autonomy and cultural distinction. Here, a different chronological profile, historical base and set of social conditions identifies a model of institutional development that, though not radically divergent from the English case, does still point to important local differences. So, if England's journey to a mature fine-art field was idiosyncratic and contrasted somewhat to continental Europe, the case of Scotland is slightly removed again. This should not be surprising since Scotland survived the Union of 1707 as a separate 'civil society' and as a nation.

The Early Modern Context I: 1540–1707

Before the advent of modernity, however, as continental Europe enjoyed the visual fruits yielded by absolute monarchical power, and England slowly worked out the relations between official power, patronage and the market, Scotland was well-nigh paralysed by the spasms of conflict which belonged to an older system of social disorder.

For most of the sixteenth and seventeenth centuries Scotland was a poverty-stricken, factioned and feudal kingdom blighted by famine and political turmoil. As a result, before the mid-eighteenth century Scotland did not possess much in the way of talented indigenous artists, centralised units of patronage, or arenas where art could be used as a form of conspicuous representation. More so than England, a unified court of regal display did not materialise in Scotland as the early manifestation and proto-model of high cultural display. And for a long time nothing resembling the princely gallery or centralised art patronage existed in Scotland.

The problem of artistic development lay with Scotland's turbulent early modern history, implanted by 1540. On the basis of resistance to papal supremacy, Reformation figures like Knox and Melville encouraged iconoclasm – the removal of objects of idolatry to religious figures – which, in effect, purged Scotland of many of its medieval Catholic decorative schemes and sculpture.[1] The 'word', in the form of the Old Testament, had begun to replace the 'image' as the Catholic imagination had employed it, as Scotland declared its independence from Rome and dissolved its links with France. General neglect of Scotland's cathedrals, abbeys and monasteries was clearly an important factor in the ruination of its visual heritage. But the pro-active destruction of cultural objects was another matter, and the old Catholic church crumbled under the force of a movement which found papacy and its accoutrements to be tyrannical and therefore intolerable.

Moreover, at a time when the working out of the balance between old feudal regalities and a more modern state structure of laws and taxation characterised the actions of European polities, Scotland was held back by social and political

dislocation. Unlike its English counterpart, the Scottish parliament was not a powerful institution. The poorly financed monarchy found it difficult to retain control against the feudal power base of the aristocracy which, during the sixteenth century, dominated the Privy Council, the unicameral parliament and conventions. None of the administrative bodies seemed capable of presiding definitively over political affairs, for the blurred institutional edges of the Scottish polity, in which the church and the state remained for long periods at loggerheads, fragmented any movement towards centralised or absolutist mechanisms of power.

Unsurprisingly, visual culture was unable to take root in the capital in a way that would provide a rich tradition for future generations. For a long while, Edinburgh's craftsmen were drawn from the Low Countries and were relatively limited in visual output. Without the attraction of a lucrative court or centralised patronage, few artists of quality ventured north.[2] Native work tended to arise out of commissions for heraldic walls or ceilings. Some ceremonial and armorial work, for instance, is in evidence in a few houses and castles in the north-east, where the nobility commissioned coats of arms and banners for their dwellings as visual documents of historical legitimation (Holloway, 1989). However, in the early

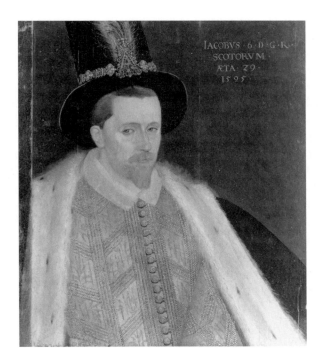

Figure 4.1 Adrian van Son, *James VI and I*, 1595, Scottish National Portrait Gallery.

modern period portraitists were Netherlandish men such as van Son and Bronckhorst. The former was the leading painter at court until 1601, but his output was limited and he was frequently left unpaid (Thompson, 1975).

Things only scarcely improved in the seventeenth century. Scotland was never likely to produce ornate buildings, forms of courtly display or grand manner paintings. Its Protestantism shaped culture into more austere forms with an emphasis on private or domestic restraint rather than public display. Some architectural schemes and paintings of the late seventeenth and early eighteenth centuries give a vague sense of continental influence. But the social, economic and political situation was way too unsettled for a court style to grow. In its place, a more fragmented and circumspect culture emerged from the chaos of Caroline society, only rarely showing evidence of consistent patronage and visual display.

It was certainly becoming easier for the richer Scottish families like the Clerks of Penicuik to obtain old masters and contemporary foreign works, and auctions provided a useful outlet. Smout (1992), for instance, provides evidence of paintings sent from Holland by Andrew Russell, a Scottish merchant based in Rotterdam, between 1669 and 1691. And by the end of the century, there were Rembrandts in Holyrood Palace, Dutch landscapes in Hopetoun House, and an abundance of similar pictures at Prestonfield. Indeed, that Scotland and the Netherlands shared a similar set of social, religious and political conditions made the interchange of goods, labour and ideas particularly smooth. Like the Stewart 'court', the House of Orange was by no means an extravagant court of Baroque splendour; both nations were suffused with strong forms of Calvinism; and, like the Dutch Republic, Scotland's burgher classes were beginning to show signs of economic and urban vitality, looking beyond the domestic market to Europe for trade in order to satisfy Protestant virtues of hard work and commercial gain (Smout, 1969).

In contrast to the Dutch Republic, however, Scotland did not experience a take-off in cultural and intellectual life in the seventeenth century. It could borrow from other successful nations but could offer very little in return. For this was a century of constant upheaval, in-fighting, political fragmentation and economic uncertainty. The Union of the Crowns of 1603 had removed James VI and his court from Edinburgh, leaving in its wake an obfuscated system of rule, reliant more on the principles of feudal rivalry and the ideas of the Protestant church than on kingship and central power. James prided himself on his ability to rule Scotland from afar, with the 'pen' rather than the 'sword'. To this end, the Privy Council had nominal authority in matters of governance and for a time peace and stability broke out in Jacobean Scotland. However, the absent court left a big hole as far as patronage of cultural activity was concerned. Hence, while James and his son, King Charles I, commissioned Rubens and Van Dyck at Whitehall, in Edinburgh there was no longer the spectacle of courtly life to draw other foreign artists north (Lynch, 1991).

At the level of royal and political authority, what was a nebulous system of rule in Britain was more de-centralised in Scotland. Since the principal source of authority lay four hundred miles south (a journey that the King only managed once, in 1617), the way was left open for a variety of political and religious interests to battle for power and to resist the imposition of James's innovatory mechanisms of government. Scotland's parliament remained ineffectual and symbolically impotent, its jurisdiction constantly undermined by the counter-vailing forces of religion, class and feudal loyalty.

The situation inherited by Charles I in 1625 was, therefore, one in which a desire for British unity could remain only a vague dream. The reality was that the kingdom of the north had begun to resent the insensitivity of a king who willed a single British church without recognising Scotland's own religious idiosyncrasies. In particular, Charles I's inauguration of a new liturgy, a new prayer book, the retainment of church grants and the movement of bishops into key positions of authority sparked a counter-attack in the form of the National Covenant, a document that recovered the most concentrated aspects of the Reformation and turned them into a political force of some weight.[3]

Always more puritan in its brand of Protestantism than the Dutch Republic, seventeenth-century Scotland was imagined to be a realm of godly discipline, its citizens implored to embrace strict bodily deportment and personal piety. But, as Smout (1969) remarks, whilst Dutch momentum to financial growth and economic individualism grew from its brand of Calvinism, in Scotland the medieval ties of old society had remained a residual brake on economic expansion in the burghs. The strong links between individual behaviour and economic wealth, in other words, were less marked in Scottish Protestantism. In fact, regardless of religious hamstrings, Scotland's factional and increasingly unstable socio-political order remained a major obstacle to economic and cultural advancement for most of the seventeenth century. Whilst Edinburgh underwent a mini-Renaissance in the 1680s under the guidance of Charles II's brother, James, Duke of York, such tranquillity and cultural advancement did not last for long.[4] As the Duke of York became James II of England (VII of Scotland) in 1685, leaving Edinburgh for London, the way was again left open for political and religious turmoil. Eventually, James's aggressive Roman Catholic policies were ignored by the Scottish parliament, resulting in their imposition by royal prerogative. Not long after James had introduced a Catholic printing press at Holyrood, and concern had grown over the religious education of James's newly born son, support for the revolution of the House of Orange, a product of parliamentary power south of the border, was secure in Scotland.

William, however, never visited Edinburgh during his reign and was never crowned in Scotland, favouring James VI's method of ruling from afar. The Scottish parliament still convened but only with the assent and control of the king

and London. As Jacobite insurgence in Glencoe was put down by crown and parliament in the 1690s, it became apparent that politics in Williamite Scotland was still a product of local loyalties and historical vendettas rather than modern national-state administration.

The drift to Union in 1707 reflected parliament's desire for peace but also Scotland's need for commercial stability and a share in colonial wealth. Worked out by politicians on both sides in 1706, Union appeared to safeguard Scottish commercial interests and national independence in education, law and religion. The removal of parliament, however, also removed the grand nobility and their powers of patronage. Patrimonial absence after the Union was, hence, a further setback to visual cultural production, thickening the scars of seventeenth-century upheaval, conflict and fragmentation.[5] In fact the social fabric of Scotland had worn so thin by the early eighteenth century that most of the elite's vital energies could never have been given over to patronage in the grand style, even if the resources were available. In comparison to London, the cumulative de-centralis-ation of Edinburgh's seats of power was a process that did untold damage to coherent forms of visual ostentation and artistic support. As spectacular structures of visual display flourished in countries with centralised sites of power, absolute monarchs and princely galleries, Edinburgh would always lag behind.

Precisely because of western European shifts towards the modern, however, the potency of absolutism and its princely forms of exhibition became slowly diluted, to be replaced by national, constitutional arrangements deriving from the impulses of civil society. And in certain respects Edinburgh was better placed to enjoy the fruits of these modern arrangements, to 'catch up' with artistic fields elsewhere. This all pointed to a brighter century to come as political and economic instability in Scotland gradually gave way to calmer waters where the vessels of cultural achievement could float with greater confidence.

The Early Modern Context II: 1707–60

Before the achievements of the Enlightenment, however, there was still a period of adjustment to the new world that Union had brought. For several decades poverty, instability and upheaval continued to characterise the social, political and cultural life of Edinburgh. Areas such as the Canongate fell into disrepair with the loss of the greater nobility; the threat of Jacobite unrest was felt acutely with the uprisings of 1715 and 1745; and economic depression continued to dog Scottish society as market competition with continental Europe and Ireland exposed Scot-land to the perils of free trade, leading to the virtual collapse of its linen industry.

Only after these upheavals had subsided did the leaders of Scottish society, the minor nobility, gentry and professionals, gather themselves to mobilise institutions

and organisations in Edinburgh in order to rejuvenate economy and society. One institution that gave expression to the modernising urge was the Board of Trustees for the Manufacture of Agriculture and Fisheries, founded in 1727. The Board comprised of lesser nobility and substantial gentry and was established by central government to administer a £2,000 per annum grant to Scotland's developing industries. This was a political concession to Scotland to offset losses from customs, taxes and excises appropriated by the English government, which helped to secure peace and stability north of the border. The Board earmarked funds for three areas – herring fisheries, linen and hemp manufacture, and coarse wool – but during the course of the century became engaged in the promotion of commercial design and, later, the development of national art institutions in Edinburgh (NG 1/1/35–44).

Like the Honourable Society for the Improvement of Knowledge in Agriculture, the Board of Trustees exercised a fair degree of control over its own interests. It may have been funded from government, but the Board's detailed business was run locally by Scottish landed improvers. It was able to do this because the state of Scotland's system of political rule after the Union allowed it. Far from being ruled with an iron fist from London, Scotland retained a great deal of autonomy in matters of national governance. Political management resided in a system of relatively autonomous institutions in Edinburgh that set the pace of social change. Economic and agricultural reform, for instance, was often implemented not by British central government, but by pro-active landlords and merchants (Paterson, 1994). The governmental affairs of Scotland were rarely heard in the London parliament, and this also goes for art matters, as I will intimate later. What was in place by the mid-eighteenth century was a framework of 'benign neglect' (Paterson, 1994) that allowed a civil society of enterprising leaders and *literati* to emerge in the capital and to shape the urban infrastructure. This was important precisely because it enabled the ideas of enlightened thinkers to flourish and crystallise into non-governmental institutions and activities in Scottish society.

Accordingly, signs of a more complex field of cultural activity were evident by the early decades of the eighteenth century with the rise of small societies that met to discuss and encourage a range of intellectual, cultural and economic activities. Many of these were short-lived and unimpressive in membership, but they were formal in structure and drew their cohort from Edinburgh's elite: gentlemen, professionals, lawyers, doctors, artisans and ministers (Phillipson, 1975).

Allan Ramsay, father to the enlightened portraitist of the same name, was one such figure. A poet in the bucolic idiom, Ramsay helped to organise various clubs in the capital as well as opening a theatre, a lending library and a bookshop which sold engravings of well-known pictures and views. In doing so, Ramsay helped to supplement Edinburgh's lack of official patronage after the Union. As a poet, Ramsay wrote *The Gentle Shepherd* in 1725, establishing the idiom of 'national

pastoral' in Scotland. This provided subject matter for artists, vernacular poets and novelists alike and his influence on Burns, MacPherson and Scott is noteworthy (Pittock, 1991; Noble, 1982). As an organiser and would-be patron, he was also a prime mover in setting up Edinburgh's first academy of painting and drawing, St Luke's Academy, in 1729.

St Luke's was Scotland's first 'art' institution, an academy of art that reflected the aspirations of some of Edinburgh's patrons and professionals to raise the status of art in the capital above that of its past. Setting up an academy, in other words, represented the striving for professional recognition that had hitherto evaded visual culture, with its close connections to a pre-modern system of craft. Modelled on academies elsewhere (Sir Godfrey Kneller's in London and the *Academia* of San Luca in Rome), the academy took residence in rooms at the Edinburgh college at the invitation of the city council (Cummings, 1994). Its prescribed aim was 'the encouragement of these excellent arts of Painting, Sculpture, Architecture, etc., and Improvement of the students' (Holloway, 1989: 105), whose training involved copying originals, engravings, casts, medals and drawings. In spite of the relatively short lifespan of the academy – it disbanded after two or three years – its key figures went on to practise in more advantageous artistic conditions in the latter half of the eighteenth century. Its relative failure perhaps spoke of the gap that existed at this time between the wishes of cultural leaders and the actual civic infrastructure that could support them: that is, between the ideas of emergent professionals and the relative immaturity of the field.

As it happened, artistic conditions had changed quite markedly from the seventeenth century. From 1707 to 1750, some civic leaders such as George Drummond, the Lord Provost, exercised the power of patronage in chosen cultural ventures – Palladian architecture and university education as well as portraiture. Edinburgh was beginning to play host to more auctions, with pictures and engravings circulating at a faster rate, many of them bought on the continent, Rome especially. For Scottish aristocrats on their Grand Tours there were ample opportunities to procure art works for interested friends and relatives back home. The travel diaries of John Hope, Second Earl of Hopetoun, for instance, describe a five-year Grand Tour of the Low Countries, France and Italy, undertaken between 1722 and 1727 (Hopetoun Research Group Studies, 1987). Hope travelled with his tutor, William Dundas, and visited picture galleries, palaces and chapels in Antwerp, Düsseldorf, Florence, Milan and Paris. While abroad, Hope was urged by his uncle, Lord Annandale, to make contacts befitting the status of the young aristocrat. Lord Annandale's most urgent request, however, was for the procurement of pictures – 'his commissions' as he termed them. Annandale was a collector of art objects, and his request of knowledge for the French fashion in arranging pictures is testament to the desire for such aristocratic 'men of taste' to emulate continental trends in Scotland by the 1730s. This was particularly relevant in the

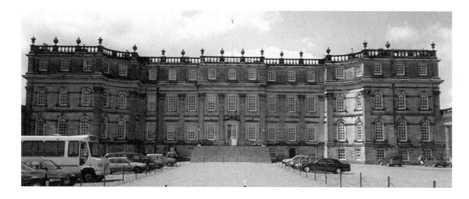

Figure 4.2 Hopetoun House entrance front, photo: author.

light of the redecoration of Hopetoun House under William Adam and James Norie. Pictures were duly sent back by Lord Hope from Holland, to end up in one of the most lavish country houses in Scotland.

Hopetoun House is situated just north of Edinburgh, overlooking the Firth of Forth, and gives us an idea of aristocratic methods of visual display at this time. The house was originally built by the architect William Bruce in the late seventeenth and early eighteenth centuries, for the First Earl of Hopetoun. The decision to enlarge Hopetoun in the 1720s reflects changes in the political context of Scotland and the status of the Hope family itself. The Hanoverian Charles Hope was raised to the peerage as Earl of Hopetoun in 1703 in the wake of the Glorious Revolution; and, as with the logic of conspicuous consumption on the continent, the building had to reflect the relative position of the owner. The previous building, in other words, could not sufficiently index the power and prestige of an earl. So Hopetoun was enlarged by Scotland's 'universal architect', William Adam, not in the style of chaste Palladianism, but in the heroic manner of English Baroque design, with a giant order of fluted Corinthian pilasters and an ornate facade (Rowan, 1984). As Gow indicates, the key characteristic of Adam's houses 'lay in their state apartments and, although they followed the mould established by Bruce for Holyrood, Adam brought to them a new emphasis on magnificence' (Gow, 1990: 94). The procurement of pictures, many of which belonged to Lord Annandale, was a significant means of raising the interior effect of Hopetoun's rooms to such splendid heights.

Throughout the house, for instance, can be found evidence of the work of James Norie, the landscape decorator and painter, who worked closely with William Adam's son, Robert, in many of the country scheme decorative cycles in Scotland. Such visual adornment formed part of the overall function of any room, adding to the whole ambience or decorative effect of the house. The Great Dining Room,

for example, was painted by Norie at various times from the 1730s to the 1750s, the last in four coats of 'fine white', while the front stairs were decorated with gilded wall paintings, family crests and pastoral pieces commissioned from the Dutchman Philip Tideman.[6] Clearly, landed patrons still held the key to the status of visual display, and, as their position in the social system was consolidated, they emulated stately arrangements found south of the border and on the continent.

To an extent, this country-house culture dissolved, or least diluted, the energy needed to stimulate a modern urban field in the capital. The patronal attachments between aristocrat and artist guaranteed the utter dependence of the latter on the former at a time when elsewhere artists were beginning to break free of such ties. Something akin to an art market was starting to take shape in the capital by the middle of the eighteenth century. But collections of pictures were sold not according to the artist, but to the suitability of a piece for a particular location: 'A fine collection of pictures, some fit for halls, staircases, chambers and closets', 'A large landscape for a staircase, A landscape for a doorpiece, A landscape for a Chimney-piece' (cited in Holloway, 1990, 65). A more traditional system of craft, design and guild-based apprenticeship, therefore, remained dominant throughout Scotland until the late eighteenth century.

Edinburgh itself was a provincial city that, like Dublin, Bordeaux, Lyons and Lausanne, played host to an increasing number of organisations, but lacked the institutional complexity of a metropolis (Emerson, 1973a). In casting envious glances elsewhere, small groups and individual artists may have hoped to forge the institutional tools of a modern field, but the whole system of patronage was bigger than individual aspirations. And this system was still shot through with several centuries worth of socio-political agitation and cultural dislocation.[7] In the early eighteenth century many of Scotland's most prolific artists were still unable to live and practice in their native cities. William Aikman, for a time Scotland's grand portraitist, was forced to follow his grand clients south after the Union for lack of institutional and patronal support in Edinburgh. Aikman's colleague John Smibert (1688-1751) was driven to America to seek a more sustaining system of patronage; and the portraitist Allan Ramsay left Edinburgh in 1733 to train in London and Italy, only later to return to Scotland's capital. Clearly, it was going to take a while for artists and patrons to develop relatively autonomous institutions of artistic support. For now, Edinburgh was more often than not the early training ground for artists who would eventually emigrate.

Still, the signs were promising. An emerging middle-class urban public was in a more favourable position to purchase artistic objects, as Union slowly delivered a more stable and prosperous society. Religious forces against cultural expression were lessening, allowing theatre, dance and music to take place in the city. And the dominant constituency of Scottish society, the aristocracy and lesser gentry, were beginning to let themselves be influenced by modern, urban fashions that

the *literati* in Edinburgh were promoting with great articulacy. So, by the latter half of the century, modernity across many institutions and discourses emerged in more concentrated fashion. What provided the bedrock for this institutional modernity was the constitution of civil society.

Art, Enlightenment and Civil Society in Edinburgh, 1760–1800

It is, of course, impossible to do justice to the vastness, richness and complexity of the Scottish Enlightenment in one short section. Capturing facets of a national *mentalité* requires a large dedicated study itself, not a diminutive chapter. It is equally one-sided to concentrate on the fine arts at the expense of science, agriculture, moral philosophy or law. However, in order to locate the eighteenth century in relation to artistic advancement and models of socio-cultural develop- ment already mentioned, such shortcuts will be necessary.[8] My questions will be these: what shape did civil society take from the mid-eighteenth century and how did this impact on Edinburgh's art field? Who were the new patrons? Why, what and who did they patronise? What function did the critic and aesthetics have on the field and to what extent did spaces of high culture emerge to contain, display or market fine art objects?

In order to place this part of Scotland's socio-cultural history in relation to the models of artistic formation already assembled, it would be necessary to say that: 1) this was a period of intense development in artistic production; 2) Edinburgh's structures of cultural production and distribution appear to converge to a certain extent with those of England, and perhaps continental Europe; 3) this was in no small part thanks to the constellation of forces, discourses and institutions that have been called 'civil society'; 4) and yet there were certain important dynamics missing in the cultural field which meant Scotland still lacked nationally sponsored spaces for exhibition by the late eighteenth century; 5) therefore, as far as art galleries are concerned, this period can be seen as an important buffer zone between the artistic poverty of the seventeenth century and the fruition of the early nineteenth century. It is a period of cultural intensity that promotes and builds many things, but a national gallery is not one of them.

The Scottish Enlightenment was an intellectual outpouring of modern ideas, practices and values based on modern 'rational' precepts that swept away many of the older traditions of a feudal, religious and rural universe. It was a period of intense development founded on a bedrock of ideas regarding improvement, education, understanding and toleration that spread beyond Scotland and England into the very heart of European modernity. Links between the Netherlands, Scotland and France made the flow of ideas between these nations particularly smooth (Chitnis, 1976). In the latter two cases, and particularly in Edinburgh, the

most pro-active social agency was the same, the professional middle classes – lawyers, doctors, and university professors – who, with the powerful backing of landed society, transformed civic and national institutions under the maxim of 'improvement'.

The general flowering of a middle and upper middle-class culture goes to the heart of what was so striking about this period in Scottish history. Lowland civic centres played host to an explosion of 'refined' culture that metamorphosed the overall shape and function of the cities themselves. For this was the period in which a developing middle class fostered its 'revolution of manners' by promoting and appropriating certain distinct cultural expressions considered to be 'civilised' and 'polite'. High culture, here, grew as a relatively distinct well of forms, values and behaviours from which the intelligentsia (or *literati*), hand in hand with landed society, quaffed freely. With the added advantages of a more tolerant religious edifice, political stability and institutional support, the 'golden age of Scottish culture' nurtured classical architecture, a self-conscious body of literature and letters, clubs like the Select Society, modern portraiture, magazines, journals, projects like the *Encyclopedia Britannica* and a whole host of other innovative forms (McElroy, 1969; Dwyer, 1987; Rendall, 1978; Johnson, 1972; Emerson, 1973b; Chitnis, 1976). In short, an increasingly sophisticated cultural field, with related personnel and discourses, could develop and do battle with the ties that previously bound it to religion or the narrow interests of landed society.

All this happened within a rapidly growing urban society that compacted into half a century what other countries had taken centuries to achieve (Mitchison, 1970).[9] By the 1780s, Scotland was less the satellite economy that it had been a century before. Increasingly, capital investment took place locally, producing a wider range of manufacturing goods for export from the central belt. Scottish industrialists began to pioneer the modern techniques of production essential to the industrial revolution (Devine, 1990). And Scotland's political and administrative complex was increasingly stable in the latter half of the century, feeding off and into the fertile environment of an intellectually rendered civil society.

Culture and Civil Society in Edinburgh

As noted, Scotland possessed a fair amount of political autonomy in the eighteenth century and many of the initiatives for legislation arose from within Scotland itself (Paterson, 1994). In contrast to Ireland, whose manager was a British agent of central government, Scotland was ruled by what Fry (1987) has called 'native Scottish surrogates'. Distinctive Scottish organisations like the previously mentioned Board of Trustees for the Manufacture of Agriculture and Fisheries in Scotland may have originated in British edicts, but were nonetheless comprised of local Scottish personages with a commitment to local affairs. Such organisations

carried the ideational baggage of the Enlightenment, dwelling on the nature of 'rich' and 'poor' countries in order to shape Scotland's political economy in line with that of its southern neighbour (Hont, 1983).

What gave socio-political efficacy to such enlightened organisations was their compact, unified and consensus-based nature. For now, Scotland's intelligentsia was bound firmly to sources of aristocratic power, giving it unusual weight in the spheres of politics and civil society. Long established connections between the legal profession and the old landed orders, for example, were particularly strong – to such an extent that it was often difficult to distinguish between the two groups. What Phillipson calls the 'rump of a once homogenous and highly motivated governing class' (1973: 130) melded with elements of learned and literary culture in a system of mutual support that shaped Edinburgh's institutions, ideas and cultural products. It was this social cohesion that made the Enlightenment in Edinburgh a collective and clubbable movement, with a rich patronage system and receptive audience. The fact that the ideas of Adam Smith and David Hume could so easily be operationalised in the sphere of commerce reveals the strong currency between intellectuals and those with political and economic power.[10]

In place, then, was a self-governing system that Paterson (1994) likens to Poggi's model of the legal state – a system co-ordinated around the formal interests of lawyers that emerged out of enlightened structures of rule. In Scotland, a space had been opened for key members of Scottish and English society – lawyers, landowners and *literati* – to move into positions of institutional power made all the more possible by residues of an independent church, law and education. These helped to foster the Enlightenment and smoothed the gradual transition to a Scottish civil society. A semi-autonomous space of national authority, in other words, emerged in the gap left by parliament, banishing the memories of Cromwellian imposition and encouraging the movement towards partnership that the Union always promised. The British state was pragmatically distant in this process – recruiting allies from afar but content after 1745 to leave matters of everyday government and institutional power to the local, modern elite. The local elite's most effective defence of this state of affairs was the theoretical armature of 'civil society' itself as it came to be articulated in the *literati*'s writings.

Scottish social theory undoubtedly changed the way societies looked at themselves (Berry, 1997). The emphasis upon the *social* as an explanatory source for questions of morality and history encouraged social and cultural leaders to investigate the principles upon which they themselves led those societies. In Scotland the need to explain the civil basis to government and authority was made especially urgent given both the exceptional position of these leaders in the system of rule and the rapidity of socio-economic development at large (Becker, 1994). As much a self-conscious rendering of the 'spirit of the age' as a description of the ground on which social development could take place, the concept of civil

society was therefore central to the modernisation of a range of institutions and forms, including high culture itself.

Adam Ferguson's *An Essay on Civil Society* of 1767 was one of the first texts in Europe to set out a definition of civil society in relation to citizenship and the state. Ferguson combined tenets of civic republicanism with a theory of social change that maligned the onset of specialisation and the complexification of labour. His concern centred on the perceived impact of commercial development on civil liberty, martial spirit and heroic sensibility. In the course of this Harringtonian-inspired attack, however, Ferguson conceptualised the very components of what he called 'civil society' in a way that proved essential to later analyses of the state and stadial theories of progress (Marx's debt to Ferguson is well known).

The model of civil society formulated by Ferguson entered the arena of political philosophy as an ethical vision of social life based not on a theory of cosmic order or despotic rule but on the sociality of men (Seligman, 1992). Ferguson appealed to the civic tradition in his defence of citizenship, virtue and the need for an organic militia in Scotland.[11] He stressed the progress of society from a state of rudeness to polished civilisation with respect to the social bonds that united individuals in an intense passion of solidarity. For Ferguson, these bonds were loosened as commerce, specialisation and the growth of professional armies chipped away at the primacy of sociability and the autonomous individual. The secondary (and 'effeminate') values of commerce were replacing the primary ('masculine') ones of sociability and virtue – the ideal of which Ferguson located in the city states of Greece, the actions of the Homeric warriors and even the clans of the Highlands (Pocock, 1975; Oz-Salzberger, 1995). At base, civil society conveyed the political community of men in a state of natural citizenship. Ferguson's contribution to this formulation was to give the whole concept of civil society an air of tension: something to be analysed and deliberated, but something under threat, something to be defended.

As the vision developed in Adam Smith's political economy, the ideal community of individuals was one based on 'natural affections and sociability' which, in turn, raised the tensions between self-interest and public good inherent in the civic tradition itself (Robertson, 1983; Pocock, 1983). Smith's more positive take on commercial modernity stressed the importance of private individuals acting independently of the state's control in their own market interests. Whilst reservation was made for the autonomous sphere of civil society in Smith, it was the spirit of commercial man rather than the impulses of orthodox civic republicanism that ensured it. In particular, members of the middling rank and the gentry were attributed the progressive role that guaranteed improvement, political pragmatism and public good. The survival of free society was placed in the hands of this commercially minded group, forming the 'impartial spectators' of the body politic and inhabiting the voluntary associations, clubs and organisations of the public

sphere. As Pocock (1983) indicates, the civic tradition had been replaced by the *civil* in Smith, the military by the commercial, all rooted in an acceptance of the individual through exchange and interaction.

Hume, equally, was more embracing of commercial liberty and economic progress, leaning against Ferguson's essay in order to elevate a vision of constitutional government that enabled individuals to pursue their self-interests. Hume's 'Idea of a Perfect Commonwealth' (1779) was one in which personal freedom was maintained by the individual's liberty from governmental power. Civil liberty was the opposite of absolute government in Hume's scheme. The latter was characterised by excessive violence, indocility and the decay of commerce, although Hume recognised (in the essay 'Of Civil Liberty') the link between monarchical absolutism and progress in the arts.

Hume's vision, like Smith's, owed more to the jurisprudential tradition of Grotius and Pufendorf than it did to the civic tradition as it was transposed into English thought (Pocock, 1983). This reduced the aspirations of the Scottish elite below that of the grand aristocracy and classical heroism. Emerging models of public liberty in Scotland were based less on the gallantry of the great aristocracy and more on the 'mutual deference or civility' of the well-educated middling ranks. As Becker (1994) suggests, lessons had been learnt from the previous century: the whole civil society tradition in Scotland was a reduction of the grand ideals of heroism, religious fanaticism and aristocratic grandeur. In its place were the 'minimalist' aspirations of civil society – an informal refinement based in the pursuit of self-interest, energised in the associations of the public sphere.[12] Civil society was the shared social space where a mutual exchange could be guaranteed between sensible individuals, in turn kindling the provincial apparatuses of governance. Unlike the previous century, this space was not fractured by civil war, poverty and religious fundamentalism.

For the likes of Hume and Smith, in contrast to the 'barbarians' of the past, with their indolent lifestyles, violent manners and loss of self-command, modern civilisation was refined precisely because of its encouragement of polished manners, taste and polite culture. Luxury was defended by Hume in essays such as 'Of Refinement in the Arts' (originally titled 'Of Luxury' in 1752) in opposition to the moralising discourses of orthodox civic humanism and in distinction to the excesses of aristocratic abundance. Hume's defence of 'innocent' and virtuous luxury, instead, linked private consumption to public benefits. Luxury was a by-word, in other words, for refinement in the 'gratification of the senses'; it fostered commerce and industry by increasing the pleasures and activities of human society. A new style of life was heavily implicated in this process of civility, expressing a greater responsiveness to taste in matters of music, furniture, decoration, speech, manners and art. The very townscape of New Town Edinburgh was a spatial manifestation of this movement, built for a polite mode of living to a

restrained, uniform, classical order by the likes of Robert and John Adam (Youngson, 1966).

Regardless of differences between them, then, the civil community formulated by the *literati* of the Scottish Enlightenment was a crucial root to the idea of the nation in eighteenth-century Scotland itself. Inasmuch as the self-organisation implied in the discourse of civil society structured the relationship between the British state and the actions of Scotland's elite, the emergent theories of a semi-autonomous realm of sociality justified the *literati*'s own position as leaders of the province. What the idea of civil society meant to the thinkers of the Scottish Enlightenment was a realm of solidarity held together by the force of moral sentiments and sympathies, that acted as a buffer between common subjects and centralised systems of power. The theory, as a result, concentrated the corporate identity of the intelligentsia itself and 'bred a strain of socialised dependence' (Becker, 1994: xix). What better way to underscore the centrality of the elite's position in Scotland than the articulation of a modern theory that sought to explain this very society? As an underlying set of discourses and ideas, civil society acted as a catalyst to the cultural sphere as a whole, promoting the establishment of modern practices, institutions and forms, some of which were fully matured, while others were to reach fruition early in the next century. It was intellectual urgency that promoted cultural fermentation, theoretical engagement that provided institutional development, civil community that secured local provincial govern-ance – all beyond the immediate control of the British state. This goes, also, for the fine arts.

Collecting, Engraving and the Rise of Academies in Scotland

The question of artistic development is one that must be posed in relation to the overall status of key elements that comprised the art world in the late eighteenth century. This period has been termed 'the golden age' by Duncan Macmillan (1986) and it is certainly a veritable gold-mine of artists, patrons, collectors and critics compared to earlier times. As one might expect, the period is riddled with multiple tendencies that connect the coming modernity with an older system of training and patronage. Increasingly, however, fine art in this period breaks with the ties of a pre-modern past and develops in a sphere increasingly bounded by the values of professionalism, civic virtue, distinction and refinement – the values of civil society.

One of the key ingredients in the movement towards a self-sufficient art world was the formation of larger and more varied collections in Scotland. The relative failure of epic, historical and grand manner pictures in Scotland tended to compress collections within a range that excluded the 'highest' branches of art as the hierarchy of genres had defined it. So, aspiring artists of the classical historical

style such as Gavin Hamilton had to leave Edinburgh for Rome to search for patronage (in this case from the Borghese family). However, collections of fine art in Scotland did start to reveal the elite's aspirations towards intellectual and artistic sophistication. Collecting also fed off the burgeoning network of associations between dealers, collectors and critics that formed between the Dutch Republic, Rome and Edinburgh. As a result, artists were provided with more extensive material from which to copy or study; and particular collections formed the basis to the foundation of art academies and, later, the National Gallery of Scotland itself.

The collection of the portraitist Allan Ramsay, for instance, was a valuable mix of drawings, prints and engravings of works culled from various trips to Italy in the mid-to late-eighteenth century. Additions were made steadily to the collection by Allan's son, John, who obtained a cluster of eighteenth-century French paintings by Watteau, Greuze, Lancret and Boucher. Another important Georgian collection, later to be bequeathed to the National Gallery, was the mix of pictures, marbles and bronzes of Sir James Erskine of Torrie. Sir William Erskine (1728–95) was the first member of the family to collect pictures and commissioned some modern works by David Allan, including a large conversation piece set in the grounds of the Torrie House, Fife. It was Sir William's son, Sir James Erskine, however, who was the driving force behind the formation of the Torrie collection in the late eighteenth and early nineteenth centuries. His collection comprised Dutch, Flemish and Italian pictures of a generalised style, including landscapes by Jacob Ruisdael, genre scenes by Teniers and smaller works by Italian artists such as Veronese, Rosa and Dughet (Thompson, 1972).

The penchant for Dutch genre and portraiture, a result of the religious, political and ideological affiliations between the two countries, clearly satisfied civil society's impulse towards the detailed, restrained and 'empirical'. Robert Alexander, an Edinburgh banker and patron, owned a considerable number of Dutch paintings including Rembrandt's *Judas Repentant, Returning the Pieces of Silver*. Dutch pictures were owned and housed in Scotland by the Dukes of Buccleuch and Queensberry. There were Rembrandts, Ruisdaels and Ostades at Dalkeith Palace and Drumlanrigh Castle; and arguably the greatest collection of seventeenth-century Dutch paintings in Britain was that of the Third Earl of Bute, Prime Minister between 1762 and 1763 (Williams, 1992b).

To say Dutch art was civil society's equivalent to grand manner is perhaps overstating the issue: collections also contained Flemish, Italian and French pictures. But it is interesting that pictures from the Netherlands formed the core to growing scholarly collections such as those of the universities of Glasgow and Edinburgh. Indeed, Scottish collectors tended to start off their collections with a Rembrandt, Cuyp or Hals, to 'set the tone' without overstating the effect, and critics lauded the naturalism, taste and controlled handling of the Dutch national

style. All of this made sense in relation to the Protestant anxieties surrounding superabundance and the affirmation of a civic identity that was socially beneficial, but restrictive. What is clear is that the activities and aspirations of Scotland's elite were crucial to the building of collections as units of artistic development into which the Dutch Republic of taste was woven. And although country-house collections remained within the private remit of the landed, and were often still displayed according to an older rationale derived from the logic of decoration or ceremony, their existence was a condition of possibility for national art institutions, academies and the later formation of the National Gallery.

At the more popular end of collecting, and as significant in the commercial-isation of art, was the increased popularity of engraving amongst the middle classes in Edinburgh. A system of mass production had been formed, with London at the centre, that circulated prints to the provinces (Solkin, 1992). Domestic print collections were common in Edinburgh and were distributed through second-hand sales and booksellers. Prints varied enormously, from famous British portraits, historical pictures and the work of Hogarth, to seascapes and copies of old masters. Independent engravers such as John Kay had established businesses in Scotland's capital by 1780s, providing the middle-rank market with portrait miniatures of well-known characters and scenes from everyday civic life (Nenadic, 1997). The Scottish portraitist Allan Ramsay, similarly, sold engravings of his works through his father's bookshop, many of which were advertised for sale in Edinburgh's newspapers.

As Nenadic (1997) notes, engravings had a variety of social uses for Edinburgh's middle classes. Once glazed and framed they were combined with a room's existing ornamentation and used as decorative 'furniture' prints. The dining room, in particular, was a locus of domestic sociality by mid-century and prints were a symbolic addition to the 'luxury' items that were assembled there. Engravings may have suggested particular political or religious affiliations. Portraits of Oliver Cromwell, Mary, Queen of Scots, and King Charles I, for instance, were quite common in Scottish houses. But, as Nenadic writes, 'the expansion and increasing sophistication of print production and supply mirrored a rising popular demand to see and to own works of art' (1997: 209). The spacious rooms of Edinburgh's New Town were perfect for such ownership and display. Yet, the consumption of prints was an increasingly 'privatised' act that fed off the trend towards bourgeois domesticity. It is possible, therefore, that the rise of collecting also diluted the impulse towards the public exhibition of pictures and militated against the formation of large spaces for exhibition as a whole in late eighteenth century Edinburgh. The retreat into the spaces of bourgeois domestic civility away from public display was, of course, one feature of the shift from medieval ceremony to modern civil society. What the building of the New Town, the movement into the drawing room and the collecting of aesthetic vignettes indicated was a 'withdrawal

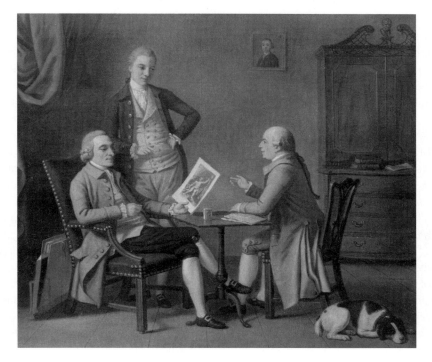

Figure 4.3 David Allan, *The Connoisseurs*, c.1770, National Gallery of Scotland.

from public space into exclusive balls [and] private repasts' (Becker, 1994: 63). At one level, then, public exhibitions may have been short-circuited by domestic collections. At another, however, the very emphasis attached to the fine arts as a realm of dinner conversation, judgement and connoisseurship was essential to their modern trajectory.[13] It is exactly the kind of arrangement suggested by David Allan's picture *The Connoisseurs*, for instance, where the educated protagonists, probably lawyers, deliberate over a classical print in the relaxed but austere space of a New Town drawing room.

Moreover, engraving was also a crucial stimulus to artists themselves, constituting the study material of some of Scotland's developing academies. Modern art fields at the very least required some places for artistic training, and the development of academies such as those in Paris and London was crucial both to the overall socialisation and support of artists and the centralisation of official art in the metropolis (Pointon and Binski, 1997; Bourdieu, 1993). In the eighteenth century, Scotland witnessed several attempts at founding an academy, only one of which, the Trustees' Academy, acquired any degree of permanence, and all of which were less centralised expressions of a 'state' or high tradition than those in existence on the continent and, to a lesser extent, England.

The short-lived Academy of St Luke's in Edinburgh has already been mentioned, but another attempt was made in Glasgow from the 1750s to the 1770s. The brothers Robert and Andrew Foulis were publishers and printers but also founded an academy in 1754 for the purpose of training and educating young artists. Painters such as David Allan were instructed in drawing and studies from the antique from a collection acquired in Holland and Paris by the brothers in the early 1750s (Miles, 1962; Thompson, 1972). This included Dutch works and French pictures in the classical style and engravings of well-known works in the Italian, Flemish and German schools. Once a year from 1761 until 1776 the Foulis collection was exhibited, out-of-doors, in the quadrangle of the Old College until the collection was sold.[14] Lack of support and public funds in the west eventually scuppered the project of the academy, and no more exhibitions were staged in Glasgow for more than a generation. But the academy's practical and commercial tempo was taken up by another academy, this time in Scotland's capital.

The Trustees' Academy was Scotland's first permanent art institution. It was also the first arts organisation in Britain to receive parliamentary support, in the form of the £2,000 annuity issued by its parent institution, the Board of Trustees.[15] Under the potent vision that the production of luxury goods was a worthy and beneficial activity, the Board established a drawing academy in 1760 for improvements in design for household goods, in order to make such objects of utility attractive for export and to satisfy demand for luxury goods in the wake of the building of the New Town (Nenadic, 1994). The practical dimension to the Trustees' Academy is significant here to the extent that it fed off tendencies in Scottish civil society towards commercial development and the cautious application of thought to matters practical. On the one hand, this was the affirmation of commercial civil society over classic civic humanism, or at least a combination of modern aristocratic notions of improvement with bourgeois aspirations towards industry. The design of domestic products was authorised in relation to enlightened principles of market competition, specialisation and the division of labour that were current in Smith's influential *Wealth of Nations*, for instance. On the other hand, the scaling down of heroic ambitions and the shunning of high expectation in civil society reduced the academy's remit to practical initiatives rather than to large-scale support for grand manner pictures of the type displayed at the Royal Academy. The first master of the academy, for instance, was the Frenchman William Delacour, an Edinburgh-based portraitist, decorative painter and designer of theatre sets, and the first pupils were mainly apprentice tradesmen – gilders, weavers, embroiders and housepainters.

Increasingly, however, the academy's remit widened to encompass aspects of fine art in distinction to that provided under the auspices of commercial design. Successive masters at the academy were proven artists in their own right as well as renowned teachers in design. Alexander Runciman and David Allan were

incumbents of the post in 1772 and 1786 respectively; and in 1798, the painter John Graham, as manager, introduced a painting class, using a collection of old master prints and casts from the antique. Indeed, it was under Graham's regime that artists such as David Wilkie, William Allan and John Watson Gordon learnt to draw and paint for a more open market. A duality of purpose was, therefore, inherent in the academy from the start; and whilst this fitted with the social mix of enlightened culture as a whole, the tension between a professional defence of art for art's sake and a more circumspect connection of art to commerce eventually fractured the academy (and the art field itself).

Portraiture: Ramsay to Raeburn

Scottish portraiture towards the end of the eighteenth century produced quite an impressive array of artistic forms, from pendants and medallions, through literary portraits, engraved portraits and animal portraiture. With landscape painting, portraiture was the most popular genre in Scotland. The expansion of the art market at the turn of the century inserted portraiture into a network of commerce that linked a thirst for individualising detail and the social need for personal ownership with an increasingly sophisticated system of production. And though Edinburgh did not challenge London as a centre of portraiture, the city played host to some of the most notable portraitists of the period – Allan Ramsay and Henry Raeburn in particular.

The relative autonomy of portraiture from the hierarchy of genres (its ambiguous status as reportage, for instance) assigned to it a sense of aesthetic ambiguity that Steiner describes as a 'general artistic problem' or 'overt conflict' between aesthetic quality and referential signification (quoted in Pointon, 1993: 8).[16] In late eighteenth-century Scotland, the presence of this ambiguity was for the moment less pressing because of the absence of a Royal Academy and high patronage. The practice of portraiture was, therefore, one that could flourish relatively unchecked, to expand into the space fostered by a growing demand for detailed representations of human subjects to themselves. Portraiture in Scotland was, in fact, validated by the emphasis on conviviality, empiricism and social enquiry that was at the heart of the Enlightenment and civil society itself.

Allan Ramsay's connections with the *literati* are well known (Emerson, 1973b; Smart, 1992, Macmillan, 1986). Ramsay rendered some of the best-known portraits of significant figures of the eighteenth century, including Rousseau and Hume, although the search for proper training and patronage forced the portraitist for long periods to Rome (1736–38) and to London (1733). Much of Ramsay's work in London was of a style and tempo that placed it alongside the grand, formal portraits of Reynolds and Kneller. He was, therefore, known as a portraitist of high society – politicians, nobles and royalty. Whilst using stock poses to paint the likes

of his grand Scottish patrons the Duke of Argyll and the Earl of Bute, Ramsay also painted in a more intimate and flexible style. This indicated a turn towards the preoccupations of the Enlightenment – benevolent good feeling, sociability, civility and rationality, in particular.

By the time Ramsay's rival, Reynolds, had returned from Italy in 1753 the Scot was compelled to seek patronage once again in Edinburgh. It was from this time that Ramsay became a founding member of the Select Society and contributed, with Hume, to the unfolding of the Enlightenment in Scotland's capital. Ramsay's *Dialogue on Taste*, for example, followed his *On Ridicule* as a speculative venture into aspects of theology, literary style and naturalism. Published in the 1750s, the tract pointed to truth and exactitude as qualities befitting 'the agreeable' in painting (Smart, 1992).

Pictures of the mid-1750s such as *Sir Hew Dalrymple, Lord Drunmore* depict the sitter in a natural state, as moderate, learned, eloquent and civil.[17] Membership of Scotland's civil elite was marked by a kind of personal immortalisation in portraiture and the emphasis on 'interior' qualities connoted by the setting, the clothes and the gestures secured this membership. It made no sense for the *literati*

Figure 4.4 Allan Ramsay, *Sir Hew Dalrymple, Lord Drunmore*, 1754, Scottish National
Portrait Gallery.

to be shown in full classical regalia, in the elevated manner of Reynolds, for instance, because this connoted a realm of high sentiments, Baroque idealism and aristocratic social association that civil society was attempting to transcend. The scaling down of heroic ambition that was current in civil society as a whole, therefore, translated into the irrelevancy in Edinburgh of *istoria* as the style to which portraiture should aspire, and perhaps literally into Ramsay's shift from full-lengths to half and three-quarter lengths.[18] Ramsay was perfectly suited to a more modest, informal, direct (and cheaper) style, the essence of which was Enlightenment empiricism and Hume's philosophy of mind – the separation of *impressions* and *ideas*, for instance.

There are few abstractions in the portraits of Ramsay's 'second style' in Edinburgh, only a directness based on observation and intimacy (Smart, 1992). Rarely did Ramsay paint anything that stretched beyond the perceived: he painted through the lens of rational anti-idealism that drew on contemporary French realism, Rembrandt's handling of light and shadow and Hume's stress on observation. In the same way that Hume's philosophy commenced with the impressions of knowledge or objects, so Ramsay's portraiture seemed to belong to the realm of sense data and to the experiential (Macmillan, 1984a, 1984b). Despite the less 'certain' and 'empirical' style of Ramsay's late pictures, his influence on the art field in Scotland was marked not just by his contribution to civil society but also by his influence on aspiring artists such as Henry Raeburn, David Martin and Alexander Nasmyth.

Indeed, it is to Raeburn that we must turn to understand the trajectory of portraiture and the art field in later eighteenth century Edinburgh. Raeburn was certainly the heir to the 'natural' style in portraiture which Ramsay had pioneered and was possibly the first Scottish artist to be lauded in Anglo-European circles despite working for most of his life in Edinburgh. Raeburn's output straddled the eighteenth and nineteenth centuries and his pictures reflected the mix of influences and styles associated with both. He formed an early awareness of Reynolds' formal portraiture, and had contact with the Royal Academy's leader during a brief period in London. But he was also drawn to the informal renderings of Ramsay's second style, and the 'matter-of-factness' of his work from the 1790s on suggests an understanding of second-generation Enlightenment philosophy. That Raeburn was able to sustain his portrait business in Edinburgh further indicates the movement towards professionalisation and modernity in the art field as a whole. In fact, by the early years of the next century it was Raeburn who helped build studios, found artistic organisations and develop modern systems of patronage in the interests of artistic autonomy in Scotland's capital.

The son of a manufacturer, Raeburn began his working life in 1772 as a goldsmith and engraver, but became a pupil of the Edinburgh portraitist David Martin and progressed from miniatures to oils, eventually supplanting Martin as

the city's chief portraitist.[19] Whilst portraits such as *Lord President Dundas* (1787) and *Dr Nathaniel Spens* (1791) indicate an acknowledgement of a grand style that flattered and idealised patrons, such a manner did not easily fit with the ideals of most of Raeburn's patrons, particularly members of the *literati*. Increasingly, the ideals of high English portraiture were replaced by adherence to exact details and informality in a style that was more naturalistic, but which still valorised the leadership of Scotland's elite. At the very least, Raeburn's contact with figures of the later Enlightenment – Thomas Reid in particular – would have lent support to his movement towards a restrained and empirical portraiture synchronous with Edinburgh's 'age of reason' as a whole. Indeed, that changes in Enlightenment philosophy were being incorporated into Raeburn's work is indicated by his gradual acceptance of the role of intuition as a basis to 'common-sense' perception and his movement away from the burden of representing the known rather than the perceived (Macmillan, 1986).

It is clear that Raeburn felt under-supported in Edinburgh and thought the city exiguous in its patronage. In reality, however, Raeburn, and other portraitists such as George Watson (1767–1837) and Archibald Skirving (1749–1819), enjoyed firmer structures of artistic production than any Scottish artists up to that time. The market for portraiture in Scotland was such that Raeburn produced well-nigh six hundred paintings, commissioned by the country's expanding middle and upper-middle classes. In fact, by the early years of the nineteenth century Raeburn was able to open his own studio and gallery at York Place, which included a novel system of shutters that varied light. In 1815 he was elected Royal Academician. In 1822 he was knighted by George IV, and the following year appointed the King's Limner and Painter for Scotland. Most importantly for the next chapter, in 1808 Raeburn helped to found a professional association of Scottish painters, the 'Society of Artists', with yearly exhibitions of modern work at his studio. This was an important catalyst to the development of the art field in that the 'autonomous' interests of modern artists were beginning to take offence against the 'outmoded' tastes of the older, aristocratic patrons. Part of Raeburn's legacy, therefore, was to help shape the relationship between artists and patrons in a way that introduced a dynamic principle at the heart of the field – that of conflict.

Landscape Painting

An understanding of the changing ways in which the Scottish landscape was depicted is central to an analysis of the art field itself. Like portraiture, landscape painting in Scotland was a potent mix of traditional and modern styles that summed up the greater diversity and variety possible in the Scottish art world. This diversity is all the more impressive when it is borne in mind that very few landscapes were painted in Scotland before the middle of the eighteenth century.

The first painters to depict Scottish landscapes were foreign artists, decorative craftsmen like the Nories and various itinerants (Holloway and Errington, 1978). Despite the desires of Edinburgh's own painters for 'artistic' as opposed to 'artisanal' patronage, individuals working in the landscape idiom often took their employment in relation to the symbolic needs of an increasingly prosperous aristocracy. Tasks included decorating town and country houses, carrying out topographies of country seats and providing ornamentation for gardens or pleasure grounds (Holloway and Errington, 1978). By the end of the century, however, landscape was one of the most popular genres in Scotland. Depictions of the Scottish countryside had shifted from generalised panoramas in the classical style to the more particular evocations of mood and rugged scenery that paved the way for the Romantic trope of the early nineteenth century. These developments fed into and off shifts both in the patronage of art and the nature of the art-consuming public in general.

Service-based Edinburgh provided ample opportunities for craftsmen such as cabinet makers, coach-painters and upholsterers. The apprentice system was still dominant in landscape work for most of the eighteenth century and apprenticed artisans like the Nories, Alexander Runciman, Jacob More and William Delacour were contracted for decorative commissions in the city's town-houses, particularly after the New Town was erected. They also continued to paint classical ruins, monuments and waterfalls for the decoration of Adam-style country houses after the Union in the tradition of seventeenth-century European landscape painting. Scotland, however, was not subject to the same impulses towards classical and generalised landscape production that England was. As with portraiture, the kinds of doctrines and strictures which formed Sir Joshua Reynolds' Academy art in England never had the same kind of hold on the Scottish portrayal of landscape. At the level of patronage, the high agency of 'disinterested' gentlemen – the progenitors of the classical humanist tradition as Reynolds saw it – was reduced in Edinburgh after parliament left for London. The ability to abstract the general from the particular in England found its expression in a taste for the ideal-panoramic as opposed to the specific, realistic and 'vulgar' (Dutch landscape pictures for instance). This went hand in hand with the possession of landed property, and came to depend on the capacity to exercise 'disinterested' public virtue in the act of political engagement. Such engagement was less appropriate to the landed gentlemen of Scotland after 1707. Leadership derived, instead, from the less high-falutin civil society – with impulses towards the commercial–professional and away from traditional classical humanism.

The lack of a grand landed constituency in Scotland translated into the ability of some Scottish artists to draw on less idealised and often more localised views without being castigated by Reynolds and the Academy. Jacob More, for instance, was, on the one hand, known for his 'civic humanist' inspired landscapes –

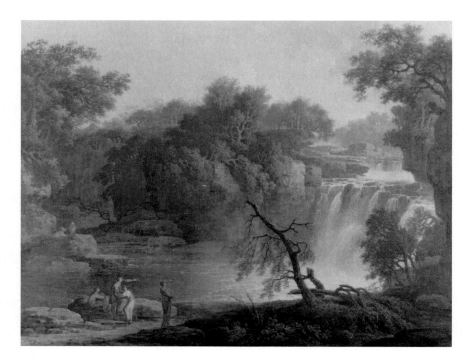

Figure 4.5 Jacob More, *The Falls of Clyde (Cora Linn)*, 1771, National Gallery of Scotland.

Claudian combinations of classical ruins, monuments and placeless idylls that Reynolds praised for their handling of 'air'. However, More also painted Scottish locations which adapted the neo-classical formula of Claude Vernet to Scottish scenes (Holloway, 1987: 7). Three pictures of the Falls of Clyde – Bonnington Linn, Cora Linn and Stone Byres Linn – in particular are representations of a place less abstract than many equivalents painted in England, although it is also true that More had to 'tame' the falls in this picture so as not to offend classical academic taste in the early 1770s (Williams and Brown, 1993).

Part and parcel of this combination of the classical with the local were the growing aspirations of Scottish civil society itself: the articulation of a taste that, while current in civilised nations elsewhere, was sufficiently confident in local forms of production. In Scotland, as throughout Europe, the grand epic poems of Ossian gripped the public imagination, representing to the inhabitants of Scotland, in particular, evidence of a poet who was Homeric in his spirit, talent and virtue. The fact that the poems were revealed as fakes, fabricated by James Macpherson, is interesting inasmuch as it reveals the pointed need to claim for Scotland the status of a nation that could produce such polished ancient poetry. And the effect

on painting overall was quite dramatic, opening up a wealth of new subject matter on which to base landscapes, epic pictures and literary scenes. Runciman's decorative commission of Penicuik House in 1767, for instance, included two ceilings, comprised of compositions drawn from Ossian, for the owner Sir John Clerk.

One of the most curious aspects to the whole period called the 'age of improvement' is that, on the one hand, it sees the formation of a modern commercial society in Scotland, the advent of the iron and steel industries, rapid urbanisation and the transformation of agriculture for capital accumulation. And yet, on the other hand, there were few depictions of urban or industrial townscapes in Scottish painting at this time, and little trace of the effects of the modernising schemes or their implementation in landscape representation (Jackson, 1986).[20] As in most English painting, we find no vestiges of enclosure, plantation, intense farming practice, labour or the commercial exploitation of woodland in Scottish landscape painting. What was distinctive about painting, generally, in this period was its recourse to images of the bucolic, rural and ideal as a retreat from urban commercial modernity – something even more pointed given the rapidity of modern social change in Scotland.

This was as true in the landscapes of More, Runciman and Nasmyth as it was in the Scottish genre scenes of David Wilkie and David Allan. Far from relaying the dirt, famine and misery of ruralism or the political threat of Jacobitism, such pictures reduced the country to a set of safe customs, manners and costumes that connoted harmony and stability. Like others, David Allan turned away from grand history pictures in the light of limited patronage and turned to pastoralism, illustrating scenes from Ramsay's *The Gentle Shepherd*. In this series, contemplative shepherds are shown in classical poses, playing the pipes, in front of cottages that are the epitome of the picturesque follies of the landed elite.[21]

Indeed, the emphasis on loss, on the implied corruption of the modern city and the affirmation of rural simplicity may have been a reiteration of Adam Ferguson's defence of heroic primitivism and the decline of classical virtue. The link to an orthodox formulation of civil society is therefore an interesting possibility, suggesting the permeation of ideas into genre and landscape painting. But the social efficacy of this movement should also be noted: of pastoralism as a kind of social cement. Peter Quinn explains:

This was the cosy vision of rural life which allowed a clear conscience in the social upheavals which were transforming the practice of agriculture in Scotland. Ramsay's work had been first published in the year after the first Leveller's Revolt and was accompanied by an obsequious dedication to Lady Buccleuch. So in 1788, on the eve of the French Revolution, David Allan was painting a picture of Scottish society in which naturally simple, lower orders acknowledge the benefits and correctness of the rule of the landed class. (Quinn, 1990: 121)

The aestheticisation of the landscape which underpinned the picturesque aesthetic fitted nicely with the ideals of the improving landowners keen on 'pleasing prospects' and the controlled disposition of nature.[22] Patently, landowners did not like to think of themselves as destroyers of rural traditions or transformers of the landscape (Williams, 1973). On the contrary, they needed to present themselves as upstanding and loyal pillars of the rural community. In landscape painting, the effacement of what Barrell (1980) has called the 'dark side of the landscape' – farm labour, social unrest, eviction, modern commercial farming techniques, communication lines, and so on – coincided directly with the industrialisation of the countryside in the late eighteenth century. But it also coincided with the 'beautification' of the landscape in the tradition of house building and landscape gardening, where the ideology of Enlightenment translated as the arrangement and alteration of nature – to hide, present and alter.

In the late eighteenth century, the Scottish landscapist Alexander Nasmyth, named the 'founder of the Landscape Painting School of Scotland' by David Wilkie (quoted in Cooksey, 1979: 3), was employed for a variety of such 'improving' schemes. As well as working within and developing the decorative tradition, Nasmyth was commissioned to paint landscape schemes that outlined a prospect after a proposed modification – a temple, neo-classical bridge or cleared line of vision. In 1801, for instance, he illustrated the effect of a planned lighthouse on the estate of the Duke of Argyll and designed gardens, pleasure

Figure 4.6 Alexander Nasmyth, *The Windings of the Forth*, c.1820, National Gallery of Scotland.

grounds, well-heads and other architectural features for wealthy aristocrats like the Duke of Buccleuch. For the most part, it was Claude and Poussin's epic, neo-classical renderings of nature that provided the ideal set of visual references in this context. These offered panoramic abstractions, classical falls, foliage and distant views which signified a 'correct' taste for the enlightened landed elite.[23] At the same time, however, Nasmyth extended the classical style in order to respond to modern tendencies that began to run through the art field in Scotland by the end of the century. Unlike Reynolds and his valorisation of Claude, Nasmyth was more and more inclined to include specific and local idiosyncrasies into his landscapes – changes in the light, rugged mountains, an evocation of personal mood or the inclusion of recognisable buildings, like Edinburgh Castle, rather than classical ruins. In fact, by the 1820s, Nasmyth had even turned towards the urban spectacle and the building of the New Town as subject matter.

This duality of the local and the general, the rural and the urban or the ideal and the particular in Nasmyth can be linked to the complex forces and discourses which characterised the art world by the turn of the century. He was commissioned by both the landed aristocracy and the emerging commercial bourgeoisie.[24] He depicted classical ruins but also favoured Gothic architecture. He was fascinated with science and the Enlightenment, but also lived on into the reign of Queen Victoria and the fancies of Sir Walter Scott. He was beginning to assert himself as an 'autonomous' artist with the establishment of the city's Society of Scottish Artists in 1808, and yet also remained servile to the directives of various patrons with their symbolic needs. He painted the picturesque Lowlands but was also interested in the Highlands and was a good friend of Robert Burns. Finally, like Burns, Nasmyth was chastised for his nationalist sympathies (Macmillan, 1986) but also stood on the threshold of Romanticism and the bowdlerisation, popular-isation and sentimentalisation of Jacobitism (Pittock, 1991). It is testament to the potential complexity and growing autonomy of Edinburgh's art world that such multiple tendencies – a growing cultural mix of patrons and styles within a middle range – were possible.

The Function of Criticism: the Critic as Arbiter of Taste

Finally, the shape of the cultural field was modified in relation to the function of criticism. It has been noted that writers during the Scottish Enlightenment enjoyed the ideational freedom that accompanied the rise of moderatism, a larger reading public and spaces for literary expression. It was also indicated in Chapter 2 how modern critics and writers such as Kant were essential to the overall morphology of 'autonomous' art fields as they began to develop in Europe from the mid-eighteenth century – to the construction of art as a social practice marked off as a specialised sphere with its own internal laws and forms (Bourdieu, 1993). The

critic was a key figure in this process because his output was part of the discursive formulation of the modern matrix of art and its reception (Eagleton, 1990; Kivy, 1994).

Raymond Williams notes in his *Keywords* that criticism developed from the seventeenth and eighteenth centuries as an orientation in literature towards taste, cultivation and discrimination that depended upon 'judgement as the predominant and even natural response'. The role of the critic was bound up with the articulation of standards of taste, backed up by 'the social confidence of a class and later a profession' (Williams, 1976: 75). As the body of ideas treating of 'taste', 'beauty' and 'art', aesthetics became part of the movement away from antiquated relations of patronage and pointed towards the construction of a modern object – the work of art and the process of perception. Aesthetics began, therefore, to ask questions not merely of the rules of beauty in the construction of art works but of aesthetic experience from the position of the viewer, the person experiencing beauty, the critic (Eagleton, 1990). The concept of taste was crucial to this endeavour because it signified the existence of an 'inner sense' that in its pure form, and possessed by the right type of critic, could recognise the transcendental value of certain objects.

The very existence of critics and a body of aesthetic thought, then, was an index of developing art worlds, and in Edinburgh the appearance of 'treatises', 'enquiries' and 'essays' on relevant artistic subjects gives us the impression that this was a cultural field undergoing significant growth (Prior, 1998; Macmillan, 1986). Indeed, the convergence between the output of some of Edinburgh's writers and those on the continent seems to express a kind of 'catching up' of intellectual output in Scotland's capital. As we might expect, the key writers in aesthetics were also those of the Scottish Enlightenment in general. The eighteenth century contained the likes of Henry Kames, Francis Hutcheson, David Hume and Thomas Reid, all writing substantial pieces on questions of taste, beauty and perception.

Francis Hutcheson's *Inquiry into the Original of our Ideas of Beauty and Virtue*, and *Essay on the Nature and Conduct of the Passions and Affections*, both of the 1720s, were probably the first tracts in Scotland to deal with aspects of taste and the idea of an 'inner sense'. His influence on aesthetics and moral philosophy as a whole in Scotland was considerable (Purviance, 1991; Kivy, 1976; Downie, 1994; Wilkinson, 1992; Daiches, 1996; Rendall, 1978). The Glasgow-based Hutcheson wrote of beauty as 'the idea raised in us' (Hutcheson, 1724: 10) and in doing so stressed the faculties of perceptual appreciation that the 'internal sense' was able to capture.[25] This, of course, created new problems of consistency in the construction of a system of universal standards that Enlightenment thinkers all over Europe still desired: the enduring notion that the classics appealed to all historical periods, for instance. How, then, could the emphasis on the mechanics of individual perception be squared with the idea of a 'correct' or 'universal' taste

that transcended subjectivity? This was the question that reached to the heart of the aesthetic problematic as it unfolded in the eighteenth century: Scotland was no exception.

Thomas Reid, the 'common-sense' philosopher, professional cleric and critic of Hume's scepticism, was another Glasgow-based thinker who dwelt on aesthetic matters. Reid was appointed to the Chair of Moral Philosophy at Glasgow University in 1764 and wrote *Essays on the Intellectual Powers of Man* (1785), *Essays on the Active Powers of Man* (1788), *Inquiry into the Human Mind* (1764) and *Lectures on Fine Arts* (1774). All of these posed questions on perception and beauty in a manner reminiscent of Hutcheson. While never abandoning the thesis that beauty resides in the objective matter of certain objects, Reid traced the production of an aesthetic response in the mind of the perceiver.

Beauty appeared as objective in Reid's analyses to the extent that it expressed some mental excellence, some 'original principle' of human nature. Objects are beautiful, in other words, when they come to express certain perfections of the mind. So, a painting is beautiful, for Reid, when it represents 'the passions and dispositions of men in the attitudes and countenances' (Reid, 1774: 50). Paintings which depict a relaxed and languid repose derive their beauty from signification of natural signs of ease which themselves express a kind of passion of human sentiment (Nauckhoff, 1994). Aesthetic pleasure was not, here, a matter of corporeal sense as in the literal meaning of 'taste' but resided, for Reid, in a lasting disposition or quality of perception that indicated an 'internal sense'. Indeed, it was this formulation that informed the portraitist Henry Raeburn's painterly excursions into the role of perception and his rejection of the abstract and ideal.

The very presence of thinkers such as Reid, who wrote and published on questions which had a bearing on artistic practice, could not fail to energise the local artistic field as a whole. Edinburgh was beginning to witness an explosion in criticism the likes of which it had never seen. Figures like Lord Kames, James Beattie, Alexander Gerard, Allan Ramsay, Hugh Blair and Archibald Alison wrote various amounts on aspects of taste, mostly in relation to moral philosophy. This all helped to define the space of the critic with respect to both the modern public and the universe of propriety by the second half of the eighteenth century. By raising modern questions on the status of the artistic object, on the issue of the particularity of taste, and on the role of the observer, the critic moved increasingly into the seat of judgement. While in no way did criticism in eighteenth-century Edinburgh exhibit the normative power of its modern nineteenth-century counter-part, critics did at least begin to contribute to the symbolic value of certain cultural forms and products, consecrating works which fitted with the ideals of a classical education in particular. Moreover, critics began to occupy a space within the field that was structurally and functionally homologous with the audience for which they wrote.

Lord Kames, for instance, a central figure in the agricultural modernisation of Scotland, turned his critical acumen to aspects of classical literature and aesthetics, and in doing so pitted the insights of the critic against the vulgar, ignorant and 'deformed'.[26] *Elements of Criticism* was published in 1762, to Voltaire's rather critical reception, and placed Kames within the intellectual field of the European *literati*. His theoretical interventions into aesthetics and literary criticism, however, also marked the impulse to refinement, polished manners and cultural civility that, in his own view, was beginning to strengthen in Scotland:

> It is an admirable sign of the progress of the human spirit that we should have coming from Scotland today rules of taste in all the arts, from the epic poem to gardening. *L'esprit humain* is extending itself every day, and we need not despair of very soon receiving treatises on poetics and rhetoric from the Orkney Islands. (quoted in Lehmann, 1971: 44–5)

The role of the 'rational science of criticism', here, was itself to cultivate 'to a high degree of refinement . . . the heart no less than the understanding' (quoted in Lehmann, 1971: 222–3). And, for Kames, the basis to all aspects of taste was a naturally derived human capacity which could be studied empirically and through the faculties of reason. Hence, the uncertainties that various other writers encountered in the establishment of taste was by-passed in Kames's view to the extent that a valid and universally acknowledged standard of taste with independent ontological status was posited. In literature, this was expressed in the valorisation of the classics: Cicero, Virgil and Homer, as well as Shakespeare, Addison and Macpherson's Ossian. If great literature was transcendental, if it passed the test of time, it was only critics possessed of the knowledge, leisure time and taste that were able to reveal this transcendence. Kames was unequivocal in this. Only those with refined sensibilities and a classical education would fit the bill. We should not, he exclaimed, refer to everyone's opinion equally. The 'greater part of mankind', those who rely for their livelihoods on 'bodily labour', should be excluded because they lack any kind of taste so far as 'fine arts is concerned' (quoted in Berry, 1997: 178).

Like elsewhere, therefore, the critic as arbiter of taste in Edinburgh worked with the logic of distinction and distanciation that began to take shape in the realm of civil society. The critic established standards of taste that marked the ability of this class to 'play the game' of criticism and aesthetic appreciation (Bourdieu, 1993). Taste in the arts allowed the aristocracy and *literati* to mark their membership of this 'polished' or 'civilised' urban public. 'High culture', in its nascent form, was identified with (and appropriated by) the group of cultural and intellectual leaders that emerged in Edinburgh from the middle to late eighteenth century (Phillipson, 1973; 1975). And part of the definition of a refined culture, and of civil society as

a whole, was the construction of its opposite – the vulgar, deformed, bodily and ignorant. It was Edinburgh's Enlightenment precepts, for instance, that underpinned the gradual institutionalisation of the mad, the sad and the bad in purpose-built spaces such as asylums, prisons and clinics (Markus, 1993). A codification of the lower 'other' was similarly reiterated in the emerging spaces of the public sphere.[27]

All of which brings us to why Hume's problematic in the essay 'On the Standard of Taste' is such a powerful expression of the project of the *literati* to attain social and cultural leadership in the second half of the eighteenth century. Criticism was a subject identified in Hume's preface to the *Treatise on Human Nature* that the 'science of man' would raise to the heights of excellence. Standards of taste would be linked inextricably, for Hume, to certain principles of criticism articulated by thinkers whose civic impulse to socialise, discuss and improve marked them as a natural public of common professionals, men of letters and taste. Hume's will-to-consensus, in other words, comprised a deeply rooted desire to establish a constituency of spokesmen who would represent the disinterested ideal of taste. Just as art struggled to be set apart from skill or abundance and took on the qualities of a sensibility in Scotland, so virtue linked in with a taste for the beautiful, civil and refined: that which marked the character of the gentleman and philosopher.

Despite the age-old recognition that artistic judgements varied – *de gustibus non disputandum est* – in the essay 'Of the Standard of Taste' this maxim was vitiated in the movement towards a 'natural' standard of taste, a rule by which the various sentiments of 'men' may be harmonised. Put another way, the potential subjectivity that was raised in the acceptance of a perceptual dimension to the reception of beauty was immediately put down in favour of 'real matters of fact' that signified an enduring standard. For Hume, underpinning critical acumen were certain possessions, of which he mentions five: 'strong sense, united to delicate sentiment, improved by practice, perfected by comparison and cleared of all prejudice' (Hume, 1779: 241). When individuals who have these characteristics agree upon aesthetic judgements, that agreement 'is the standard of taste and beauty'. Tautologically posed, good art was what critics agreed upon and a critic with taste was one who defined good art. To achieve the required sentiment towards works of art, Hume, like those before him, invoked the 'inner sense' ('strong sense' as it is termed in Hume's five dispositions) possessed by some men with 'delicacy of taste' to appreciate the subtleties of beauty and the deformities of lesser works.

Hume's aim, in a nutshell, was to find a logical link between the existence of a 'correct taste' which underwrote the timeless appeal of the classics, with this theory of an 'inner sense'. For the latter theory did not sit well with static 'rules of art', with the idea of a 'durable admiration, which attends those works, that have survived all the caprices of mode and fashion, all the mistakes of ignorance and envy' (Hume, 1779: 233). The dilemma seemed to be compounded by the apparent

lack of agreement amongst Hume's fellow critics as to what qualities aesthetic objects must have to make them tasteful. For Addison it was the sublime, novelty and beauty; for Shaftesbury it was harmony and proportion; for Hutcheson it was 'uniformity amidst variety'; and for Kames it was objective classical beauty. Hume tried to reconcile and unite these potential differences by putting his trust in a constant feature of human nature, cast in terms of the 'inner sense', but which on occasions was subject to interference from vaguely defined extraneous factors (Wilkinson, 1992). In the last analysis, however, it was still the ideal community of critics who retained the power to judge, because, in Hume's view, a true judge can never be wrong.[28] The joint verdict of such critics, arrived at through acts of reason and discussion so carefully represented in Allan's picture *The Connoisseurs*, determined the 'true standard of taste and beauty' (Hume, 1779: 241). Indeed, by the end of the essay, Hume was much more confident in this assertion, as he was in the existence of 'correct' and 'incorrect' tastes:

> Though men of delicate taste be rare, they are easily to be distinguished in society, by the soundness of their understanding and the superiority of their faculties above the rest of mankind . . . The general principles of taste are uniform in human nature: Where men vary in their judgments, some defect or perversion in the faculties may commonly be remarked; proceeding either from prejudice, from want of practice, or want of delicacy; and there is just reason for approving one taste, and condemning another. (Hume, 1779: 243)

Now, many commentators have mused on the oscillation in Hume's 'Of the Standard of Taste' between the 'objectivity thesis' (that there are definite rules and standards of artistic taste *à la* classicism) and the 'subjectivity thesis' (that beauty must also reside in what the perceiver brings to the encounter with art – what Hume calls 'understanding') (Shiner, 1996; Perricone, 1995; Noel, 1994; Gracyk, 1994; Shelley, 1994). What these accounts fail to mention, however, are the social and ideological, rather than philosophical, exigencies which made it a priority for Hume to retain both the objective and subjective in relation to questions of judgement. Clearly, if one belongs to a newly emerging cultural and intellectual elite whose distinction rests on a disposition to matters of civility and high culture, then one would need to retain a role in civil society for such a community. But what role is there in matters of taste if either a) the rules of art and beauty yield so easily to mere reason; that aesthetics was no different to any other scientific undertaking, or b) questions of judgement were relative and phenomenological; that aesthetics was a matter of 'anything goes'? Hume plumps for a middle ground between these two positions, often drawing in aspects of both, precisely because the critics he has in mind would be perceptive and 'delicate in taste' and yet would

also discover or gravitate to a certain regularity in matters of beauty, the laws of which exist outside of them. Hume, in other words, projects his own social position into the solution to the problem of aesthetics by affirming, in the last analysis, the natural foundational uniformity of his class.

Introducing the question of the sociological within the aesthetic this way reveals the project of all the critics mentioned to have a socio-genesis and function within an inchoate bourgeois public sphere. The will to consensus, to judgement, to distinction and to distanciation arose both from the *literati*'s position within the field, and, homologously, from their own social backgrounds. The ideal connoisseur in each case was someone with education, leisure and wealth; in short, a member of the aristocratic and professional classes.[29] Like Kant, Hume stressed the critical prerequisite of 'disinterestedness': he essentialised the ideal of a 'mind free from all prejudice', which contemplated nothing but the work of art itself – 'the very object which is submitted to his examination' (Hume, 1779: 239). Clearly, this faculty was a product of the educated *habitus* (Bourdieu, 1977), of the socio-economically privileged, whose distance from labour and whose level of exposure to the requisite cultural works predisposed them to speak of certain standards, taste preferences and orientations towards the pure object.

Like other critics of the eighteenth century, Hume's community of taste was one separate from the feudal order of absolutism, of the judgements of single tyrannical leaders; but also one in contradistinction to the vulgar pleasures of lower constituencies.[30] So, while taste is considered to be pure when devoid of 'fever', 'disease' or other aberrational interferences, giving it a natural quality, it is clear that the 'true judge' is not some primal savage or innocent but a highly educated and trained (male) individual with an abundance of cultural capital. 'For what is the requisite practice, comparison, and good sense of Hume's critic', asks Shusterman, 'except for the achievement and exercise of dispositions (socially acquired and refined) to react to the right objects in the culturally right way or to think in ways that society regards as reasonable?' (Shusterman, 1993: 105).

To conclude, then. What criticism did in the capital was take up a space within the public sphere: it articulated a new system of aesthetics and supported the erasure of an older, patronal system. The critic helped to provide the ideational catalyst for a more modern system of fine art in Edinburgh, by consecrating the idea of art as an object in itself. Hume, Kames, Hutcheson and Reid all, therefore, played their part in stimulating the theory and practice of art. For the first time in Edinburgh, treatises and essays constituted a new object in discourse – the monadic art object, relatively autonomous from previous rules of beauty and religious directives. Criticism also expressed the priorities of an increasingly confident middle class, backed by an aristocracy, whose aim it was to distinguish itself as a group of natural leaders, from above and below. If Enlightenment and civil society meant opening up, it also meant closing down; its dynamic was both democratic

and elitist; its public was modern but exclusive; its priorities were not merely to educate and refine but to distanciate and distinguish. This brought it into line with cultural trends elsewhere in Europe, marking a break with previous discourses of judgement and contributing to the rise of bourgeois aesthetics in mid-eighteenth-century Europe as a whole.

The differentiated art object did not spring fully formed from the pens of critics, but developed slowly in an accumulated process of attention and practice. That Edinburgh did not possess public art galleries or major spaces for exhibition at the end of the eighteenth century can be attributed to the forces that for centuries kept the field in check – poverty, instability and the lack of centralised forms of patronage. In Bourdieu's terms (1993), furthermore, the dynamic struggle between a modern and an ancient faction within the ruling class (between the extremes of a professional middle class striving for autonomy and a nobility/aristocracy positioned at the pole of heteronomy/commerce) was nascent, not yet delivering the vital impetus towards progression that Romanticism was later to bring. The *literati*, in this sense, were still part of the dominant (rather than dominated) faction of the dominant class.

In the shift away from the guilds, the rise of the market and collections, the increasing popularity of landscape painting and portraiture, as well as the development of aesthetics, however, the vital organs of a modern art body were assembling in Edinburgh. The agency of such a transition in Edinburgh, united for the moment, was that block of *literati* and aristocracy that desired to render itself visually present to itself and others in acts of distinction – not grand or heroic, but civic and tasteful. In this, Scotland's idiosyncratic position in Europe derived from its already de-centralised cultural system and fertile civil society. At once, this made for an ambiguous cultural field: lacking the official forms of power and patronage to take issue with, and yet enjoying an advanced institutional and discursive cultural system. Into the heart of the fine arts was such a double-edged process etched; into the very pictures were the nuances of socio-cultural change coded; and into the morphology of the city were such ambiguities and double codes made spatially visible.

Notes

1. Mary's newly arranged chapel at Holyrood Palace, for instance, was destroyed by the Protestant Earl of Glencairn after her disappearance in 1567; while in Perth the local population was so inflamed by Knox's sermon against idolatry in 1559 that icons, windows and books were destroyed in the aftermath (Houston and Whyte, 1989).

2. Edinburgh, despite Holyrood Palace, which for several centuries was to be sacked, refurbished and sacked again, had little in the way of official seats of central power and authority by the sixteenth century. As McKean (1991) asserts, before the early seventeenth century the city was, in effect, a civic burgh rather than a flourishing capital, with few spaces for royal or national ceremony. Some of the Stewart monarchs had attempted to use Holyrood as a centre for royal entertainment, but the palace remained first and foremost a dwelling place that lacked the finery of a royal court.

3. The National Covenant was drawn up by nobles, lesser lairds, burghers and ministers in 1638 against the 'manyfold odoures' and 'wicked hierarchies' of papistry that the Covenanters believed were undermining Scotland's (and Britain's) probity. The document called for the return of a General Assembly to Scotland and a dissolution of Anglican structures of authority in the Scottish system in the name of Presbyterian internationalism. In Edinburgh, churches were again sacked, organs destroyed, paintings burnt and musicians discharged.

4. James patronised various professional institutions including the Royal College of Physicians, the Advocate's Library, the Order of the Thistle, the Physic Garden and the Royal College of Archers. He responded to professional demands for scholarly advance, thereby securing personal political popularity amongst the most active constituency of Edinburgh society. Doctors, lawyers and academics were all given a more creative space within which to assert their intellectual and scholarly values (Ouston, 1982). Professionals intermingled increasingly with the aristocracy, and shared similar ideals of virtue, loyalty and royalty. These ideals were particularly important given James's religious affiliations and his father's execution – potent fuel for the fire that Covenanters were stoking once again.

5. Despite the social tumult, Edinburgh in the early eighteenth century did begin to show signs of general improvement in matters 'artistic'. For instance, the capital attracted the professional services of John De Medina, a portraitist from Brussels, who had originally settled in London in competition with Sir Godfrey Kneller. Medina painted portraits in a diluted Baroque style which suited his patrons, including the Earl of Leven and the Duke of Argyll, who was painted with his two sons around 1694. He managed to sustain a successful business in the capital, dabbling also in figure compositions and subjects drawn from classical mythology (Holloway, 1990).

6. Norie's work, in fact, reveals the status of landscape painting at this time, to harmonise the overall effect of certain rooms, to function, in other words, as 'up-market wallpaper' in relation to a generalised decorative scheme. Cultural workers like Norie were in no position to assert their own autonomy as 'fine artists' during this period.

7. A directory of Edinburgh in 1752, compiled by Gilhooley (1988), reveals just how few artists there were in the city. Out of a population of around 31,430, only eighteen are listed as 'painters' (including 'limners'); and the Nories are listed as 'paint and dye merchants'.

8. There is, however, a substantial literature on the 'Scottish Enlightenment' which covers much of the ground overlooked here (Rendall, 1978; Chitnis, 1976; Daiches, Jones and Jones, 1996; McElroy,1969; Phillipson, 1973, 1975; Lenman, 1981; Devine, 1990; Smout, 1969).

9. Rates of town and city growth in Scotland were among the fastest in Europe (Devine, 1990). Glasgow's population, for instance, increased by more than 500 per cent between 1755 and 1821, while Edinburgh's increased from 52,720 to 138,235 over the same period (Mitchison, 1970). From the 1740s the economic framework promoted by free trade and local resources also stimulated Scotland's commercial impulse in world markets.

10. This compact also explains the lack of political radicalism evident in the writings of the *literati* (Devine, 1990). The governing classes, including the minor nobility and substantial gentry, possessed the power of patronage, so it made no sense for the likes of Hume and Smith to attack the system of privilege and tradition that underpinned landed power. As a result, the Scottish system of elite rule was remarkably resilient and stable, particularly after the failed Jacobite revolutions of 1715 and 1745, and especially in comparison with Ireland and France.

11. Robertson defines the civic tradition as 'that body of political ideals, classical and specifically Aristotelian in origin, concerned with the phenomenon of political community in its secular and historical particularity' (1983: 138). Pocock traces its development in Renaissance thought, through Machiavelli's articulation of *virtu* and in the English thought of Shaftesbury and Harrington. Ferguson is claimed by Pocock to be 'the most Machiavellian of the Scottish disquisitions on this theme' (1975: 499).

12. This had ramifications in styles of art, too, where the grand manner and historical painting valorised by Shaftesbury and Reynolds paled alongside the local Scottish portraiture of 'empiricism'.

13. The question of 'luxury' and its relation to consumption was one that dogged Scottish morality during the eighteenth and nineteenth centuries (Dwyer, 1987). Luxury could always be justified, however, if the basis to that consumption grew out of the moderate and virtuous values of Scotland's leaders – in this case the free market and the notion that certain forms of luxury were 'beneficial' (Nenadic, 1994). Hence, the moral ambiguities inherent in collecting art works or prints – as a potentially 'effeminate', frivolous and excessive undertaking – faded as a set of modern ideas seeped through the institutions and practices of Scotland's cities. Indeed, the possession of print collections became one way in which a refined, enlightened, and metropolitan sensibility was fashioned.

14. Interestingly, the justification for such display was couched in terms of what art could do for the amelioration of manufactures in Scotland rather than in terms reserved for art itself. To local commercial and industrial patrons the Foulis brothers found it necessary to 'represent . . . to them [art] as a finer kind of manufacture, that would take a longer time to . . . produce profit, but that in the end would make full amends for the delay, by affording more ample profits, because the manufactures were not produced from dear materials' (quoted in Miles, 1962: 26–7).

15. It would be a mistake, here, to see the academy as a surrogate agent of a centralised British state. Like the Board itself, the Trustees' Academy relied on Scotland's own personnel and the impulses of Edinburgh's civil society as a whole. The initial suggestion for its existence, for example, came from the enlightened landowner-lawyer Lord Kames as a means of improving the design of linen. It was from the outset, then, a commercial undertaking, backed by official funds, but which received little attention south of the border. As Minihan writes, 'the annuity was granted for commercial purposes and, once granted in perpetuity, its administration over the years attracted the interests of few MPs. English legislators would doubtless have been surprised to learn that an important precedent was being modestly set north of the border' (1977: 9).

16. It was a problem that transcended the status of particular artists and styles to become a question at the very heart of collecting and the later formation of the National Gallery itself: namely, are portraits to be commissioned, collected and displayed for aesthetic reasons, for the renown of the sitter or for the purpose of personal record?

17. A good deal of portraiture was intended for some form of public disposition and therefore sitters had to be portrayed with qualities befitting their social role. This is

particularly true of professionals, whose portraits were often displayed within the hospitals, banks, universities and board rooms of Edinburgh.

18. This, in turn, by-passed the nuances of gentlemanly deportment – particularly the position of the feet, which had to be shown turned outwards to signify aristocratic elegance (Smart, 1992).

19. At the height of his popularity Raeburn was taking around four sitters a day, for up to an hour and a half each and for four or five sittings (Armstrong, 1888). He painted the most notorious and influential Scotsmen of the day, including Viscount Melville, William Robertson, David Hume, Sir Walter Scott, James Boswell, Adam Smith, Hugh Blair, Lord Kames and Francis Jeffrey. In 1784 Raeburn left for Rome on Reynolds' advice but returned to Edinburgh in 1787, and stayed for thirty-six years. His marriage in 1780 to a rich widow delivered financial security to Raeburn, and his subsequent ventures into landownership (Youngson, 1966) matched him socially with many of the subjects of his portraiture: the mix of aristocracy, lesser gentry and professionals that led Scottish civil society as a whole.

20. In this sense there were no Scottish equivalents to Joseph Wright of Derby. This is even more surprising given the overlap in subject matter between Wright and someone like Jacob More, both of whom painted volcanic eruptions. Wright even painted his self-portrait for More, but this was subsequently passed to Josiah Wedgewood (Holloway, 1987).

21. The symbolic construction of the Scottish countryside, here, is not dissimilar to that outlined in Raymond Williams' description of English 'romantic retrospects' in *The Country and the City* (1973). Indeed, the contrast of town and country suffused Scottish painting and writing from the latter part of the eighteenth century, reaching its apotheosis with Sir Walter Scott. This allowed the Scottish middle and upper classes to avoid the social realities of capitalism. As Noble writes, 'perhaps no European society was more flooded by this lachrymose tide than Scotland' (1982: 242).

22. William Gilpin, an influential champion of the picturesque, expressed the general distaste for working landscapes in 1792: 'In a moral view the industrious mechanic is a more pleasing object than the loitering peasant . . . in a picturesque light it is otherwise. The arts of industry are rejected; even idleness . . . adds dignity to a character. Thus the lazy cowherd resting on his pole, or the peasant lolling on a rock may be allowed in the grandest scene' (quoted in Jackson, 1986: 23).

23. They also fitted with an emerging tradition of the picturesque based on the inclusion of variety in the visual scheme, adjusting the rural environment to cater to the ideologies of Scotland's enlightened landowners. For landowners required foliage in their com-missioned pieces in order to render themselves visible as progenitors of taste and protectors of the land. Most of Alexander Nasmyth's work emphasised and reproduced this landed aesthetic.

24. One such businessman was Patrick Miller, a man of the Enlightenment and Edinburgh banker, who gave Nasmyth ,500 to enable him to go to Rome in 1782. Nasmyth returned to Scotland in 1785.

25. Or as Hutcheson himself puts it: 'All beauty is relative to the sense of some mind perceiving it' (Hutcheson, 1724: 23).

26. Kames was born in 1696 into a wealthy Berwickshire landowning family. He became Lord of Justiciary in 1763, and maintained close companionship with David Hume. His contributions to legal theory, to the various clubs and societies in Edinburgh and to 'national improvement' in general have been noted by Lehmann, among others (Lehmann, 1971).

27. The very definition of 'civil society' written for the Edinburgh-based *Encyclopedia Britannica* of 1771 is sufficient to make the point: 'The welfare, nay, the nature of civil society, requires that there should be a subordination of orders or diversity of ranks and

conditions in it; – that certain men, or orders of men, be appointed to superintend and manage such affairs as concerns the public and happiness . . . The superiority of the higher orders, or the authority with which the state has invested them, entitle them, especially if they employ their authority well, to *the obedience and submission of the lower*, and to a proportionate honour and respect from all. *The subordination of the lower ranks claims protection, defence, and security from the higher* . . . Public spirit, heroic zeal, love of liberty, and the other political duties, do, above all others, recommend those who practise them to the admiration and homage of mankind; because, as they are the offspring of the noblest minds, so they are the parents of the greatest blessings to society' (1771, vol. iii: 295, my emphasis).

28. To this extent, Hume's 'double standard of taste' – that of the rules of art and that of the joint verdict of critics – cannot conflict given the true judge's perfection. Or as Shelley puts it: 'correctly formulated rules of art turn out simply to be the rules according to which the critical faculty of a true judge operates' (Shelley, 1994, 441).

29. Indeed, that Hume privileges the professional middle class is apparent in his essay 'Of the Middle Station of Life'. This social position is conducive to virtue, ambition and happiness, according to Hume, fostering advancements in learning and the arts. In this it is distinguished both from the miseries of the low, who are 'too much occupy'd in providing for the Necessities of Life, to hearken to the calm Voice of Reason' (Hume, 1779: 546), and from the excesses of the 'great' – 'There are more natural Parts, and a stronger Genius requisite to make a good Lawyer or Physician, than to make a great Monarch' (Hume, 1779: 548).

30. In Hume this took the form of a rejection of 'prejudice', 'interest', 'labour' and 'barbarism'; in Kames it was the 'exclusion of classes so many and numerous [which] reduces within a narrow compass those who are qualified to be judges in the fine arts' (quoted in Shusterman, 1993: 107). In Smith's *Theory of Moral Sentiments* (1759), on the other hand, the advancement of a consensual mode of perception and solidarity among members of the new elite turned on the idea that the useful, mechanical, bodily and detailed should be excluded from the aesthetic process. What defined the 'impartial spectator', here, was the suppression of the 'other'- bodily appetites, for instance – which were considered antithetical to proper citizenship and judgement. Indeed, the exclusion of women from this public universe of taste, criticism and citizenship may well have been bound up with the denial of the particular (Bohls, 1993).

The Birth of the National Gallery of Scotland, 1800–59

In the pursuance of their own interests, several key institutions struggle over the stakes of the art field in the early nineteenth century. The outcome of these struggles is the foundation of the National Gallery of Scotland in 1851. The objective of this chapter is to unravel the specific conflicts at work within the artistic field and point to the elementary economic, cultural and social conditions which underpinned the foundation of the gallery. I hope to reveal key transformations in the morphology of the fine-art field in Edinburgh between 1800 and 1859, reconstructing the shape of the field through an analysis of the position-takings of the most influential institutions. For as Bourdieu (1993) indicates, the structure of any field is dependent both on the internal distribution of possible positions and on the social characteristics of the agents occupying them. That is to say, the structure of the field at any given time is firmly reliant on the oppositions, combinations and altercations of the constituting agents or systems of agents.

Here, Bourdieu uses the notion of force-field to characterise the artistic field as a locus of struggles between agents who use the force of their capital to maintain or improve their position within the field. Agents possessed of specific capabilities (or in Bourdieu's terminology, a sum of capital, composed chiefly of economic and/or cultural resources which energise the *habitus*) engage in strategies appropriate to their location in the game. Those in a position of dominance will tactically deploy their capital in order to *conserve* their position, whereas agents looking to outflank, displace or overtake those in a dominant position (*arrivistes,* avant-gardistes, heretics, the 'dominated fraction of the dominant social class') will attempt strategies of *succession* or *subversion* (Bourdieu and Wacquant, 1992: 98–9). Indeed, this on-going battle between orthodoxy and heresy – which in the artistic field has been drawn between defenders of traditional, aristocratic or centralised structures of patronage and defenders of an unfettered modern art – constitutes the driving dialectic of change in all cultural fields:

the process that carries works along is the product of the struggle among agents who, as a function of their position in the field, of their specified capital, have a stake in

conservation, that is routine and routinisation, or in subversion, i.e., a return to sources, to an original purity, to heretical criticism, and so forth. (Bourdieu, 1993: 183)

Here, struggles which often take the form of demands for recognition just as easily become struggles over the dominant criteria of legitimacy. In the field of artistic production, orthodox artists, connoisseurs or patrons endorse existing definitions, whereas heterodox artists, critics or patrons explicitly challenge the dominant standards and actively set out to revise the criteria that underpin the distribution of artistic capital. In turn, the attempt to impose a definition of legitimate practice – what is worthy art – often overlays questions regarding the limits of the field itself and the movement to symbolically exclude practices and members from the game. In this sense, as Bourdieu explains, struggles over definitions between poets, novelists, ancients and moderns are more than mere conflicts with words, they are actually 'experienced by the protagonists as questions of life or death' (Bourdieu, 1993: 184).

The following, then, should be read as an instance of the endeavour to operationalise the field concept. It is an attempt to unravel the stakes and tools used in the struggles to augment the interests of Edinburgh's art institutions by the early decades of the nineteenth century and the resultant construction of a modern space for art. The movement towards a pure aesthetic, the belief in setting art apart from other value spheres or forms of activity, was the manifestation of a cluster of ideas, personnel and institutions that marked the onset of conflict and fragmentation in Edinburgh's art field. This movement was tied up, in turn, with changes in the composition and power of Scotland's upper classes and the resources that certain factions could draw upon to affirm their own cultural interests. A desire to professionalise the field and encourage the market were the most visible aspects of this movement; but also important was the re-profiling, by the 1840s, of the city's art field to accommodate the interests of its most powerful art institution, the Royal Scottish Academy. The specifics of this struggle point to a profile that is relatively unique to Scotland, but which fits with Bourdieu's concern to follow Bachelard's advice and plot the variant in the common (Bourdieu, 1998: 2). The new National Gallery of Scotland (1851), in this view, emerged in particular conditions of a finite space of possibilities and can be differentiated structurally from the Louvre (1793) and the National Gallery in London (1824).

1808–13: The Associated Society of Artists

As indicated in the last chapter, Raeburn's efforts to promote the interests of professional artists resulted in the foundation of the Associated Society of Artists (ASA) in 1808. This was the first artist-led institution of its kind in Scotland, and

its remit included the annual exhibition of the modern pictures produced by mainly local artists in Raeburn's York Place studio. A small catalogue accompanied the exhibition and adverts were placed in the city's main newspapers and journals. By all accounts the exhibitions comprised an eclectic mixture of genre scenes, portraits and Scottish landscapes which showed mainly to members of the *literati* and wealthy patrons in the capital. Indeed, the first ASA exhibition in 1808 was limited and rudimentary. As Thompson writes: 'An impression is left of a trade shop window, with few exhibitors who had any very elevated notion of their vocation' (1972: 21), and even the catalogue decried the lack of quality in many of the pictures (Gordon, 1976).

However, the ASA continued to exhibit every year in Raeburn's private studio until 1813 and to an extent heralded the beginnings of professionalisation in art matters in Scotland. This is illustrated by both the rise in the status of artists themselves – Raeburn, Nasmyth and Wilkie being three of the most renowned men of the day – and the desire to found a life drawing class in the city. From 1810, in particular, improvements in the arts were marked, a fact embodied in Henry Cockburn's quip that 'there were more and better, and better paid artists in Edinburgh in the next ten or fifteen years then [sic] there had been in Scotland during the preceding century', (quoted in Gordon, 1976: 5). Yet, for the artists there were still battles to be fought and obstacles to be overcome in Edinburgh. Indeed, rather ironically, the biggest obstacle was the rise to power of another more traditional arts organisation, the Institution for the Encouragement of Fine Arts in Scotland.

1819–26: The Institution for the Encouragement of Fine Arts in Scotland and the Associated Artists

> Thus the crystalline purity of this aristocratic body was protected from all contact of pallet or brush!
>
> (Monro, 1846: 104)

Following the example set by the British Institution for Promoting the Fine Arts in the United Kingdom, founded in London, the Institution for the Encouragement of Fine Arts in Scotland was set up in Edinburgh in 1819. The Institution had around one hundred and fifty members drawn from the nobility and aristocracy, each of whom subscribed twenty to twenty-five guineas a year. The primary aim was to exhibit old master paintings – the private property of individual members – and to form a collection of ancient art, which was later to form part of the National Gallery collection. In 1819 the Institution held its first exhibition of old masters, based on a temporary transference of paintings from country to city (from

Edinburgh's surrounding country houses to Henry Raeburn's gallery at York Place), for which 1s. was charged for admission (NG 3/1/1). Born of a private, aristocratic culture, the show's commercial failure appeared to be tempered by the Institution's pleasure at the more exclusive private evening viewings, and 'by the attention of the higher classes' (NG 3/1/1:10). A year later, attendance was further depleted and, according to the sixpence catalogue, only twelve pictures were exhibited. These included a mix of seventeenth and eighteenth-century generalised landscapes, portraits, religious and classical scenes by the likes of Ruysdael, Titian, Rubens, Velásquez and Gavin Hamilton (EUL: Institution Catalogues and Misc. Pamphlets, 10/42–4: 7).

Clearly, the Institution's membership (comprised of owners of inherited landed capital) disposed it towards a set of traditional aesthetic values that pointed up its position as guardian of patrician culture. It spoke fondly of the Royal Academy and of the works of Reynolds, Gainsborough and Richard Wilson, spent time canvassing for the 'interest of the nobility and gentry of Scotland in the objects of the Institution' (NG 3/1/1: 48) and received the patronage of Prince George, as Regent, in 1819. Core members such as the Earl of Elgin, the Marquis of Queensberry, the Earl of Moray, the Earl of Penicuik and the Duke of Hamilton comprised a group of aristocratic patrons in the classical sense. Using the rhetoric of civic humanism and 'disinterestedness', this coterie of amateur collectors was disposed to preserve the shape of the field as it was, and to resist any attempt by artists to modernise structures of artistic production.

However, by 1820 the Institution was proposing the substitution of the work of living artists for ancient masters in the light of the lack of a steady, varied and popular supply of older works to the city. This was expedient for both parties: the artists gained exhibition space and potential patrons at a time when the market was still in its infancy, and the patrons exploited the growing popularity of modern art in Edinburgh to convey their self-perceived status as the field's chief sponsors, despite their allegiance to a more antiquated system of patronage. That the artists themselves were growing increasingly wary of the Institution's control is indicated by the gradual divide between the two constituencies from the late 1820s. For now, however, patrons and artists had little choice but to use each other in order to bolster their own relative positions within the field.

From 1820 until 1831, then, Edinburgh played host to modern exhibitions on a scale unmatched in Scotland up to that point. The venue was changed from 1821 to 1826 to galleries at Waterloo Place in order to make room for larger audiences and for the growing number of modern works submitted. The exhibitions were a success, attracting local art buyers and proving to be somewhat of a shop window for portraitists, landscapists and genre artists. Many painted accessible subjects – local views, commissioned portraits, cottage scenes, 'sleeping girls' – in a direct style that suited the growing middle-class audience. But exhibitions were still run

under the Institution's auspices, so whilst sixteen artists were admitted as associate members in 1823, they were excluded from any form of management or control, such as hanging procedures. Professional men, suggested the Institution, could not be trusted to wield voting rights with the requisite 'disinterestedness' that connoted aristocratic conduct.

Control of the Institution's affairs, instead, resided in an inner circle of aristocratic directors, whose confidence, wealth and connections with the Board of Trustees served to place the Institution towards the centre of the field in the 1820s. Indeed, by 1826, the Institution was calling for the reintroduction of annual shows that displayed 'pictures preserved in private collections, country halls or colleges' (NG 3/1/1: 134). For it was in the display and judgement of ancient art, the Institution asserted – a practice 'more generally inherent in the well educated class of society'- that higher and 'purer' standards of taste could be reached ('pure' meaning, here, divested of the kinds of 'gratuitous', pecuniary impulses that drove artists). Predictably, when modern Scottish artists were praised, it was the likes of Jacob More, Gavin Hamilton and Alexander Runciman, with their classical abstractions and connections to 'the most esteemed masters of the ancient and foreign schools', who were singled out (EUL: Institution Catalogues and Misc. Pamphlets: 10).

Figure 5.1 Alexander Nasmyth, *Prince's Street with the Royal Institution Building under Construction*, 1825, National Gallery of Scotland.

By 1825, the Institution's position was further buttressed by an application for a Royal Charter and the implementation of a purchasing policy for old masters, prints, casts and books, secured by dealers sent to London and Paris. Since the French invasions of Italy, some important works had become available, and the Institution wasted no time in commissioning the dealer Andrew Wilson to procure pictures such as Van Dyck's *Lomellini Family*. Talk was of fostering a 'Gallery of National Importance' under the dominion of the Institution and of raising the taste of artists by providing them with traditional examples that would inspire history painting (Thompson, 1972). Further success was achieved in 1827 with royal incorporation and work began on the construction of a new dedicated building, designed by William Henry Playfair, sited at the head of the Mound and named after the new 'Royal Institution'.

Built in Doric style, with eight front columns and a portico, the building was to eventually house several semi-national institutions of learning and commerce in the city, including the Society of Antiquaries and the Royal Society. The Board of Trustees, whose responsibilities had been re-defined by directives in 1828 to include the fine arts, was given overall charge of the building, which was completed in time for the Royal Institution's fifth exhibition of modern pictures in February 1826. The Board also footed what amounted to a £47,000 bill and took residence in the building. Accommodation for exhibitions and the Board of Trustees' Academy was provided in the double-storey building and additional

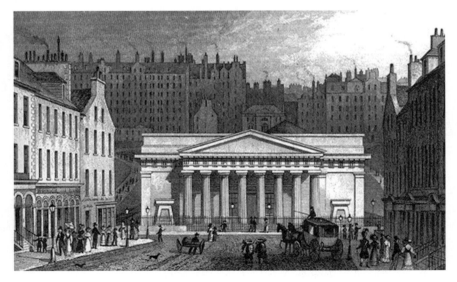

Figure 5.2 The Royal Institution Building, engraving by S. Lacy, 1826.

rooms for a library and committee room were built. It was the Royal Institution's galleries, however, which took centre stage.

The self-congratulatory tempo of the Royal Institution's reports at this time indicates an organisation at the height of its powers in the art field. It wasted no time in clarifying its intention to exist 'not as a Society of Artists, but for their benefit' (EUL: Catalogues and Misc. Pamphlets: 10/42–4), reiterating its desire to set up a permanent gallery and academy to train artists in its own image. Meanwhile, the artists' own energies towards independence and power were bearing less official fruit with the news that their application for incorporation had been scuppered, in turn fuelling rumours that the Board of Trustees and Royal Institution had short-circuited their application in order to retain a monopoly over the art field in the city.[1] In fact, the ties between the Royal Institution and the Board of Trustees were particularly strong. The Institution received its grant from the Board and cross-membership between them was high. While the Board was not merely a one-dimensional vehicle for classical aristocratic power (the encouragement of Scotland's economic infrastructure and its design school indicated a more commercially aware, compact civil elite, and at times the Board acted more like a pendulum, swinging expediently between the state, the artists and the patrons), it was very much open to the influence of the Institution. Furthermore, social trends suggested that landed power in Scotland – based on inheritance, old ties, land rights and property – was still significant by the second decade of the nineteenth century (Devine, 1990).

A further affront to the artists took the form of an exclusion from free access to the new galleries built on the Mound, reserving such privileges for the Life Governors only. All of which was topped by the inconsistencies over the status and whereabouts of proceeds taken from the previous modern exhibitions that were to be injected into a separate fund for artists.[2] From 1826 a series of memos and letters circulated between the three institutions that heralded the onset of overt conflict in Edinburgh and mobilised the artists into a more cohesive and offensive position in the field.

For a while, public battle had been joined in the city's newspapers between the patrons and artists: both claimed rights to the exhibition funds and cast aspersions on the taste and propriety of the other. As far back as 1825, a letter signed by artists such as Hugh William Williams, William Allan and Alexander Nasmyth raised 'doubts whether the Institution, in its present state, is of any material advantage to the Fine Arts in Scotland . . . there is no inducement held out to Scotch Artists, to send their works to the Institution, more than to any other Exhibition in which they have no concern' (NG 3/7/3/18: 11). Henceforth, the layered antagonisms of social class, aesthetics and institutional conduct had ceased to be latent, and spilled copiously into the city's public sphere.

1826–34: The Birth of the Scottish Academy and the Royal Institution in Decline

> The great upheavals arise from the eruption of newcomers who, by the sole effect of their number and their social quality, import innovation regarding products or techniques of production, and try to claim to impose on the field of production, which is itself its own market, a new mode of evaluation of products.
>
> (Bourdieu, 1996: 225)

Galvanised by the perceived injustice enacted on the faction, a breakaway group of twenty-four artists tendered their resignation from the Institution and canvassed others to withhold pictures from the Institution's modern exhibitions in order to gain independence from aristocratic tutelage. In May 1826, the first general meeting of 'The Scottish Academy of Painting, Sculpture and Architecture' was held. Academicians were to pay twenty-five guineas for membership and govern-ance of the institution was to rest in the hands of a central council, the President and the collective body of the Academicians.[3] As the Scottish Academy was attempting to hive off a professional sphere of artistic value that would recognise art *qua* art, certain guidelines were laid down in order to restrict the kinds of objects that would be exhibited. This represented a concerted lurch away from the pre-modern conception of art as a dedicated and functional activity or craft, and pointed up the Academy's authority to name, judge and categorise legitimate artistic practice. As long as art was attached to the imperatives of a patronal system of demand, art was presumed to 'sink to the level of the mechanic trades and handicrafts' (Roundrobin, 1826: 47). The new principles of 'vision and division' that accompanied the Academy's *nomos* (Bourdieu, 1996: 236) excluded from exhibition needle-work, shell-work, artificial flowers, cut paper and models in coloured wax, much to the consternation of the Board of Trustees, whose remit had been to encourage the 'useful arts' and 'artisans' (NG 1/2/8).

The Academy's inaugural exhibition of 1827, held at the Waterloo Place gallery, was a success, raising over £900 in entrance fees and picture sales (RSA catalogue, 1827). By 1828, this sum had increased markedly, prompting the Academy to claim it to be 'the most numerous Exhibition of Works of Art which has ever taken place in Scotland' (RSA Annual Report, 1828). Predictably, the catalogue attacked the Royal Institution as an 'auxiliary' that 'ought not to supersede or repress the combined efforts of the artists themselves', and reiterated professional autonomy as a cause worthy of struggle (quoted in Holme, 1907: x). Now, however, the Academy was emphasising the distinction of its own social position in relation to the possession of specialised knowledge and taste. The artists' symbolic capital,

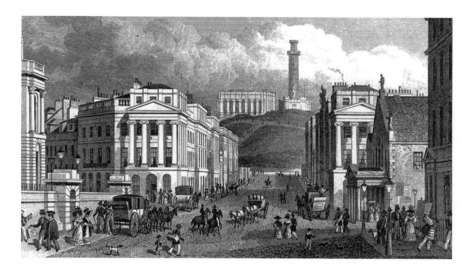

Figure 5.3 Waterloo Place, engraving by T.H. Shepherd, c.1830.

in Bourdieu's terminology, resided in their mastery of a newer game of art that had growing currency throughout Britain: of art as a specialised realm of meaning and classification and of artists as a distinct category of producers of symbolic goods. In the Academy's view, this necessitated lectures in aspects of painting, drawing, perspective and anatomy, a library and a school for aspiring professional artists, for all of which the Academy petitioned money from the Board of Trustees.

Clearly, power in the capital's artistic field was slowly shifting towards the Academy. Artists who previously had sought patronage under the auspices of the aristocratic Royal Institution now flocked to the Academy and its desire to replace the culture of an aristocracy (by birth) with an 'aristocracy of culture' (through knowledge) (Fyfe, 1993). For painting, in the Academy's eyes, could no longer reside in the sphere of the 'unpractised amateur' – the task would, therefore, be to reconceptualise art in terms of pictorial meaning and the artist's own authority (RSA Annual Report, 1825: 9). Unlike France, however, this wasn't to be achieved centrally, through strict procedures of training and normalisation laid down by an official state-backed institution, but by a steady professionalisation in civic-artistic life that grew out of a struggle for recognition and autonomy. In this sense, Academy artists in Scotland were the most 'radical' in the field – not yet the epitome of conservative academicism, nor artistic representatives of aristocratic ascription (like the Royal Academy up to the mid-nineteenth century) but members of a popular, urban, artistic assembly whose attacks on the traditional Royal Institution were assertions of an almost Romantic conception of the artist.

Such a conception was increasingly homologous with the sensibilities of Edinburgh's own growing middle-rank audience. Hence, enthusiastic acclaim greeted the Scottish Academy's annual exhibitions in the city's press and in art journalism. One critic enthused in later years:

> Our Art and Exhibitions are unquestionably the best things our country can boast. Put together our yearly crop of books, forensic speeches, and pulpit preachments, consider them, and then pass into the Academy's exhibition, and admit that the artists are clearly our best and cleverest of men. (Iconoclast, 1860: 4)

In contrast, the Royal Institution's civic popularity was being undermined by the growing antipathy towards aristocratic grandeur and older vestiges of patronal control. Certain newspapers, in particular, attacked the pomp of the Institution: 'To find such a body pluming itself upon its high honours and lofty position, and insulting the individuals to whom it is indebted for all that it possesses, is, indeed, a marvellous and somewhat revolting spectacle' (Monro, 1846: 110–11). *The Scotsman,* in addition, charged the Institution with exploiting public amenities – the gaslight which lit their evening promenades – for private purposes (*The Scotsman,* 25 March 1826). With the weight of this tide against them, the Royal Institution rescinded claims to the profits from the modern exhibitions in the summer of 1829, promising to make the library, life academy and collection available to the artists, and agreed, in principle, to provide exhibition space for the Academy. By the following year, the Institution was requesting assurances from the Academy that some members would still be sending works to the Institution's annual exhibitions, lest the whole event would collapse. The Academy's reply – 'they could not support the ensuing exhibition at the Royal Institution, without materially injuring the establishment with which they are more immediately connected' (cited in Holme, 1907: xii) – indicated an inversion of positions between patrons and artists.

The growing strength of the Academy, therefore, fed off the flowering confidence of the artists as a coherent social interest group, or a fraction in the field, whose position-takings appeared more and more to be supported by social trends in other fields, including the field of power as a whole.[4] A distinct middle-class culture was increasingly detectable in religion, politics, law as well as intellectual thought, cultural consumption and education (Nenadic, 1988), while the general expansion of middle-class occupations was secured by the expansion in domestic and overseas trade and the growth in urban manufacturing in Scotland's central belt.[5] In short, aristocratic traditions were being gradually chipped away by the vicissitudes of an increasingly urban society. Art itself was a site of competing class allegiances and used to facilitate the constitution of a more distinct sphere of

professional, bourgeois values. Hence, Cockburn's laconic attack on the Royal Institution can be read as a broader declaration of confidence in a progressive constellation of values in distinction to the vestiges of aristocratic control in the spheres of politics *and* culture:

> Begun under great names, it had one defect and one vice. The defect was that it did, and was calculated to do, little or nothing for art except by its exhibitions of ancient pictures which could not possibly be kept up for long, for the supply of pictures was soon exhausted. A rooted jealousy of our living artists as a body (not individually) by the few persons who led the institution was its vice. These persons were fond of art no doubt, but fonder of power, and tried indirectly to crush all living art, and its professors, that ventured to flourish except under their sunshine. The result was that in a few years they had not a living artist connected with them. Their tyranny produced the Academy; and then having disgusted the only persons on whose living merit they could depend, the institution itself sank into obscurity and uselessness. (Cockburn, 1854: 49)

This was the beginning of the end of the aristocratic Institution. Its 1832 exhibition of old masters at the Royal Institution galleries was conspicuous defiance in the light of the Academy's new-found success, but only thirty-nine pictures are listed in the catalogue and the whole event was far less popular in the city than the Academy's efforts. The Academy was even outshining the Institution with respect to the purchase of high-profile pictures. Its acquisition of a Rubens and several pictures by William Etty indicated the Academy's symbolic achievements in the field. Etty's *Judith and Holofernes* and *The Combat*, in particular, were significant guarantors of permanence and success in the Academy's eyes given Etty's renown and professional standing at the time.[6] The Institution's position, on the other hand, waned, despite its connections and possession of a £500 annual state grant.

So, where once the pact between *literati* and landed had melded Enlightenment culture, now the relative divergences between the older vestiges of a lesser and middling aristocracy and a newer more progressive bourgeois class were apparent. In effect, the key stimulant for motoring the art field in the early nineteenth century was conflict between two fractions previously co-existing in harmony. Certainly, the pointed struggles between orthodoxy and heresy, subversion and conservation, which, for Bourdieu (1993), represent a critical force in the evolution of the art field in France, were really the principal factor in the development of national art institutions in Scotland. In particular, the outmoded conception of art as craft, symbol of aristocratic virtue or handmaiden to patrician living was subject increasingly to the attacks of artists and critics who were aiming to insert art into a more professional field made possible by the market and by another crucial catalyst – Romanticism.

The Edinburgh Art Union, Romanticism and Landscape Painting in Early Nineteenth-Century Scotland

> The interference of patrons, in the character of guardians, is no longer admissible, and would therefore be impertinent. The arts have come of age, and can manage themselves.
>
> (Monro, 1846: 113)

Part of the impetus for the rise to power of the Royal Scottish Academy came from the formation of an organisation which was to have vital effects on the intensification of the modern art market from the 1830s on – the Association for the Promotion of Fine Arts in Scotland, or the Edinburgh Art Union. One of the first such unions in Britain, the Association, founded in 1834, boasted up to 6,000 members world-wide and extended the patronage principle to a more middle-class public in the city (Forbes, 1997). The Association based its very existence on principles of popular ownership and the failures of state patronage:

> In most other countries of Europe, where intelligence, liberality and refinement prevail, Painting, Sculpture and Architecture are under the patronage of the state and the sovereign; and it is always deeply to be regretted when a government does not appear to be sufficiently alive to the national importance of cherishing the Fine Arts. But the Association, by interesting the population at large, and by securing the dispersion of numerous works of Art throughout the country, does more than any Government could do towards extending among the people of Scotland such a love of art as must conduce to their own enjoyment and happiness, and to the proper encouragement of its professors.
> (Royal Association Annual Report, 1837–38: 4)

Members of the Association subscribed a guinea a year, the money being used to buy modern art, mainly landscapes, from the Academy exhibitions. The Association comprised a mix of lesser aristocracy, financiers, professionals and merchants, although a distinction was clear between the middle-class populism of the general membership and the more high-standing committee who chose the pictures and dictated policy. Members were provided with popular engravings and the chance to win a painting in the annual lottery and helped the artists gain prime position in the field by buying Academy pictures and distributing them by lot to subscribers. It also formed a fund to purchase selected pictures to become part of the National Gallery of Scotland's collection. These were the new patrons: modern, market-led and favouring the immediacy of localised pictures and genre scenes. Indeed, it was the Association that helped to support an emerging vision of the professional Scottish artist and of landscape painting in particular, based in the idiom of Romanticism.

Romanticism did not spring fully formed in early nineteenth-century Scotland, but came to develop during the latter half of the eighteenth century as a response to similar social and cultural conditions faced by a number of western societies. The paradox of its inception turns on the fact that it developed in the Enlightenment period of order, rationality, science and reason. In a sense, of course, it was a pointed repudiation of these values – a 'counter-movement' which stressed the mind, feeling, subjectivity and expressive freedom. There was, however, a complex intermeshing of Enlightenment and Romanticism which raises the possibility that Romanticism was the 'revolutionary reawakening of Enlightenment' (Brown, 1993: 46).[7] Still, the gradual shift to a Romantic 'structure of feeling' in Scotland did parallel the slow waning of empiricism and the certainties of a 'stable' civil society in tandem with rapidly changing social, economic and political conditions (Becker, 1994).

Romanticism in Scotland was given early expression through the work of certain writers whose elegiac scenes and characters were informed by an aristocratic rural simplicity. John Home's *Douglas* (1756) and MacPherson's translations of the poems of Ossian (1760s) portrayed a poetic Highland past and a remote, exotic world of rugged landscapes peopled by grand heroic characters. The popularity of these writings coincided with the zenith of Romanticism.[8] By the early nineteenth century, Scotland, in Hook's words, was a 'kind of romantic archetype', 'the most romantic country in the world', whose 'mythopoeic vision' was embodied in the works of the 'Wizard of the North', Sir Walter Scott (Hook, 1988: 317, 318, 316).

Scott's presence towers gigantically over nineteenth-century Scotland and it would be impossible to do justice to his significance here. The popularity of novels such as *Waverley* in 1814 and *The Heart of Midlothian* in 1818 has been attributed to Scott's focus on historical detail, costume and local setting. But equally significant was the bourgeois, quotidian quality of Scott's output, the inclusion of 'common' or 'middle of the road' heroes and the demise of the exclusive values of landed society (Lukács, 1962: 33). Scott exemplified the fact that Romanticism was a middle-class movement, the 'middle-class literary school par excellence, the school which had broken for good with the conventions of classicism, courtly-aristocratic rhetoric and pretence, with elevated style and refined language' (Hauser, 1962: 166).

In the visual arts, the transition from the smooth and pleasing views of the picturesque to the more Romantic trope of landscape representation followed the path which Scott had forged in his descriptions of wild, barren landscapes. Scott's literary evocations of the minutiae of highland scenery: 'ledges of rock', 'healthy and savage mountains, on the crests of which the morning mist was still sleeping', 'imperceptible notches', 'huge precipices', 'crags of huge size presented in gigantic bulk' (Scott, 1814: 144-5, 175), were firmly ensconced in the public

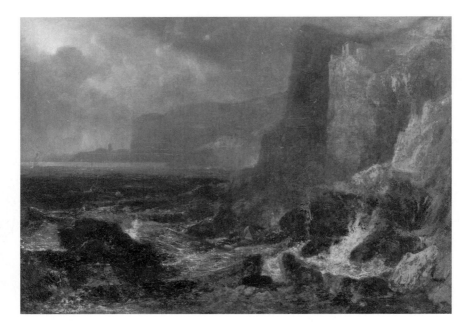

Figure 5.4 John Thomson, *Fast Castle from Below*, c.1824, National Gallery of Scotland.

imagination. Illustrations to Scott's texts by Joseph Turner, who collaborated with him in 1818, and the Reverend John Thomson of Duddingston, an Edinburgh landscapist and minister of the Kirk, began to convey a new enthusiasm for the bleak, stern, bold and solitary. Central to this enthusiasm was the unconventional style of rendering accidental effects in nature and the expression of subjective states and personal responses.

Thomson's expressive handling of weather and sea effects has been termed 'the first thoroughly Romantic treatment of Scottish scenery' (Williams and Brown, 1993: 133). But it was Turner's vigorous depictions of the maelstrom of nature in the Highlands, of nature as awe-inspiring and infinite, quasi-divine and transcendent, which provided the most full-blooded treatment of Scott's vision. The key ingredient to early nineteenth-century landscapes turned on the affirmation of subjectivity, of individual expression and feeling, of weather conditions, moods and affections. This paralleled the loosening of patronage as Academy artists were able to escape from aristocratic directives, practice in a variety of styles and produce for an anonymous market. Romanticism helped to further break down the hierarchy of genres according to which 'grand manner' or 'history painting' had been presumed to be qualitatively superior to still-life and landscape. As a rule, artistic value was coming to depend on individual subjectivity and creativity as

expressed in a swelling body of art criticism. Articles and commentaries in newspapers focused with enthusiasm on aspects of expression, genius and monadic authorship in describing the Academy exhibitions.

By the 1840s, landscape pictures in Scotland wholeheartedly embodied the 'rugged', 'realistic' and 'detailed' tendencies which were present in Scott. Shifts in ideas on landscape to the sublime aesthetic were supported by the rise of scenic tourism, itself dependent on the improved communications which made the Highlands accessible by train in the 1840s (Withers, 1992). Pictures still aimed to convey 'feeling', but in the Victorian period this was subjugated to the aim of conveying particularity and detail in recognisably local settings. Once characterised as vulgar, barren and barbarous by followers of the picturesque aesthetic, the mountains of the Highlands were now *de rigeur*. They represented solitude, the imagination, the soul, the infinite and the unyielding. They became the repository of a mythologised Scotland as the area was emptied and exploited for commercial gain.[9]

Horatio McCulloch (1805-67) was the most popular High Romantic landscape painter in Scotland. His idealised and particularised depictions of the Highlands

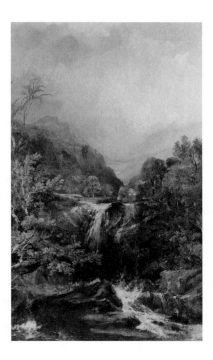

Figure 5.5 Horatio McCulloch, *Highland Landscape with Waterfall*, c.1850, National
 Gallery of Scotland.

from the 1840s eventually epitomised, along with those of Edwin Landseer, Scotland's abiding image, from within and without.[10] McCulloch was born in Glasgow but painted for most of his life in Edinburgh and gave true visual form to Scotland as 'land of the mountain and the flood'. Like other landscapists, McCulloch staged the Highlands as spatial repositories of counter-civilisation; of the pathos of a conquered province, but through a one-dimensional aesthetic which actually glossed over the trace of the modernising hand, urbanism and the rural poor.[11] The bourgeois penchant for verisimilitude and detail – the development of photography under the direction of D.O. Hill in Scotland progressed in parallel – found expression in McCulloch's exact observations of individual elements in the landscape. His portrayal of variations in the texture and surface appearance of rocks, water and greenery, for instance, signified a fidelity to the details of nature which reached an apogee in the 1850s and 1860s with followers of Ruskin and the Pre-Raphaelite Brotherhood.

Exemplifying the thirst for landscape pictures were the actions of the previously mentioned Association for the Promotion of Fine Arts in Scotland, from the mid-1830s. Before 1842, of the £22,000 spent on painting and sculpture of all types, about £12,700 had been spent on landscapes of one sort or another. And some of the highest prices paid were for landscape works. Especially adored were John Thomson and Horatio McCulloch and the works of these artists were often engraved and distributed among subscribers. In 1837–38, for instance, McCulloch's 'Loch-an-Eilin' was chosen to be engraved by the Association, whose committee justified the choice in the following terms:

> The recommendation this year was, that a work should be selected from the landscape department, which had long flourished in Scotland, and it would have been strange to him [the secretary of the committee] if it had not done so in a country such as this – a country the fit nurse of poetical imaginations – *the land of the mountain and the flood; a land which contains within itself all the features of loneliness, of majesty, and sublimity*; a land whose grandeur and beauty, both in the Lowlands and Highlands, has been increased by the increase of knowledge, and the progress of art, the useful arts themselves having shed additional beauty and grandeur on *the beautiful and sublime features of nature*. (Royal Association Annual Report, 1837–38: 124, my emphasis)

Similar tones of Romanticism coloured the activities of the Union throughout the period in question and fuelled the purchase of localised, detailed and 'sentimental' landscapes and seascapes. Academy artists quickly tapped into this burgeoning market, producing not for a sole patron but for the more impersonal market. The takings at Academy summer exhibitions which hardly reached £400 in the early 1830s, had risen to over £4,000 by 1838, including nearly £3,000 spent by the Association. Artists tended to paint what they knew they could sell at exhibitions;

and what they could sell at exhibitions, apart from portraiture, which was always popular, was landscape painting, broadly in the Romantic/realist idiom. Royal Scottish Academy catalogues show a rising quantity of localised, often Highland scenes from the 1830s, with titles such as: 'River Scene in Argyllshire', 'Scene at Pass of Ben-Cruachan', or 'Ben Nevis – Scene after a Thunder Shower'. Indeed, by 1838, Academy artists were clearly exploiting this thirst in the market, provoking the Union to complain that artists had put up their prices and that art was in danger of becoming a 'matter of traffic' (Royal Association Annual Report, 1838-39: 16-17).

Inspecting the broad effects which Romanticism had on the art world in Edinburgh yields a further observation. In Campbell's *The Romantic Ethic and the Spirit of Modern Consumerism* (1987) the author makes a connection between modern consumption habits in the late eighteenth and early nineteenth centuries and the cultural movement of Romanticism, which 'introduced the modern doctrines of self-expression and fulfilment' (Campbell, 1983: 279). Campbell's key claim is that the necessary motivations for a modern consumer society, which emerged alongside the modern producer society in Europe from 1750 to 1850, can be found in the doctrines of Romanticism. The Romantic emphasis on individual uniqueness, experience, feeling and detail provided, for Campbell, an intellectual justification for the consumptive mode – the limitless desire 'for more novel and varied consumptive experiences' (Campbell, 1983: 282). Freeing up the tropes of self-expression and individualism also shifted the emphasis away from con-sumption as an act of utility and morality towards consumption as an end in itself. The powerful notion of subjectively apprehended experience, in other words, along with the 'freedom of the artist to create without hindrance from traditional, moral or religious taboos and restrictions' (1983: 289), naturally induced forms of 'consumer sovereignty' in early nineteenth-century Britain – in particular, the freedom of the consumer *vis-à-vis* cultural products.

So, we might usefully make sense of the rapid concentration and aggrand-isement of the art market in the early nineteenth century by suggesting that individuals and artistic societies with the economic means to purchase works of art were now given the ideational motivations to do so with Romanticism. Despite, on the surface, perhaps disapproving of the 'will to possess' luxury goods like art (given the continued distrust of luxury and conspicuous consumption and the Presbyterian emphasis on temperance), the unforseen consequences of these individuals' actions were profound. The will to possess art works may well have been part and parcel of the need for the middle classes to exhibit their cultural capital and differentiate themselves from lower and higher classes. But key tendencies within Romanticism, in particular the stress on novelty, also gave these groups the inclination to buy up more and more works of art and embrace the exigencies of the market. Certainly, it was a key feature of the Edinburgh Art Union

that, either through engravings or through purchases at exhibitions, members were given a variety of choices to own new works of art. When a new purchase or engraving was made, its novelty value was highly played. A perpetual cycle of artistic consumption was consequently (and, perhaps, ironically) set in train.

Moreover, one of the outcomes of the commodification and romanticisation of the landscape idiom in the early nineteenth century was the proliferation of visual media which depicted nature or landscape. As well as illustrations in novels, engravings and photography, the 'spectacle of nature' was widely disseminated through fine art books, travel and tourist literature, guide books, mementos, postcards, souvenirs, relics and stationery (Green, 1990). Landscape images were a recurrent feature of urban luxury commodities now being purchased by a visually hungry middle class, itself partially freed from the restrictions on consumption and the taboos on free time.[12] The aestheticisation of the landscape and the Highlands, of course, was a process with long historical roots, but from the 1840s the scope of the commodity was broader than ever. Queen Victoria's Scottish excursions (which reached a peak with the purchase of Balmoral in 1848) accelerated the pageantry of tartanry and the cult of a non-threatening Jacobitism which has had lasting consequences on Scottish national identity. But a by-product must also have been the production of an internal middle-class public well versed in the codes of landscape representation and the image in general. Hence, from the mid-1830s, when the Scottish Academy had staged regular exhibitions in the capital, an appreciative, informed audience possessed of the correct faculties for approaching such images may well have been formed, in part, through this visual phantas-magoria of nature. In other words, as Edinburgh's gallery spaces were being sited in the 1840s and 1850s, so an urban constituency of gallery-goers equipped with new modes of visual consumption was 'sighted', in the sense of being familiarised with a 'purer' aesthetic and the visual.

The point, of course, should not be overstated. The primacy of the ocular and the ability to 'appreciate' gallery art was also dependent on a whole set of other considerations – class distinction, art education and the appearance of other visually orientated media in the lives of the urban middle classes such as theatres, magazines, shops and so on. But to deny the salience of Romanticism and the landscape trope would be to deny a prime cultural force in the maturation of the art field in early nineteenth-century Scotland. The role of Romanticism was to act as a catalyst and a cultural legitimator whose presence galvanised the development of the market, legitimated the role of the artist and fed the thirst for certain types of visual images in the city. Its effect, when conjoined with the potent landscape idiom, was to sustain the momentum begun by civil society and the Enlightenment towards cultural achievement. Landscape imagery was not merely the reflex of a contemporary obsession with the countryside but was part of the ideational complex that motivated cultural forms. Despite losing impetus from mid-century

its initial drive was enough to keep the art world in motion. And in accordance with the role it played in other European countries, Romanticism – not necessarily the 'revolutionary' Romanticism of England's Shelley and Byron, nor the politically motivated separatist movement of new nations, but the domesticated and therefore widespread movement of Scott and McCulloch – was to open up new possibilities for the development of art institutions in Edinburgh. It articulated with the movement towards autonomy to provide the Scottish Academy and its allies with valuable cultural support.[13]

1834–47: The 'Royal' Scottish Academy, Altercations Over Space and the Foundation of the National Gallery

From 1834 to 1847 Romantic aspirations towards independence were heavily implicit in the Academy's continuing struggles for cultural authority. On the grounds that art could only be furthered with the specialised knowledge of professional agents, the Scottish Academy petitioned the Board of Trustees for public money, permanent exhibition space and the possibility of a life academy, a more relevant form of training in the 'higher arts' in the Academy's view. After all, declared the Academy, the Royal Institution continued to receive a £500 annual grant and yet possessed no 'professional experience' (NG 1/73/13/1: 10). Furthermore, both the Royal Academy in London and the Royal Hibernian Academy

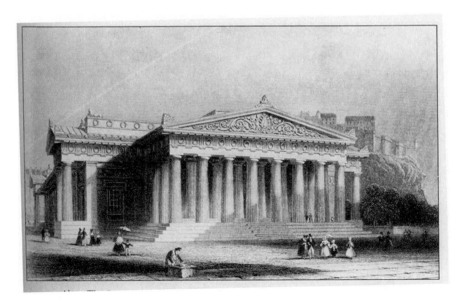

Figure 5.6 The Royal Institution, engraving after George Meikle Kemp, c.1835.

received public funds, the latter an annual sum of £300. The Board's reply to the Academy was tepid: access was granted to the Board's 'statue gallery' on four days a week and agreement to have the Royal Institution's south octagon room for the annual exhibition was given, but no guarantees of official backing or any degree of permanence to these arrangements were made (NG 1/73/13/2).

Despite being extended by sixty feet, space in Playfair's Royal Institution building was becoming increasingly scarce by the late 1830s. The rooms were used by the Royal Society, the Society of Antiquaries, as well as the Board of Trustees, the Royal Institution and their respective collections. The Board's design school – the Trustees' Academy – was also resident in the building, its head being chosen from the ranks of academicians. Tensions were further heightened on the acquisition of casts of the Elgin marbles from the British Museum in 1837 (the earl being an active member of the Board) and two hundred and fifty casts of Greek and Roman portrait busts from the Italian Fillipo Albacini.

Clearly, the possession of exhibition space in Edinburgh was a principal stake in the field by the late 1830s because it was emblematic of the power to 'name', classify and divide art, to consecrate favoured artists and to have a series of symbolic goods recognised as legitimate by an audience. Disharmony, therefore, increasingly revolved around who had access to and control over dedicated art

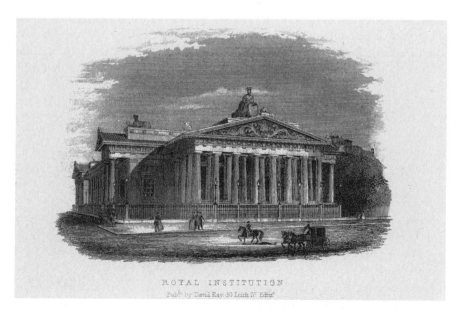

ROYAL INSTITUTION
Pub. by David Hay 30 Leith St Edin.

Figure 5.7 The Royal Institution after Playfair's additions, engraving by David Hay, c.1840.

rooms. On the one hand, the Academy's position in the struggles over space was supported by the official apparatus of governance in London in the movement away from aristocratic control. In 1838, the Academy was finally successful in its application for a Royal Charter which fixed its constitution and laws. On the other hand, however, the Royal Institution and Board of Trustees had residual hold over accommodation in the Royal Institution building and used their official standing in the field to make the Royal Scottish Academy's position uncertain.

In 1844, for instance, a picture by the son of Thomas Dick Lauder, secretary of the Board of Trustees and the Royal Institution, was moved by the Academy council to a less visible position in the annual exhibition. This set in train a series of disputes over who had control of the building and command of the knowledge of hanging procedures. For the Academy defended their decision with respect to the 'nature of the colouring throughout the picture, which seriously injured the effect of the exhibition at that place . . . its discordance with the surrounding pictures' (cited in Monro, 1846: 11), and thereby revealed their territories to be based upon art-knowledge. The Academy, in other words, claimed the right to exclude Board and Royal Institution members from access to their exhibition space before exhibition, in order to 'purify' the art space and retain independence.[14]

The Board, on the other hand, claimed that the Academy had acted interestedly and that: 'no public confidence can be placed in future in a council which can allow . . . the judgement of its Hanging Committee . . . to be swayed and over-turned by every unworthy intrigue that may be originated by selfish individuals in the body which it ought to govern' (quoted in Gordon, 1976: 100). Sir Thomas Dick Lauder, in particular, argued that access to the galleries must be constant since the Board could not surrender control of the building to a 'series of individuals changed every year, and of whose habits and even names they are ignorant!' (quoted in Maxwell, 1913: 239). As the Board's position in the field had been dislodged by an attempt to exclude them symbolically and physically from the Academy's exhibitions, a show of strength was chosen by the Board's traditional members to reaffirm its status as landlord, official treasury for the fine arts and institutional gatekeeper. The Board's impulse towards conservation translated as an attack on the artists' impulse towards autonomy and modernity – 'ungrateful rebels' who were changing the rules of art forever.

The most controversial disagreement, however, was reached with the Board's final broadside at the Academy in the guise of an effective 'notice to quit' from the galleries of the Royal Institution. In 1845, the Board took custody of the Torrie collection of 'ancient masters' from Edinburgh Town Council and vowed to place the collection on permanent display in the exhibition rooms at that time used by the Academy for the annual shows. This was to be exhibited *gratis* to the public at least two days a week, to become the nucleus, in the Board's view, 'of a kind of national Gallery of paintings . . . which may be daily expected to increase without

any expense to the public' (NG 1/1/38: 137). The work of the 'ancient masters', in other words, was being deployed as a symbolic resource by the Board and Royal Institution to displace the incursions of the modern artists and the increasing popularity of the Association for the Promotion of Fine Arts. Lord Meadowbank's attack on modern art is caught, for instance, in the following:

> This fact [the inflation of modern art] is proved by a circumstance altogether indisputable, that the Association for Promotion of the Fine Arts have year after year been reduced to the necessity of purchasing and distributing as prizes from these exhibitions many pictures which few would ever think of suspending upon their walls from their great inferiority . . . I submit it to be expedient because it has a direct tendency to increase the number of bad painters, and a depraved taste for Art among the people, which it has been the object of the government and the Board to prevent by the establishment of the School of Design and the Exhibition of Ancient Pictures. (NG 1/1/38: 186–96)

The ensuing legal battle between artists and patrons over accommodation was compounded by a series of public disputes in the city's press and in the correspondence between the various institutions. From the artists' perspective, the very purpose of the building was to hold modern exhibitions, and it was partly the success of these that provided the Royal Institution with the means to buy the old masters and to acquire a library. However, the way the affairs of the Board and the Royal Institution had been co-ordinated under the auspices of a small coterie of traditionalists had undermined the rights of the Academy. The appearance of separateness was, indeed, a favourite device employed by the Board and the Institution to use in official representations and in grant applications. 'In reality', wrote David Scott, RSA, the Royal Institution was 'a mere appendage of the Trustees; and in this transaction the one is so mixed up with the other, that each may be considered to represent the other' (Scott, cited in Monro, 1846: 8). Nothing less than a thorough investigation of the accounts and minutes of the Royal Institution would reveal the injustices enacted on the artists, declared the Academy, who wrote to the Treasury and the Board of Trustees to such an effect.

Precisely because of the Academy's growing influence amongst a widening art public, its interests were taken up by key institutions and individuals, including Edinburgh's Lord Provost, Henry Cockburn (Solicitor General), the London Art Union and influential newspapers such as the *Edinburgh Evening Post*. It was the Provost and Sheriff of Edinburgh, for instance, who modified the agreement under which the Torrie collection was to be displayed in order to allow the RSA requisite space during exhibition season. Moreover, key members of the Board itself were gradually moving towards the Academy's position, and new appointments made to the Board by the Treasury included Academy members in key posts. The public's general sympathy with the Academy was clearly evident in the series of

articles and letters that appealed for public support and defended the artists against the 'eviction order' served to them in 1845. Sheriff Monro's summaries of the conflict were, in fact, so popular that a collection of the essays, with appended documents, was published in Edinburgh in 1846.

More symbolic power accrued to the Academy with the results of the accountant's report into the whereabouts of the profits of the Royal Institution's modern exhibitions. Concrete documentation had been supplied by the RSA to show how the Royal Institution had creamed off profits from these shows in order to build up their own library and collection of old masters. The Institution's initial response to this was to publicly charge the artists with 'wilful and deliberate falsehood'. Now they had to retract this charge and the imputations made against the President and the council, and accepted inconsistencies in their handling of the profits. The violations of the Royal Institution were now publicly aired, placing the Board itself in a very precarious position. By this time, news of the growing conflicts north of the border had reached state offices in London, whose response to the growing mess was the ordering of an official inquiry into the positions, histories and claims of Edinburgh's various art institutions and the search for a solution.

The British State and Edinburgh's Art Field

> The practical result of the circumstances which I have brought under your Lordships' notice, with respect to the Royal Academy, is, that Edinburgh presents to us the remarkable phenomenon of an existing Royal Academy of Fine Arts, chartered by the Crown, which has not the opportunity of carrying on an exhibition of Modern Art, and which is practically excluded from all share in instruction in that important branch of knowledge.
>
> (Sir John Shaw Lefevre, Government Report, 1847)

The state's intervention in art matters in Scotland represents a distinct phase in the history of the field. Despite stronger state involvement in social policy – the poor laws and school inspectors for instance – Westminster, on the whole, appeared remote from Scottish affairs in the early nineteenth century (Paterson, 1994). The real controllers of Scotland were figures such as the Lord Advocate, lawyers, professionals and aristocrats. Social legislation was very often administered through supervisory boards, or local and national committees in a system of trusteeship. After all, the British state was too preoccupied with matters of Empire to get too involved in the daily running of the territory north of the border; and there was little threat of nationalist uprisings, for Scotland's 'dual national

consciousness' (both British and Scottish) contrasted markedly with separatist nationalism elsewhere (Nairn, 1974). London, then, intervened only when invited to do so by Scottish factions. The tendency was for local MPs to deal with Scottish affairs outside Parliament and then to notify the full house for formal ratification. In a sense, Scotland possessed its own quasi-state inasmuch as all the key elements of an official rule-making system were in place and domestic governing structures resided in the burghs, counties and civic institutions (Paterson, 1994).

If Scotland did not possess a formal state, then, it was still able to operate within an enabling framework that gave it similar powers. Scottish professionals, on the one hand, were sceptical of unwieldy state bureaucracy, but, on the other, perfectly willing and effective players in civic and national life. Their governing institutions were those that developed out of the powerful configuration of civil society, sometimes transposed into a philanthropic key resonant with ideas of individual responsibility, social welfarism and localism. Influential Victorian moralists saw it as the duty of a strong middle class to protect the 'weak'. The state, in other words, should only provide the institutions through which the philanthropic venture could be consolidated. The Evangelical Thomas Chalmers, in this connection, espoused a kind of *laissez-faire* principle of welfarism that seemed to develop aspects of civil society, science and Protestantism, with a desire to upgrade the sentiments of the lower classes (Smith, 1983).[15]

What is clear is that the building of a Scottish infrastructure depended on a permissive framework that, while borrowing from English models and examples, retained a distinct profile and local complexion. In this respect, sub-statist groups moulded older facets of civil society in order to offer provisions which they felt the state would have a duty to offer. Such rational self-government pulled in Enlightenment reason and civil society to construct a modern, local version of national community:

> The governing institutions were part of civil society and were often informal: as was common throughout the highly decentralised British state, they were the creation of localities rather than impositions from the centre. (Paterson, 1994: 71)

But how far is this true with regard to Scotland's art field? Well, the situation of Edinburgh's art world seemed to reflect the mixture of autonomy, tentative supervision and indifference from the state that characterised nineteenth-century Scottish civil society as a whole. State–art relations in Scotland can be approached, therefore, as a more acute version of autonomy to that pertaining in England. The conflicts that fractured the art field in the early nineteenth century were conflicts internal to Edinburgh, between official patrons with a conventional idea of artistic provision and modern artists seeking the establishment of a more innovative game

of *fine* art. Hence, there were duller and less frequent forms of official intervention than elsewhere, and state directives were very often mediated by local personnel. While the Board of Trustees was ultimately responsible to the Treasury, it operated with a high degree of autonomy and local power, particularly from its inception in 1727 until the 1830s. It was often successful in resisting attempts at government deregulation and interference, defending its right to distribute funds in a way befitting the station of its members. Indeed, communication was often so poor between the state and the Board that the latter had to rely on its members who happened to be MPs (such as Lord Melville and the Duke of Buccleuch) to gain crucial information on policies that directly affected the Board itself. The Board was, in fact, very rarely mentioned in Parliament, but left to its own devices, with legislation so loose in direction that it allowed a great deal of interpretation at the Scottish end.

Similarly, for the period up to the late 1840s, Edinburgh's other art institutions enjoyed a degree of institutional freedom from the British state that was rare elsewhere. The Royal Institution may have received its £500 from the Treasury, via the Board of Trustees, but to all intents and purposes operated as a private members' institution. At the same time, the Academy's affairs were little known in Parliament up to the 1840s – a situation that was both expedient and an annoyance to the Academy. The Academy's affairs could be misrepresented by the Board and the Royal Institution which both had more official leverage; however, the move towards autonomy as a whole by the Academy was based on the pretext that official bodies such as the state would entrust art to the professional nurturing of the artists themselves. Complaints about English indifference coexisted, then, with contentment for independence.

On the whole, however, in matters of art, as in other matters, governments awake when local, private issues threaten to billow into public domains, accelerated in this case by the widening of art to a broader audience (Fyfe, 1993). By the 1840s, then, there *was* a development of state intervention that reached a high with the government inquiry into the affairs of Edinburgh's key institutions in 1847, as the altercations threatened to spill over into the visible domains of civic and national life. Intervention, then, can be read as state pragmatism in the face of internal conflict north of the border and one suspects that the government would have reacted further if the situation had called for it, just as it would have in civil society in general if Scotland had threatened with revolt or nationalist insurgence. In the background was the state's growing desire to police the boundaries of culture under the auspices of rationalisation, democratisation and the construction of a national state-arts apparatus, which reached a climax in 1851 with the Great Exhibition and the South Kensington complex of museums, schools and collections (Fyfe, 1993; Pearson, 1982; Minihan, 1977; Corrigan and Sayer, 1985).

As it stood, the report into the affairs of Edinburgh's art field by the secretary of the Board of Trade, Sir John Shaw Lefevre, was extensive and far-reaching. The Academy was to label the report 'one of the most important documents which have ever come under the Scottish Academy, and may be said to constitute an era in the history of Scottish Art' (RSA Annual Report, 1847: 9). Indeed, it was the Academy which came out of the report the best. £10,000 was to be earmarked out of the Board's funds to be given to the RSA for them to build their own galleries. The RSA was to have its own life academy, for its own pupils, and given a brief to teach those of the Trustees' Academy. The separation between 'design' and 'fine art' was sanctioned by the state in the recommendation that the RSA's life class was to stick to painting and drawing from the model, whereas the Trustees' Academy was to concentrate on craft, the antique and commercial design. In the meantime, until the building had been erected, the RSA was to have use of the galleries in the Royal Institution building for its exhibitions and teaching. The RSA was recognised as a 'body of importance' in Edinburgh, with two of the inquiry's comments reading:

> Ist. The giving to the RSA, which must be considered as the representative of the artists of Scotland, its due position in reference to the promotion and teaching of the Fine Arts ... 4th. The restoration of harmony and good feeling between the Scotch Royal Academy, comprising the principal professors of Art, and the Board of Trustees and Royal Institution, comprising the principal promoters and admirers of the Fine Arts in Scotland. (Lefevre, 1847: 12–13)[16]

In effect, the inquiry executed the *coup de grâce* on the Royal Institution, taking away its grant and declaring its private collection to be national and public. For a time the Treasury and MPs had been writing to the Royal Institution with requests to 'democratise' conditions of access to its collection and provide cheaper catalogues. Now, all of its power was devolved to the Board of Trustees, and its collection of old masters given to the Scottish nation to comprise part of a new National Gallery of Scotland collection. This was to be permanently displayed in the Royal Institution building until such a time as the RSA had been rehoused in their new building. As the inquiry stated:

> In consequence of the establishment of a National Gallery, my Lords assume from the correspondence that has taken place upon the subject, that the objects of this, at the time it was established, most valuable institution – forming, as it has done, the real foundation of the National Gallery – having been otherwise provided for, neither the rooms occupied, nor the grant received by them, will be any longer required. (Lefevre, 1847: 551–2)

In curtailing the privileges of an outmoded aristocracy, the state reinserted the objects of a history of private patronage into the public domain as 'national art'.

Slowly, the Institution's accounts were wound up and their powers dissolved, despite symbolic resistance from Lord Meadowbank and some final spectacular purchases: Veronese's *Last Supper* and *Mars and Venus* and Zurbaran's *Immaculate Conception*. Their erstwhile partner-institution, the Board of Trustees, ignored a last-minute plea to retain the £500 grant, and articulated the need for economic rationalisation in relation to its new duties to look after the National Gallery. The Board thereby requested that all ties and accounts between the two institutions be cut.

As for the Board of Trustees itself, the social composition of its membership and its brief had been slowly re-shaped in favour of closer alliance with the RSA. By 1850, D.O. Hill, Lord Cockburn, John Watson Gordon and John Steel, all RSA members, had been appointed to the Board, which no longer comprised of upper and middling aristocracy (lords, dukes, earls), but of the baronetcy, professionals and financiers. Indeed, the Treasury had written to the Board asking it to appoint artists to its membership in order to include an 'artistic element' within the Board's affairs (NG 1/73/23/11).[17] Still, the dual purpose that had always characterised the Board (the promotion of fine arts and commercial design) was intact inasmuch as the Trustees' Academy continued to instruct in 'practical skill', 'industrial design' and the principles of 'decorative and ornamental art' (Lefevre, 1847: 10). For the time being, the state was content to sanction this dual role, although by 1858 the autonomy of the Trustees' Academy was further diluted when it was affiliated with the Department of Science and Art in London as a government school of design. The Board was henceforth entrusted with the foundation and development of the National Gallery of Scotland, its status flattened to guardian of a collection forged in the struggles between various institutions over which it adjudicated.

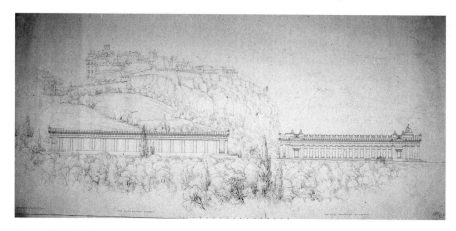

Figure 5.8 William Henry Playfair, Eastern Elevation of Royal Scottish Academy and National Gallery of Scotland with Castle Rock, 1848, Edinburgh University Library.

Eventually, Lefevre's proposals were applied, but with some notable modifications. For the purposes of rationalisation, the building was to be shared between the Academy and the National Gallery collection, as it was for a time at Trafalgar Square and, indeed, at the Louvre. William Henry Playfair was to build the edifice in neo-classical style on the Mound, to the south of the Royal Institution building, from 1850, with funds provided by the Board, but also a £30,000 government grant. Despite being voted down on grounds of expense, Parliament eventually ratified the foundation of the gallery, to provide 'opportunities, which cannot be over-estimated, of rational amusement, mental cultivation, and refinement of taste' (Lefevre, 1847: 15).

For a while, the RSA was still cautious of its position, having been promised its own dedicated building; but all fears were laid to rest on assurances from the Lord Provost and the Treasury as to the Academy's importance in education as well as in 'improving taste'. Furthermore, no rent was to be charged to the Academy and the curator of the National Gallery was to be chosen from a short-list of Academy members, 'for the beneficial and harmonious working of the National Gallery, and for securing the confidence of the public' (NG 1/1/41: 327). All of which, in effect, delivered a kind of art world monopoly to the Academy.

The National Gallery of Scotland was founded on the fissured terrain that was Scottish and British social and cultural history. Its presence threw into relief centuries of poverty, uncertainty and conflict – a symbol of civic and national well-being, bourgeois confidence and state guidance. It grew on the fertile cultural soil of civil society, later reconfigured in the context of Victorian self-reliance, Romanticism and class conflict. It was the summation of pointed struggles for recognition amongst a modern group of artists, whose claims to space, coupled with a desire for autonomy, placed an incendiary in the field. Such struggles between the 'ancients and the moderns' mirrored those of elsewhere, and, in this sense, the broad cultural game was recognisable. In Ireland, for instance, a similar divergence can be found between the Dublin Society, comprised of aristocratic patrons, and the Royal Irish Academy, who were artists striving for artistic authority.[18] As Bourdieu (1993) notes in 'The Market for Symbolic Goods', the enduring friction between artists/intellectuals and aristocrats/patrons over legitimacy is one correlative with the growing complexity of the field and therefore with the growth of consumers, agencies and other modern art institutions. To this extent, the conflict in Edinburgh's art field matched the conflicts of complex fields elsewhere.

If the fact of struggle was universal, however, the details were distinct, local and Scottish, and some of them I hope to have revealed. The National Gallery of Scotland was both a concession to the Scottish art field (mainly the RSA) and a solution to the conflicts which had dogged it for the last half century. To an extent, the gallery was less a centralised, state-run organisation of the continental type, a

space of republican or nationalist victory, and more of a fragmented hotch-potch of influences with a trustee-based management. If 'national' is understood in its limited meaning of relating to a state, then the gallery was 'non-national'. However, that the relevant institutions saw themselves as progenitors of both civic and national ideals speaks of the currency of eighteenth-century ideals of civil society – of provincial government, national improvement and semi-autonomous cultural organisation.

The collection itself reflected this: not based on a state purchase like the National Gallery in London, but made up of the Torrie Collection, the Royal Institution's collection of ancient masters, pictures acquired by the Edinburgh Art Union, Academy pictures and the casts and pictures owned by the Board itself. The building contained two parallel sets of rooms, five in each set. The western rooms were dedicated to the permanent exhibition of the collection of national pictures, the five eastern rooms devoted for the use of the Academy. The continued distance of the British state was not only evident in the fact that it provided only a portion of the public funds for the building, but also clear from the debates which preceded the final decision to start work on the gallery. Hence, in the House of Commons, in 1850, MPs voiced opposition to the building on the grounds that: 'There could be no justice in giving to the city of Edinburgh the sum of £25,000 for an object in which the rest of the country had no interest'; and that 'far greater claims for the vote of this nature' were had by Liverpool, Manchester, Leeds and Birmingham (*Parliamentary Papers*, 1850, vol. CXIII).

The gallery's foundation stone was laid in August 1850 by Prince Albert to an elaborate civic-national ceremony. A bottle was buried at the site, into which were put mementos from the relevant institutions. So very aptly squeezed together in a fragile space were placed objects from the RSA, the Royal Institution, the Board of Trustees, the Lord Provost of Edinburgh and the Edinburgh Art Union. Prince Albert's speech praised the 'rigour' and 'independence' of industry, and reinforced the practical advantages of extending the scope of the 'younger and weaker sisters the Fine Arts' to a broader population and the improvement of the British nation as a whole (NG 1/1/39: 212).[19] That such rhetorics of nationhood and universal access veiled the gallery's status as symbolic capital – a cultural space that served to elevate the 'pure', 'high' and 'refined' and abjured the 'low' and 'vulgar' – forms the basis to the final chapter.

Notes

1. The Academy complained that its first petition for a royal charter was rejected on the grounds that the Scottish Lord Advocate, Lord Meadowbank, had interfered. The Prime

Minister, Robert Peel, believed the Academy to have 'the interests of the Fine Arts in Scotland most sincerely at heart, and that, had it not been for the "decided and unequivocal opinion" of the Lord Advocate "that it would not be expedient for the Secretary of State to advise his majesty to grant a Charter of Incorporation to the members of the Scottish Academy", he would have most cheerfully recommended that Association to the protection and patronage of the Throne' (Scottish Academy Annual Report, 1828: 21). This situation recalls the autonomy which Scotland had over its art matters in this period – that the Prime Minister and his Westminster advisors left decisions regarding patronage to indigenous personnel. But even though the Lord Advocate held an official post as controller of Scottish society, he was also a member of the Board of Trustees and the Royal Institution. Hence, his decisions in art matters were clearly swayed.

2. According to the artists, the Royal Institution had promised support for Scottish artists and, in the 1826 catalogue of modern pictures, the possibility of an amelioration fund for artists and their families was raised (SRO, Catalogues and Misc. Pamphlets: 10/42–4). From the artists' perspective, this proposal was reneged, despite the popularity and commercial success of the modern exhibitions comprised of their works. In fact, the Royal Institution had decided to pool all profits made in the modern exhibitions into a general fund, without separation, to be expended 'in whatever manner shall seem advisable to the directors' (NG 3/1/1: 155).

3. Three categories of membership were announced, as with the Royal Academy in London: academicians, associates and associate engravers, although the Scottish Academy was significantly different from the London institution in terms of social composition, power and aesthetic motivation: it was certainly less patrician.

4. This is to recognise that 'the internal struggles always depend, *in outcome*, on the correspondence that they maintain with the external struggles – whether struggles at the core of the field of power or at the core of the social field as a whole' (Bourdieu, 1996: 127). In fact, in a field like Edinburgh's, which only set out on its journey to autonomy in the late eighteenth century, the 'space of possibles' was still heavily reliant on developments in the broader field of power. For instance, many of the Academy's most powerful members were also lawyers, doctors, academics and MPs who wielded their economic capital alongside their cultural capital. Indeed, Bourdieu identifies the existence of agents who occupy 'median positions, almost equally rich in economic capital and cultural capital (the liberal professions like doctors, lawyers and so on)' (Bourdieu, 1996: 259-60) and whose field strategies tend to be 'transversal'.

5. This was validated politically, of course, by the Great Reform Act of 1832, the Scottish version of which was drawn up by Henry Cockburn, legal champion of the Academy (Cockburn, 1854).

6. Indeed, William Etty visited the Academy in 1844 and praised the artists for their 'independent exertion of mind unawed by fear and uninfluenced by favour . . . the Artists . . . are undoubtedly the best judges of what Art requires' (reprinted in Monro, 1846: appendix XXII: 110).

7. Hume's dictum that 'Reason is and should be the slave of passions' is a cursory indication of this relationship, but so is the landscape painter Alexander Nasmyth's career and the modes of fancy, history, realism and social observation that intermeshed in the work of Sir Walter Scott.

8. So, whilst Ramsay's *The Gentle Shepherd* was written in 1725, the height of its fame was between 1780 and 1820 when Romantic attitudes began to take hold in literature and the arts.

9. 'We have reason to be proud of our northern land', opined one Academy review, 'not only because it numbers many native painters of unchallenged excellence, but because its whole people are generally conscious of the magnificence that has its home in our "Caledonia stern, and wild, fit nurse for a poetic child"' (*Edinburgh News and Literary Chronicle*, Saturday 26 March 1859).

10. To this extent, McCulloch came to play a similar role in Scotland to that which Constable had played in England, but using Highland mountains instead of rustic settings and rolling valleys (Holloway and Errington, 1978).

11. The export of black cattle, the commercial programme of enclosure and modern techniques of commercial agriculturalism, which transformed the Scottish countryside from the late eighteenth century, for instance, were disavowed. As Nenadic suggests in this connection: 'The speed and extent of change, coupled with the existence within Scotland – in the Highlands to be precise – of the purest European manifestation of the romantic ideals of the undisturbed, sublime landscape and primitive peoples, grasped the attention of Scots, English and Europeans alike; not least because such ideals of landscape and people, which were constantly invoked by fiction and art as an integral part of Scottish national identity, were being rapidly destroyed by advancing capitalism' (1994: 166). The myth of the Highlands, therefore, concealed the harsh realities of Scottish urban living and helped disseminate an idealised regional image of a peaceful rural Scotland.

12. Fraser (1990) indicates that in Scotland, by the 1840s, 'among the bourgeoisie there appeared a much more systematic pursuit of leisure, as something quite separate from home and work. Once frowned upon as signs of the innate idleness of the labouring classes or of dissipation among the aristocracy, recreational activities began to attract middle-class attention as a rational, moral way of filling increased leisure time' (1990: 38). The impact of the Romantic ethic may well have been significant in this.

13. This point can be concretised with a brief contrast between Germany and America. Romanticism in the former country emerged in the eighteenth century as an artistic, literary and philosophical movement with absolute impulses towards the artist's need to succumb to interior feeling and the hermeneutic (Hauser, 1962). Apart from the security of the artist which this expression implied, one of the outcomes of the German Romantic movement was the building of galleries as spiritual temples to art. In America, on the other hand, for various economic, social and cultural reasons, Romanticism came in a weaker form and later, as did its art museums. The crucial dynamic of a vigorous bourgeois art field was absent in America, until middle-class power was secured and literary Romanticism had begun to make inroads into the popular imagination. The irony, here, is that, as Lehmann (1978) and Hook (1988) have indicated, this form of Romanticism in America actually came to derive from the influence of Scottish Romanticism.

14. The defence of a 'pure aesthetic' was fast becoming the Academy's *raison d'être*: they were defending a 'disinterested view for the promotion of Art which are [sic] inwoven with its existence . . . and that an ardent devotion to the cause of Art on the part of the Academy, as a body, is the only effectual and permanent mode of securing the interests of the Artists themselves' (RSA Annual Report, 1844: 8).

15. Chalmers' desire was for a kind of local ethical state that promoted improvement and the diffusion of useful knowledge based in Protestantism and science. Modes of civility centred on domestic life could be used to promote a kind of 'popular enlightenment' that would be secured through the beneficial effects of libraries, museums and parks, instead of the alehouse or gambling den. Indeed, Gramsci's description of the ethical state appears to fit quite closely with the tenor of middle-class welfarism in Scotland from mid-century –

the inculcation of bourgeois norms and thereby the temperance of radicalism and potential insurgence. Only the broad principle of self-reliance permeated Edinburgh's art institutions, however, for social welfarism and the philanthropic venture found outlets in Thomas Dick's 'mechanics institutes', George Millar's writings and Chalmers' evangelical programmes of moral improvement (Smith, 1983). Like England, systematic programmes of reform in Scotland gained momentum by the latter nineteenth century; for now, it was imperative for the middle-class cultural elite to create an artistic space between patrician abundance and popular vulgarity that marked this group as refined, modern and distinct.

16. As for the Edinburgh Art Union, the use of the lottery as a means of organising the distribution of pictures had come under question by the mid-1830s, to the extent that Westminster sought clarification of the constitution, composition and history of the Association with the House of Commons Select Committees of 1836. The Association defended itself as a utilitarian body which diffused a taste for art among the 'masses' and played up its role in cultivating and refining manners in Scotland. Now, however, the Association was threatened with illegality on the basis that lotteries were immoral and encouraged gambling. These charges resulted in the Select Committee of 1845, whose purpose it was to consider the position of Art Unions generally. The Edinburgh Art Union was called to London to defend itself in a question and answer session. J. A. Bell, secretary of the Union, defended the practice of awarding prizes – not money prizes for the winner to spend, but the allocation of a work of art chosen by the committee from the Academy exhibitions. The Association also answered charges of exclusivity and defended buying 'high art' as opposed to utility arts or design arts. Finally, the Select Committee asked the Union whether, if a National Gallery was built in Edinburgh, it would present every year a painting from the Scottish School. Bell answered in the affirmative and in 1849 the Association purchased Lauder's *Christ Teacheth Humility* for the national collection. A Bill was duly passed in 1845 which made Art Unions, including the Edinburgh Art Union, permanent and legal; the Association was left to its own devices after the granting of a Royal Charter in 1846–47 and continued to promote the market, bourgeois patronage and modern art in the city (Forbes, 1997).

17. Clearly, the Board were cautious of this move, and a follow-up letter from Lefevre replies to the Board's resistance to this proposal by saying that an 'artistic element' was prevalent at Somerset House that would be 'of great utility to the School of Design in Edinburgh, both in respect of Fine Art and of ornament:- and I anticipate various ulterior advantages in reference to the Fine Arts in Scotland' (NG 1/73/23/12).

18. Similarities between the Irish and Scottish cases were noted by Monro in 1846, who cited 'N.M.', in an article titled 'Irish Artitsts', from the *New Monthly Magazine*, in 1823. The author, in vitriolic tones, claimed that: 'painters and connoisseurs mutually distrust each other . . . so that the project of an amicable, not to say advantageous connexion, between an academy of art and a committee of gentlemen, appears altogether Utopian and impracticable . . . why should we – how can we, with taste, propriety, or judgment, expect, that a Council of R.A.s shall patiently or profitably submit to be 'protected' by a junta of private gentlemen?' (1846: 109).

19. Meanwhile, the idea of a national gallery had attracted several bequests and gifts, including Gainsborough's full-length of *The Hon. Mrs. Graham*, Tiepolo's *Finding of Moses* and Terbrugghen's *Beheading of St. John*. The Academy itself was making some high-profile purchases, including Bassano's *Adoration of the Kings*, bought for £600 in 1856, although its most notable collection was formed through the assemblage of modern diploma pictures (Thompson, 1972).

The High Within and the Low Without: The Social Production of Aesthetic Space in the National Gallery of Scotland, 1859–70

I.2a. Outside (or out of) the place mentioned or implied; especially outside of the house or room; out of doors.
III.8a. In a state of not possessing; not having (as a possession of any kind, a part, an advantage, etc.); in want of, destitute of, lacking.

Without (*Oxford English Dictionary*, 1989)

The idea that history begins at the layers of individual spatial experience, 'at ground level, with footsteps' (de Certeau, 1985: 129), has been crucial to some contemporary forms of social, geographical and cultural enquiry. The work of the new cultural geographers, Harvey, de Certeau, back to Simmel, Benjamin, Lefebvre and the Situationists, has opened up the spaces, forms and activities of everyday life to a rich social analysis that deals with the interfaces between our experience of space and its social context. Some of these propositions have been applied to the environment of the museum. The recent turn towards a social or political 'anthropology' of museums, in particular, has concentrated on the spatial arena itself as operating to fulfil certain 'ceremonial' programmes or ideological 'scripts' (Karp and Lavine, 1991; Sherman and Rogoff, 1994; Pearce, 1992; Duncan, 1995; Vergo, 1989). The visitor, here, is inscribed in a web of sequenced spaces and arrangements of sounds, colours and objects that provides a 'stage set', shaping and structuring the visit according to dominant aesthetic and social interests.

Museums, under such scrutiny, are symbolic sites which circulate ideological effects. Through their systems of installation, the layout of their rooms, the labelling of their objects and their iconographic schemes, museums have been claimed to produce colonial identities (Coombes, 1988), confer artistic value on objects (Bourdieu, 1993) and authorise state ideologies (Duncan and Wallach,

1980). The museum's artefacts, in turn, are not considered to be neutral or static units of value that present the same face to all. Rather, they are set up as active shapers of experience that take on multiform effect according to both the museum context – its design and visual representation – and the visitor's own social and cultural identity.

Every museum, then, makes and remakes its space through layers of visual and ideological effect. Often this is an invisible organisation. In fact, the very socio-political efficacy of the museum is a product of the appearance of purity, neutrality and legitimacy that is produced by its own texts, architecture and iconography. These cultural and spatial forms give the museum an air of timeless truth, or an internal coherence (Sherman, 1987; Saumarez-Smith, 1989). The task of critical analysis, however, is to by-pass this anonymity. The critical analyst must look at the museum as a class of object which, through the construction of material 'events', purposefully frames space and people in space according to historically and ideologically specific conditions. This leads commentators such as Duncan and Wallach (1980) to characterise museums as 'ceremonial monuments', resembling traditional sites of power/knowledge such as churches.

This chapter fits into a similar turn to the 'spatial' via the 'critical' in that it seeks a socio-cultural investigation of the spatial relations that pertain to the National Gallery of Scotland from 1859 to 1870. This ensemble consists of architectural, aesthetic, decorative, and behavioural layers of meaning which accompanied the early structuring of the building's internal and external environment. There would be several ways of organising this investigation, but I have chosen a more or less chronological analysis that supposes a hypothetical visit. Starting from (1) the initial external sight of the gallery – its architecture and setting – the visitor confronts (2) the gallery's internal topography, ornamentation and decor. From here our putative observer encounters (3) the collection itself, the layout of the objects and their iconographic effect, and coterminously (4) the internal regulations and codes of behaviour expected and reinforced in the gallery. The combination of these zones of museological effect was potent precisely because it produced meanings that were crucial to the core function of the gallery as a whole: these included the particular field of power relations that gave the museum its essential character, its high cultural status and inner workings.

Two broad themes run through this chapter. Firstly, the gallery is analysed as a professionally controlled space. Having in mind Chaney's remark that 'professionals can be characterised by their ability to control social space' (1994: 141), I have sketched some of the relations between the National Gallery of Scotland's external/internal domain and the precepts of Edinburgh's professional leaders. This is particularly apt since the idea of a gallery relied very much on notions of classical purity that marked the Enlightenment world-view. Secondly, I have focused on a resultant facet of the gallery's aesthetic space – that it was internally

and socially differentiating. At work through the gallery's spatial relations were certain distinctions between groups of visitors, the informed/high and the uninformed/low, in particular. Despite being lauded as universally accessible, the gallery, in effect, served to privilege professional and bourgeois identities and modes of contemplation above lower or popular modes and identities. The coherent set of cultural dispositions and orientations belonging to the former, which can be subsumed under Bourdieu's term *habitus*, fitted well with the gallery's spatial order: whereas the values and predispositions of the uncultured *habitus* fitted less well with the space.[1] Indeed, this socio-spatial hierarchisation of the gallery pointed up the historical genealogy of the institution as a whole. The gallery emerged as a domain of cultural capital that articulated and reinforced (Edin)bourgeois norms of civility and sociation. The high aesthetic, to this extent, was a central resource for professional expertise and purity, the gallery a privileged space for performances of bourgeois distinction.

The External Spatial Zone of the National Gallery

Starting with the building itself, then. Even before a visitor enters an art museum, a range of effects, presuppositions and modes of perception are set in play. The

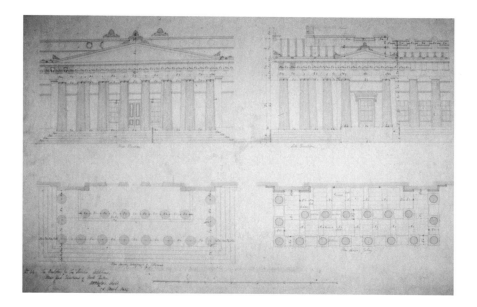

Figure 6.1 William Henry Playfair, Plan and Elevation of North Portico of the National Gallery of Scotland, 1832, Edinburgh University Library.

external shell of the edifice, itself a complex historical product of ideas on style, systems of funding and architectural technicalities, imposes itself contiguously on the viewer who stands before it. The first concrete experience, in other words, relates to form. The shape, style, colour and formal composition of the building initiates the interface between perceiver and object. Such stylistic elements suggest the purpose of the building, expected codes of behaviour and to whom the visitor is responsible for the visit. In short, buildings 'do things'; they leave clues, circulate ideologies and set up certain expectations as to what's 'in store'. A corollary package of meanings are dispersed with the mere knowledge of the building's type. Buildings carry with them verbal labels ('prison', 'school', 'church') that imply in any given culture a set of meanings as to their function and status.

Turning our gaze to the National Gallery of Scotland, we can pose a series of questions on how the building might have operated externally to shape visitors' expectations. In what sense did the building relay the nature of its contents? What effect did the geographical setting have on the gallery's cultural efficacy? And how did this work to reinforce the status claims and identities of some constituencies of Scottish society over others?

In 1861, the Board of Trustees of the National Gallery of Scotland wrote to the National Gallery in London to request information on security arrangements and, in doing so, wrote proudly of the National Gallery of Scotland that it 'stands within that enclosure isolated by itself' (NG 1/3/32). Through the Board's eyes, the gallery's setting on the Mound provided a kind of cultural amphitheatre that

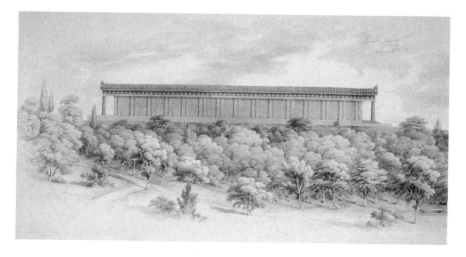

Figure 6.2 William Henry Playfair, Preliminary Plan of NGS, c.1845, Edinburgh University Library.

produced, preserved and protected the 'sacred' content of the works inside. This self-enclosed feel was concentrated by Playfair's other buildings, the Royal Institution and the Free Church college, which closed off the vista to the south. The gardens, further, provided a semi-tranquil formality which set the gallery within its own quasi-hermitage. Immediately, the gallery's purpose, in other words, was identified with something civilised, majestic and separate from the blemishes of everyday life.[2]

By the 1830s and 1840s, Prince's Street had become a highly commodified thoroughfare; home to ladies straw hat shops, coffee rooms, dyers, furriers, a cigar shop, a tax office as well as an elaborate series of banks and insurance companies. Many of the street's residential bourgeoisie had already fled the commercial tumult to the relative serenity of the New Town. The railway had also brought the 'seedier' side of Victorian production to the pleasure grounds of the original gardens, and declared itself the harbinger of industrial progress from the west.[3] The combination of these two features of modernity (commerce and rail) may not have whole-heartedly disturbed the sensibilities of all the Mound's gatekeepers. As noted, the Board of Trustees was already combining commercial interests with fine art and design from the eighteenth century; and subsequent methods at the Trustees' Academy had been based on the utility of fine art for industrial and commercial products. But, as I will intimate below, even the Board found itself sanctioning the difference between high art and a less 'pure' realm of value as it was adorned in the clothes of refined culture. And, for adherents of a 'pure aesthetic' such as the architect Playfair, who detested commercial buildings, and others of Scotland's intelligentsia, impinging commercial values were a particular source of concern. In fact, Playfair was already experienced in banishing the stains of Victorian economy from the area, having been given the task of suppressing the visibility of the railway in the mid-1840s. Playfair marshalled the construction of a large stone wall and embankment 'high enough to conceal the locomotives and rolling stock from the drawing-room windows of the houses in Prince's Street' (Youngson, 1966: 278). He also refused to design a single commercial building and took severe exception to William Burn's willingness to design factories.

So, the concealment of any features which might detract from the purity of the scene was a task particularly befitting the detached civility of the building. Besides the setting of the Moundscape itself, which provided a 'natural' sanctuary for the sacred contents, what gave the signification of the pure aesthetic added potency was the *form* of the building itself.[4] Like other 'ritual sites', including other museums, the external appearance of the National Gallery of Scotland actually helped to sustain, authorise and legitimate art as special, refined and distinguished. Paradoxically, the neo-classical stringency of the National Gallery design (a result, partly, of radical budgeting from the Treasury) adds to its overall impact. The Gallery exerts a monumental effect on the surroundings. In particular, the east/west

screens of columns, even today, dominate the townscape from North Bridge, despite the low Doric order. The long lengths of pilasters help to circulate the necessary connotations of the treasure house, the civic sanctuary and puritan aestheticism. And the Attic walls which 'tower above the spectator as though in a high-security prison' (Gow, 1988: 26) complete the imposing feel of the edifice. In fact, Playfair had raised the central section four steps above the flanks for external effect. With the archetypal conjunction of Ionic columns supporting an entablature at the portico entrances (of which there were two – one for the RSA and one for the National Gallery in 1859) this austere, but powerful, spatial ensemble helped to connote the existence of a higher reality operating within its walls – that of high culture. The gallery became the first stage in the symbolic production of the works inside, helping to render the ensuing experience as refined and polite, as implying an aesthetic mode of receptivity.

We must add to this observation, however, a point on social differentiation. Like all texts, buildings do not present the same face to all. The exact content and meaning of the encounter depends on the visitor's own socio-biography, creating internal divisions in modes of contemplation. What a viewer brings to the encounter in the way of previous experiences and socially acquired systems of perception alters exactly how the building is 'read' as such. Without detailed knowledge of visitors' reactions to the gallery in the 1850s and 1860s, it is impossible to reconstruct the lines of demarcation between various social constituencies. What is clear, however, is that members of the middle class would have been much more at ease with the building's imposition, as well as the idea of the museum itself, than those of the 'lower orders'. After all, classical was the very aesthetic that permeated the feeling of the New Town itself, with its Palladian Adam houses, in which the respectable and polished urban population resided and that saw the city's elite partake of the refined arts, learning and politeness.

Classical, in short, was the symbolic style of the Edinbourgeois – cultivated, restrained and rational. Broadly, the classical revival had been embraced by Edinburgh's lawyers and professionals, whose strong adherence to enlightened order, coupled with a fascination for classical history, science and calculation, represented one of the dominant cultural trends of the period. Indeed, the likes of Jeffrey, Cockburn, Erskine and other Whig lawyers were sought for their cultural expertise and shared the responsibility for many of the developments in Edinburgh (the national monument on Calton Hill, for instance). What was at issue for Scotland's enlightened leaders was the desire to rise above bad taste and immorality by espousing a classical model of art, scientific rationality, Whig reform and civic progress. A classical education remained intrinsic to a professional career, and helped to reinforce the appropriate aesthetic tropes.

Furthermore, the Enlightenment had already set itself the task of sweeping away social disorder and medieval unreason; hence the proliferation of building types

like prisons, hospitals, clinics and asylums, that indicated the gradual desire to confine, discipline, cure, restrain or improve. William Adam's Edinburgh Infirmary of 1738, for instance, was built to house the diseased and infirm in a sparsely ornamented 'u-shaped' design. His son Robert's New Bridewell Gaol was built on Calton Hill in 1791 to the Benthamite model of the panopticon, in which the building's spatial order worked to the principle of 'invisible inspection', while Robert Reid's Lunatic Asylum, modelled on Tuke's Retreat in York, was built in Morningside in 1823. Though not universally classical, the appearance of such buildings illustrates Scotland's leaders' aspirations to transcend darkness, ignorance and social disorder (Markus, 1982). And many of Edinburgh's other buildings of social order and stability, including the university, merchant's halls, law courts, schools, churches and hospitals, did bear the clean, distinguished and symmetrical features of neo-classical architecture.[5]

Extirpating barbarism from the increasingly respectable gaze of Edinburgh's classical New Town also meant symbolically connecting the Old Town with a backward, rude and deranged constitution. Notwithstanding the potent memories of romance and collective camaraderie that the Old Town had elicited, by holding up classical as a vital and cultivated urban trope, Edinburgh's ruling elite had condemned the former as antiquated, filthy and as 'other'. 'The time is not very distant when the most wealthy and fashionable inhabitants of this town were content to reside in wynds or alleys, which their servants would now disdain to lodge in', wrote a correspondent to the *Scots Magazine*, in 1820. The classical New Town, it was believed, actually symbolised the nation's ability to appreciate the highest forms of culture. In particular, Edinburgh's elite could now look upon the Parthenon in the requisite cultivated manner; that is, with an informed gaze:

A taste for higher comforts having sprung up, the New Town rose to gratify it; this indulgence naturally begot still farther refinements . . . we shall furnish our country with the means of extending the national taste beyond any assignable limits. *We are therefore, it appears, just arrived at that happy moment when we can appreciate such a building as the Parthenon.* (Anonymous, *Scots Magazine*, 1820, my emphasis)

This was particularly important as Scotland's leaders attempted to construct a respectable national culture in the wake of its Jacobite history. In contrast to classical, the medieval national resonances of 'Scotch Baronial', with its pinnacles, castellated ornamentation and Romantic asymmetry, were clearly problematic for Scotland's 'men of taste'. Consequently, 'Baronial' remained largely an aristocratic extravagance with little popular hold or use in urban architecture. On the one hand, 'national' to this constituency was the organic totality of Britain and its architecture was to reflect the rich and elegant tradition that the continent (and England)

provided. On the other hand, the Scottish castle implied a more 'rude, gaunt and perhaps too-well remembered past' and was not accepted with anything like the enthusiasm which classical had generated amongst Edinburgh's middle and upper-middle classes (Brogden, 1995: 31).

This does not mean, however, that classical was somehow more *popularly* accessible and vital. For Edinburgh's lower orders, for instance, the National Gallery exterior would have remained scarce and uncomfortable. The very imposition of the building, the aesthetic mode of reception that was implied for its entry, the lack of any quotidian features to the building that may have provided the uneducated with relief; all of this would *not* have formally excluded Scotland's subordinate classes from entrance, but, equally, the spatial ensemble certainly would not have worked to encourage popular participation. It is likely that awe, mystification, indifference or astonishment were the more prevalent reactions from these groups. As for the operation of a set of informal exclusions, it should not go unnoted that the Prince's Street Gardens area, of which the National Gallery was a part, was said to keep the poor population of the Old Town at a physical distance from the residences of the New Town in the 1850s. Superior urban space, here, had become a means by which the lower orders and their pleasures could be distanciated.

By the same token, classicism was perhaps the least accommodating of architectural systems for ordinary reception; it remained impervious to the untutored gaze and imperial in its imposition. Interestingly, one of Ruskin's Edinburgh lectures of 1853 had irreverently exposed the 'contemptible' author-itarianism of Greek architecture in Edinburgh. On subjecting Greek to criticism for its lack of naturalism (and comparing the lions' heads on Playfair's Royal Institution to those drawn from nature by Millais), Ruskin spoke of the classical proclivity to place ornamentation, if at all, at the elevated levels of building tops, rather than at eye level. 'Walk round your Edinburgh buildings, and look at the height of your eye . . . Nothing but square cut stone – square cut stone – a wilderness of square cut stone for ever and for ever; so that your houses look like prisons, and truly are so; for the worst feature of Greek architecture is, indeed, not its costliness, but its tyranny' (Ruskin, 1855: 76). From the perspective of Ruskin's social-democratic aesthetics, classical architecture delivered nothing for the ordinary urban dweller but difficulty, expense and a sore neck.

A more varied, friendly and natural architecture, for Ruskin, was Gothic. In contrast to Greek, pointed architecture introduced the ornament 'close to the spectator'. At the medieval Lyon cathedral, for instance, the important details were merely eight feet off the ground. Hence, Gothic operated at a more 'collective' level – an architecture for 'all men to learn' (Ruskin, 1855: 11). Yet, Edinburgh had adopted its own ancient idiom for national and civic purposes and, apart from some churches and the Scott monument, Gothic was always secondary and

marginalised, even in the late Victorian era. Official pressure to favour the resonant styles of Gothic or Elizabethan (the Houses of Parliament, in London, were supposed to elicit memories of an 'English' medieval past) never materialised in Edinburgh. Much of what Ruskin espoused in his vitriolic lectures in Edinburgh, hence, fell on deaf ears. Always on the defensive, one suspects Ruskin knew in advance how much classical had permeated bourgeois Edinburgh's cultural *weltanschauung*. On subjecting Playfair's building on the Mound to social critique, for instance, Ruskin was careful not to make his diatribe into a personal slur, declaring: 'It is not his fault that we force him to build in the Greek manner' (Ruskin, 1855: 80).

Ruskin's mapping of architecture as socially communicative, that is, as materially productive and efficacious in the urban setting, returns us to the National Gallery. I have already spoken of the building acting like a frame, controlling the composition, establishing boundaries and eliciting memories. Through its setting, its acerbic style and its known existence as an art museum, the gallery functioned externally to keep the profane at a distance. No sign declared 'for refined culture and its devotees only' because the pure and distinguished pleasures of its collection were already signified via its external imposition. Paradox and dual-codedness, however, remained central to the National Gallery, as they did to the project of the museum as a whole. Another level of effect, in other words, was secreted through the gallery's syntax that did not necessarily smack of exclusion.

Official buildings like museums, adorned with the accoutrements of classical civilisation, *could* connote the hallowed virtues of universal education, refinement and national improvement, thereby maintaining the appearance of their universal access. The mere appearance of the temple structure imparted the widely held belief that everyone was, in theory, welcome to partake of the educational ideal. The values ascribed to ancient civilisation – democracy, learning, inspiration and civic virtue – particularly suited the interests of official patrons. Hence, in its statement on the role of the National Gallery, the Board of Trustees spoke of the 'opportunities which cannot be overestimated of rational amusement, mental cultivation and refinement of taste' (NG 1/1/41). The Parthenon building was appropriated to reiterate these principles of national access and pedagogy. Merely seeing the temple structure was sometimes claimed to be sufficient to improve taste, to impart 'correct manners' to all classes and to furnish Scotland's national population with a more refined set of perceptions. The writer to the *Scots Magazine* in 1820 offers exactly these sentiments:

> To place the Temple of Minerva *before the eyes*, not of one or two travellers, but of the whole public, is the most certain means of *cultivating our national taste* and happiness at home, and, consequently, the power and importance of our country amongst other nations. (Anonymous, *Scots Magazine*, 1820, my emphasis)

To this extent, the National Gallery's guardians officially justified the museum in terms of the national social good and placed themselves as forward-looking, benevolent and active protectors of the spiritual wealth that it contained. This was an identification of the gallery's purpose with the model of bourgeois culture it helped bring about and which connected with other spaces and discourses in the city such as theatres, concerts, libraries and philosophical societies. Visitors to the gallery could be construed as beneficiaries of civic culture and collective property; the gallery's nominal accessibility signified as an instance of the bourgeoisie's enlightened and democratising approach. Any potential critiques of the gallery's 'exclusionary' nature could thereby be circumvented. What we are left with, in effect, is a building that, while securing professional civic distinction, was able to appeal magnanimously to paternalism, public service and the ideals of mass national improvement. The gallery's symbolic power, in fact, resided exactly in its ability to do both.

The Entrance, Interior Topography and Decor

> When not just the contents but the whole museum becomes part of the collection, the barrier is felt at the front door. Stepping out from the newly refurbished National Gallery of Scotland, for example, on to the streets of Edinburgh, is a disorienting experience. What's inside has nothing to do with what's outside. After the plush, lush interior, the daylight is harsh and there is litter. There is a sense of being let down, which has more to do with the after-effects of entertainment than of art.
>
> (Spalding, 1991: 167)

The process of entering a building is always a crucial level of the museum's productive force. This is particularly marked in the transition from the street and its attendant buzz to the relative solemnity and hush of the interior. In the case of many continental art museums the transition is flagged or predetermined, with the walk up a flight of monumental steps. This, in effect, extends the building's zone of production outwards and downwards in a form of invitation. Each step towards the museum represents a step closer to the revered temple and higher to its consecrated objects. The grand entrance, usually a large classical, columned portico with imposing doors, completes the journey up and into the shell.

Such a scenario was never so clear-cut for entrants to the National Gallery of Scotland. The overall neo-classical arrangement had already sent out the requisite signals of high culture. Yet, the effect was not particularly concentrated by the small elevation up to the wooden doors, which themselves were comparatively modest.

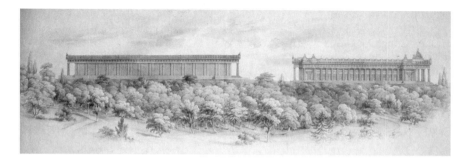

Figure 6.3 William Henry Playfair, Side Elevation of the NGS and Royal Institution, c.1845, Edinburgh University Library.

As far as the interior as a whole was concerned, 'ornate', 'splendid', 'opulent' and 'luxurious' were not adjectives that accurately described the general feel. By all accounts the rectangular entrance hall, for instance, was rather stark, consisting of 'Railing, Ticket Taker's Stand, Umbrella Stand, Table', all in oak, that were ordered in 1859 just before the gallery opened (NG 6/1/1). Equally, the decorative treatment of the gallery space was not ostentatious, fitting with the principles of civic rationality that symbolised the genesis of the gallery. Always residual in the design of the interior, in other words, was a quite rigorous adherence to stringent, enlightened bourgeois notions of taste: an amalgam of intellectualised pure aesthetics and dominant trends in the handling of country house decor in Scotland. This all suited the operational requisites of the professional middle-class *habitus*.

Playfair's topological treatment of the gallery's internal structure revolved around the construction of two sets of octagonal galleries, one set for the RSA and one set for the National Gallery, with additional smaller octagons freed up in the middle as cabinet rooms. This was a maximum utilisation of space, with the deep arches connecting the octagons allowing additional areas for pictures. The biggest octagons in the middle could accommodate the largest pictures and were pure geometrical compositions. The other rooms varied in height to carefully co-ordinate the amount of light coming from above and ensure even illumination. In fact, the choice for top-lit galleries was becoming increasingly dominant in Europe and England, and illustrated the enlightened bourgeois approach to building galleries. As a result, the overall feel of the space very much resembled earlier examples of gallery construction in England. Gow (1988), Waterfield (1991) and Clifford (1982; 1987; 1988) have all noted the similarities between the top-lit galleries and round-headed arches at Dulwich, the suites of rooms at Boydell's Shakespeare Gallery by George Dance and Playfair's National Gallery interior.

Inasmuch as the suite of arched rooms presented a certain fluidity and perm-eability to the space, it was actually possible to look through the set of galleries in

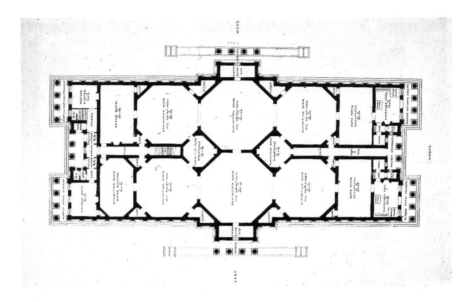

Figure 6.4 William Henry Playfair, Topographical Plan of the Interior of the National
Gallery of Scotland, 1849, Edinburgh University Library.

one visual sweep. This in itself was quite unusual for a European gallery but was
made possible by the small size of the gallery in Edinburgh. A by-effect of this
linkage of axial galleries was to immediately open up the function of the gallery
to all visitors: its mode of operation, its expected forms of behaviour, who did
what, with whom and where, and the objects on display. In other words, an
awareness of the gallery's core epistemology – to display, collect, survey, classify,
entertain – and of the kinds of people who used and felt comfortable in the gallery,
was secreted instantaneously on the viewer in and through the linear sequencing
of the National Gallery space. Structurally, this was a part reversal of the order of
the 'total institution' (such as the asylum) where inhabitants resided deep within
the shell, facilitating surveillance, and where those who ran the building permeated
its surfaces. In a concentrated sense, the National Gallery of Scotland's visitors
flitted through the visible channels and were 'surveyed', less extensively, from
afar, while those professionals who created the rules of the building inhabited the
deep structures beyond the boundaries and limits of the visitor. So, the gallery was
not an institution of confinement but of display.[6] Spatial control worked *indirectly*
through certain conventions, texts and regulations on behaviour and authority, as
I will develop later.

Turning towards the decoration and furniture for a moment, we can briefly
outline how the National Gallery's interior continued to articulate the ideo-logics

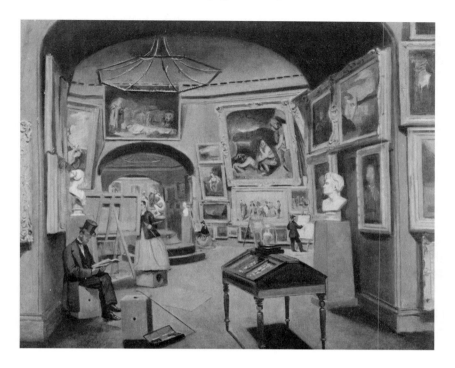

Figure 6.5 Anonymous, *Interior of the National Gallery of Scotland*, c.1867–77,
National Gallery of Scotland.

of Edinburgh's professional faction, thereby maintaining the purity of the space.
In accordance with the gallery's economy of taste, as well as its historical genesis
as a semi-national, semi-civic, yet non-regal institution, the decor was particularly
stringent. Unlike many of the big continental museums, the gallery did not contain
friezes, palatial chandeliers, elaborate ceilings, monumental staircases or sumpt-
uous rococo furniture. For both financial and aesthetic reasons its lodestar was
hyper-rationality and the excision of all that detached from the pictures themselves.
And, to this extent, the gallery resembled sparse seventeenth-century Dutch interiors.

The design of the interior had been assigned to Playfair and his most cherished
decorator D. R. Hay. Hay was considered to be the 'first intellectual house painter'
in Britain whose ideas on colour theory and rational design had taken on the patina
of science. From his experiments in country and town houses, Hay had developed
a scheme of harmonious colouring that was claimed to particularly suit picture
galleries and the hanging of old masters. The core feature was the use of red or
claret as the background for pictures. Such a colour was believed to be 'most
effectual in giving clearness to works of high art, such especially as may have

suffered from imperfect pigments employed by the artist' (Clifford, 1988: 47), while harmony in colour was grounded in the principle that the background should not be brighter than the brightest tones in the picture or darker than the darks (Waterfield, 1991).

This was not a particularly novel scheme. Most pictures in country houses were foiled against tones of red silk or other fabric in the eighteenth and early nineteenth centuries. As Clifford indicates, 'Nash used maroon for the picture gallery at Attingham, Shropshire, in 1805-7, as did the painters Benjamin West and J. M. W. Turner for their own galleries' (1988: 48). In Scotland, the Duke of Argyll's princely seat at Inverary Castle had richly decorated rooms, including a saloon with walls hung with crimson silk to display the series of family portraits. And the walls of the Great Drawing Room at Blair Castle by Steuard Mackenzie were adorned with red silk damask (Gow and Rowan, 1995; Gow, 1992). Both Playfair and Hay would have been *au fait* with trends in country house arrangements through their architectural and decorative commissions in Scotland. Indeed, it was Hay who took on the task of designing the interior of Scott's Abbottsford, Queen Victoria's Holyroodhouse and, in the urban context, Henry Raeburn's studio in York Place, again using a claret colour for the walls.

Unlike country houses, however, the National Gallery did not hang sumptuous fabrics like silk. Instead, the vertically ordered planks were kept visible and painted 'claret', while the cove was painted cream and the cornice appeared to be pale oak grained. The chairs, designed by Playfair, were of the classical style and similar to those found in the Royal College of Surgeons. The legs resembled columns, with scrolls for decoration – archetypal New Town chairs, in fact. All benches and seats were covered red and the guard rope was maroon. In accordance with Hay's colour scheme, the carpet (Dutch weave) was of a green hue which completed the sense of professional co-ordination; green had been intellectually 'proven' to be the most effective complementary colour to red (Clifford, 1988; Gow, 1992).

All this served to retain a rigid form of aesthetic Puritanism to the internal space. Very little decorative clutter competed with the primacy of the objects on display. Victorian restraint in its professionalised form had coded the interior in such a way as to reaffirm the pure aesthetic. It was an aesthetic based in both New Town gentility (where, of course, pictures also hung) and country house fashion, but filtered through classical and enlightened rationality. This 'intellectualisation of taste' conjoined a utility of display with a professional middle-class distinction, part of which was the assertion of social distance from the patrician idea of culture as ostentation. The decorative ensemble was far from splendid or luxurious, but neither was it overly welcoming, especially to those classes who had no real experience of, or education in, the idea of the absolute or pure value of the work of art; that is, the effacement of all that was extraneous to the efficient display of the work itself.

The Collection, Catalogue and Iconography

The next set of questions we must answer includes these: how did the material arrangement of the collection contribute to the gallery's overall distinction? How were the art objects ordered and classified? To what extent did the collection interact with the internal space in order to 'produce' the gallery's epistemology? What texts or discourses accompanied the arrangement and whose interests and identities were privileged or circumvented?

Perhaps more than any other single layer in the social production of aesthetic space, the manner in which a gallery's aesthetic objects are acquired, disposed and made visible is primary to its mode of operation. A gallery's 'iconographic programme' structures a multiplicity of socio-aesthetic meanings, each of them crucial to the overall function and status of the gallery, to its patrons or commanders (be they nation-states, cities or private individuals) and to the varying forms of reception that are possible or elevated. The collection it is, in short, that forms the locus of the eye, of power and of the gallery's self-definition as culturally refined.

The Collection Layout

Clearly, the National Gallery of Scotland's iconographic scheme cannot be compared with those of other 'Universal Survey Museums' in breadth or intensity. The visual order of the gallery did not overly resemble the post-revolutionary Louvre's (re)presentation of French art as the summation of cultural civilisation, for instance (Duncan and Wallach, 1980). Nevertheless, the classification and installation of the Edinburgh gallery's three hundred or so objects was an important moment in the organisation of its ceremonial experience. The iconographic pattern, in other words, diffused a requisite level of high cultural codes for the constitution of a distinctive, 'public', civil and hierarchised space of representation. In every room it is possible to decipher some component feature in the overall production of the gallery's cultural order: of the socio-aesthetic priorities of the trustees, of the modes of perception played out by the 'educated' and 'naive', and of the turning of erstwhile hidden objects of private delectation into 'public' objects of artistic contemplation.

As with much else to do with the gallery, aesthetic predilection was always tempered by available resources, which in this case were scant. For a start, the gallery's collection could not boast decent or representative specimens of the 'canon' and was seriously deficient in many areas of art history. Having at least a representative of the key periods in the Enlightenment narrative of art was a prerequisite for Universal Survey Museums on the continent. The ensuing chronological hang, according to schools and periods, was believed to unveil the underlying laws, truths, rules and structures behind the progress of art and to

thereby foster an amelioration in the educative capacities of visitors. Mechel's arrangements in Vienna were based in exactly this kind of combination of enlightened bourgeois pedagogy and disaffection with Baroque or decorative principles of abundance, and in early nineteenth-century Germany a set of principles had been formulated by Dr Waagen and the architect Schinkel. Seling sums up their programme on acquisition and layout as follows:

> Is a work to be hung 'a good painting', that is, 'a worthy representative of the time and school to which it belongs?' Once this is settled your aim should be (1) to 'display the originators of the various trends . . . as fully as possible as the true, principal and fundamental masters', (2) 'to obtain a complete idea of those great masters who are specially noteworthy for spirited variety, as for instance Rubens', (3) to show 'national painters who are at the same time great artists . . . as completely as possible', (4) 'to be saving in pictures by masters of limited individuality . . . and who tend to repeat themselves', and (5) 'to represent only by one or two examples subordinate masters working in a particular trend'. (Seling, 1967: 114)

As a result, Universal Survey Museums collected *en masse* heterogeneous objects from different periods, filtered them through the homogenising assumptions of enlightened philosophy and established 'ideal paths' for visitors to follow through the collection (Duncan and Wallach, 1980). Typical quantities of displayed objects ranged from four hundred and fifty to six hundred or more. Authoritative texts or briefs gave added coherence to the museum's iconography, making explicit the axioms of art history, further directing the visitor's tour according to historicist, rational and universal truths and resolving all of the individual objects into an essence of European civilisation and its component styles.

For the most part, no such simple overriding system of taxonomy was implemented at Edinburgh. In fact, the base assumptions articulated by Waagen and Schinkel could never have been carried out even if the gallery's administrators were willing. A cursory review of the collection reveals why. Apart from a few choice examples acquired by the key players in the gallery's development, the National Gallery of Scotland really had no significant representatives of Italian art from Raphael to the late seventeenth century, of the 'French School' pictures of Claude or Poussin, or of the notable works of Flemish, Dutch or Spanish masters. Gaps in the historical scheme were slowly filled over the decade with bequests and gifts (most notably Lady Murray's bequest of 1861 of foreign masters including French paintings by Greuze, Watteau, Boucher and Lancret); but, in general, the weakness of the collection militated against the implementation of a complete historical scheme. This all proved to be an agitation for the critic of the *Daily Scotsman* who was obviously familiar with the working hypotheses of other European galleries and their contents:

A public gallery ought to fulfil two conditions – to be capable of teaching art, and of forming the taste of the public. To accomplish this successfully, the gallery ought to contain a due proportion of works by the principal artists of each school or country, as it is only by comparing and contrasting the properties of the different schools that their merits can be ascertained, and correct judgments formed. Judged by this standard, the present gallery is lamentably deficient. It contains no specimens of the revival of art in either Italy or Germany – that pure spring from which Raphael and succeeding artists quaffed so freely. None of the succeeding great masters of the Roman and Florentine schools are represented and the leading men of the Flemish and Dutch schools with the exception of Vandyke, are also wanting, or are represented by unfavourable . . . specimens. As a collection of the comparative claims of genius, it is therefore quite useless, and likely even to cause false notions and unfounded conclusions. (*Daily Scotsman*, Saturday 19 March 1859)

However, it would have been odd to expect otherwise. In addition to the limited nature of the collection itself, space was never in abundance for the trustees. With only six rooms to distribute the collection in, including the small cabinet-sized octagon, it would have been difficult to impose a strict chronological hang. Size often determined the placement of a picture and if an object was considered overly large it was sometimes rejected. Secondly, the amount of 'modern' pictures in the collection (mainly provided by the Royal Scottish Academy) unbalanced the ensemble in favour of the contemporary and precluded a thorough historical sweep. Thirdly, the National Gallery of Scotland appeared to suffer a certain disfavour in the acquisition of surplus pictures from London, which may have considerably bolstered its programme. In the period 1859-70, in particular, the Board regularly complained at the order of preference that prevailed in the disposition of London's 'surplus pictures'. At times, the Edinburgh gallery appeared to be overlooked in favour of Dublin's National Gallery and the South Kensington Museum, at a moment of centralisation in official arts policy in Victorian London (Minihan, 1977; King, 1985). Finally, the principles of the continental Enlightenment hang did not fully materialise in British galleries, generally, until quite late. As indicated in Chapter 3, the National Gallery in London, on its inception, did not hang its pictures according to continental fashions of historical development but stuck to a more traditional scheme – what Waterfield (1991) has termed a 'picturesque hang'. Robert Peel and important collectors opposed a national acquisition policy based on historical principles, instead preferring a decorative or 'aristocratic' approach. This unified pictures into a jumbled ensemble from which the amateur was supposed to decipher the comparative claims of ancient masters. Resisting continental tastes in the light of the Napoleonic campaign was certainly a factor (the distrust of French aesthetic theory, for instance), as was lack of space and of collections that would allow a full evolutionary hang. In any case, Parliament did not actively sanction an

acquisition policy for the National Gallery based on the historical value of pictures until the second half of the century.

For all these reasons, then, the gallery at Edinburgh was organised loosely around two primitive categories – 'Ancient Masters' and 'British Artists', which effectively split the collection into ancient and modern works (there being very little of note in the 'British School' that could be considered 'ancient' or 'masterly'). The inclination to make such a distinction in Edinburgh can be traced back to the arrangements of the earlier Royal Institution galleries and to the memos of the National Gallery's curator, William Johnstone, to the Board in view of the gallery's opening. Within the Royal Institution galleries the Board of Trustees, in May 1850, resolved to maintain 'a more distinct separation between the Ancient and Modern pictures of the collections' (NG 1/1/39). In effect, this meant putting the Torrie collection in the north octagon and Etty's modern historical pictures in the south octagon. It was believed that the effect of both suffered if hung too close. In particular, the curator had focused on the difference in tone between old masters (dark) and the modern pictures (light) which disharmonised them. By 1858, this general principle of organisation had been transposed to the National Gallery and, after some experimentation, a rudimentary hanging scheme had emerged. We can loosely reconstruct the initial configuration from Johnstone's memos to the Board, the first catalogue and from newspaper accounts on the gallery's opening.

The Hanging Scheme

My dear Johnstone, how goes our the National Gallery? are your pictures yet arranged? are there any spaces of wall yet left?

(Letter from David Roberts to William Johnstone,
14 December 1858)

Perhaps the most striking difference a visitor today would have noticed of the National Gallery on its opening was the crowded mode of its arrangement. From all accounts, the pictures covered the wall, virtually obliterating any trace of the planks beneath. This was carpet-to-cornice hanging at its most extreme, making maximum use of the small space for the three hundred objects. Installation procedures certainly contrasted heavily with the more 'pedagogical', ordered and evolutionary presentation on the continent. The 'mixed hang' of the National Gallery of Scotland resembled much more the aristocratic schemes of the eighteenth century, where the overall effect was crucial. An urgency to keep the walls overflowing with pictures, frame to frame, pervaded the actions of the gallery's superintendents, and indicated the logistical juggling that was required to keep the jigsaw whole. Frequently, the gallery was forced to rearrange the ensemble in order to 'fill up the blanks upon the walls' when pictures were loaned

to other exhibitions in the Kingdom – the International Exhibition of 1862, in London, for instance (NG 1/1/42). If no replacements were found in time, vacant sections of the walls were 'filled up with dark red hangings' which 'much improved the appearance of the Gallery' (NG 1/1/43). Pictures were hung on the walls of the arches between the galleries and over the top of the arches, as high as the walls would allow.[7] Many of the pictures in the National Gallery collection were inordinately large – a fifteen foot Terbrugghen, a thirteen foot Lauder, a nine foot Van Dyck and so on. In fact, it had been forced upon Johnstone to hang these large pictures first as it was 'impossible to form any opinion as to where smaller pictures are to be placed, 'till these are put out of the way' (NG 6/7/28).

Rooms I–V

If we can now take a progressive 'walk' through the gallery, we will be in a position to focus on certain issues which pertain to the organisation, status and ethos of each room. In the light of the later foundation of the National Portrait Gallery in 1882 (opened in 1889), it is interesting to note that the whole of the first room had been dedicated to portraits. Indeed, this room was often termed a 'portrait gallery' in itself (NG 6/7/28). The catalogue spoke of the importance of the recent decision to institute a National Portrait Gallery in London and alluded to a similar interest north of the border. Portraiture was a very popular genre in Scotland and despite the fact that this was one of the smaller rooms in the gallery, the general effect of the thirty-four pictures of Scottish figures, hung close, must have been impressive. Placed here were modern pictures by the likes of Thomas Lawrence, Henry Raeburn, Allan Ramsay, John Watson Gordon and John Runciman.

Portraiture, however, caused a problem which struck at the very heart of the Board of Trustees' historical role in the encouragement of art in Scotland, as well as the position of the gallery itself. Such was the ambiguous aesthetic status of portraiture, which could range from the historically grand and ideal to the most vain, vulgar and technically deficient (Pointon, 1993), that the Board found itself increasingly stuck on the horns of a dilemma. What criteria should be used in deciding whether or not to accept and display a portrait? Should the historical importance (or celebrity status) of the sitter override the aesthetic or high artistic status of the picture? The problem arose every time the Board was offered a picture of a well-known figure, particularly if the character had connections with the Board itself. A set of resolutions was suggested to clarify matters of acquisition and other galleries in Britain were sounded for their policies. In the event, the Board was pressed into fully embracing its role as guardian of a high aesthetic by nominally rejecting portraits which fell outside the 'principles upon which a National Gallery ought to be formed – which it was essential should be strictly confined in its purposes to the encouragement of high art' (NG 1/1/41). In other

words, 'none but works of artistic merit find a place in the National Gallery' (NG 1/1/41). In subsequent years, many offers were deflected to the likes of Register House or the Industrial Museum where the sitter rather than the style or form was primary.

Despite this concerted effort to retain an aesthetic purity to the gallery space, however, critics still found fault with the first room in the gallery. The reviewer for *The Scotsman* of 2 April 1859, for instance, spoke of the pictures by Ramsay, Runciman and Laing as well as others in this room as lacking in 'sufficient merit as works of art to entitle them to a place in a National Gallery of Art, however well adapted they may be for a Portrait Gallery'. Portraiture, it seemed, did not lend itself so easily to aesthetic ideals. Often, its import was synonymous with historical or antiquarian tastes, interests which sat uneasily with those of high aesthetics; interests, in fact, which provided the later basis to the foundation of a separate portrait gallery in Edinburgh.

The visitor who moved into the second room, a more substantial octagon, would have encountered around forty pictures of the Flemish, Spanish and Italian schools which made up a substantial part of the Marquis of Abercorn's collection. This included two interiors by Panini, Velásquez's *Don Balthazar Carlos*, two pictures by Tintoretto, *The Marriage of St Catherine* by Albano, *The Adoration of the Magi* attributed at the time to Titian, but later revealed as a Bassano, and what the *Edinburgh Evening Courant* in March 1859 called 'a very doubtful Rembrandt' (*Deposition from the Cross*).

The question of attribution was central to the Board's claims to display a representative, worthwhile and authentic collection. The trace of the signature or the expert's official sanction clearly made all the difference between a valorised object of aesthetic desire and a mere copy or derivative ('school of'). Hence, objects of uncertain authorship, inasmuch as authorship was considered to be held down to one individuated 'creator', posed a problem for the Board. On the one hand, the gallery could not make outlandish claims to the art world regarding its objects that could be subsequently revealed as specious or unfounded. On the other hand, and especially given the gallery's lack of specimens of the international canon, the trustees had to play on what they already had as a 'National Gallery' with the cultural distinction that this label implied.

The tensions in this position were manifest on the revelation that the Board had taken at face value the claims of dealers or patrons as to the history of the objects in the collection. The Board, in other words, could not itself guarantee the work's authenticity, and doubts were raised over some of the pictures in the Torrie collection, as well as the 'Rembrandt' and 'Titian' mentioned above. Indeed, a reviewer went as far as to cast aspersions on the accuracy of the catalogue and, by implication, the Board's professional credentials as an artistically cognisant national guardian of taste. 'It is somewhat anomalous to find a national institution

sheltering itself under such a declaration' suggested the critic in reference to the Board's acceptance of dealer authorship in the catalogue. He continued: 'Whatever may be the reason for dealing so tenderly with the pictures already in the Gallery, we trust that both for the sake of art and truth the claims of future contributions will be carefully weighed before they are recorded under the names assigned to them by the donors' (*The Scotsman*, Saturday 2 April 1859). All of which would have seriously affronted the Board's professional credo.

In response, the Board became more vigilant in verifying authenticity, especially with the older objects, using official catalogues and experts where possible. For the aura of the 'hand of the master' was paramount in conferring museological value on art; signatured objects became fetishised objects – rare and luminous. The gallery's labels helped to secure a plethora of meanings relating to authenticity, legacy, ownership and taxonomy. They conveyed standard information for British galleries, including subject, name of artist, date of birth and date of death. Yet, on designating a picture as the work of a master, a label would have invited the visitor (where possible) to 'read' a more powerful set of connotations into the work-as-fetish. It is to this extent that a label operates as a 'system of classification' that, in Jordanova's words, 'confers value and status, and thereby constructs a setting for the item' (1989: 24). This principle of individuation may at first sight appear to contradict the presentation of the collection as an aggregate. But the combination of universalism and particularism, of form and content was at the very heart of the gallery's logic, as it was of modernity as a broader project. It was a matter of displaying the dual principles of totality and uniqueness; of the creator/painting and 'art' as an organic system (Negrin, 1993).

The small cabinet-sized octagon was entered via the second room. The room appeared to act rather as an ancillary space for less worthy, original or 'awkward' specimens, including Reinagle's copy of Rubens' *Crucifixion* and Urquhart's copy of Raphael's *Transfiguration*. While the procurement of sixty-three watercolour copies of old masters from European museums helped to supplement the gaps in the international canon, their status both as copies and non-oils undermined their aesthetic weight, so they were consigned, with nine drawings after Fra Angelico's *Coronation of the Virgin*, to this octagon. Further, the room's obscurity helped to deal with art which appeared to offend delicate, official Victorian morality. In its depiction of the moment after St John had been beheaded, Feti's *Beheading of St John Baptist* (now attributed to Terbrugghen) was one of the only 'originals' to be relegated to the room. Seemingly, if the picture had represented the moment before the decollation, as it had with Etty's *Judith and Holofernes* or Van Dyck's *St Sebastian*, its repugnance would have been lessened. As it stood, the 'Feti' fell into the category of Old Masters who, while admired in the 'excellence of their art', were denigrated for 'the horrible details of suffering they have chosen to represent' (EUL: I* 15/2.6:78).[8]

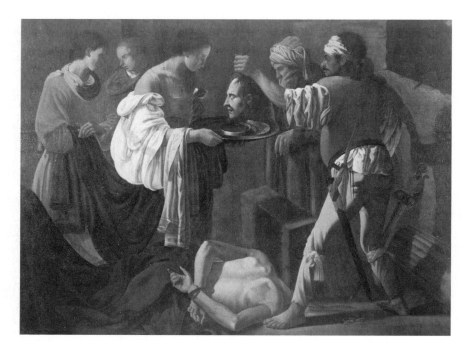

Figure 6.6 Hendrick Terbrugghen (?1588–1629), *Beheading of St John Baptist*, National Gallery of Scotland.

Perhaps rather surprisingly, the biggest and most focal space of the gallery was given over to 'modern pictures'. The centre octagon, from which the rest of the collection branched and balanced out, displayed around fifty-five late eighteenth and early nineteenth-century pictures of 'British Artists'. These were mainly Royal Scottish Academy diploma pictures and some by notable English artists – Lawrence, Reynolds, Wilson, Gainsborough and Etty. In effect, the centre-piece was little more than an extra forum for the Royal Scottish Academy, containing its most valued products and major purchases, and indicating the literal degree to which the Academy's interests lay at the heart of the gallery's evolution.

The decision to dedicate the centre octagon to the modern appeared to rest on practical grounds, although the practical is never untouched by the ideological in these matters. In his memo to the Board of December 1858, William Johnstone focused on the peculiar size and nature of the central octagon, with its high walls and high skylights. For the curator, the tonal distribution of the room did not make it conducive to pictures hung on the line because the light had further to reach. As a result, many of the ancient pictures, it was declared, which were dark in tone (the Van Dycks were mentioned in particular), but had to be hung on the line

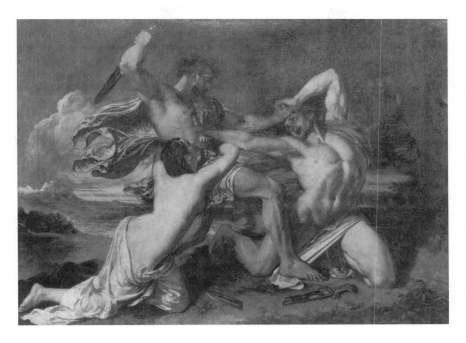

Figure 6.7 William Etty, *The Combat*, 1825, National Gallery of Scotland.

because of their size, would 'not be seen so well in the centre room as in any of the other octagons' (NG 6/7/28). On the other hand, good light was in evidence at higher levels upon the walls, where modern works in temporary exhibitions were accustomed to reside. In fact, in the Royal Scottish Academy side, Johnstone pointed out, it had 'always been found necessary in order to prevent the centre octagon having a base appearance to hang there one row more of pictures'. Evidently, then, the desire to cover the walls of this room tapestry-style was a safeguard against an adulteration of the overall effect of the collection, a fear indicated in Johnstone's later comment that he doubted there be enough ancient objects to make a selection of pictures to fill up the centre octagon, in which case 'the general effect of the galleries would be marred' (NG 6/7/28).[9]

As to the latent claims regarding the import of Scottish painters in the canon, nothing explicit was done to connect the evolution of great art or of ancient masters to a consummation in Scottish art. Waagen and Schinkel's maxim that a gallery should show 'national painters who are at the same time great artists . . . as completely as possible' (Seling, 1967) did not, and could not, materialise in Edinburgh. The centre octagon tended to stand on its own – a collection within a collection that made no claims to summation. The catalogue, rather than extolling the virtues of the great and coherent 'Scottish School' within historical civilisation,

tended to establish points of derivation and influence from the English and continental schools. Hence, John Thomson's manner was based on that of Poussin as well as the Dutch Masters; Patrick Gibson 'painted landscape compositions based on the style of Claude and Poussin' (EUL: I* 15/2.6:78:71); Raeburn's style was modelled on Reynolds'; and other artists were considered 'British' rather than 'Scottish' *tout court*.[10] In no sense could the gallery be held to circulate an iconography of national glorification via the workings of its texts and visual installations. In keeping with its socio-genesis, and its twice removedness from the continental model, the iconographic programme was modest, straightforward, rational and professional, based in civic interests and factional struggles rather than state power and political upheaval.

'Museofication' in the National Gallery

> A museum only begins when what is individual resolves into a new whole.
>
> (Hauser, 1982: 498)

The last two rooms contained what was left of the collection. Room IV, a substantial octagon, was dedicated to the pictures collected by the Royal Institution before its accounts were wound up – three important Van Dycks and sixteenth/ eighteenth-century Venetian pictures, in particular. Room V, a less sizeable room, contained the Torrie collection. Here, it is of interest to note the quantity of objects whose origins lay within a context far removed from that of the museum, whose organic function was certainly not to be collected, framed, labelled and hung in a way that signified its existence as an object of artistic inspection. On this realisation, it is apt to ask to what extent the gallery itself worked to re-socialise its objects and why. How did acquisitions come to play a totally different role to that for which they had been originally assigned? And what does this say about the power of the space and the context in the conferral of value in the case of the gallery and its art?

Firstly, many of the smaller pictures in the Torrie collection, especially from the seventeenth-century 'Dutch school', were 'cabinet pictures'. That is to say, they were originally intended to fit into plain, domestic or intimate bourgeois interiors and to be viewed at close range. Even if, as is likely, these pictures were hung low down in Room V for close inspection (the less detailed and larger old masters would have been placed higher), the organic connection to primary utility was immediately dissolved.

Secondly, decorative works were abundant in the rooms. Many of the classical landscapes after Claude or Poussin would have been fitted up to match the feel of a seventeenth or eighteenth-century country house or palace. Their utility in a

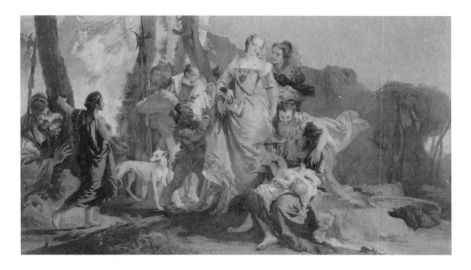

Figure 6.8 Giovanni Battista Tiepolo, *The Finding of Moses*, c.1738–40, National Gallery of Scotland.

spatial scheme would have been subsumed under ideas of decorative or ornamental sentiment, not under statements on the stature of the seventeenth-century French landscape school. The fact that some of the pictures in the National Gallery had been previously cut down suggests the extent to which they were formerly treated akin to wallpaper. Tiepolo's *Finding of Moses* (Room IV), for instance, an eighteenth-century fantasy piece with wooded landscape, was said to have been a decorative composition and has been both cut down at the top and separated from a large section from the right-hand side which belonged to a separate collector until recently. Closely related to decoration was personal glorification and many of the portraits in the collection were certainly meant as presents, mementos or objects of vanity, and often as part of a series of works. The 1957 catalogue, for instance, reports that Van Dyck's *Italian Noble* was one of a pair of portraits in the palace of Giacomo Gentili which Wilkie later saw 'fitted into the wall' of a room in the Palazzo Lomellini. Equally, a Flemish landscape was claimed to be one of 'four panels representative of the periods of the day painted by Titian to decorate the bedstead of the Emperor Charles V, which was in the possession of the Vivaldi Pasqua family' (National Gallery of Scotland, 1957: 86).

Finally, a large proportion of these works were religious and originally located in a suitable environment – churches, temples, monasteries and palaces. Pordenone's *Christ on the Mount of Olives*, for instance, like others of this artist, may have been either for a cycle of religious pictures for an Italian cathedral, for a decorative project or for palatial glory. *The Last Supper* by Bonifazio was originally

from the Carthusian monastery of San Andrea de Lido. 'Michaelangelo's' wax models were from the tombs of the Medicis from San Lorenzo, Florence. And, in 1862, the Board borrowed from the National Gallery, London, an altarpiece 'with cuspidi or points and side pilasters' containing eighteen pictures on wood, some attributed to Andrea del Castagna (NG 1/1/42). This came from the convent of St. John the Evangelist at Prato Vecchio in the Casenlino, Florence. Clearly, all of these objects would have formerly played spiritual, devotional or decorative roles that were stripped on entry to the gallery.

And yet this is exactly what the project of the museum was about – extracting objects from their veridical settings and turning them into museum pieces. It was about establishing meaningful connections between disparate objects like altar pieces and modern pictures such that they begin to denote a similar sign, 'art', with canonised figures, 'artists'.[11] It was about making a nominally public display piece out of an entity that may have only been for select eyes. It was about re-socialising, objectifying and fetishising cultural monads as symbols of a higher reality. It was about cutting up the world into categories, periods and schools in order to provide a 'cultural cohesion of dominant styles' (Sherman and Rogoff, 1994: xi). In short, it was about the (re)presentation of objects via space and its attendants.

On display, cultural works drastically transmuted; they were now 'framed' by the building, art history, the collection, the frame itself, the label, in a way that invited visitors (if they could) to perceive the object as a secular cultural triumph of humanity. Images that in isolation or out of context may have disturbed the sensitivities of Victorian morality could receive a public airing in the museum because this was a sanctioned environment. In Scotland, at least, the National Gallery must have been one of the only 'public' institutions were one could see naked flesh without incurring the wrath of Protestant admonition. To this extent, 'museofication' was a complex process of transformation that was central to the overall epistemology of the National Gallery and to the meaning of its contents. All the gallery's materials were active in shaping a certain receptivity and transfiguring the works that, particularly in Rooms IV and V, were never meant to end up there. Despite limitations in its collection, its modest iconography and its mixed hang, the National Gallery space provided certain conditions for opening up the surface of the picture to the 'contemplative gaze', giving a possible sense of direct contact with the artist and the act of creation.

The 'Naive' and the 'Educated' in the National Gallery

The naive 'beholder' differs from the art historian in that the latter is conscious of the situation.

(Panofsky, cited in Bourdieu, 1993: 218)

But as Bourdieu does, we must ask whose gaze this was. If professionalism had stripped the gallery of all that was superfluous to efficient display, leaving a space dedicated to disinterested and refined cultural pleasures and aesthetic knowledge, whose socio-ocular dispositions did this favour? Like other galleries, the National Gallery of Scotland's context worked to differentiate viewing publics by establishing a level of cultural capital that was required to play the game of informed appreciation. A hierarchy of perception was implicated, in other words, in the way the gallery set out its collection, in the quality of its 'texts' and the codes of behaviour enforced by the trustees. A basic line of distinction was implied between the educated middle classes – those equipped with the requisite aesthetic disposition – and the 'naive' or 'uneducated', who could be physically present, but made to feel obviated, or at least could not operate at the levels of perception that were valorised in the gallery.

Apart from the varying gallery times themselves (with, in 'descending' order, but with increasing consternation on the Board's count, private views, sixpence days, copy days and free days), one way in which such a hierarchy can be unveiled is by looking at the catalogue. Sold at sixpence, the one-hundred page catalogue was significant to the visit. It provided a historical description of the pictures and their authors as well as critical remarks on particular styles and schools. By appearing to summarise the collection and its import, the catalogue appeared to stand outside it: a neutral text of iteration and knowledge that presented the same face to all. Yet, on investigation, the catalogue was an ideologically active text which differentiated subject positions, reinforcing divisions between the cognisant and the untaught.

The Board's attitude to catalogues had been revealed in 1854 to the Royal Institution for the Encouragement of Fine Arts, whose collection of old masters and modern pictures in the Royal Institution galleries had been accompanied by a plush, high-quality catalogue. On the one hand, in keeping with its historical role as art educator, its challenge to the narrow privacy of the old aristocratic faction, and in response to pressures from London, the Board wrote to the Royal Institution asking them to reduce the existing price which was 'quite out of the reach of the working classes'. 'To such persons' the Board observed, the ownership of a catalogue was 'a pleasing recollection of the Exhibition they had seen and by shewing [sic] it to their friends might be a means of exciting an interest in the Exhibition and of making it more widely known and appreciated' (NG 1/3/27). On the other hand, and fitting with its increasingly specialised and professionalised role as guardian of fine art, the Board suggested keeping the present high-quality stock for the 'higher classes', who would prefer to pay the higher price for it 'for the sake of obtaining that superior printing and style of this catalogue which make it *the best for reference in viewing the pictures*' (NG 1/3/27, my emphasis).

The educated middle and upper classes were offered a superior set of cultural references because this satisfied their socially accumulated hunger for aesthetic works. 'But common people', wrote the Board, *'would be satisfied with much less'* (NG 1/3/27, my emphasis) and a restricted, inferior catalogue was produced for this social constituency. Those who probably needed as much assistance to reception as possible were given a cheap, Spartan experience which reinforced their inability to 'play the game'. In fact, *The Scotsman* had intimated that the minimal information conveyed by the label (subject, name, date of birth/death) would have been enough for such visitors 'who are contented with these particulars [and] need not incur the expense of a catalogue' (*The Scotsman,* Saturday 2 April 1859).

This was the operation of a 'cultural arbitrary' (Fyfe, 1993) that functioned to reinstate the divisions between the aesthetic of a cultured middle class and that of the working class, the stranger or the uneducated. The latter were registered in the gallery but in a way which subordinated their presence and subject position. Primacy was given to the cultivated gaze that could delve under the surface of the pictures, that could decipher the invisible codes and make them coherent, that could place works and artists into recognisable movements, schools and styles.

So, the educated eye was a source of visual power and observation that could animate the gallery's objects and meet the demands made by the spatial aesthetics of the gallery. This included the knowledge base or artistic competence needed to use the catalogue in the sense demanded. Schools, movements and styles were discussed as if the reader was familiar with their definitions. The 'Bolognese School', the 'Venetian School', 'Mannerism', 'the Picturesque', 'the Eclectic School', 'the Spanish School', 'the Flemish School' were all listed without explanation (or without proper separation in the gallery, of course). There was 'truth and simplicity of treatment' in Bassano, whose greens 'had a kind of vitreous sparkling appearance'; Giorgione's 'pictures bear the impress of great power and have a luminousness and internal glow contrasted with a solemn and dignified repose'; Bonifazio's 'style is broad and simple, and in colour he nearly approaches Titian'; Bordone 'looked much at the works of Giorgione'; Ostade's 'pictures have great depth and transparency, produced by an unctuous mode of working, exactly the opposite of Teniers'; and in Tiepolo 'an intelligent art student may . . . find technical qualities of manipulation, texture and colour, from which benefit may be derived' (EUL: I* 15/2.6). On British artists the catalogue was slightly less lofty and polysyllabic. Greater description was given over to historical events, recognisable subjects, details on costumes and so on. But overall, the catalogue was geared towards the informed visitor and a technology of seeing that fell in with the middle-class *habitus*.

Thus, at the level of knowledge, the National Gallery was patterned according to an intertextual or relational system of comparisons and differences. Consider

the following typical statement in the catalogue: 'Guido . . . displayed more originality in his works than any other pupil of the Caracci, and was the great opponent of Caravaggio, and the naturalisti of that period, aiming at lightness in his colouring and elegance in his forms' (EUL: I* 15/2.6). A visitor could only make sense of this knowledge if s/he was possessed of the codes of classification, the stylistic indices, the generic codes, that made it possible to differentiate the 'naturalisti' from 'Caracci' and 'Caravaggio' and apprehend the meaning of 'lightness' and 'elegance' in painting. Without these codes there merely exists a cacophony of indecipherables – words, lines, colours that refuse to cohere into a system. In this case, visitors feel displaced, precluded, 'out of their depth' (Bourdieu, 1993: 225). In the absence of a historical hang even chronology was omitted as a possible precept of organisation for the uninitiated. In short, nothing in the morphology of the gallery made it easy for this constituency of visitor.

Codes and Modes of Conduct

> A picture gallery appears to be thought of as a fair, whereas what it
> should be is a temple, a temple where, in silent and unspeaking humility
> and in inspiring solitude, one may admire artists as the highest among
> mortals.
>
> (Tieck and Wackenroder, cited in Hudson, 1987: 43)

Working coterminously with the gallery's internal spatial arrangements were the informal rules, regulations and codes that stipulated the kinds of behaviour expected in the gallery. Normatively inscribed forms of conduct became integral to the mode by which the gallery regulated its space. Indeed, most museums had formal regulations or prescribed rules for dealing with the public. As Sherman notes, the Louvre issued instructions 'fraternally to invite citizens to move along' (1987: 51) before 1793, and other continental museums recruited guards to prevent visitors touching works of art, to suppress unruly or drunken behaviour, and to deny access to those accompanied by dogs. This was clearly part of the attempt to mark off the gallery space, like its antecedents in the bourgeois public sphere, as a realm of cultural distinction and contemplation. Conditions of consumption had to reflect the reservation of the gallery site for a quality experience, divested of vulgarity and the pleasures of the low orders. Hence, rules against spitting, swearing, fighting, eating, drinking and so on served to expel the values of the fair and the tavern, leaving instead a pure space of etiquette and eminence.

On its opening, the National Gallery of Scotland had no set of formal regulations from which we can extract a clear-cut operation of purifications and exclusions. But what we do find is the existence of certain decisions and statements on the

gallery's visitors and the organisation of the visiting space from which certain assumptions on its audience can be drawn. In particular, it is possible to look at the gallery's position on security arrangements and on the Board's reaction to certain events or accidents which disrupted the refined and respectable space as coded incidents of an informal set of prohibitions. This indexed the same ideologics which served to distinguish those who 'naturally' felt at ease in the gallery and obeyed its rules without thinking from those who were less congruent with the codes, and who were often posed as a threat to the gentility of the space.

First of all, then, the question of access – who was and was not welcomed into the gallery – remained a thorny question for the Board. Inasmuch as the National Gallery was a nominally public institution, the Board found itself confronting the possibility of having to welcome visitors of all classes, ages, temperaments and states of sobriety. Indeed, part of the movement to elevate the taste and behaviour of both Scotland's industrial class and its 'drunken denomination' to a level less commensurate with radicalism, intemperance or 'idleness' found occasional expression in the encouragement of such constituencies into the gallery. In the 1850s and 1860s, for instance, the Board accepted requests from the Society of the Suppression of Drunkenness and the Campsie Mechanics Institute to attend the galleries under the supervision of the Board. That the Board was not totally at ease with such visits is indicated by its condition that policemen and security guards be in greater attendance. This went also for public holidays when the gallery could be visited by those who ordinarily worked during opening hours. In fact, in a fit of pique, the Board complained to the police that unless more officers were given at their disposal on public holidays, the National Gallery would not be able to open at all, as 'the articles in the collections are to be exposed to injury from disorderly visitors' (NG 1/1/44). On private views when similar numbers had attended the galleries, of course, no such recourse was needed in the Board's view; a less troublesome audience was implied on such occasions.

A suspicion of the popular, profane and boisterous appeared to be a defining characteristic of the trustees' regulation of the gallery space. The possible inclusion of the 'masses' gave rise to caution for the potential escape of transgressive, disruptive or 'eccentric' behaviour which might undermine the respectable foundations of the space. Guards were asked to be particularly vigilant against the touching of pictures and the entrance staff of the Royal Institution galleries warned against 'persons trying to get admission [who] are not quite sober, and troublesome' (NG 1/3/28). By the Board's own directives, 'disorderly visitors' were to be checked and 'misconduct' suppressed by the police, who were constantly drafted in by the Board (NG 1/2/28), while officers were empowered to 'refuse admittance to suspicious characters' (NG 1/1/44).

As with the National Gallery in London, precisely because the Scottish gallery had been carved out as a space of rank, hierarchy and professional regulation, that

body of the unpalatable 'other' had to be either kept distant or controlled. The image potential of the low and transgressive was enough to spark the Board into marginalising the order and visibility of this constituency as feasibly as a public gallery would allow. Indeed, as argued in Chapter 3, eliminating or distancing the rude, the dirty, the primal and the venal was a defining moment for Europe's bourgeois. For, as Stallybrass and White (1986) indicate, the fear and subsequent representation of elements of the 'Great Unwashed' – the sewer, the rat, the prostitute, the contagious – a fear which, paradoxically, returned in sublimated ways as desire and fascination, marked out the boundaries between the high and low that collectivised and purified the former. By stipulating that drunks, criminals and suspicious visitors were kept in check, the Board was merely acting out the historical role that the civilisation process had instilled in this class, raising the stakes of manners and codes of conduct in such a way that mapped the cultural primacy of the bourgeois subject onto the space of contemplation. The gallery, in other words, had become an index of what Stallybrass and White have called the 'great labour of bourgeois culture' (1986: 93), the attempt to discursively and symbolically territorialise a space 'separate from the court and the church on the one hand and the market square, alehouse, street and fairground on the other' (1986: 93-4). This was a space with refined laws and protocols of behaviour and language like the theatre, the law court, the library, and the drawing room, that embodied a 'subliminal elitism' (Stallybrass and White, 1986: 202) through which the bourgeois class, especially in countries like Scotland with its Protestant morality of clean living, marked itself as salubrious, distinctive and superior.

We might look at the question of the inclusion/exclusion of children and infants, for instance, as a test of the Board's intolerance of the spontaneous, unpredictable and 'crude'. In the Board's view, the child represented a potentially promiscuous constituency in the gallery; it was still at a 'rude' stage of social development that could be dirty, visceral and noisy. By the mid-1860s, complaints were registered from the curator who suggested that 'all children under 4 years of age should be excluded' (NG 1/1/43). This proposition was rejected but, interestingly, 'Babies in arms' were excluded. Presumably, the risk of the infant's touch (or vomit) was lessened if the baby was confined to the pram. In effect, of course, this would have served to censure poorer mothers who could not afford amenities such as a cot. By 1866, further edicts were issued to limit the admission of boys and girls under 10 years of age and a rope was placed around pictures 'so as to make it more effective for keeping off children' (NG 1/1/44). Indeed, the Board's antipathy to dirt, as well as its desire to subject the 'unruly' to discipline and public regulation, were evident in the curator's observation of the 'hands of ragged little boys and girls' who he then pointed out to the assistant curator 'as to be specially looked after' (NG 6/7/29).

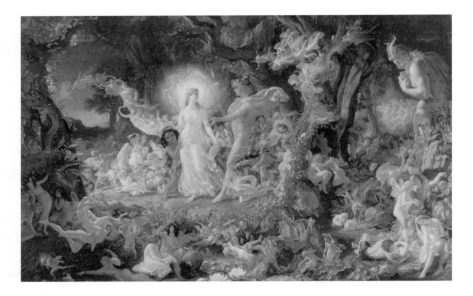

Figure 6.9 Joseph Noel Paton, *The Quarrel of Oberon and Titania*, 1849, National
Gallery of Scotland.

Still, the pictures remained a constant security scare for the Board. Guards were increasingly ordered to keep watch and suppress any physical tendencies. But additional measures were required for some pictures. By the mid-1860s it was revealed that Noel Paton's *Quarrel* and *Reconciliation of Oberon and Titania* attracted much attention of an extrinsic nature. The detail in the pictures was a particular source of fascination for visitors, depicting the fantastical minutiae of lizards, plants, snails, foliage, spiders and sprites from Shakespeare's *A Midsummer Night's Dream*. The Board's discomfort, here, hinged on the fact that it did not want to appear to distrust a public it had welcomed by intimating such a behaviour. For the respectable public, this was all supposed to have gone without saying. Overt labels, on this count, 'would be *unbecoming in the National Gallery*' and, anyway, were 'not usual in the great National Galleries of Europe' (NG 1/3/28, my emphasis). On the other hand, the Board still had to safeguard its objects and discourage 'recklessness towards fine works of art' (NG 1/3/28). Touching pictures, in other words, had to be put down. So increased vigilance was stressed with regard to Paton's pictures and guards were instructed to prevent any inclination towards corporeal involvement beyond the ocular and contemplative. This reiterated the ideals of the civilised *habitus*, to control the boundaries of the body – touching, eating, defecating, spitting, expelling mucus – and to keep the socially inadmissible in check (Elias, 1978; 1982). Corporeal occlusion, for

instance, was surely the basis to the Board's tragi-comic decision to cancel copying tickets for a Mr Weiss who 'being subject to epileptic fits' appeared both to alarm visitors and 'endangered any works of art he might be near' (NG 1/1/44), while its later decision to cover the two Paton pictures with glass was an additional safeguard against tactile promiscuity (NG 1/1/43).

Finally, the strengthening of a silent mode of contemplation, inoffensive, graceful and dignified, was always one of the main aims of the Board of Trustees. To the extent that sound always works interdependently with space, hush appeared as a defining component of the gallery's interior. The physical parameters of sound, the rhythms and circulations of silence, most probably penetrated the gallery's spatial materiality, as it did in museums, theatres, concerts and libraries throughout Britain. Indeed the gallery's carpet was claimed as an integral facilitator of quietude; it banished the 'constant footfalls of visitors' that was 'extremely irritating to those desiring the calm and contemplative study of art' (NG 6/6/16). It is likely, in addition, that the progressive expulsion of young children turned on matters of noise, the crying of babies in particular. Infantile disturbances threatened the gallery's ability to deliver distinction and impaired the professional rectitude that had been so carefully layered *vis-à-vis* the neo-classical building, the decor and the gallery's 'texts'.

In contrast to the hubbub and conviviality of popular pleasures and street spectacles, then, the National Gallery elevated a dormant specular concentration

Figure 6.10 St Mary's Wynd from the Pleasance, etching by T.H. Shepherd, c.1830.

that again petrified divisions between the naive and the informed visitor. On the one hand, like neo-classicism, silence fitted well with the *habituses* of the latter. The domestic gentility of the New Town drawing room, the theatre, the church and other places of bourgeois assembly in the city presupposed an ability, at designated moments, to suppress coarse laughter or noisy participation and assume a refined bodily deportment of hushed humility. On the other hand, the popular proclivity for filling up space with noise, the laughter of carnival and the verbosity of folk sociation – idioms, gestures and symbols that signposted the wynds of Edinburgh's Old Town and the markets of its High Street – such a tendency was at odds with the gallery's solemnity. Silence, a prerequisite in most galleries of Europe, was not only golden, but genteel and hegemonic.

In a broader sense, at the gallery's scene of reception, the popular was a literal target for expulsion. In 1863, the Board of Trustees was pressed into writing to the police to take steps to ban 'disruptive' performances of Punch and Judy at the side of the Royal Institution galleries (NG 1/3/32). The clamour of 'two rival performances' had caused boys to spill over into the 'interior side steps of the Royal Institution within its Railings . . . clambering up its Pillars'. 'Moreover', wrote the Board, 'a leading access to the National Gallery for foot passengers is blocked by the *crowd* and made *very disagreeable* to pass.' On the pretext of damage to the pillars, the Board declared: 'This of course cannot be allowed and must be put a stop to' (NG 1/3/32, my emphasis). In short, carnival was severed, folk culture extricated from the visual field, leaving an unsullied space where bourgeois recognised bourgeois, but in relative hush. Or rather, we should say, folk culture in its *overt* and *palpable* materiality was extricated from the National Gallery of Scotland. For the genre scenes of the Dutch Masters in Room V (Lingelbach's *Figures at a Door of an Alehouse* and Teniers' *Peasants Playing at Skittles*, for instance), the modern Scottish genre scenes of Walter Geickie and others in Room III, as well as the later acquisitions of David Allan and David Wilkie, all depicted the rural and labouring poor and scenes from popular celebrations such as weddings.

The repressed or unpalatable, however, had returned in nostalgic or palatable form. The characters had been bowdlerised, sentimentalised or turned into objects of humour. They were divested of dirt and famine, ordered and knew their rank. The lower orders had returned, in other words, as *spectacle*, as distanced, once-removed, voyeuristic, unreal; as framed and therefore controlled. Like the religious, decorative or cabinet pictures themselves, the lowly had been fetishised 'inside'. 'Why Edinburgh?' ask Stallybrass and White: because the art of space in modern European cities was to construct 'a clean ideal sphere of judgment . . . defined in terms of a low and dirty periphery, a notional and literal "outside" which guaranteed a coherence and privilege to the "inside"' (Stallybrass and White, 1986: 109).

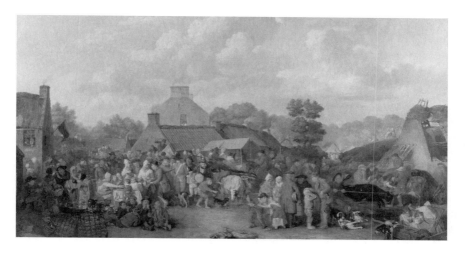

Figure 6.11 David Wilkie, *Pitlessie Fair*, 1804, National Gallery of Scotland.

On its opening, the Lord Provost of Edinburgh spoke of the National Gallery as a 'source of refined and intellectual enjoyment to all classes of the community, from the highest to the lowest' (*The Scotsman*, Wednesday 23 March 1859). The trustees and their catalogue reiterated this idea of universal accessibility. The collection was said to admit of the industrial worker, the intelligent student and the amateur a capacity to make inferences 'by comparison, calculated to advance him in the theory and practice of art' (EUL: I* 15/2.6). But what was disavowed in these statements was the fact of uneven distribution *vis-à-vis* the possession of an informed aesthetic *habitus*, of the cultivated visitor's capacity to stave off the necessities of work and survival and partake of the refined pleasures that education and leisure offered.

Administrators assumed a public that, whilst being structurally and experientially differentiated in the gallery, was held up as an unproblematic whole. Rarely did the gallery's idea of its public coincide with the actual community it served most naturally. Only in a limited sense did the gallery cater for and invite a universal populace. In contrast to some of the science and technology-based projects of the 'popular enlightenment' in Scotland (Smith, 1983), the gallery did not emerge as an institution of mass improvement. Its remit was never to inculcate 'useful knowledge' in as many of the lower classes as possible, or to de-radicalise potential agitators. Bourgeois subject positions and identities were clearly marked out for preference and fulfilment. The gallery's four layers of spatial effect became a marked argot by which Edinburgh's superintendents of high art collectively established a familiar set of codes that, in turn, constructed a known space. The gallery, to this extent, was saturated with its own social history.[12]

Literally, the space and setting that framed the gallery symbolised Edinburgh's move to refinement. The Mound had been built from earth extracted from the basements of New Town houses. More than providing an enclosed setting for high art, though, the Mound was the visible means whereby the Old Town and its vulgar populace were obscured, distanced and disconnected. The Prince's Street Garden area, of which the National Gallery was a part, was declared in the 1850s 'to keep from the too close view of the New Town gentry the poor population of the Old Town' (cited in Youngson, 1966: 256). The gallery project, therefore, spoke of the polarisation of class divisions in power, leisure and education.

In his essay on the '*musée*', Bataille characterises the museum project, and the Louvre in particular, as bearing the marks of blood that the guillotine had left after 1789 (Hollier, 1992). For Bataille, such institutions embody contradictory energies. The rise of the museum is also the metaphorical rise of the slaughterhouse (the guillotine); there is cleanliness but also a 'dirty' history; art is secular but the experience can be profoundly ritualistic. These oppositions contain but also hide each other. No blood tainted the Mound as such. But this does not mean the site was as unsullied as the objects it displayed. For regardless of the differences between the political impulses underpinning the Louvre and the National Gallery of Scotland, they both emerged as spatial constellations at the interplay between displaying, legitimating and excluding.

All of which brings us back to the social parameters of space. For 'no space is "innocent" or devoid of meaning' in Chaney's words (1994: 149). The organisation of space is a highly potent mode of establishing identities, boundaries and subject positions. Places embody, but also circulate and hierarchies, social interests. They can, therefore, be 'read', or 'deconstructed' if you like, as cultural 'texts' themselves, with audiences, idioms, narratives, socially located readers, methods of distribution, and socio-cultural genealogies. The task of organising space is a necessity for all communities that order social experience. Not all spaces are equal, however. Many are manipulated by powerful social forces and inscribed with historically patterned ideologies which elevate them beyond the reaches of the collective. We make and remake space, not in circumstances of our own choosing but under circumstances directly transmitted according to economic, social and political interests (Duncan and Ley, 1993).

From this perspective, in which space is not an empty site of representation but loaded with power, the question of displacement and privilege in the gallery has to become central. For 'where somewhere is' pertains not to the rhetorics of ideologues and professionals, but to the material levels of experience – levels which, in the gallery, are coded in a distinction between those with an aesthetic disposition and those strangers without.

Notes

1. On the *habitus* see Chapter 2, note 20. Some core features are worth re-emphasising, however. 1) Schemes of perception, the ability to classify, decode or understand practices and texts are acquired or learnt. Cumulative exposure to particular social conditions, formal/ informal education, for instance, instils in the individual a matrix of dispositions and strategies which generate behaviours and reactions to familiar 'events'. 2) These competences are so bound up with the conditions in which they are acquired that they lay outside the apprehension of the actor. Behaviour appears to take the form of objectively guided ends – 'agents to some extent fall into the practice that is theirs' (Bourdieu, 1990a: 90). 3) *Habitus* is essentially a corporeal quality in that it exists in and through the bodily practices of individuals – ways of talking, dressing, holding oneself, moving, looking.

2. Including some rather pungent smells! Just before the gallery opened in 1859 complaints were made of 'unwelcome exhalations . . . in the elevated district at the head of the Mound, *where of all places*, one might least expect to suffer from defective drainage' (*Edinburgh Evening Courant*, Tuesday 1 March 1859, my emphasis).

3. From the 1810s to the 1830s private feuars had keys to the nurseries in Prince's Street Gardens and railway proposals were met with strong opposition from proprietors (including Lord Meadowbank of the Board of Trustees). By 1844, however, rail interests had gained sway and agreement was reached to extend the railway to Waverley.

4. The position of the Gallery, sandwiched between Playfair's other buildings, gives an added sense of seclusion. To an extent, the Royal Institution building, which directly faced the busy Prince's Street, cushioned the vagaries of commerce from the National Gallery. As the former was the home of the Board of Trustees, itself a semi-commercial body, this would not have posed such a problem.

5. By virtue of its simplicity and stringency classical also suited the strong current of Calvinism which ran through Edinburgh society, particularly in its middle-class philanthropic guise. Without espousing programmatic doctrines, committees, trustees and civic sponsors naturally endorsed classical at a time when superabundance was dealt with caution. As Nenadic (1994) has argued, the evangelical backlash against luxury and conspicuous consumption in the wake of the Napoleonic wars and economic downturn had all sorts of ramifications for Scottish material culture. The anxieties wrought by increased bankruptcies and unemployment, coupled with the Protestant distrust of fancy and sensuous culture in the 1820s and 1830s, tempered the acceptability of luxurious furnishings and clothes. The ensuing approval of a 'new restraint' in cultural display – a form of 'conspicuous parsimony' – marked itself in the pastoral and paternal novels of the time. The new restraint also chiselled itself into the Edinburgh skyline in the form of puritanically stringent classical buildings with very little in the way of ornamentation for relief.

6. Unless one considers a Foucauldian reversal where it was the art works rather than the public that were confined and surveyed.

7. Next door in the Royal Scottish Academy suite of rooms, things appeared even more crowded. At times, eight hundred and fifty pictures hung in virtually the same available space as the National Gallery, although temporary exhibitions such as the Royal Scottish Academy's attracted smaller pictures (the walls of middle-class town houses, where many of the pictures ended up, could probably not have taken large canvases).

8. The room's relative isolation also made it less visible to the curators. In the Board's view, the room was therefore at greater risk from the 'careless or mischievous visitor' and it was logical to dispose less valuable works here (NG 6/7/28).

9. The order, it was said, arose out of 'necessity' and of the need to 'add to the general appearance of the galleries' (NG 6/7/28). Indeed, without the capacity to parade a comprehensive historical assemblage, the Board was somewhat pressed to make the best of what it had; and what it had in abundance was the fruit of a flowering academy at the height of its powers.

10. There is uncertainty as to the precise meaning of the category 'Scottish art' at this time, as in the catalogue's claim that David Allan, the eighteenth-century genre painter, 'was the first in Scotland who imparted to it a national feeling, and introduced the style that Wilkie followed out so successfully' (EUL: I* 15/2.6:78:60); or that Wilkie himself rejected the grand and ideal in favour of 'the simplest of national styles, which, however, he elevated to a higher point than any former artist had carried it' (EUL: I* 15/2.6:78:99). But, clearly, the sense in which an obdurate and ancient tradition of Scottish art had been constituted by the early twentieth century – with deep structures and essences, philosophical modalities and preoccupations and national aesthetic threads and forms – was not in evidence in the mid-nineteenth century. In fact, 'national' when related to art appeared not as a deep immanence but as a more or less coherent set of themes or subjects. Surface concerns arose especially in the depiction of Scottish characters in genre scenes or of Scottish portraits (portraits *of* Scottish people rather than portraits *in* a national style), and in scenes from Scott, Burns and Scotland's religious history. All of which suggests the middle-class exhibition goers' proclivity for modern, local pictures in the modern style.

11. As Fyfe writes, 'it is *Leonardo's* Virgin to which the museum directs attention rather than the mother of Christ' (1993: 14).

12. Part of this social history was bound up with the Board of Trustees' own role. As this organisation gradually shed its commercial role and its aristocratic membership, it came to embody the tensions in the democratic project that emerged with the bourgeoisie's own contradictory historical role. For bourgeois democracy, whilst certainly enlightened and progressive in its ideals (the Board was undoubtedly serious about its task to open up the art world in Scotland to a broader social constituency), was also the harbinger of codes and practices that creamed off the leading class from those below. Notwithstanding the liberal and emancipatory character of its democratic reforms, this class had etched into its cultural identity marks by which it rendered itself distinctive and pre-eminent.

7

Conclusion

Artistic development towards autonomy progressed at different rates,
according to the society and field of artistic life in question.

(Bourdieu, 1983: 113)

Rather than summarise or reiterate previous chapters, I want to conclude by teasing out five implications from this study. This will, of course, include the process of summarising, but in combination with a spirit of opening out the book to broader and current concerns in the field. Comment will therefore be made on the status of historical comparison and models of museum development that, in turn, raise questions of contemporary significance respecting the status of the museum, space and social inclusion.

Firstly, only by recognising *relational* social determinations, both structures and dispositions, can the socio-cultural history attempted in this book succeed. Such an awareness promotes a balanced understanding divested of the distortions of excessive national feeling that is better placed to deal with 'the particularities of different *collective histories*' (Bourdieu, 1998: 3). The claim that Scottish social development wound a totally different path to that of England's, for instance, replaces an 'us too' sociology with a 'not us' sociology (McCrone, 1992) based on just such distortions. At a political-economic level, the terms 'client', 'periphery', 'domination' and 'colony' have readily been applied to understand Scotland's industrial growth and voting behaviour (Dickson, 1989), while, at a cultural level, Scotland's distinct civil society has been posited as the ground on which radical national divergence is fostered and consolidated, giving rise to specificity across a range of cultural and ideological forms. In Beveridge and Turnbull's account (1989), recovering Scottish distinctiveness is, hence, a matter of cutting through cultural inferiorism and revealing independent national practices unsullied by English culture.

The search for core national attributes, however – the emphasis on a 'democratic intellect' (Davie, 1961), intransigent Kirk or unique empiricism – has a tendency to morph into an introspective search for a national *geist* that says more about a historiographical and political present than it does about a social history of the past. While 'truculent exceptionalism' might be a useful corrective to over-generalised

accounts of 'British history', it too easily becomes incommensurate with a properly relational understanding of development (Wrightson, 1989). If Scottish culture is viewed too long through the lens of 'particularism', questions of historical genealogy begin to take on the search for an internal national cognition. This distorts the thrust of comparative social history and narrows the scope of enquiry to a selective excavation of a national *sine qua non* or style. What must be attempted, instead, is an approach that steers between the Scylla of particularism and the Charybdis of universalism – a matter of recognising Scottish development in terms of parallels and divergences, concentrated in the 'same as/different to' calculation (McCrone, 1992: 74).

Secondly, the implications for models of museum development can be similarly assessed. On the one hand, 'relatively distinct' cases such as England and Scotland may necessitate a re-consideration of accounts which stress a 'general museum idea' (Duncan, 1991), based on a 'history-as-revolutions' approach to artistic development, and more generally an approach to historical transition based on hermetic dichotomies and ideal typologies of culture. To treat the Louvre case as a paradigmatic model which is more or less generalisable to other cases is perhaps misleading. The problem, as with all ideal types, is that many cases escape the limits of what is explainable under the model, suggesting the deficiencies of this model. In other words, understanding might be stymied by adherence to paradigms which are unable to do justice to local conditions of production. For every field, as Bourdieu's opening quote indicates, has unique influences which shape the contours of the institutions involved.

On the other hand, within limits, everywhere is unique. The task of cultural history is, ideally, to locate local productions within global conditions. Or rather, an historical cultural sociology should find its task not merely in the primacy of relations, but in a consideration of the variant in the common, what Bachelard terms a 'special case of what is possible' (cited in Bourdieu, 1998: 2). The National Gallery of Scotland, in this view, emerged in particular conditions of a finite space of possibilities. It was delivered in and through a unique combination of forces, problems, struggles and movements bounded by the British and European contexts. Hence, a broad fit is apparent with those aspects of museum formation outlined in chapters 2 and 3 – a role for Enlightenment, civil society, the growth of market patronage, and the gradual autonomisation of the field of cultural production. Further, like all galleries of fine art, Edinburgh's was grounded in a process of exclusivity that codified it as a sign of symbolic capital, a cultural resource predisposed to demarcate, valorise and select refined modes of apprehension. Where distinctions can and should be made between cases is in the nuanced differences of pace, chronology and the detailed profile of the key social agents involved. Along these lines, valid contrasts may indeed be drawn which would advance understandings of *bona fide* rarities in the progression of cultural fields.

Thirdly, if historical forms are relational, then so are texts. This raises the question of how the present book fits with other contemporary studies of museums and galleries. The problem with answering this lies with the disparate and shifting nature of the field of research in this area. Museums, in particular, are rich in their research potential, not only because they appear to fortify a cultural *doxa* under threat in postmodern social space (permanence, nationhood, teleology, art, history), but because they have a unique power to represent identities, objects and histories. Against 'reductionist' readings of art and classification, however, recent scholarship has tended to suggest that museums were, and are, open and negotiated terrains of social life, not predetermined by a single class, but subject to persistent struggles over space and identity (Macdonald and Fyfe, 1996; Fyfe, 2000). In effect, they are indeterminate, contradictory, shifting spaces, it is claimed, subject to contesting meanings and open-ended acts of (mis)interpretation: sites of cultural flows and unexpected practices that signify divergences between the intentions of regulators and the practices or interpretations of 'consumers'. The historical accounts of French art museums presented by Sherman (1987) and Duncan and Wallach (1980), in this view, present 'an over-integrated account of the state–museum–class configuration', ignoring considerable ruptures and contingencies in the system of relations between class and museum (Fyfe, 1996: 206). What should be counterposed to dominant ideological readings, it is argued, is the museum as process and agency, as a space of flows and discursive conflicts.

Whilst the present book might similarly be charged with failing to capture the indeterminate and contingent character of museum identities, emphasising, as it does, social control and regulation as a dimension of the bourgeois struggle for cultural distinction, the book has attempted to map some of the tensions and struggles, as well as closures, that characterised the evolution of national galleries – particularly the conflicts between vying artistic factions in Edinburgh's art field in the early nineteenth century. It has dealt with processes of institutional, material and ideational *becoming*, because the conflicts and evolutions were both historical and open-ended, as the subsequent history of the Scottish art field shows.[1]

Furthermore, while the book is broadly grounded in neo-Marxist approaches to culture, it has also striven to avoid over-integrated accounts that reduce artistic phenomena to mere reflections of preconstituted socio-economic relations, instead emphasising the transformative role that the former have on, and in, the latter. The very targets of analysis – space, artistic practice, the 'nation', Romanticism, civil society, the Enlightenment – have intimated an approach to cultural artefacts that is responsive to the duality of cultural production: of products stabilising a field of operations in which they are made and re-made (Brain, 1994; Crane, 1994). A greater sensitivity is, therefore, implicit in cultural methodologies that resist ready-made fusions of economy and culture and that acknowledge that the two can, and do, occupy relatively distinct social spaces. The fact that the fields under

study have often yielded to an investigation of economic/political over artistic/ cultural conditions says more about their relative underdevelopment historically (as heteronomous fields) than it does about the theoretical or methodological assumptions.

Equally, while the notion of 'exclusion' does not extinguish the range of possibilities of museum logics in the cases mentioned, only more research of particular cases will reveal this.[2] In principle, then, the book can be read as an intervention into the field of cultural history and, perforce, an incitement to greater dialogue and research across disciplines. Moreover, it is an antidote to the often automatic reliance on fashionable rejoinders to social control – indeterminacy, flux, the active consumer – which displaces analysis away from an understanding of an enduring feature of art museums – that they endure. This must at least alert us to the process of reproduction that has been so central to Bourdieu's sociology. Bourdieu himself cannot provide all the answers, but he at least asks the most pertinent questions, *viz.*: How are social formations sustained? Where do galleries fit in these formations? What constitutes a field of cultural production? How is art classification achieved? Whose gaze is it? And how is taste implicated in the reproduction of inequalities? While often more useful in the French context, and on the mechanics of symbolic violence and stasis rather than symbolic invitations and social change, these questions remain central to the on-going problem of culture-mediated power relations and social order.

Fourthly, to sketch some implications in the contemporary cultural terrain. The National Gallery of Scotland today remains, as it was, an institution of high culture: a little more commodified (the guards wear 'tartan trews' and the shop is all-important), a little less exclusive (the summer festivities in Edinburgh bring 'carnival' regularly to the area outside the gallery and distinct *habituses* are much harder to discern), a little more rationalised (an extra level has been added and the gallery now possesses one of the most significant art collections outside London), but still a national gallery of fine art – a space of taste, national identity and refinement.[3]

The populist education department and the director's ventures into connoisseurship co-exist; as do the blockbuster exhibitions (Monet to Matisse, German Romanticism) with the permanent collection. Similarly, the Scottish and British flags fly simultaneously atop the neo-classical edifice, the former gaining greater credence as Scottish civil society reasserts its independence and as a canon of *Scottish* Art is reconstructed, commodified and displayed in the new galleries of art in Edinburgh and Glasgow. Finally, the on-going disputes between the Royal Scottish Academy and the National Galleries of Scotland in the cultural field is testament to the reality of history as a palimpsest, delivering a cultural legacy of conflict to a new generation of artistic agents. For while the RSA was given its own quarters, the old Royal Institution building, after the National Galleries of

Scotland Act in 1906, and the Board of Trustees became a down-sized board of seven trustees for the National Gallery of Scotland, the two institutions have fought consistently over the stakes of the contemporary art field (Williams, 1992). Some degree of rapprochement is evident in the 'Playfair Project', a £17 million refurbishment plan, due to be completed in 2004, which will include an underground link between the two institutions. But this clearly undermines the Academy's traditional desire for artistic autonomy and greatly enhances the National Gallery's presence at the site in the heart of the city.

Elsewhere, in the last twenty-five years, museums have become the focus of unprecedented levels of political and economic attention as institutions variously trading on spectacle, commerce and cultural tourism reach for new audiences. The most prominent artefacts in art museums are no longer just the art objects but the striking buildings themselves, many of them designed by fashionable 'postmodern' architects in unconventional and eclectic styles. What impresses in museums such as the Tate Modern, the various Guggenheim museums, the Pompidou Centre and the 'Grand Louvre' is the massive expansion of the visual art complex itself. For museums are more eager than ever to embrace commercial impulses and provide accelerated levels of entertainment and sensation. The emphasis on shopping and eating as central to the experience of visiting a museum is complemented by popular techniques of display, blockbuster exhibitions and interactional information systems that intensify the visual and turn the museum into a 'distraction machine' (Virilio, 1994; Harvey, 1989). I. M. Pei's immense glass pyramid entrance to the Louvre, for instance, covers both the shopping centre and the Louvre itself and is a forceful emblem of a hypermodern culture in which opera and soap opera, mall and museum, high and low mingle, whilst another of the institutions discussed earlier, the National Gallery in London, underwent an extension in 1991 – the Sainsbury Wing – designed by postmodern American architects Robert Venturi and Denise Scott Brown and financially endowed by a British supermarket chain. Venturi himself has spoken of the parallels between the National Gallery and sports stadia in the sheer scale and crowds attracted to both (Barker, 1999).

Whither, then, the aesthetics of contemplation? Whither the project of bourgeois culture? Whither the European 'civilisation process' and the museum as guardian of the pure aesthetic? Well, the museum clearly finds itself at a crucial juncture in its history – facing the potential dissolution of an autonomous high culture and thereby facing its own demise. For writers like Baudrillard (1982), Featherstone (1991) and Virilio (1991; 1994), the expansive crowds at the new 'supermarkets of culture' move through at a bewildering speed, impatient and carnivorous, no longer searching for aesthetics but agitated in an aesthetics of the search – scanning the cultural horizon for ever more spectacular forms of entertainment. High culture has collapsed, in this argument, under the weight of mass consumption and a

hyperactive crowd intent on eating, touching and 'sacking the shrine'. 'The masses rush there not because they slaver for this culture', says Baudrillard of the Beaubourg Museum in Paris, 'but because, for the first time, they have a chance to participate *en masse*, in this immense work of mourning for a culture they have always detested' (Baudrillard, 1982: 7). A culture of meaning and pathos is emptied, for Baudrillard, in the process of mass participation and simulation.

But such characterisations are all too loose, ahistorical and inexact. Crowds, as shown in chapters 2, 3 and 6, were a threat to museums from the start, framed as a problem to the distinction and purity of the space itself; and archetypal 'postmodern' venues like cafés were often attached to museums, albeit as forums for public discussion, conviviality and artistic encouragement (Tait, 1989). Conversely, one does not readily encounter a fomented crowd of homogeneous visitors to museums today, bent on touching, eating and swiping everything. Audiences are both culturally diverse and socially stratified and cannot be understood as an undifferentiated mass (Hooper-Greenhill, 1997). Furthermore, a trip to the art museum is still suffused with a sense of hushed reverence and awe, a fact guaranteed by the solemn and dignified arrangements as well as vigilant security guards! Indeed, most of the museums discussed in this book have retained the values and traditions of the nineteenth century. The majority have kept to modernist principles of order – a chronological arrangement of works according to national school, movement or style, for instance (Barker, 1999). They still, on the whole, celebrate values worked up by traditional art history, including ideas of genius, expression and cultural transcendence, but to this they add new technologies and flamboyant modes of exhibition: if you like, recycling the modernist impulse whilst transforming it.

Ready made characterisations of the postmodern museum are therefore misplaced and imprecise. It is the fusion of old and new techniques, values and ways of seeing that is etched in the practices of the contemporary museum. The museum is now, as it has always been, schizophrenic, providing aesthetic contemplation *and* entertainment, connoisseurship *and* consumption, private delectation (in the form of previews, gatherings, etc.) *and* public provision, interpretation *and* experience (Serota, 1996). Indeed, the sharpest and most astute museum directors, traditional and modern alike, are those who understand and exploit the fact of double-coding by tapping into the rich vein of meanings possible in the museum.

Which is where this account must end: with the ambiguities inherent in the national art gallery, a space of taste and conflict, within a space of the imagined, the nation. Both were furnished out of prior constellations – absolutist, princely, enlightened – and reconfigured into cultural territories symbolically appropriated by Europe's rising historical classes. In the new millennium, they are being reconfigured again to accommodate a series of more radical contradictions and ambiguities.

But, finally, what of the figure of the 'stranger'? I finished Chapter 6 with a cursory suggestion that the stranger was somehow *without*, implying a kind of dispossession, alterity, externality. My assumption was that the gallery was a space that fitted ill with the *habituses* of the lower classes, effectively turning them into strangers. Perhaps we can take this a step further and suggest that the nation, too, has worked *'to deal with the problem of strangers'* – 'foreigners', 'aliens', 'immigrants', 'rebels', 'outsiders' (Bauman, 1988: 153). Such figures exist in a tension between inclusion/exclusion, friend/enemy, known/unknown, inside/outside (Simmel, 1950).[4] They are formally welcomed and rhetorically incorporated but informally vetoed and symbolically repudiated. While the figure of the stranger perhaps captures more adequately the position of women in the symbolic space of the nation (Kristeva, 1993), it serves to raise some serious issues about all social groups whose position in the social order is assumed rather than analysed (evident in the dubious generality of 'citizenship', for instance).

The stranger upsets these assumptions by unmasking the ambiguities of social space, defamiliarising the familiar, making us re-interpret the limits of the known, threatening refined order with the 'fear of the other' (Kristeva, 1991). Most famously in Camus, *l'étranger* was the figure 'condemned because he doesn't play the game' (Camus, 1942: 118), for playing the game marks one's inclusion in any social space, dependent on possessing the relevant frame of reference: demeanour, dress, linguistic codes, for instance. The rules lie beyond careful formulation because 'correct' participation is implicit in the very logic of the field for those with the dispositions. Without over-stretching the parallels, the high cultural spaces of Edinburgh's New Town, its National Gallery, and those throughout Europe, were spaces which demarcated the familiar from the strange for each country's leading classes. Estrangement, it follows, was a principal mode of operation, not least because membership of a social, political or cultural community was bounded by historical limitations – the franchise, property, privation, for instance. Refined social space does not act in mechanical collusion with the predetermined calculations of the higher classes, but it is surely an aspect of their difference, their elevation. And if sociology is still a matter of unveiling cultural arbitraries and systems of power – the common sense of social space – then it must still be incumbent on us to register the strange as well as the familiar.

Notes

1. Just as the modernist impulse transmuted modes of painting and appreciation throughout Europe in the second half of the nineteenth century (as outlined in Bourdieu's (1993) analysis of the Parisian art field in the age of Manet), so Glasgow's vitality as a

modern artistic centre impressed the Scottish art field with more fissures. Academy artists were now placed in the position of conservers of an outmoded aesthetic that was being attacked by a new breed of modernists, the 'Glasgow Boys'. Painters such as Guthrie, Hornel, Lavery and MacGregor incorporated continental modes of representation into their bucolic scenes, insisting on the primacy of form and style over content or narrative. This signalled a rupture with 'academic art', of traditional bourgeois forms, and a turn to the 'pure aesthetic' that was central to the field's on-going logic of conflict and autonomy. As for patronage, Glasgow's prosperity as a centre of British manufacturing concentrated market power amongst industrial magnates, who also built their own museums and galleries (the Burrell collection and the McLellan Galleries, for instance). Needless to say, the Royal Scottish Academy experienced rapid atrophy in this period, its takings down from £5,000 in 1863, to £1,280 in the 1890s (Thompson, 1972). The Academy's ability to define art therefore dissolved, as the cultural field modernised, diversified and de-centred.

2. See, for instance, Trodd's recent reading of the National Gallery in mid-Victorian London as a space of ocular fluidity at the interplay of 'incongruous social meanings' – of hygiene, wonder, work, learning, leisure, etc. (1998: 14). This sets itself quite explicitly against disciplinary or totalising analyses of museums and galleries, but displaces analysis away from the field as a totality, including the differentials in capital possessed and mobilised by social agents before they enter the gallery. What is often at issue, here, is a question of social control, intention and 'readership' that mirrors the debates rehearsed in popular and media studies in the 1980s, out of which Gramsci was posited as a 'saviour'. Certainly there is room for a Gramscian reading of the struggle for hegemony undertaken historically by competing social factions over the museum (the state, private philanthropists, reformers, industrialists, populists, connoisseurs), who may or may not gravitate towards a definite ideological set. This is worth considering if only because hegemony implies an on-going cultural struggle for social authority that must accommodate alternative social positions. However, another way out of avoiding a free-for-all sociology of readership might be recourse to a notion of 'preferred readings' (Hall, 1980). As an event is always framed, managed and ordered (usually dependent on a great deal of stage work/authorship), the boundaries of readership are shaped within certain limits – cultural norms, physical possibilities, particular languages – outside of which meaning is improbable. We might argue that there was a 'preferred reading' managed in the organisation of the museums mentioned, authored but not closed by professional bourgeois norms. Other readings were certainly possible but normatively peripheralised and devalorised.

3. Indeed, the historical correspondences are more than accidental: today, the gallery has been refurbished to a scheme that the director, Timothy Clifford, claims to authentically emulate that of 1859 – red cloth-hung walls, period furniture, 'cluttered hang' and all. Whether this is postmodern nostalgia or an entrenched defence of connoisseurship is a matter of speculation. That Clifford's penchant is for the latter, however, is suggested by his inclination to defend retro-style in the lexicon of 'taste' rather than populism; and the desire for antiquarian academicism is signalled by the disposition of some pictures out of public sight, resting as they do above the large arches which dominate the gallery. 'What worries me is that a new generation is growing up that is being selected to work in museums not because they are passionate amateurs but because they have proven administrative skills, and perhaps little else . . . My plea is that museums and their governing bodies should set greater store by their staff's powers of connoisseurship and scholarship' (Clifford, 1992: 35–7). Clifford's defence of the 'gentlemanly' or 'cluttered hang' is couched in terms of the public's active role in ranking various artists from different schools, although

historically such an ability presupposed in the viewer a Grand Tour education and a knowledge of critical terms, forms and concepts in an approach to old masters (McLellan, 1994; Duncan, 1995).

4. In Simmel's formulation: 'The stranger is close to us, insofar as we feel between him and ourselves common features of a national, social, occupational, or generally human, nature. He is far from us, insofar as these common features extend beyond him or us, and connect us only because they connect a great many people' (Simmel, 1950: 406).

Bibliography

A: Primary Archive Sources

This section is divided according to archive, sub-divided according to institution.

Scottish Records Office (SRO), West Register House, Edinburgh

Board of Manufactures

Minute Books

NG 1/1/35	1824–1830
NG 1/1/36	1830–1835
NG 1/1/37	1835–1843
NG 1/1/38	1843–1848
NG 1/1/39	1848–1851
NG 1/1/40	1852–1855
NG 1/1/41	1855–1858
NG 1/1/42	1858–1862
NG 1/1/43	1862–1869
NG 1/1/44	1869–1873

Index to Minutes ('Scroll Minutes')

NG 1/2/7	1820–1828
NG 1/2/8	1828–1837
NG 1/2/9	1837–1843

Agendas, Sederunts, etc.

NG 1/1/58	1820
NG 1/1/59	1832
NG 1/1/60	1833
NG 1/1/61	1834
NG 1/1/62	1835
NG 1/1/63	1836–1838

Bibliography

Letter Books

NG 1/3/24 1829–1833
NG 1/3/25 1833–1839
NG 1/3/26 1839–1848
NG 1/3/27 1848–1852
NG 1/3/28 1852–1855
NG 1/3/29 1855–1857
NG 1/3/30 1857–1858
NG 1/3/31 1858–1859
NG 1/3/32 1859–1864
NG 1/3/33 1864–1869

Private Letter Books: Correspondence

NG 1/4/1 1848–1866
NG 1/5/7 1829–1831
NG 1/5/8 1832
NG 1/5/9 1833
NG 1/5/10 1834
NG 1/5/11 1835
NG 1/5/12 1836
NG 1/5/13 1837–1845
NG 1/5/14 1823–1844 (additional letters)
NG 1/5/15 1854–1897
NG 1/5/16 1854–1906

Miscellaneous Papers

NG 1/73/13 1835
NG 1/73/23 1847–1848

Royal Institution for the Encouragement of Fine Arts in Scotland

Minute Books

NG 3/1/1 1819–1867

Letter Books

NG 3/3/1 1820–1861
NG 3/3/2 1853

Miscellaneous Correspondence

NG 3/4/1–36 1819–1854
NG 3/7/1 1817
NG 3/7/3 1820–1845

NG 3/7/6 1847
NG 3/7/11a 1835–1857
NG 3/7/30 1971 (notes on provenance of papers and history of Royal
 Institution)

Royal Association for the Promotion of the Fine Arts in Scotland

Minute Books

NG 4/1/1 1853–1856
NG 4/1/2 1856–1884
NG 4/1/3 1884–1897

Miscellaneous Papers

NG 4/3/1 1856–1873
NG 4/3/3 Printed rules of the Association
NG 4/3/4 1857
NG 4/3/5 1876
NG 4/3/6 1878

Bequest Files

NG 5/5/1 1861
NG 5/5/2 1864
NG 5/5/3 1864
NG 5/5/4 1864, 1937

Records of the National Gallery of Scotland

Minute Books/Annual Reports

NG 6/1/1 1858–1859
NG 6/1/2 1861
NG 6/1/3 1860–1873
NG 6/1/4 1984–1906

Letter Books

NG 6/2/1 1850

Order Books

NG 6/3/1 1851–1876
NG 6/3/2 1896–1940

Annual Abstract Returns of National Gallery of Scotland

NG 6/4/1

Bibliography

Building Records

NG 6/5/1 1855
NG 6/6/1–22 1849–1930

Miscellaneous Papers

NG 6/7/1 1850
NG 6/7/2 1856
NG 6/7/3 1856–1858
NG 6/7/4 1857–1869
NG 6/7/5 1862
NG 6/7/6a 1867
NG 6/7/7 1871
NG 6/7/9 1875
NG 6/7/12 1887
NG 6/7/28 1856–1859
NG 6/7/29 1860–1866

Appendix I of NG 2–9

National Gallery of Scotland: Survey of Papers, Plans and Photographs Held by the Board of Trustees or Deposited in the Scottish Records Office, Relating to the Building, its Decoration and Furnishing, 1839–1979.

Royal Scottish Academy (RSA), The Mound, Edinburgh

Royal Scottish Academy

Annual Reports of the Royal Scottish Academy: 1828–1849.
Miscellaneous Correspondence, Incidental Reports, Statements, from Annual Reports of the Royal Scottish Academy.
Catalogues of the Royal Scottish Academy: 1827–1832.

National Gallery of Scotland (NGS), The Mound, Edinburgh

Royal Association for the Promotion of Fine Arts

Annual Reports

Volume I 1834–1841
Volume II 1841–1847
Volume III 1847–1852
Volume IV 1852–1857
Volume V 1857–1863

National Library Of Scotland (NLS), George IV Bridge, Edinburgh

'Letter to Lord Meadowbank and the Committee of the Honourable Board of Trustees for the Encouragement of Arts and Manufactures on the Best Means of Ameliorating the Arts and Manufactures of Scotland in Point of Taste', William Dyce and Charles H. Wilson (1837), Edinburgh: Thomas Constable, mf. Ry 1.3.54.

Sub-committee of National Monument

Ms. 638
Ms. 639, including 'Restoration of the Parthenon', *Scots Magazine*, February 1820 to the Lord Advocate from 'A Traveller'.

Newspapers and Journals

Building Chronicle, 1 July 1856, no. 28.
Edinburgh News and Literary Chronicle, 1859.
Edinburgh Evening Courant, 1859.
Daily Scotsman, 1859.

Edinburgh University Library (EUL), George Square, Edinburgh

Royal Institution for the Encouragement of Fine Arts in Scotland

Royal Institution for the Encouragement of Fine Arts in Scotland, Catalogues and Misc. Pamphlets, vol. 10: ATT. 80, pp. 10/42–44, including: Institution for the Encouragement of Fine Arts in Scotland, Annual Exhibition Catalogues 1820–1832.

Royal Association for the Promotion of Fine Arts in Scotland

Prospectus and Result of the Distribution of Pictures at the Annual General Meeting in May 1836.

MISC.

Catalogue of the Collection of Pictures, Marbles and Bronzes Bequeathed to the University of Edinburgh by Sir James Erskine of Torry, Bart. and now Deposited for Public Inspection in Galleries of the Royal Institution.
Catalogue of Architectural Drawings of the National Gallery of Scotland, William Henry Playfair, with article by Ian Gow, 'Architect to the Modern Athens'.
Drawing Plans: Pf. 38 4751–4879
Catalogue Descriptive and Historical of the National Gallery of Scotland, under the Management of the Board of Manufactures (1859), W. B. Johnstone, RSA, Principal Curator and Keeper, Edinburgh, I* 15/2.6.
Royal Scottish Academy; Letter from William Etty to William Allan, January 1848.

Bibliography

Government Reports, Bills, etc.

Report from the Select Committee on Arts, and their Connexion with Manufactures; with Minutes of Evidence, Appendix and Index, 1836, vol. 3.

Report from the Select Committee on Fine Arts; Together with the Minutes of Evidence, Appendix and Index, June 1841.

Report from the Select Committee on National Monuments and Works of Art with the Minutes of Evidence, and Appendix, June 1841.

Report from the Select Committee on Art Unions, *Parliamentary Papers 1800– 1900,* vol. VII, 1845, (612).

Lefevre, Sir J. S. (1847) Report into the Affairs of Edinburgh's Art Institutions, London: Board of Trade, NG 3/4/22/18/2.

Lefevre, Sir J. S. (1850) Report to Treasury Respecting the Erection of Galleries of Art in Edinburgh, *Parliamentary Papers 1800–1900*, vol. XXXIV, (586).

National Gallery (Edinburgh) A Bill For the Erection on the Earthen Mound in the City of Edinburgh of Buildings for a National Gallery, and Other Purposes Connected Therewith and with the Promotion of the Fine Arts in Scotland, 1850, *House of Commons Bills, Public* (168), (648), IV.

Supply – National Gallery (Scotland), 1850, *Hansard's Parliamentary Debates, third series*, vol. 113, 19 July–15 August.

Report from the Select Committee on the National Gallery with Minutes of Evidence, Appendix and Index, *British Parliamentary Papers, Education and Fine Arts 4*, Irish University Press, session 1852–53.

Report of the National Gallery Site Commission, Together with Minutes, Evidence, Appendix and Index, 1857, London: Harrison and Sons.

Reports from the Select Committees and Commissioners on Fine Arts and on the National Gallery with Minutes of Evidence, Appendices and Indices, 1847–63, *British Parliamentary Papers: National Gallery; Promotion of Fine Arts, Education, Fine Arts 3*, Shannon, Ireland: Irish University Press.

B: Printed Books and Articles

Abrams, P. (1982) *Historical Sociology*, Bath: Open Books.

Adorno, T. (1972) *Aesthetic Theory*, London: Routledge and Kegan Paul.

Alexander, E. P. (1979) *Museums in Motion*, Nashville: American Association for State and Local History.

Altick, R. (1978) *The Shows of London*, Cambridge, Mass.: Harvard University Press.

Anderson, B. (1983) *Imagined Communities: Reflections on the Origin and Spread of Nationalism*, London: Verso.

Anderson, P. (1964) 'Origins of the Present Crisis', *New Left Review*, vol. 23, Jan./ Feb.

Anonymous (1829) 'Scottish Academy of Painting, Sculpture and Architects', *New Scots Magazine*, no. XIII, November, 334–48.

Bibliography

Anonymous (1889) 'How I Became an A.R.S.A', *Scottish Art Review*, November, 163–6.

Armstrong, W. (1888) *Scottish Painters: A Critical Study*, London: Seeley.

Bakhtin, M. (1968) *Rabelais and his World*, Cambridge, Mass.: MIT Press.

Barker, E. (ed.) (1999) *Contemporary Cultures of Display*, New Haven and London: Yale University Press.

Barrell, J. (1980) *The Dark Side of the Landscape*, Cambridge: Cambridge University Press.

Barrell, J. (1986) *The Political Theory of Painting from Reynolds to Hazlitt*, New Haven: Yale University Press.

Barrell, J. (ed.) (1992) *Painting and the Politics of Culture: New Essays on British Art 1700–1850*, New York: Oxford University Press.

Bartholomew, M., Hall, D. and Lentin, A. (1992) (eds), *The Enlightenment*, Milton Keynes: Open University Press.

Baudrillard, J. (1982) 'The Beaubourg-effect: Implosion and Deterrence', *October*, vol. 20, Spring.

Bauman, Z. (1988) 'Strangers: The Social Construction of Universality and Particularity', *Telos*, no. 78, Winter.

Baxandall, M. (1972) *Painting and Experience in Fifteenth-century Italy*, Oxford: Oxford University Press.

Bazin, G. (1967) *The Museum Age*, New York: Universal Press.

Becker, H. S. (1982) *Art Worlds*, Berkeley: University of California Press.

Becker, M. (1994) *The Emergence of Civil Society in the Eighteenth Century*, Bloomington and Indianapolis: Indiana University Press.

Becq, A. (1993) 'Creation, Aesthetics, Market: Origins of the Modern Concept of Art', in P. Mattick, Jr. (ed.), *Eighteenth Century Aesthetics and the Reconstruction of Art*, Cambridge: Cambridge University Press.

Benjamin, W. (1986) *Reflections: Essays, Aphorisms, Autobiographical Writings*, translated by E. Jephcott, New York : Schocken Books.

Bennett, T. (1988) 'The Exhibitionary Complex', *New Formations*, no. 4, Spring.

Bennett, T. (1995) *The Birth of the Museum*, Routledge: London.

Berman, M. (1983) *All That is Solid Melts into Air*, London: Verso.

Bermingham, A. (1986) *Landscape and Ideology: The English Rustic Tradition*, London: University of California Press.

Bermingham, A. and Brewer, J. (eds) (1995) *The Consumption of Culture, 1600–1800*, London: Routledge.

Berry, C. J. (1997) *Social Theory of the Scottish Enlightenment*, Edinburgh: Edinburgh University Press.

Best, S. and Kellner, D. (1991) *Postmodern Theory: Critical Interrogations*, London: Macmillan.

Beveridge, C. and Turnbull, R. (1989) *The Eclipse of Scottish Culture: Inferiorism and the Intellectuals*, Edinburgh: Polygon.

Blonsky, H. (1985) *On Signs: A Semiotics Reader*, Oxford: Blackwell.

Bohls, E. (1993) 'Disinterestedness and Denial of the Particular: Locke, Adam Smith, and the Subject of Aesthetics', in P. Mattick, Jr. (ed.), *Eighteenth Century*

Aesthetics and the Reconstruction of Art, Cambridge: Cambridge University Press.

Bourdieu, P. (1977) *Outline of a Theory of Practice*, Cambridge: Cambridge University Press.

Bourdieu, P. (1984) *Distinction*, London, Melbourne and Henley: Routledge and Kegan Paul.

Bourdieu, P. (1990a) *In Other Words: Essays Towards a Reflexive Sociology*, Cambridge: Polity.

Bourdieu, P. (1990b) *The Logic of Practice*, Cambridge: Polity.

Bourdieu, P. (1993) *The Field of Cultural Production: Essays on Art and Literature*, Cambridge: Polity Press.

Bourdieu, P. (1996) *The Rules of Art*, Cambridge: Polity.

Bourdieu, P. (1998) *Practical Reason: On the Theory of Action*, Cambridge: Polity.

Bourdieu, P. and Darbel, A. (1991) *The Love of Art: European Art Museums and their Public*, Cambridge: Polity.

Bourdieu, P. and Wacquant, L. (1992) *An Invitation to Reflexive Sociology*, Cambridge: Cambridge University Press.

Bowler, A. (1994) 'Methodological Dilemmas in the Sociology of Art', in D. Crane (ed.), *The Sociology of Culture*, Oxford: Blackwell.

Brain, D. (1994) 'Cultural Production as "Society in the Making": Architecture as an Exemplar of the Social Construction of Cultural Artifacts', in D. Crane (ed.), *The Sociology of Culture*, Oxford: Blackwell.

Brewer, J. (1995a) 'The Most Polite Age and the Most Vicious: Attitudes towards Culture as Commodity, 1660–1800', in A. Bermingham and J. Brewer (eds), *The Consumption of Culture, 1600–1800*, London: Routledge.

Brewer, J. (1995b) 'Cultural Production, Consumption and the Place of the Artist in Eighteenth-century England', in B. Allen (ed.), *Towards a Modern Art World*, New Haven and London: Yale University Press.

Brogden, W. A. (1995) 'John Smith and Craigievar Castle', in I. Gow and A. Rowan (eds), *Scottish Country Houses, 1600–1914*, Edinburgh, Edinburgh University Press.

Bronner, S. and Kellner, D. (eds) (1989) *Critical Theory and Society: A Reader*, New York: Routledge.

Brown, J. (1995) *Kings and Connoisseurs: Collecting Art in Seventeenth-Century Europe*, New Haven and London: Yale University Press.

Brown, M. (1993) 'Romanticism and Enlightenment', in S. Curran (ed.), *British Romanticism*, Cambridge: Cambridge University Press.

Brubaker, R. (1992) *Citizenship and Nationhood in France and Germany*, Cambridge: Harvard University Press.

Burgin, V. (1986) *The End of Art Theory*, London: Macmillan.

Calder, A. (1994) *Revolving Culture*, London: Tauris.

Calhoun, C. (1990) 'Putting the Sociologist in the Sociology of Culture: The Self-reflexive Scholarship of Pierre Bourdieu and Raymond Williams', *Contemporary Sociology*, vol. 19, no. 4, 500–5.

Campbell, C. (1983) 'Romanticism and the Consumer Ethic: Intimations of a Weber-style Thesis', *Sociological Analysis*, vol. 44, no. 4, 279–96.

Campbell, C. (1987) *The Romantic Ethic and the Spirit of Modern Consumerism*, Oxford: Blackwell.

Camus, A. (1942) *The Outsider*, London: Penguin, 1983.

Caw, J. (1932) *Scottish Painting Past and Present*, Edinburgh: T. C. and E. C. Jack.

Certeau, M. de (1985) 'Practices of Space', in H. Blonsky (ed.), *On Signs: A Semiotics Reader*, Oxford: Blackwell.

Chaney, D. (1994) *The Cultural Turn: Scene-Setting Essays on Contemporary Cultural History*, London: Routledge.

Chaplin, E. (1994) *Sociology and Visual Representation*, London: Routledge.

Cheape, H. (1987) 'The World of a Nineteenth-Century Artist in Scotland', *Revolution of Scottish Culture*, no. 3, 77–90.

Checkland, O. and Checkland, S. (1984) *Industry and Ethos: Scotland 1832–1914*, Edinburgh: Edinburgh University Press.

Chitnis, A. (1976) *The Scottish Enlightenment: A Social History*, London: Croom Helm.

Clifford, T. (1982) 'The Historical Approach to the Display of Paintings', *International Journal of Museum Management and Curatorship*, vol. 1, 93–106.

Clifford, T. (1987) 'Picture Hanging in Public Galleries', *Proceedings of the Royal Society of Arts*, September, 718–34.

Clifford, T. (1988) 'A Brief History of the National Gallery after 1859', in I. Gow and T. Clifford (eds), *The National Gallery of Scotland: An Architectural and Decorative History*, Edinburgh: Trustees of the National Galleries of Scotland.

Clifford, T. (1992) 'The Connoisseur's Role', *The Antique Collector*, July/August.

Cobban, A. (1969) *The Nation State and National State Determination*, London: Collins.

Cockburn, H. (1854) *Journal of Henry Cockburn 1831–1854, vol. 1*, Edinburgh: Edmonston and Douglas.

Colley, L. (1992) *Britons: Forging the Nation 1707–1837*, London: Pimlico Books.

Compton, M. (1992) 'The National Galleries', in J. Thompson (ed.), *Manual of Curatorship: A Guide to Museum Practice*, London: Butterworth.

Cooksey, J. (1979) 'Introduction' to *Alexander Nasmyth*, Exhibition Catalogue, Balcarres Gallery, Crawford Centre for the Arts, University of St Andrews.

Coombes, A. (1988) 'Museums and the Formation of National and Cultural Identities', *Oxford Art Journal*, vol. 11.

Copley, S. (1992) 'The Fine Arts in Polite Culture', in J. Barrell (ed.), *Painting and the Politics of Culture: New Essays on British Art 1700–1850*, New York: Oxford University Press.

Corrigan, D. and Sayer, P. (1985) *The Great Arch: English State Formation as Cultural Revolution*, Oxford: Blackwell.

Cosgrove, D. and Daniels, S. (eds) (1988) *The Iconography of Landscape*, Cambridge: Cambridge University Press.

Crane, D. (ed.) (1994) *The Sociology of Culture*, Oxford: Blackwell.

Crimp, D. (1984) 'On the Museum's Ruins', in H. Foster (ed.), *Postmodern Culture*, London: Pluto Press.

Crow, Thomas E. (1985) *Painters and Public life in Eighteenth Century Paris*, New Haven: Yale University Press.

Cultural Trends (1995) Issue 28, Policy Studies Institute.

Cultural Trends (1998) Issue 31, Policy Studies Institute.

Cummings, A. (1994) 'The Business Affairs of an Eighteenth Century Lowland Laird: Sir Archibald Grant of Monymusk 1696–1778', in T. Devine (ed.), *Scottish Elites*, Edinburgh: John Donald.

Daiches, D. (1996) 'The Scottish Enlightenment', in D. Daiches, P. Jones and J. Jones (eds), *The Scottish Enlightenment 1730–1790: A Hotbed of Genius*, Edinburgh: Saltire Society.

Daiches, D., Jones, P. and Jones, J. (eds) (1996) *The Scottish Enlightenment 1730–1790: A Hotbed of Genius*, Edinburgh: Saltire Society.

Danto, A. C. (1999) 'Bourdieu on Art: Field and Individual', in R. Shusterman (ed.) *Bourdieu: A Critical Reader*, Oxford: Blackwell.

Davie, G. (1961) *The Democratic Intellect: Scotland and her Universities in the Nineteenth Century*, Edinburgh: Edinburgh University Press.

Denvir, B. (1984) *The Early Nineteenth Century: Art, Design and Society 1789–1852*, New York: Longman.

Devine, T. M. (ed.) (1989) *Improvement and Enlightenment*, Edinburgh: John Donald.

Devine, T. (1990) 'The Failure of Radical Reform in Scotland in the late Eighteenth Century: The Social and Economic Context', in T. Devine (ed.), *Conflict and Stability in Scottish Society*, Edinburgh: John Donald.

Dickie, George (1975) *Art and the Aesthetic: An Institutional Analysis*, Ithaca: Cornell University Press.

Dickson, T. (1989) 'Scotland is Different, OK?', in D. McCrone, S. Kendrick and P. Straw (eds), *The Making of Scotland: Nation, Culture and Social Change*, Edinburgh: Edinburgh University Press.

DiMaggio, P. (1979) 'Review essay: On Pierre Bourdieu', *American Journal of Sociology*, vol. 84, no. 6, 60–74.

DiMaggio, P. (1987) 'Classification in Art', *American Sociological Review*, vol. 53, August, 440–55.

Docherty, T. (ed.) (1993) *Postmodernism: A Reader*, London: Harvester Wheatsheaf.

Donald, D. (1996) *The Age of Caricature: Satirical Prints in the Reign of George III*, New Haven and London: Yale University Press.

Downie, R. S. (1994) 'Introduction' to *Francis Hutcheson: Philosophical Writings*, London: Orion.

Dufrenne, M. (ed.) (1978) *Main Trends in Aesthetics and the Sciences of Art*, New York and London: Holmes and Meier Publishers.

Dulwich Picture Gallery (n.d.) *Dulwich Picture Gallery*, Westerham Press.

Duncan, C. (1991) 'Art Museums and the Ritual of Citizenship', in I. Karp and S. Lavine (eds), *Exhibiting Cultures: The Poetics and Politics of Museum Display*, Washington, London: Smithsonian Institution Press.

Duncan, C. (1995) *Civilizing Rituals: Inside Public Art Museums*, London: Routledge.

Duncan, J. and Ley, D. (1993) *Place/Culture/Representation*, London: Routledge.

Duncan, C. and Wallach, A. (1980) 'The Universal Survey Museum', *Art History*, vol. 3, no. 4, 448–69.

Dwyer, J. (1987) *Virtuous Discourse: Sensibility and Community in Late Eighteenth-Century Scotland*, Edinburgh: John Donald.

Dwyer, J., Mason, R. and Murdoch, A. (eds) (1982) *New Perspectives on the Politics and Culture of Early Modern Scotland*, Edinburgh: John Donald.

Dyce, W. (1853) *The National Gallery: Its Formation and Management*, London: Chapman and Hall.

Eagleton, T. (1984) *The Function of Criticism*, London: Verso.

Eagleton, T. (1990) *The Ideology of the Aesthetic*, Oxford: Blackwell.

Eastlake, Sir C. (1845) *The National Gallery: Observations on the Unfitness of the Present Building for its Purpose in a Letter to the Rt. Hon. Sir Robert Peel, Bart.*, London: Clowes and Sons.

Eley, G. (1994) 'Nations, Publics and Political Cultures: Placing Habermas in the Nineteenth Century', in N. Dirks, G. Eley and S. Ortner (eds), *Culture/Power/History: A Reader in Contemporary Social Theory*, New Jersey: Princeton University Press.

Elias, N. (1978) *The Civilizing Process*, vol. 1 *The History of Manners*, Oxford: Blackwell.

Elias, N. (1982) *The Civilizing Process*, vol. 2 *State Formation and Civilisation*, Oxford: Blackwell.

Elias, N. (1983) *The Court Society*, translated by E. Jephcott, Oxford: Blackwell.

Emerson, R. (1973a) 'The Enlightenment and Social Structures', in P. Fritz and D. Williams (eds) *City and Society in the Eighteenth Century*, Toronto: Hakkert.

Emerson, R. (1973b) 'The Social Composition of Enlightened Scotland: The Select Society of Edinburgh 1754–64', *Studies in Voltaire*, vol. 114, 291–329.

Errington, L. (1979) *The Artist and the Kirk*, Edinburgh: National Galleries of Scotland Catalogue.

Farnborough, Lord (1826) *Short Remarks and Suggestions upon Improvements Now Carrying on or under Consideration*, London: J. Hatchard and Son.

Featherstone, M. (1991) *Consumer Culture and Postmodernism*, London: Sage.

Ferguson, A. (1767) *An Essay on the History of Civil Society*, ed. D. Forbes, Edinburgh: Edinburgh University Press, 1966.

Forbes, C. (1997) *Artists, Patrons and the Power of Association: The Emergence of a Bourgeois Artistic Field in Edinburgh, c.1775–c.1840*, unpublished PhD thesis, University of St Andrews.

Foss, M. (1971) *The Age of Patronage: The Arts in Society, 1660–1750*, London: Hamilton.

Foucault, M. (1970) *The Order of Things: An Archaeology of the Human Sciences*, London: Tavistock.

Foucault, M. (1977) *Discipline and Punish: The Birth of the Prison*, London: Allen Lane.

Fox, C. (ed.) (1992) *London: World City 1800–1840*, London and New Haven: Yale University Press.

Fox, D. M. (1970) 'Artists in the Modern State: The Nineteenth Century Background', in M. C. Albrecht, J. H. Barnett, J. H. and M. Griff (eds), *The Sociology of Art: A Reader*, London: Duckworth.

Fraser, N. (1993) 'Rethinking the Public Sphere: A Contribution to the Critique of Actually Existing Democracy', in B. Robbins (ed.), *The Phantom Public Sphere*, Minneapolis: University of Minnesota Press.

Fraser, W. H. (1990) 'Developments in Leisure', in W. H. Fraser and R. J. Morris (eds), *People and Society in Scotland, vol. II, 1830–1914*, Edinburgh: John Donald.

Fry, M. (1987) *Patronage and Principle: A Political History, 1832–1924*, Aberdeen: Aberdeen University Press.

Fullerton, P. (1982) 'Patronage and Pedagogy: The British Institution in the Early Nineteenth Century', *Art History*, vol. 5, no. 1: 59–72.

Funnell, P. (1992) 'The London Art World and its Institutions', in C. Fox (ed.), *London: World City 1800–1840*, London and New Haven: Yale University Press.

Funnell, P. (1995) 'William Hazlitt, Prince Hoare, and the Institutionalisation of the British Art World', in B. Allen (ed.), *Towards a Modern Art World*, New Haven and London: Yale University Press.

Fyfe, G. (1986) 'Art Exhibitions and Power During the Nineteenth Century', in J. Law (ed.), *Power, Action and Belief*, London: Routledge and Kegan Paul.

Fyfe, G. (1993) 'Art Museums and the State', *University of Keele Working Papers*, no. 2, Keele.

Fyfe, G. (1996) 'A Trojan Horse at the Tate: Theorizing the Museum as Agency and Structure', in S. Macdonald and G. Fyfe (eds), *Theorizing Museums*, Oxford: Blackwell, 203–28.

Fyfe, G. (2000) *Art, Power and Modernity: English Art Institutions, 1750–1950*, London and New York: Leicester University Press.

Gale, I. (1994) 'The Clifford Inheritance', *The Guardian*, Tuesday 23 August.

Gardiner, M. (1992) *The Dialogics of Critique*, London: Routledge.

Garnham, N. and Williams R. (1986) 'Pierre Bourdieu and the Sociology of Culture: An Introduction', in R. Collins, J. Curran, N. Garnham, P. Scannell, P. Schlesinger and C. Sparks (eds), *Media, Culture and Society: A Critical Reader*, London: Sage.

Gerth, H. and Mills, C. W. (eds) (1958) *From Max Weber*, New York: Oxford University Press.

Gifford, D. (ed.) (1988) *The History of Scottish Literature, vol. 3: The Nineteenth Century*, Aberdeen: Aberdeen University Press.

Gifford, J. (1989) *William Adam 1689–1748*, Edinburgh: Mainstream.

Gilhooley, J. (1988) *A Directory of Edinburgh 1752*, Edinburgh: Edinburgh University Press.

Gilmore, S. (1990) 'Art Worlds: Developing the Interactionist Approach to Social Organisation', in H. Becker and M. McCall (eds), *Symbolic Interaction and Cultural Studies*, Chicago and London: University of Chicago Press.

Girouard, M. (1978) *Life in the English Country House: A Social and Architectural History*, New York and London: Yale University Press.

Girouard, M. (1985) 'The Power House', in G. Jackson-Stops (ed.) *The Treasure Houses of Britain*, London and New Haven: Yale University Press.

Golby, J. M. and Purdue, A.W. (1984) *The Civilisation of the Crowd: Popular Culture in England, 1750–1900*, London: Batsford Academic and Educational.

Gombrich, E. H. (1972) *The Story of Art*, London: Phaidon.

Gordon, E. (1976) *The Royal Scottish Academy 1826–1976*, Edinburgh: Charles Skilton Ltd.

Gordon, I. (ed.) (1985) *Perspectives on the Scottish City*, Aberdeen: Aberdeen University Press.

Gow, I. (1988) 'The Northern Athenian Temple of the Arts', in I. Gow and T. Clifford (eds), *The National Gallery of Scotland: An Architectural and Decorative History*, Edinburgh: Trustees of the National Galleries of Scotland.

Gow, I. (1990) 'The Eighteenth Century Interior in Scotland', in W. Kaplan (ed.), *Scotland Creates: 5000 Years of Art and Design*, London: Glasgow Museums and Art Galleries.

Gow, I. (1992) *The Scottish Interior*, Edinburgh: Edinburgh University Press.

Gow, I. and Clifford, T. (eds) (1988) *The National Gallery of Scotland: An Architectural and Decorative History*, Edinburgh: Trustees of the National Galleries of Scotland.

Gow, I. and Rowan, A. (eds) (1995) *Scottish Country Houses, 1600–1914*, Edinburgh, Edinburgh University Press.

Gracyk, T. (1994) 'Rethinking Hume's Standard of Taste', *The Journal of Aesthetics and Art Criticism*, vol. 52, no. 2, Spring, 169–82.

Gramsci, A. (1971) *Selections from the Prison Notebooks*, London: Lawrence and Wishart.

Gramsci, A. (1985) *Selections of Cultural Writings*, ed. G. Forgacs and G. N. Smith, Cambridge: Harvard University Press.

Graña, C. (1967) 'The Private Lives of Public Museums', *Trans-Action*, no. 4 (5) 20–5.

Graña, C. (1971) *Fact and Symbol*, New York: Oxford University Press.

Grant, E. (1988) 'The Sphinx in the North: Egyptian Influences on Landscape, Architecture and Interior Design in Eighteenth- and Nineteenth-Century Scotland', in D. Cosgrove and S. Daniels (eds), *The Iconography of Landscape*, Cambridge: Cambridge University Press.

Green, N. (1990) *The Spectacle of Nature: Landscape and Bourgeois Culture in Nineteenth Century France*, Manchester: Manchester University Press.

Greenhalgh, P. (1989) 'Education, Entertainment and Politics: Lessons from the Great International Exhibits', in P. Vergo (ed.), *The New Museology*, London, Reaktion Books.

Habermas, J. (1981) 'Modernity – An Incomplete Project', in T. Docherty (ed.), *Postmodernism: A Reader*, London: Harvester Wheatsheaf.

Habermas, J. (1989a) *The Structural Transformation of the Public Sphere*, Cambridge, Mass.: MIT Press.

Habermas, J. (1989b) 'The Public Sphere: An Encyclopedia Article', in S. Bronner and D. Kellner (eds), *Critical Theory and Society: A Reader*, New York: Routledge.

Hall, S. (1980) 'Encoding/Decoding', in S. Hall (ed.), *Culture, Media, Language: Working Papers in Cultural Studies, 1972–79*, London: Unwin Hyman.

Harris, J. (1970) *Government Patronage of the Arts in Great Britain*, Chicago and London: University of Chicago Press.

Harris, N. (1993) *National Liberation*, London: Penguin.

Harvey, D. (1989) *The Condition of Postmodernity*, Oxford: Blackwell.

Haskell, F. (1971) *Patrons and Painters: Art and Society in Baroque Italy*, New York and London: Harper and Row.

Haskell, F. (1976) *Rediscoveries in Art: Some Aspects of Taste, Fashion and Collecting in England and France*, London: Phaidon.

Haskell, F. (1985) 'The British as Collectors', in G. Jackson-Stops (ed.), *The Treasure Houses of Britain*, New Haven and London: Yale University Press.

Haskell, F. (1989) 'Charles I's Collection of Pictures', in A. MacGregor (ed.), *The Late King's Goods: Collections, Possessions and Patronage of Charles I in the Light of the Commonwealth Sale Inventories*, London and Oxford: Oxford University Press.

Hauser, A. (1962) *The Social History of Art, vol. III: Rococo, Classicism, Romanticism*, London: Routledge.

Hauser, A. (1982) *The Sociology of Art*, London: Routledge and Kegan Paul.

Hazlitt, W. (1824) 'Sketches of the Principal Picture Galleries in England and Notes of a Journey Through France and Italy', in *The Complete Works of William Hazlitt*, ed. P.P. Howe, volume 10, London and Toronto: J.M. Dent and Sons, Ltd, 1932.

Hemingway, A. (1995) 'Art Exhibitions as Leisure-Class Rituals in Early Nineteenth-Century London', in B. Allen (ed.), *Towards a Modern Art World*, New Haven and London: Yale University Press.

Hobsbawm, E. (1990) *Nations and Nationalism since 1790: Programme, Myth and Reality*, Cambridge: Cambridge University Press.

Hobsbawm, E. and Ranger, T. (eds) (1983) *The Invention of Tradition*, Cambridge: Cambridge University Press.

Hoetink, H. (1982) 'The Evolution of the Art Market and Collecting in Holland', *The International Journal of Museum Management and Curatorship*, vol. 1, 107–18.

Hoffmann, D. (1994) 'The German Art Museum and the History of the Nation', in D. Sherman and I. Rogoff (eds), *Museum Culture: Histories, Discourses, Spectacles*, Minneapolis: University of Minnesota Press.

Hollier, D. (1992) *Against Architecture: The Writings of Georges Bataille*, Cambridge: MIT Press.

Holloway, J. (1987) *Jacob More*, Scottish Masters Series, Trustees of the National Galleries of Scotland.

Holloway, J. (1989) *Patrons and Painters: Art in Scotland 1650–1760*, Trustees of the National Galleries of Scotland.

Holloway, J. (1990) 'Scotland's Artistic Links with Europe', in W. Kaplan (ed.), *Scotland Creates: 5000 Years of Art and Design*, London: Glasgow Museums and Art Galleries.

Holloway, J. (1994) *The Norrie Family*, Edinburgh: National Galleries of Scotland.

Holloway, J. and Errington, L. (1978) *The Discovery of Scotland: The Appreciation of Scottish Scenery Through Two Centuries of Painting*, Edinburgh: National Gallery of Scotland.

Holme, Sir C. (ed.) (1907) *Royal Scottish Academy 1826–1907*, London: The Studio. Introduction by A. C. Baldry.

Holme, Sir C. and Baker, C. H. (1924) *The Making of the National Gallery 1824–1924*, London: The National Gallery.

Hont, I. (1983) 'The 'Rich Country–Poor Country' Debate in Scottish Classical Political Economy', in I. Hont and M. Ignatieff (eds), *Wealth and Virtue: The Shaping of Political Economy in the Scottish Enlightenment*, Cambridge: Cambridge University Press.

Hood, W. (1853) *The National Gallery: remarks on the pictures in the National Gallery, which have recently been cleaned, together with some observations relative to the art of cleaning and restoring oil paintings*, London: T. and W. Bone.

Hook, A. (ed.) (1987) *The History of Scottish Literature*, Aberdeen: Aberdeen University Press.

Hook, A. (1988) 'Scotland and Romanticism: The International Scene', in D. Gifford (ed.), *The History of Scottish Literature: The Nineteenth Century*, Aberdeen: Aberdeen University Press.

Hooper-Greenhill, E. (ed.) (1997) *Cultural Diversity*, London: Leicester University Press.

Hopetoun House Catalogue (1996), Derby: Pilgrim Press.

Hopetoun Research Group Studies (1987) 'The Diaries and Travels of Lord John Hope 1722–1727', paper no. 1, University of Edinburgh.

Houston, R. and Whyte, I. (eds) (1989) *Scottish Society 1500–1800*, Cambridge: Cambridge University Press.

Hudson, K. (1975) *A Social History of Museums: What Visitors Thought*, London: Macmillan.

Hudson, K. (1987) *Museums of Influence*, Cambridge: Cambridge University Press.

Hume, D. (1779) *Essays: Moral, Political and Literary*, ed. E. Miller, Indianapolis: Liberty Press, 1987.

Humphreys, A. (1992) 'The Arts in Eighteenth-Century Britain', in B. Ford (ed.), *Eighteenth-Century Britain*, The Cambridge Cultural History, vol. 5, Cambridge: Cambridge University Press.

Hunt, L. (1984) *Politics, Culture and Class in the French Revolution*, London: Methuen.

Hutcheson, F. (1724) *Inquiry Concerning Beauty, Order, Harmony and Design*, in *Inquiry into the Original of our Ideas of Beauty and Virtue*, ed. P. Kivy, The Hague: Martinus Nijhoff, 1973.

Hutchinson, J. and Smith, A. D. (1994) *Nationalism*, Oxford: Oxford University Press.

Iconoclast (1860) *Fine Art Pamphlets – Scottish*, 4: Royal Scottish Academy.

Impey, O. and MacGregor, A. (eds) *The Origins of Museums: The Cabinet of Curiosities in Sixteenth and Seventeenth Century Europe*, Oxford: Clarendon Press.

Irwin, D. and Irwin, F. (1975) *Scottish Painters at Home and Abroad 1700–1900*, London: Faber and Faber.

Jackson, T. (1986) 'Images of Industry', in *Signs of the Times: Art and Industry in Scotland 1750–1985*, Exhibition Catalogue, Edinburgh: Talbot Rice Gallery.

Jackson-Stops, G. (1985) 'Temples of Art', in G. Jackson-Stops (ed.), *The Treasure Houses of Britain*, New Haven and London: Yale University Press.

Jeffery, S. (1992) 'Architecture', in B. Ford (ed.), *Eighteenth-Century Britain*, The Cambridge Cultural History, vol. 5, Cambridge: Cambridge University Press.

Jenkins, R. (1992) *Pierre Bourdieu*, London: Routledge.

Johnson, D. (1972) *Music and Society in Lowland Scotland in the Eighteenth Century*, London: Oxford University Press.

Johnson, R. (1976) 'Barrington Moore, Perry Anderson and English Social Development', *Cultural Studies*, vol. 9, Spring 1976.

Jordanova, L. (1989) 'Objects of Knowledge: A Historical Perspective on Museums', in P. Vergo (ed.), *The New Museology*, London: Reaktion Books.

Kaplan, W. (ed.) (1990) *Scotland Creates: 5000 Years of Art and Design*, London: Glasgow Museums and Art Galleries.

Karp, I. and Lavine, S. (eds) (1991) *Exhibiting Cultures: The Poetics and Politics of Museum Display*, Washington, London: Smithsonian Institution Press.

Kavanagh, G. (ed.) (1991) *The Museums Profession*, Leicester: Leicester University Press.

Keane, J. (1988) *Civil Society and the State: New European Perspectives*, London: Verso.

King, L. S. (1985) *The Industrialisation of Taste: Victorian England and the Art Union of London*, Ann Arbor: UMI Research Press.

Kivy, P. (1976) *The Seventh Sense: A Study of Francis Hutcheson's Aesthetics and its Influence in Eighteenth-Century Britain*, New York: Burt Franklin and Co.

Kivy, P. (1994) 'From Literature as Imagination to Literature as Memory: A Historical Sketch', in R. J. Yanal (ed.), *Institutions of Art: Reconsiderations of*

George Dickie's Philosophy, Pennsylvania: Pennsylvania State University Press.

Klingender, F. (1968) *Art and the Industrial Revolution*, London: Paladin.

Kristeva, J. (1991) *Strangers to Ourselves*, New York: Columbia University Press.

Kristeva, J. (1993) *Nations Without Nationalism*, New York: Columbia University Press.

Kuzmics, H. (1988) 'The Civilizing Process', in J. Keane (ed.), *Civil Society and the State: New European Perspectives*, London: Verso.

Landes, J. (1988) *Women and the Public Sphere in the Age of the French Revolution*, Ithaca and London: Cornell University Press.

Landes, J. (1992) 'Re-thinking Habermas's Public Sphere', *Political Theory Newsletter*, no. 4.

Lang, P. H. (1973) 'Music and the Court in the Eighteenth Century', in P. Fritz and D. Williams (eds), *City and Society in the Eighteenth Century*, Edinburgh: John Donald.

Lash, S. (1990) *Sociology of Postmodernism*, London: Routledge.

Lee, P. (1997) 'The Musaeum of Alexandria and the Formation of the *Muséum* in Eighteenth-Century France', *Art Bulletin*, vol. LXXIX, no. 3, September, 385–412.

Lefebvre, H. (1991) *The Production of Space*, Oxford: Blackwell.

Lehmann, W. (1971) *Henry Home, Lord Kames and the Scottish Enlightenment*, The Hague: M. Nifhoff.

Lehmann, W. (1978) *Scottish and Scots-Irish Contributions to Early American Life and Culture*, Port Washington, NY: National University Publications.

Lenman, B. (1981) *Integration, Enlightenment and Industrialisation: Scotland 1745–1832*, London: Edward Arnold.

Lewis, G. (1992a) 'Collections, Collectors and Museums: A Brief World Survey', in J. Thompson (ed.), *Manual of Curatorship: A Guide to Museum Practice*, London: Butterworth.

Lewis, G. (1992b) 'Museums and Their Precursors', in J. Thompson (ed.), *Manual of Curatorship: A Guide to Museum Practice*, London: Butterworth.

Lightbrown, R. (1989) 'Charles I and the Tradition of European Princely Collecting', in A. MacGregor (ed.), *The Late King's Goods: Collections, Possessions and Patronage of Charles I in the Light of the Commonwealth Sale Inventories*, London and Oxford: Oxford University Press.

Lloyd, C. (1966) 'John Julius Angerstein, 1732–1823', *History Today*, vol. 16, June: 373–9.

Lorente, J. P. (1996) 'Galleries of Modern Art in Nineteenth-Century Paris and London: Their Location and Urban Influence', *Urban History*, vol. 22, pt. 2, August, 187–204.

Lorente, J. P. (1998) *Cathedrals of Urban Modernity: The First Museums of Contemporary Art, 1800–1930*, Aldershot: Ashgate.

Lowe, D. (1982) *The History of Bourgeois Perception*, Brighton: Harvester Press.

Lukács, G. (1962) *The Historical Novel*, London: Merlin Press; translated by Mitchell, H. and Mitchell, S.

Lumley, R. (ed.) (1988) *The Museum Time-Machine: Putting Cultures on Display*, London: Routledge/Comedia.

Lynch, M. (1991) *Scotland: A New History*, London: Century.

McCaffrey, J. (1981) 'Thomas Chalmers and Social Change', *Scottish Historical Review*, vol. 60, no. 169, 32–60.

McCosh, J. (1875) 'David Hume', chapter XIX of Scottish Philosophy, http://www.utm.edu/research/iep/text/mccosh/mc-19.htm.

McCrone, D. (1992) *Understanding Scotland*, London: Routledge.

McCrone, D., Kendrick, S. and Straw, P. (eds) (1989) *The Making of Scotland: Nation, Culture and Social Change*, Edinburgh: Edinburgh University Press.

Macdonald, S. (1996) 'Theorizing Museums: An Introduction', in S. Macdonald and G. Fyfe (eds), *Theorizing Museums*, Oxford: Blackwell.

Macdonald, S. and Fyfe, G. (eds) (1996) *Theorizing Museums*, Oxford: Blackwell.

Mace, R. (1976) *Trafalgar Square: Emblem of Empire*, London: Lawrence and Wishart.

McElroy, D. (1969) *Scotland's Age of Improvement*, Pullman: Washington State University Press.

Macinnes, A. (1994) 'Landownership, Land Use and Elite Enterprise in Scottish Galedom: From Clanship to Clearance in Argyllshire 1688–1858', in T. Devine (ed.), *Scottish Elites*, Edinburgh: John Donald.

McKay, W. (1906) *The Scottish School of Painting*, London: Duckworth.

McKean, C. (1991) *Edinburgh: Portrait of a City*, London: Century.

McKendrick, N., Brewer, J. and Plumb, J. (1982) *The Birth of a Consumer Society*, London: Europa.

McLellan, A. (1994) *Inventing the Louvre: Art, Politics and the Origins of the Modern Museum in Eighteenth Century Paris*, Cambridge: Cambridge University Press.

McLennan, J. C. (1860) *Fine Art Pamphlets – Scottish*, Edinburgh: John Menzies.

Macleod, D. (1996) *Art and the Victorian Middle Class*, Cambridge: Cambridge University Press.

Macmillan, D. (1979) 'The Tradition of Painting in Scotland', *Cencrastus*, no. 1, Autumn.

Macmillan, D. (1980) 'Scotland and the Art of Nationalism', *Cencrastus*, no. 4, Winter, 33–5.

Macmillan, D. (1984a) 'Scottish Painting 1500–1700', *Cencrastus*, no. 15, New Year.

Macmillan, D. (1984b) 'Scottish Painting: Ramsay to Raeburn', *Cencrastus*, no. 17, Summer.

Macmillan, D. (1984c) 'Scottish Painting: The Later Enlightenment', *Cencrastus*, no. 19, Winter.

Macmillan, D. (1986) *Painting in Scotland: The Golden Age*, Oxford: Phaidon.

Macmillan, D. (1990) *Scottish Art: 1460–1990*, Edinburgh: Mainstream.

Malraux, A. (1954) *The Voices of Silence*, London: Secker and Warburg.

Mann, M. (1986) *The Sources of Social Power, vol. 1*, Cambridge: Cambridge University Press.

Mannings, D. (1992) 'The Visual Arts', in B. Ford (ed.), *Eighteenth-Century Britain*, The Cambridge Cultural History of Britain, vol. 5, Cambridge: Cambridge University Press.

Markus, T. (ed.) (1982) *Order in Space and Society*, Edinburgh: Mainstream.

Markus, T. (1985) 'Domes of Enlightenment: Two Scottish University Museums', *Art History*, vol. 8. no. 2, 158–77.

Markus, T. (1989a) 'Class and Classification in the Buildings of the Late Scottish Enlightenment', in T. Devine (ed.), *Improvement and Enlightenment*, Edinburgh: John Donald.

Markus, T. (1989b) 'Buildings of the Late Scottish Enlightenment', in T. Devine (ed.), *Improvement and Enlightenment*, Edinburgh: John Donald.

Markus, T. (1993) *Buildings and Power: Freedom and Control in the Origin of Modern Building Types*, London: Routledge.

Martin, G. (1974) 'The Founding of the National Gallery in London', *The Connoisseur*, in nine parts, vol. 185–6, April–December.

Mason, J. H. (1993) 'Thinking About Genius in the Eighteenth Century', in P. Mattick, Jr. (ed.), *Eighteenth Century Aesthetics and the Reconstruction of Art*, Cambridge: Cambridge University Press.

Mattick, Jr., P. (ed.) (1993a) *Eighteenth Century Aesthetics and the Reconstruction of Art*, Cambridge: Cambridge University Press.

Mattick, Jr., P. (1993b) 'Art and Money', in P. Mattick, Jr. (ed.), *Eighteenth Century Aesthetics and the Reconstruction of Art*, Cambridge: Cambridge University Press.

Maxwell, J. S. (1913) 'The Royal Scottish Academy', *Scottish Historical Review*, vol. X, no. 39.

Meyer, K. (1979) *The Art Museum: Power, Money, Ethics*, New York: William Morrow and Co.

Miles, H. (1962) 'Early Exhibitions in Glasgow (1761–1838)', *Scottish Art Review*, vol. 8, no. 4, 26–30.

Miller, E. (1974) *That Noble Cabinet: A History of the British Museum*, Athens, Ohio: Ohio University Press.

Miller, K. (ed.) (1970) *Memoirs of a Modern Scotland*, London: Faber and Faber.

Minihan, J. (1977) *The Nationalisation of Culture: The Development of State Subsidies to the Arts in Great Britain*, London: Hamilton.

Mitchell, W. J. T. (1995) 'Gombrich and the Rise of Landscape', in A. Bermingham and J. Brewer (eds), *The Consumption of Culture: Image, Object, Text*, London: Routledge.

Mitchison, R. (1970) *A History of Scotland*, London: Methuen and Co. Ltd.

Mitchison, R. (1983) *Lordship to Patronage: Scotland 1603–1745*, London: Edward Arnold.

Monro, A. (1846) *Scottish Art and National Encouragement*, Edinburgh: Blackwood and Sons.

Mordaunt-Crook, J. (1972) *The British Museum*, London: Allen Lane.

Moriarty, M. (1994) 'Structures of Cultural Production in Nineteenth-Century France', in P. Collier and R. Lethbridge (eds), *Artistic Relations: Literature and*

the Visual Arts in Nineteenth-Century France, New Haven and London: Yale University Press.

Murdock, A. and Sher, R. (1988) 'Literary and Learned Culture', in T. Devine and R. Mitchison (eds), *People and Society in Scotland, vol. 1, 1760–1830*, Edinburgh: John Donald.

Nairn, T. (1964) 'The English Working Class', *New Left Review*, no. 23, Jan./Feb.

Nairn, T. (1970) 'The Three Dreams of Scottish Nationalism', in K. Miller (ed.), *Memoirs of a Modern Scotland*, London: Faber and Faber.

Nairn, T. (1974) 'Scotland and Europe', *New Left Review*, no. 83, 57–82.

Nairn, T. (1977) *The Breakup of Britain*, London: Verso.

National Gallery of Scotland (1957) *Catalogue of Paintings and Sculpture*, 51st edn, Edinburgh, Printed for the Trustees.

National Galleries of Scotland (1989) *National Galleries of Scotland*, London: Scala Books.

National Galleries of Scotland (1990) *Scotland's Pictures: The National Collection of Scottish Art*, Trustees of the National Galleries of Scotland.

Nauckhoff, J. C. (1994) 'Objectivity and Expression in Thomas Reid's Aesthetics', *The Journal of Aesthetics and Art Criticism*, vol. 52, no. 2, Spring, 183–91.

Negrin, L. (1993) 'On the Museum's Ruins', *Theory, Culture and Society*, vol. 10, 97–125.

Nenadic, S. (1988) 'The Rise of the Urban Middle Classes', in T. Devine and R. Mitchison (eds), *People and Society in Scotland, vol. 1, 1760–1830*, Edinburgh: John Donald.

Nenadic, S. (1990) 'Political Reform and the 'Ordering' of Middle Class Protest', in T. Devine (ed.), *Conflict and Stability in Scottish Society*, Edinburgh: John Donald.

Nenadic, S. (1994) 'Scottish Fiction and the Material World in the Early Nineteenth Century', in A. Cummings and T. Devine (eds), *Industry, Business and Society in Scotland Since 1700*, Edinburgh: John Donald.

Nenadic. S. (1997) 'Print Collecting and Popular Culture in Eighteenth-Century Scotland', *History*, vol. 82, no. 266, 203–22.

Noble, A. (1982) 'Versions of the Scottish Pastoral: the Literati and the Tradition 1730–1830', in T. Markus (ed.), *Order in Space and Society*, Edinburgh: Mainstream.

Nochlin, L. (1971) 'Museums and Radicals: A History of Emergencies', *Art in America*, vol. 54, no. 4, 26–39.

Noel, J. (1994) 'Space, Time and the Sublime in Hume's *Treatise'*, *British Journal of Aesthetics*, vol. 34, no. 3, July, 218–25.

Oliver, C. (1989) 'Art in Scotland', in P. Zenzinger (ed.), *Scotland: Literature, Culture, Politics*, Heidelberg: Carl Winter Publishers.

Ouston, H. (1982) 'York in Edinburgh: James VII and the Patronage of Learning in Scotland, 1679–1688', in J. Dwyer, R. Mason and A. Murdoch (eds), *New Perspectives on the Politics and Culture of Early Modern Scotland*, Edinburgh: John Donald.

Oz-Salzberger, F. (ed.) (1995) 'Introduction', in A. Ferguson, *An Essay on the History of Civil Society*, ed. D. Forbes, Edinburgh: Edinburgh University Press.

Panofsky, E. (1955) *Meaning in the Visual Arts: Papers in and on Art History*, Garden City, N.Y.: Doubleday.

Paterson, L. (1994) *The Autonomy of Modern Scotland*, Edinburgh: Edinburgh University Press.

Pearce, S. (1992) *Museums, Objects and Collections: A Cultural Study*, Leicester: Leicester University Press.

Pears, I. (1988) *The Discovery of Painting: The Growth of Interest in the Arts in England 1680–1768*, New Haven and London: Yale University Press.

Pearson, N. M. (1982) *The State and the Visual Arts: A Discussion of State Intervention in the Visual Arts in Britain, 1760–1981*, Milton Keynes: Open University Press.

Perkin, H. (1990) *The Rise of Professional Society Since 1880*, London: Routledge.

Perricone, C. (1995) 'The Body and Hume's Standard of Taste', *The Journal of Aesthetics and Art Criticism*, vol. 53, no. 4, Fall, 371–8.

Pevsner, N. (1940) *Academies of Art: Past and Present*, Cambridge: Cambridge University Press.

Pevsner, N. (1970) 'French and Dutch Artists in the Seventeenth Century', in M. C. Albrecht, J. H. Barnett and M. Griff (eds), *The Sociology of Art: A Reader*, London: Duckworth.

Pevsner, N. (1976) *A History of Building Types*, London: Thames and Hudson.

Phillipson, N. T. (1973) 'Towards a Definition of the Scottish Enlightenment', in P. Fritz and D. Williams (eds), *City and Society in the Eighteenth Century*, Edinburgh: John Donald.

Phillipson, N. T. (1975) 'Culture and Society in the Eighteenth Century Province: The Case of Edinburgh and the Scottish Enlightenment', in L. Stone (ed.), *The University in Society, Vol. II*, London: Oxford University Press.

Phillipson, N. T. (1981) 'The Scottish Enlightenment', in R. Porter and M. Teich (eds), *The Enlightenment in National Context*, Cambridge: Cambridge University Press.

Phillipson, N. T. (1983) 'Adam Smith as Civic Moralist', in I. Hont and M. Ignatieff (eds), *Wealth and Virtue: The Shaping of Political Economy in the Scottish Enlightenment*, Cambridge: Cambridge University Press.

Pittock, M. (1991) *The Invention of Scotland: The Stuart Myth and the Scottish Identity 1638 to the Present*, London: Routledge.

Plumb, J. H. (1972) 'The Public, Literature and the Arts in the Eighteenth Century', in P. Fritz and D. Williams (eds), *City and Society in the Eighteenth Century*, Edinburgh: John Donald.

Pocock, J. G. A. (1972) 'Virtue and Commerce in the Eighteenth Century', *Journal of Interdisciplinary History*, vol. 3, 119–34.

Pocock, J. G. A (1975) *The Machiavellian Moment: Florentine Political Thought and the Atlantic Republican Tradition*, Princeton: Princeton University Press.

Pocock, J. G. A. (1983) 'Cambridge Paradigms and Scotch Philosophers: A Study of the Relations between the Civic Humanist and the Civil Jurisprudential Interpretation of Eighteenth Century Social Thought', in I. Hont and M. Ignatieff (eds), *Wealth and Virtue: The Shaping of Political Economy in the Scottish Enlightenment*, Cambridge: Cambridge University Press.

Poggi, G. (1978) *The Development of the Modern State*, London: Hutchinson.

Poggi, G. (1990) *The State: Its Nature, Development and Prospects*, Oxford: Polity.

Pointon, M. (1993) *Hanging the Head: Portraiture and Social Formation in Eighteenth Century England*, New Haven and London: Yale University Press.

Pointon, M. (ed.) (1994) *Art Apart: Museums in North America and Britain Since 1800*, Manchester: Manchester University Press.

Pointon, M. and Binski, P. (eds) (1997) *National Art Academies in Europe 1860–1906: Educating, Training, Exhibiting, Art History*, vol. 20, no. 1, March.

Pollock, G. (1988) *Vision and Difference: Femininity, Feminism and the Histories of Art*, London: Routledge.

Pomeroy, J. (1998) 'Creating a National Collection: The National Gallery's Origins in the British Institution', *Apollo*, August 1998: 41–9.

Pomian, K. (1990) *Collectors and Curiosities, Paris and Venice, 1500–1800*, Cambridge: Polity Press.

Preziosi, D. (1994) 'Modernity Again: the Museum as Trompe L'Oeil', in P. Brunette and D. Wills (eds), *Deconstruction and the Visual Arts: Art, Media, Architecture*, Cambridge: Cambridge University Press.

Prior, N. (1995) 'Edinburgh, Romanticism and the National Gallery of Scotland', *Urban History*, vol. 22, pt. 2, August.

Prior, N. (1998) *Taste, Nations and Strangers: A Socio-Cultural History of National Art Galleries with Particular Reference to Scotland*, unpublished PhD thesis, University of Edinburgh.

Pugh, S. (1990) *Reading Landscape: Country, City, Capital*, Manchester: Manchester University Press.

Purser, C. (1833) *The Prospects of the Nation in Regard to its National Gallery*, London: Cochrane and McCrone.

Purviance, S. (1991) 'Intersubjectivity and Sociable Relations in the Philosophy of Francis Hutcheson', in J. Dwyer (ed.), *Sociability and Society in Eighteenth-Century Scotland*, Edinburgh: Mercat Press.

Pye, J. (1970) *Patronage of British Art*, London: Cornmarket Press.

Quinn, P. (1990) 'David Allan (1744–1796)', *Edinburgh Review*, vol. 83, 120–1.

Rawdon, Colonel (1851) *Letter to the Trustees of the National Gallery*, London: Ridgway.

Rees, A.L. and Borzello, F. (eds) (1986) *The New Art History*, London: Camden Press.

Reid, T. (1774) *Lectures on Fine Arts*, in P. Kivy (ed.), *Thomas Reid's Lectures on the Fine Arts*, The Hague: Martinus Nijhoff, 1973.

Rendall, J. (1978) *The Origins of the Scottish Enlightenment 1707–1776*, London: Macmillan.

Robbins, B. (ed.) (1993) *The Phantom Pubic Sphere*, Minneapolis: University of Minnesota Press.

Robertson, J. (1983) 'The Scottish Enlightenment at the Limits of the Civic Tradition', in I. Hont and M. Ignatieff (eds), *Wealth and Virtue: The Shaping of Political Economy in the Scottish Enlightenment*, Cambridge: Cambridge University Press.

Robinson, J. (1867) *The National Gallery Considered in Reference to Other Public Collections and to the Proposed New Building in Trafalgar Square*, London: James Toovey.

Rock, J. (1995) 'Relugas and the Dick Lauder Family', in I. Gow and A. Rowan (eds), *Scottish Country Houses, 1600–1914*, Edinburgh: Edinburgh University Press.

Rosenthal, M. (1992) 'The Fine Arts', in B. Ford (ed.), *The Romantic Age in Britain*, Cambridge and New York: Cambridge University Press.

Roundrobin, R. (1826) 'A Letter to the Directors and Members of the Institution for the Encouragement of the Fine Arts in Scotland and other correspondence', Royal Scottish Academy: Edinburgh.

Rowan, A. (1984) 'The Building of Hopetoun', *Architectural History*, vol. 27.

Rudé, G. (1971) *Hanoverian London, 1714–1808*, London: Secker and Warburg.

Ruskin, J. (1855) *Lectures on Architecture and Painting Delivered at Edinburgh in November 1853*, London: Smith, Elder and Company.

Saumarez-Smith, C. (1989) 'Museums, Artefacts, and Meanings', in P. Vergo (ed.), *The New Museology*, London: Reaktion Books.

Schama, S. (1991) *The Embarrassment of Riches*, London: Fontana.

Schildt, G. (1988) 'The Idea of the Museum', in L. Aagaard-Morgensen (ed.), *The Idea of the Museum*, Lewiston: Edwin Mellor Press.

Scott, W. (1814) *Waverley*, Edinburgh: Archibald Constable.

Seligman, A. (1992) *The Idea of Civil Society*, New York: Free Press.

Seling, H. (1967) 'The Genesis of the Museum', *Architectural History*, vol. 141, no. 840.

Sennett, R. (1977) *The Fall of Public Man*, Cambridge: Cambridge University Press.

Serota, N. (1996) *Experience or Interpretation: The Dilemma of Museums of Modern Art*, London: Thames and Hudson.

Seton-Watson, H. (1977) *Nations and States: An Enquiry into the Origins of Nations and the Politics of Nationalism*, London: Methuen.

Shelley, J. (1994) 'Hume's Double Standard of Taste', *The Journal of Aesthetics and Art Criticism*, vol. 52, no. 4, Fall, 437–45.

Shepherd, T. and Britton, J. (1831) *Modern Athens: Edinburgh in the Nineteenth Century*, reprinted by Arno Press: New York, 1978.

Sher, R. (1985) *Church and University in the Scottish Enlightenment*, Edinburgh: Edinburgh University Press.

Sherman, D. (1987) 'The Bourgeoisie, Cultural Appropriation and the Art Museum', *Radical History*, Spring, no. 38.

Sherman, D. (1989) *Worthy Monuments: Art Museums and the Politics of Culture in Nineteenth-Century France*, Cambridge, Mass., and London: Harvard University Press.

Sherman, D. and Rogoff, I. (1994) *Museum Culture: Histories, Discourses, Spectacles*, Minneapolis: University of Minnesota Press.

Shiner, R. A. (1996) 'Hume and the Casual Theory of Taste', *The Journal of Aesthetics and Art Criticism*, vol. 54, no. 3, Summer, 238–49.

Shusterman, R. (1993) 'Of the Scandal of Taste: Social Privilege as Nature in the Aesthetic Theories of Hume and Kant', in P. Mattick, Jr. (ed.), *Eighteenth Century Aesthetics and the Reconstruction of Art*, Cambridge: Cambridge University Press.

Sicca, C. M. (1992) 'Holkham Hall, Norfolk', in B. Ford (ed.), *Eighteenth-Century Britain*, The Cambridge Cultural History, vol. 5, Cambridge: Cambridge University Press.

Simmel, G. (1950) 'The Stranger', in K. Wolff (ed.), *The Sociology of Georg Simmel*, New York: Free Press.

Smailes, H. (1991) 'A History of the Statue Gallery at the Trustees' Academy in Edinburgh and the Acquisition of the Albacini Casts in 1838', *Journal of the History of Collections*, vol. 3, no. 2, 125–44.

Smart, A. (1992) *Allan Ramsay: Painter, Essayist and Man of the Enlightenment*, New Haven and London: Yale University Press.

Smith, A. D. (1991) *National Identity*, London: Penguin.

Smith, J. V. (1983) 'Manners, Morals and Mentalities: Reflections on the Popular Enlightenment of Early Nineteenth Century Scotland', in W. Humes and H. Paterson (eds), *Scottish Culture and Scottish Education*, Edinburgh: John Donald.

Smout, T. C. (1969) *A History of the Scottish People 1560–1830*, London: Collins.

Smout, T. C. (1992) 'Scottish–Dutch Contact 1600–1800', in J. Williams (ed.), *Dutch Art and Scotland*, Exhibition Catalogue, Edinburgh: National Galleries of Scotland.

Solkin, D. (1992) *Painting for Money: The Visual Arts and the Public Sphere in Eighteenth Century England*, New Haven and London: Yale University Press.

Solomon, M. (1979) *Marxism and Art: Essays Classical and Contemporary*, Brighton: Harvester.

Spalding, J. (1991) 'Is There Life in Museums?', in G. Kavanagh (ed.), *The Museums Profession*, Leicester: Leicester University Press.

Stallybrass, P. and White, A. (1986) *The Politics and Poetics of Transgression*, London: Methuen.

Steegman, J. (1987) *Victorian Taste*, London: National Trust Classics.

Swartz, D. (1997) *Culture and Power: The Sociology of Pierre Bourdieu*, Chicago and London: Chicago University Press.

Tait, S. (1989) *Palaces of Discovery: The Changing World of Britain's Museums*, London: Quiller Press.

Taylor, B. (1999) *Art for the Nation*, Manchester: Manchester University Press.

Telman, J. (1996) 'The Creation of Public Culture in Pre-1848 Berlin', unpublished conference paper, *The Nineteenth Century City: Global Contexts, Local Productions*, University of Santa Cruz.

Thomas, A. (1999) 'The National Gallery's First 50 Years: "Cut the Cloth to Suit the Purpose" ', in G. Perry and C. Cunningham (eds), *Academies, Museums and Canons of Art*, New Haven and London: Yale University Press.

Thomas, P. W. (1977) 'Charles I of England: The Tragedy of Absolutism', in A.G. Dickens (ed.), *The Courts of Europe: Politics, Patronage and Royalty, 1400–1800*, London: Thames and Hudson.

Thompson, C. (1972) *Pictures for Scotland: The National Gallery of Scotland and its Collection*, Edinburgh: Trustees of the National Galleries of Scotland.

Thompson, C. and Brigstocke, H. (1978) *The National Gallery of Scotland Shorter Catalogue,* Edinburgh.

Thompson, D. (1975) *Painting in Scotland 1570–1650*, Edinburgh: Exhibition Catalogue, National Portrait Gallery, Trustees of the National Galleries of Scotland.

Thompson, E. P. (1978) *The Poverty of Theory and Other Essays*, London: Merlin Press.

Thompson, J. (ed.) (1992) *Manual of Curatorship: A Guide to Museum Practice*, London: Butterworth.

Tilly, C. (1975) *The Formation of National States in Western Europe*, Princeton, NJ: Princeton University Press.

Trodd, C. (1994) 'Culture, Class, City: The National Gallery, London and the Spaces of Education, 1822–57', in M. Pointon (ed.), *Art Apart: Museums in North America and Britain Since 1800*, Manchester: Manchester University Press.

Trodd, C. (1997) 'The Authority of Art: Cultural Criticism and the Idea of the Royal Academy in mid-Victorian Britain', *Art History*, vol. 20, no. 1, March, 3–22.

Trodd, C. (1998) 'Being Seen: Looking at the National Gallery in mid-Victorian London', unpublished conference paper, ESRC, Museum and Society Seminar 1: Disciplines of the Museum, University of Keele.

Van Luttervelt, R. (1960) *Dutch Museums*, London: Thames and Hudson.

Veblen, T. (1949) *The Theory of the Leisure Class*, London: Unwin Books.

Verax (1847) *The Abuses of the National Gallery with the Letters of "AG" of "The Oxford Graduate"; the Defence of Mr Eastlake in "The Daily News" etc.*, London: William Pickering.

Vergo, P. (1989) *The New Museology*, London: Reaktion Books.

Virilio, P. (1991) *The Aesthetics of Disappearance*, New York: Semiotext(e).

Virilio, P. (1994) *The Vision Machine*, London: British Film Institute.

Waagen, G. (1854) *Treasures of Art in Great Britain*, London: John Murray.

Walker, F. (1985) 'National Romanticism and the Architecture of the City', in I. Gordon (ed.), *Perspectives on the Scottish City*, Aberdeen: Aberdeen University Press.

Warnke, M. (1993) *The Court Artist: On the Ancestry of the Modern Artist*, Cambridge: Cambridge University Press.

Waterfield, G. (ed.) (1991) *Palaces of Art: Art Galleries in Britain 1790–1900*, London: Dulwich Picture Gallery.

Weber, E. (1973) *Peasants into Frenchmen: The Modernization of Rural France, 1870–1914*, London: Chatto and Windus

Westermann, M. (1996) *The Art of the Dutch Republic 1585–1718*, London: Everyman.

White, H. and White, C. (1965) *Canvases and Careers*, New York: John Wiley.

Whitley, W. (1930) *Art in England, 1821–1837*, Cambridge: Cambridge University Press.

Wiener, M. (1981) *English Culture and the Decline of the Industrial Spirit 1850–1980*, Cambridge, New York: Cambridge University Press.

Wilkinson, M. (1992) 'Hume's Of the Standard of Taste', in M. Bartholomew, D. Hall and A. Lentin (eds), *The Enlightenment*, Milton Keynes: Open University Press.

Williams, A. G. (1992) 'An Edinburgh Intrigue', *Arts Review*, May, 183.

Williams, A. G. and Brown, A. (1993) *The Bigger Picture: A History of Scottish Art*, London: BBC Books.

Williams, J. (ed.) (1992a) *Dutch Art and Scotland*, Exhibition Catalogue, Edinburgh: National Galleries of Scotland.

Williams, J. (1992b) 'Dutch Art and Scotland', in J. Williams (ed.), *Dutch Art and Scotland*, Exhibition Catalogue, Edinburgh: National Galleries of Scotland.

Williams, R. (1973) *The Country and the City*, London: Chatto and Windus.

Williams, R. (1976) *Keywords: A Vocabulary of Culture and Society*, London: Croom Helm.

Williams, R. (1981) *Culture*, London: Fontana.

Williams, R. (1990) 'Between Country and City', in S. Pugh (ed.), *Reading Landscape: Country, City, Capital*, Manchester and New York: Manchester University Press.

Withers, C. (1992) 'The Historical Creation of the Scottish Highlands', in I. Donnachie and C. Whatley (eds), *The Manufacture of Scottish History*, Edinburgh: Polygon.

Witkin, R. (1995) *Art and Social Structure*, Cambridge: Polity.

Wittlin, A. (1949) *The Museum: Its History and its Tasks in Education*, London: Routledge and Kegan Paul.

Wolff, J. (1981) *The Social Production of Art*, London: Macmillan.

Wolff, J. (1983) *Aesthetics and the Sociology of Art*, London: Allen and Unwin.

Wolff, J. (1991) 'Excess and Inhibition: Interdisciplinarity in the Study of Art', in L. Grossberg, G. Nelson and P. Treichler (eds), *Cultural Studies*, London: Routledge.

Wolff, J. and Seed, J. (eds) (1988) *The Culture of Capital: Art, Power and the Nineteenth Century Middle Class*, Manchester: Manchester University Press.

Womack, P. (1988) *Improvement and Romance: Constructing the Myth of the Highlands*, London: Macmillan.

Bibliography

Wrightson, K. (1989) 'Kindred Adjoining Kingdoms: An English Perspective on the Social and Economic History of Early Modern Scotland', in R. Houston and I. White (eds), *Scottish Society 1500–1800*, Cambridge: Cambridge University Press.

Yapp, G. W. (1853) *Art Education at Home and Abroad: The British Museum, the National Gallery, and the Proposed Industrial University*, London: Chapman and Hall.

Youngson, A. (1966) *The Making of Classical Edinburgh, 1750–1840*, Edinburgh: Edinburgh University Press.

Zolberg, V. (1984) 'American Art Museums: Sanctuary or Free-for-all?', *Social Forces*, vol. 63, no. 2, December, 377–92.

Zolberg, V. (1990) *Constructing a Sociology of the Arts*, Cambridge: Cambridge University Press.

Zolberg, V. (1992) 'Debating the Social: A Symposium on, and with, Pierre Bourdieu', *Contemporary Sociology*, vol. 21, no. 2, 151–61.

Index

Index

Beaubourg Museum, 214
 see also Pompidou Centre
Beaumont, Sir George, 77, 81
beauty, 26, 128–9, 131–2
Becker, Howard, ix, 6
Becker, Marvin, 113
Benjamin, Walter, 60n14, 171
Bennett, Tony, 50–1, 59n9, 61n19
Bentham, Jeremy, 83, 177
Berlin, 47, 53, 60n11, 89
Bernard, Sir Thomas, 77
Beveridge, Craig, 209
Blair, Hugh, 129, 137n19
Blair Castle, 184
Blenheim Palace, 71
Board of Trade, London, 164
Board of Trustees, 174–5, 179, 188–91
 *passim,*196–203 *passim,* 208n12, 213
 and Royal Institution for the
 Encouragement of Fine Arts in
 Scotland, 143–7
 and Royal Scottish Academy, 157–61
 passim
 and state, 161–7 *passim*
 and Trustees' Academy, 118, 136n15
 see also Board of Trustees for the
 Manufacture of Agriculture and
 Fisheries, Scotland
Board of Trustees for the Manufacture of
 Agriculture and Fisheries, Scotland,
 105, 110
 see also Board of Trustees
body, 70, 91, 94, 131, 138n30
Bohls, Elizabeth, 70
Bonaparte, Napoleon, 40, 45, 47
Bonifazio, 195, 198
Boswell, James, 137n19
Boucher, Francois, 30
Bourdieu, Pierre, 20, 38, 134, 147, 168n4,
 197
 field, 6–8, 11n4, 95n7, 139–40, 149,
 166, 215n1
 habitus, 61n20, 173, 207n1
 nomos, 146

symbolic violence, 94, 212
 The Love of Art, 51–7 *passim*
 see also cultural capital, distinction,
 field, genetic structuralism, *habitus*,
 symbolic violence
Bourgeois, Francis, 78
bourgeoisie, 5, 24, 48, 56, 59n6, 66
 and court, 27
 modes of distinction, 22, 38–9
 and public sphere, 52
British Institution for Promoting the Fine
 Arts in the United Kingdom, 77, 141
British Museum, 54, 74, 94n1, 158
Bronckhorst, Arnold, 102
Brown, Denise Scott, 213
Bruce, William, 107
Buccleuch, Duke of, 115, 127, 163
Buckingham, Duke of, 64
Burgin, Victor, 25
Burn, William, 175
Burns, Robert, 106, 208n10
Bute, Earl of, 115, 120
Byron, Lord, 157

cabinet of curiosities, 58n1
Calvinism, 207n5
 see also Scotland; Protestantism
Campsie Mechanics Institute, Scotland,
 200
Camus, Albert, 215
Canova, Antonio, 1
capitalism, 24, 31, 39
Cardinal Geronimo Colonna, 19
Cardinal Mazarin, 16, 19
Cardinal Richelieu, 16
Carr, Holwell, 81
Catherine the Great, 28
Certeau, Michel de, 171
Chalmers, Thomas, 162, 169n15, 170n15
Chaney, David, 172, 206
Chardin, Jean Siméon, 29
Charing Cross, London, 82
Charles I, 64–6, 103
Charles II, 66